D1192378

CELEBRATION OF THE LAND

THE LAST SANCTUARIES

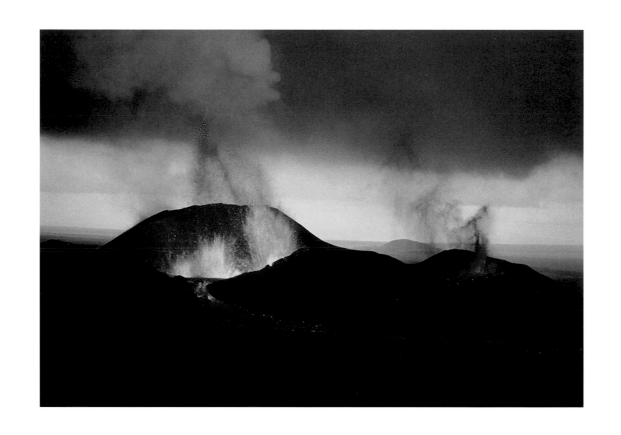

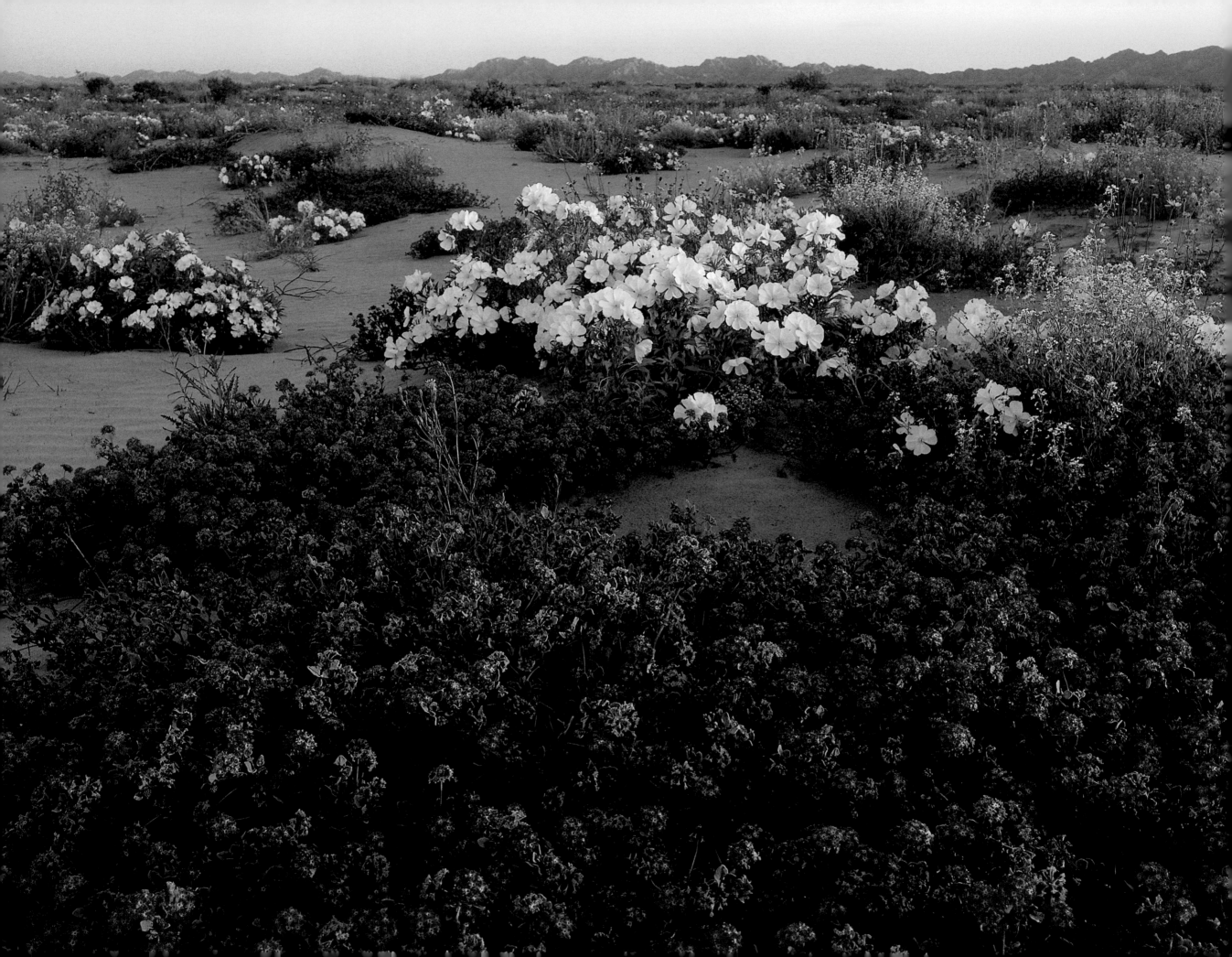

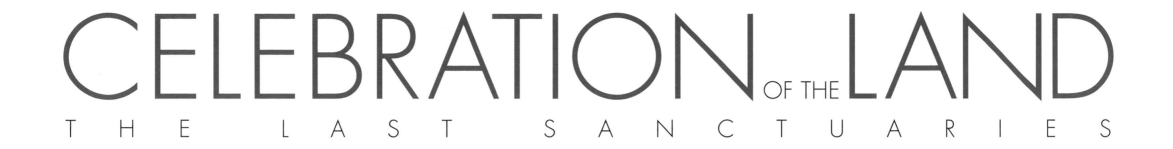

CELEBRATION OF THE LAND
THE LAST SANCTUARIES

FOREWORD

H.R.H. THE PRINCE OF ASTURIAS

TEXTS

JAMES LAWRENCE

PHOTOGRAPHS

THOMAS D. MANGELSEN, ANDRÉ BÄRTSCHI, JAMES BRANDENBURG, TUI DE ROY,
ART WOLFE, PATRICIO ROBLES GIL, MITSUAKI IWAGO, FRANCISCO MÁRQUEZ, FRANS LANTING,
GÜNTER ZIESLER, FRITZ PÖLKING, ALAIN COMPOST, JEAN-PAUL FERRERO

CEMEX

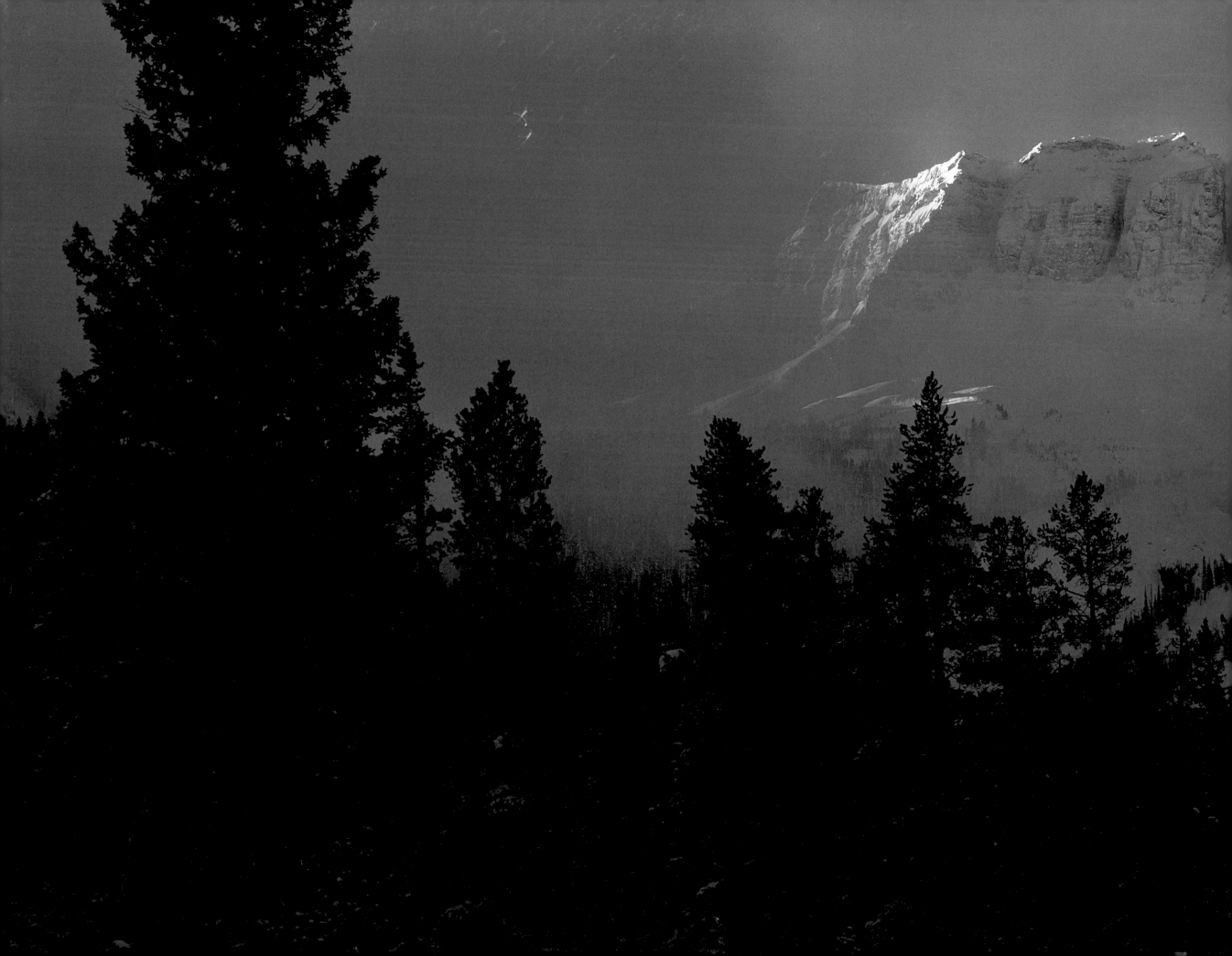

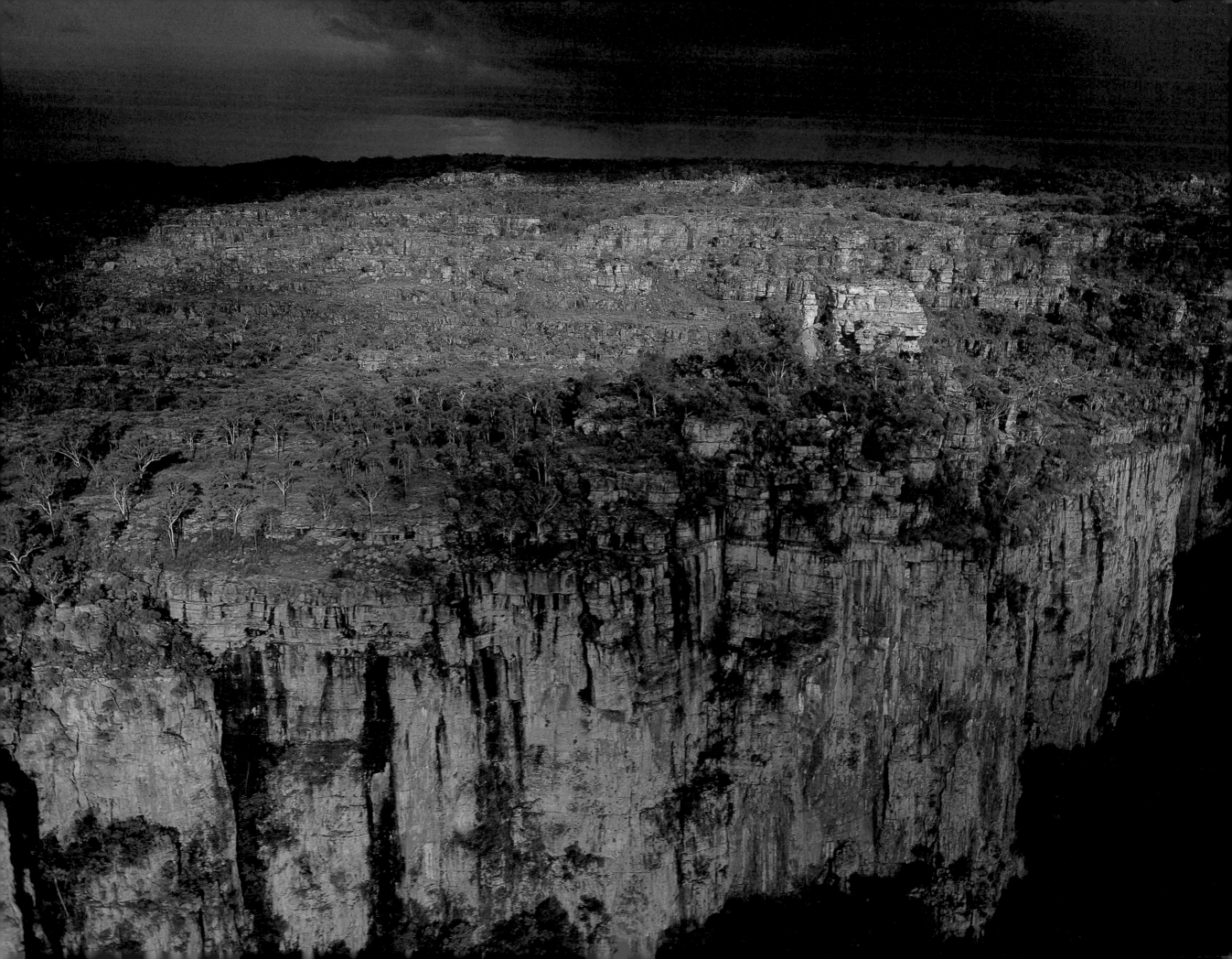

Deep, deep inside Earth's woods, rainforests, and deserts one can still find unimaginable landscapes where our gaze is lost on the horizon. These are veritable sanctuaries of a world from which we all spring, a world to which we all belong. If we stopped just long enough to listen, we would realize that the call of this world is so penetrating that we could hear it reverberate to the beat of our hearts.

"In wildness is the preservation of the world," said the poet and humanist Henry David Thoreau in 1851. The echo of these words serves as an incentive for us with regard to the fate of the last wilderness areas on our planet: How many natural regions will survive into this century? How many will succumb under the pressures exerted by population growth?

In a new effort to reassess the importance of the natural world, CEMEX presents *Celebration of the Land. The Last Sanctuaries*, our eighth book on themes related to biodiversity, the environment, and conservation, a work that underlines an environmental policy which is already firmly ensconced on world agendas: the conservation of wildlife and ecosystems by means of protected natural areas.

From the creation of the first reserve over a century ago to date, in all the world more than 2 000 parks, reserves, and sanctuaries have been established in work done by thousands of individuals and hundreds of governments that have thus reminded us of our moral obligation to future generations and to the other living things with whom we share this planet. Proof of this are the words of His Royal Highness the Prince of Asturias, who has written the foreword to this book and thus highlights its significance.

In this volume we present thirteen regions, all of which are outstanding for their beauty and appeal. At present they all enjoy some degree of protection and represent different ecosystems; over half of them join together several parks, reserves, or sanctuaries. This also underlines the need to conserve biological corridors between protected regions, which often extend beyond political boundaries.

Each of the chapters describing these regions is documented with images taken by a single photographer, who also tells us about some of his or her experiences in an interview conducted by James Lawrence. Nevertheless, these photographs speak for themselves and embrace a passionate commitment to preserving the natural world. In more than one case, the work of the photographer in question has made the region known all over the world.

We have put limits upon our own ambition. The future of these marvelous places depends on each and every one of us.

These regions are living museums; they are unique, and afford us pleasure and inspiration. They are spaces of extraordinary beauty, original fragments of our past.

CEMEX

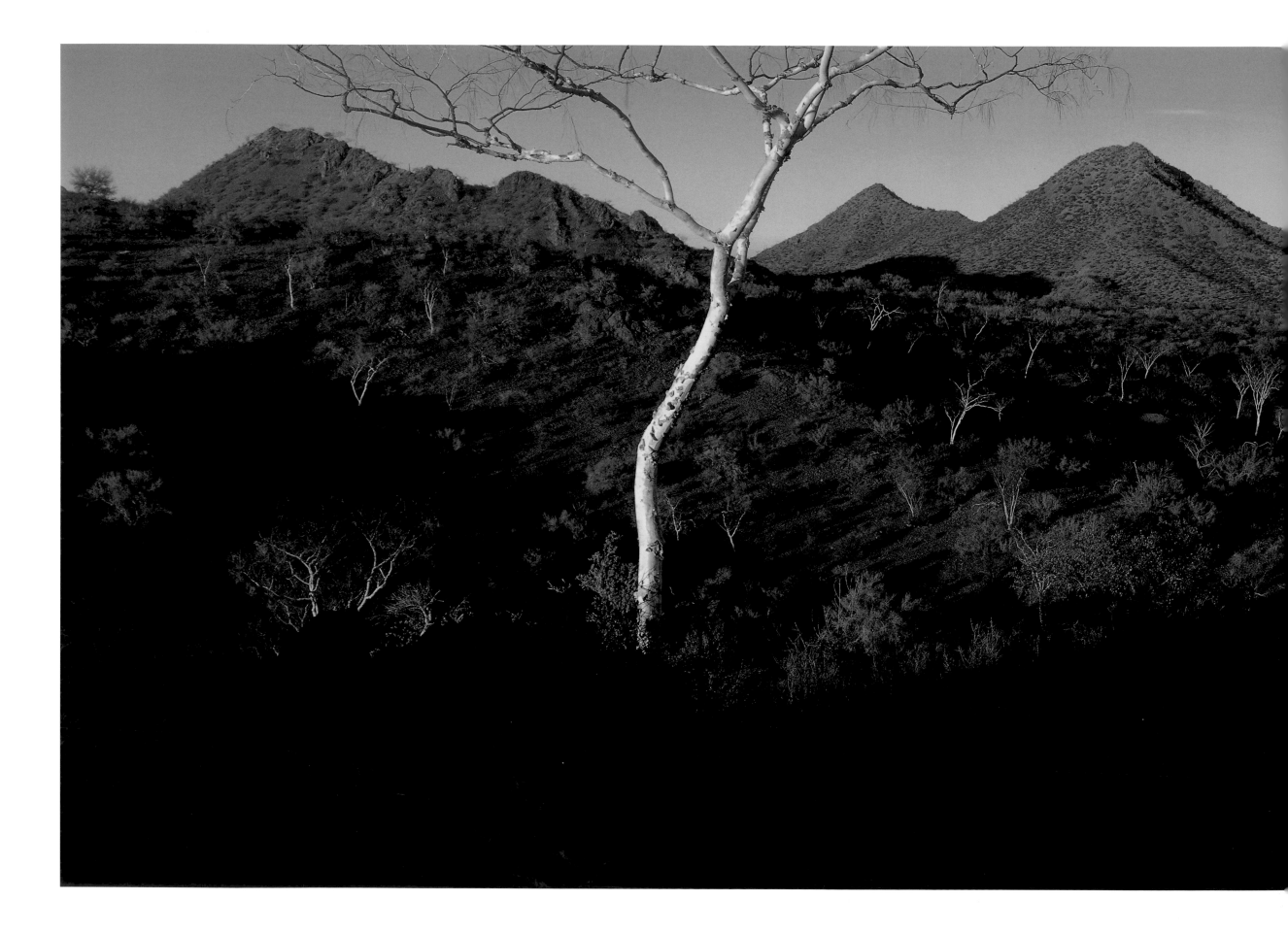

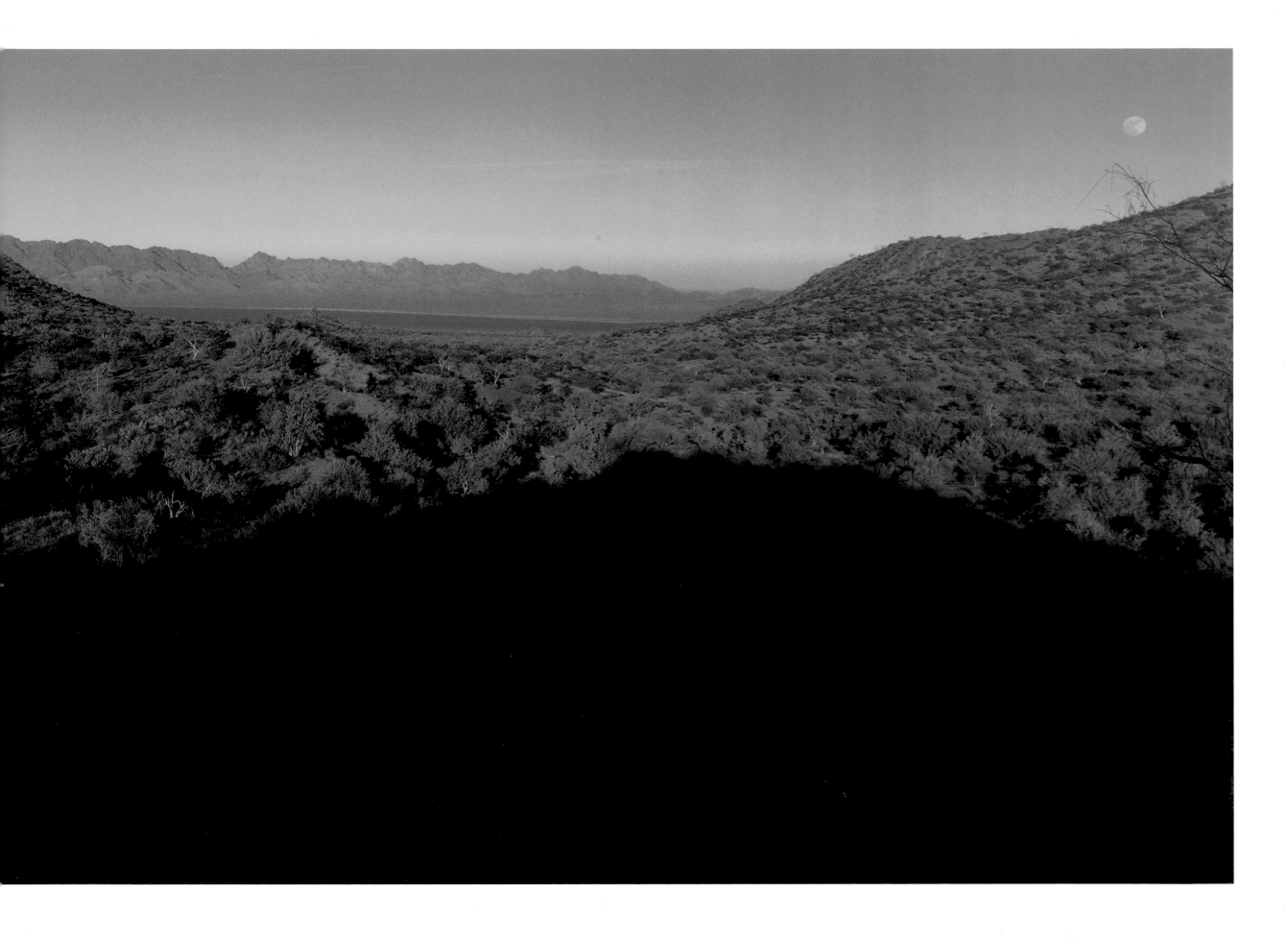

For several millennia, we humans have left our mark on Earth. We have explored, tilled and studied it, piecing together a wealth of knowledge about the world in which we live. Nothing seems to be beyond our bounds, if we put our minds to it. Scientific breakthroughs never cease to astound us and are happening with gathering momentum.

So far, we have had the privilege of co-existing with millions of species, with thousands of forms of life that find refuge in different regions of the planet; amazing ecosystems that are a true reflection of worlds in which time seems to have stopped; paradises of sweeping horizons that store up a wealth of resources and the drama and beauty of the natural pace of life.

However there are now many places where nature is being threatened by selfish and rash manifestations of progress and technology. While the vast dissemination of knowledge has helped give us greater breadth of vision, the increasing harassment of natural sanctuaries spells an impoverishment which in some cases is proving tragically irreversible.

The idea of "conquering and exploring nature" has unfortunately turned into the dangerous symbol of a destructive adventure which we should all help to stop, employing the right mechanisms and without relinquishing the benefits of ingenuity and intelligence that have made mankind progress as never before. That very ingenuity, harnessed to real environmental principles, will help dispel the fraught tension between material progress and nature conservation and respect for the environment.

Our national and regional communities are beginning to appreciate the value of natural resources and the need for them to be used and enjoyed properly. Despite that, there is a lot of ground to cover, and the task of paving and building a civilization that restores us to our roots and leads us back to Mother Earth or Pacha Mama, as they say in the Andes, is enormous.

For that reason, it is a great pleasure for me to join in the effort and impetus put into this book, *Celebration of the Land. The Last Sanctuaries*, which stunningly portrays the beauty and diversity of some of the planet's most famous natural parks and reserves, including Cabañeros in Spain, an example of Europe's natural Mediterranean habitat.

Photographers from several different countries have joined forces to pool their talent and offer us this multiple and marvellous testimony of these resources. The concept of last sanctuaries referred to in the subtitle of the book is an invitation for us to hasten our efforts to strengthen that new culture, in which mankind's new-found appreciation of nature and perception of Earth represent one of history's great intellectual revolutions.

In addition to supranational efforts, it is vital for each country, social sector, company, and even every individual, to pledge their commitment to this project. By doing so, this collective and pressing effort to maintain large expanses of natural, virgin and primitive ecosystems, where nature can continue at its own pace, will be judged by the next generations with gratitude and admiration. They will realise that, at the end of the 20th century, men and women concentrated their energies on successfully carrying out a praiseworthy undertaking: that of safeguarding and preserving the priceless treasures of our home on Earth.

Príncipe de Asturias

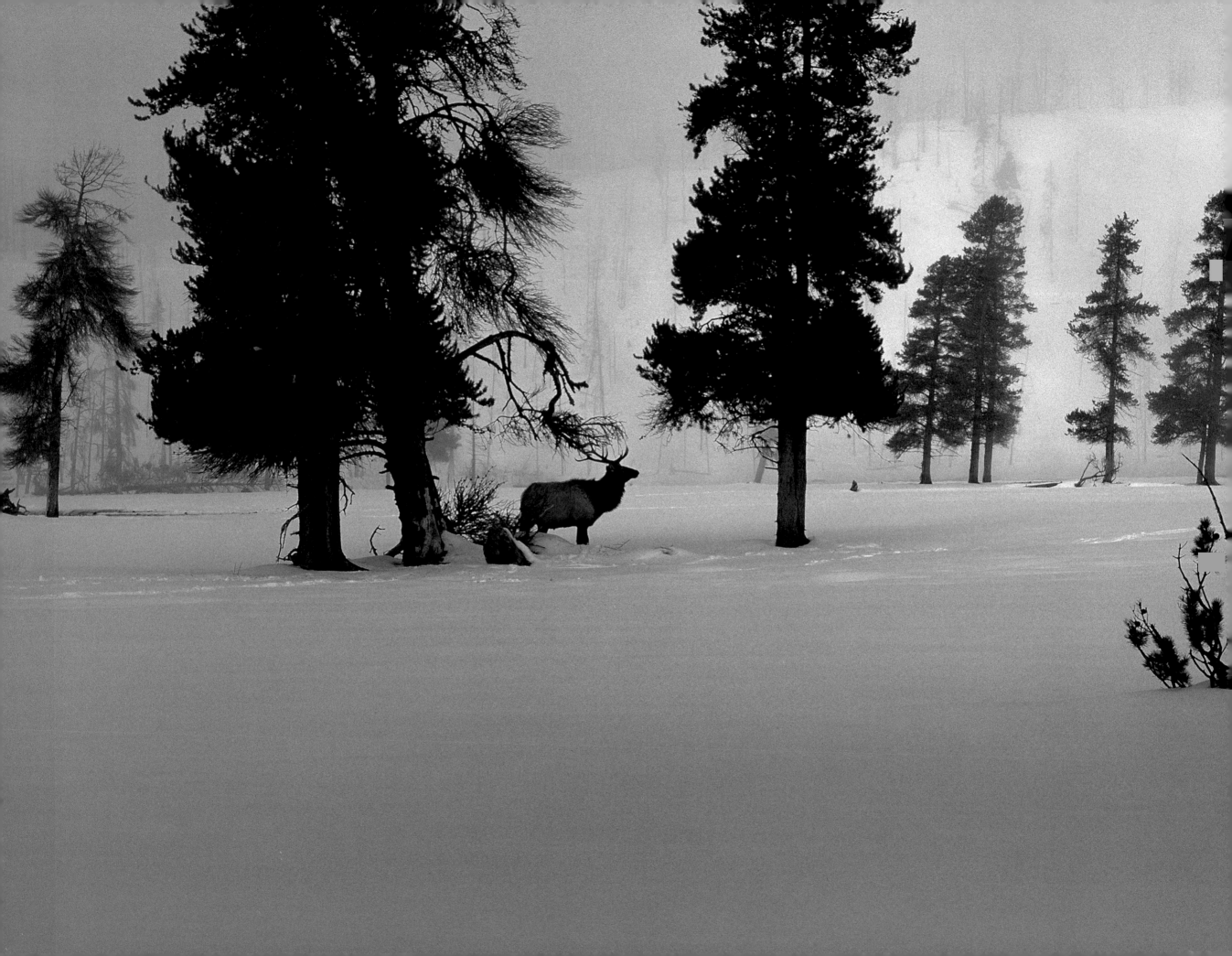

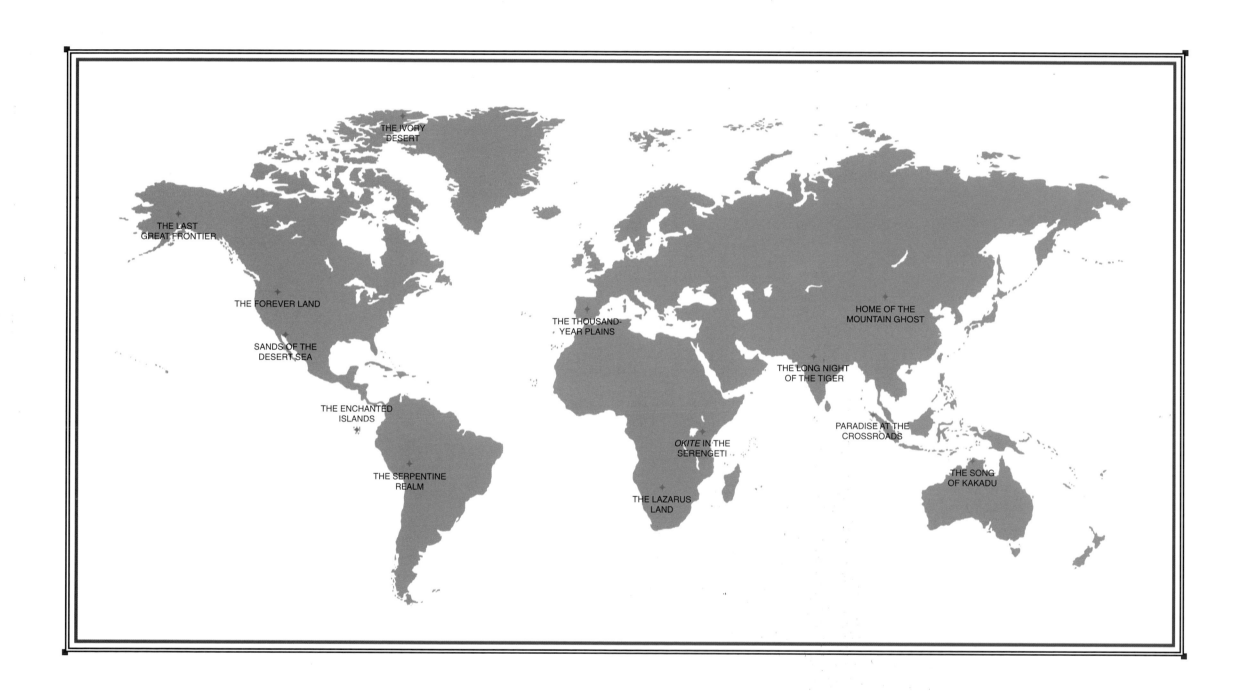

THE IVORY
DESERT

THE LAST
GREAT FRONTIER

THE FOREVER LAND

THE THOUSAND-
YEAR PLAINS

HOME OF THE
MOUNTAIN GHOST

SANDS OF THE
DESERT SEA

THE LONG NIGHT
OF THE TIGER

THE ENCHANTED
ISLANDS

PARADISE AT THE
CROSSROADS

OKITE IN THE
SERENGETI

THE SONG
OF KAKADU

THE SERPENTINE
REALM

THE LAZARUS
LAND

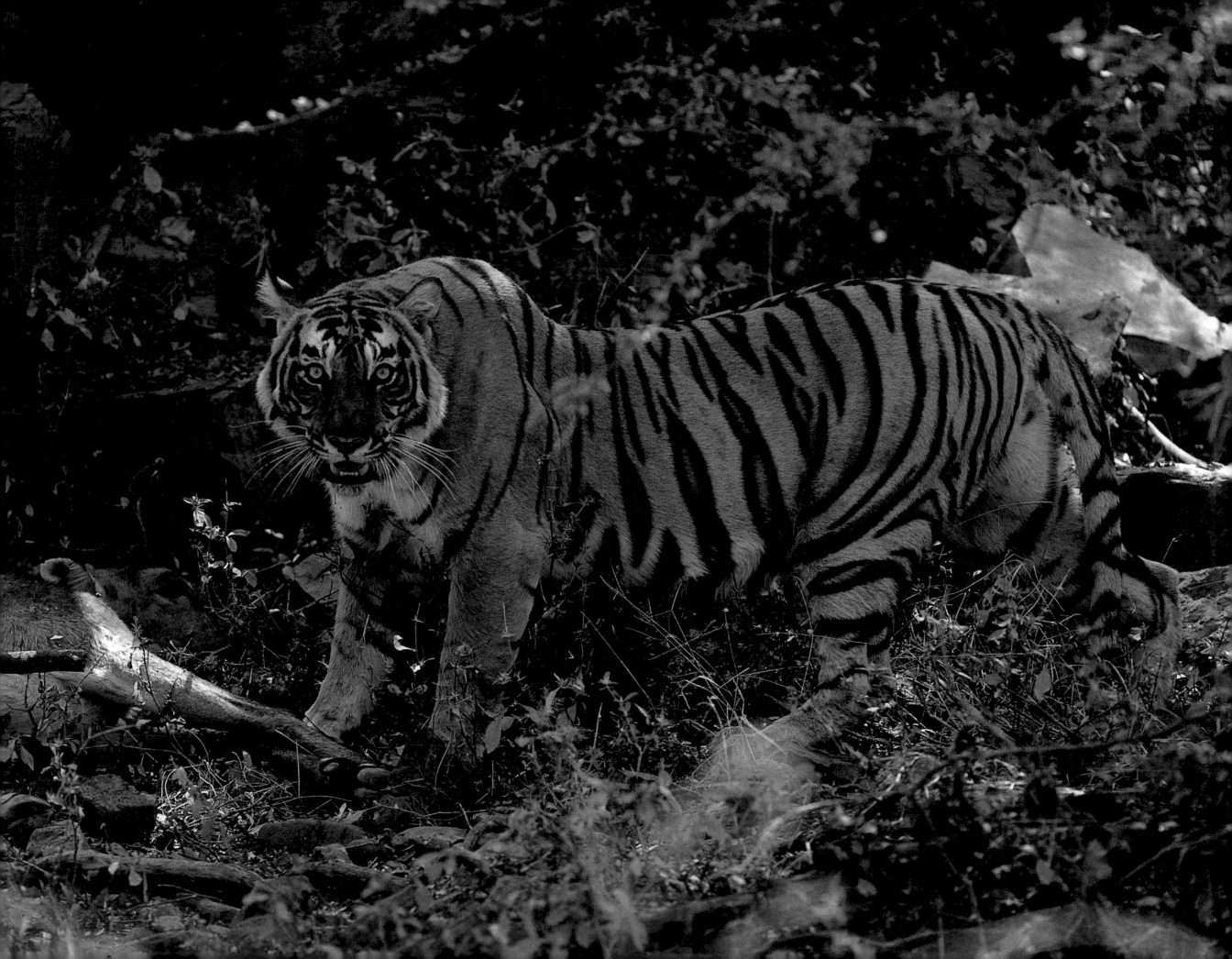

I am glad I shall never be young without wild country to be young in.
ALDO LEOPOLD

How many of us can really comprehend the depth and meaning of those words? How many have had the opportunity to know a natural place where we could gaze upon open country stretching out beyond the horizon, so vast a panorama that it would be a challenge for our imagination?

I consider myself to be very fortunate: since I was a child, I have been in contact with that natural world which became my passion and also my commitment. During the last twenty years of my life I have traveled, as a photographer and conservationist, to the world's most wonderful ecosystems, natural areas in which I look for tranquility and encounter beauty; where, although I feel very small, I find that I am complete and my spirit is reborn.

We photographers are very privileged indeed: we are the eyes of the human conscience, and our passion drives us on. In the drama of daily life we find our inspiration.

Being a conservationist means coming face to face with the marvel of creation and, at the same time, becoming aware of its threats. It means feeling lonely and powerless when witnessing nature's gradual deterioration but, above all, when observing with despair the huge breach between the natural world and the world of urban dwellers, which consumes natural resources with the belief that they are inexhaustible, and relies on technology to find solutions to all human problems.

Celebration of the Land. The Last Sanctuaries seeks to reassess our major natural regions as sources of inspiration and hope, as natural symbols that can help us regain our confidence in the future.

For eight years, CEMEX has devoted its publishing efforts to bringing to the public's attention different conservation strategies the world over. This book presents several regions of this planet that have been lucky enough to have one or more categories of protection within their borders. Be they biological reserves, refuges, or national parks, all of them are protected natural areas.

Choosing the regions that were to appear in this volume entailed a lengthy process of consulting with conservationist groups, specialists, publishers, and photographers.

We were interested in regions that stood out not only for their scenic beauty, biological significance, and natural phenomena, but also because they were areas constituting one of the last refuges for flagship species or threatened ones. We also tried to see to it that these regions were representative of Earth's different terrestrial ecosystems on the five continents.

Our initial universe was reduced to approximately twenty regions, the majority of which coincide with the criteria regarding priority conservation areas defined by international organizations such as World Wildlife Fund's Global 200 ecoregions or the hotspots and wilderness areas defined by Conservation International.

Our final selection was guided by a more pragmatic criterion: to invite some of the world's most renowned photographers, one for every region, to participate, with the idea of offering a more personal vision; through the work of each, we found lovely images that took months or years to achieve. In many cases, these are photographs that are now known around the world.

As a whole, the work of this group of photographers is most impressive, especially due to their commitment to the natural world. Bringing their photographs and thoughts together in this volume represents a great concert paying tribute to life on Earth.

The challenge for writer James Lawrence, who interviewed all the photographers, was to ensure that we could attain an intimate view of each of the regions. With his excellent work, James transports us to these places just as they were seen by the first persons to describe them; through his texts we learn about the vicissitudes of these parks and the threats they face, as well as the commitments, challenges, and adventures of these photographers.

Another of the features that enhances this work, making it a unique book, is the fact that there are no photographs of animals in captivity: all the photos were taken in the wild, and cover a wide range of species, including many endemic and threatened ones that are very difficult to photograph, such as the jaguar or snow leopard.

The conditions of each region, and the circumstances under which the photographers operated, varied greatly. Nevertheless, all bring with them their experience, zeal and, above all, a remarkable sensitivity for this world. The most surprising, moving photographs attest to their profound knowledge and great tenacity.

Yet now I think about the images and the unique moments which eluded the camera and which, seen in the minds of these photographers for a fleeting instant, have accompanied them in their memory throughout their lives.

This portfolio is comprised of those that were not lost, and constitutes a universe of images telling us about real worlds, living ecosystems that have survived for millions of years and today represent the last sanctuaries at the dawn of this new millennium.

In their spiritual quest, humans find peace in different religions. With that same devotion, each person, at least once in his or her lifetime, ought to journey to a pristine world, dwell on its wonders, and discover our roots.

My dreams have a recurring theme: time and again, I return to the wilderness. That is where I find meaning for life. That is where I find peace.

PATRICIO ROBLES GIL
President
Agrupación Sierra Madre

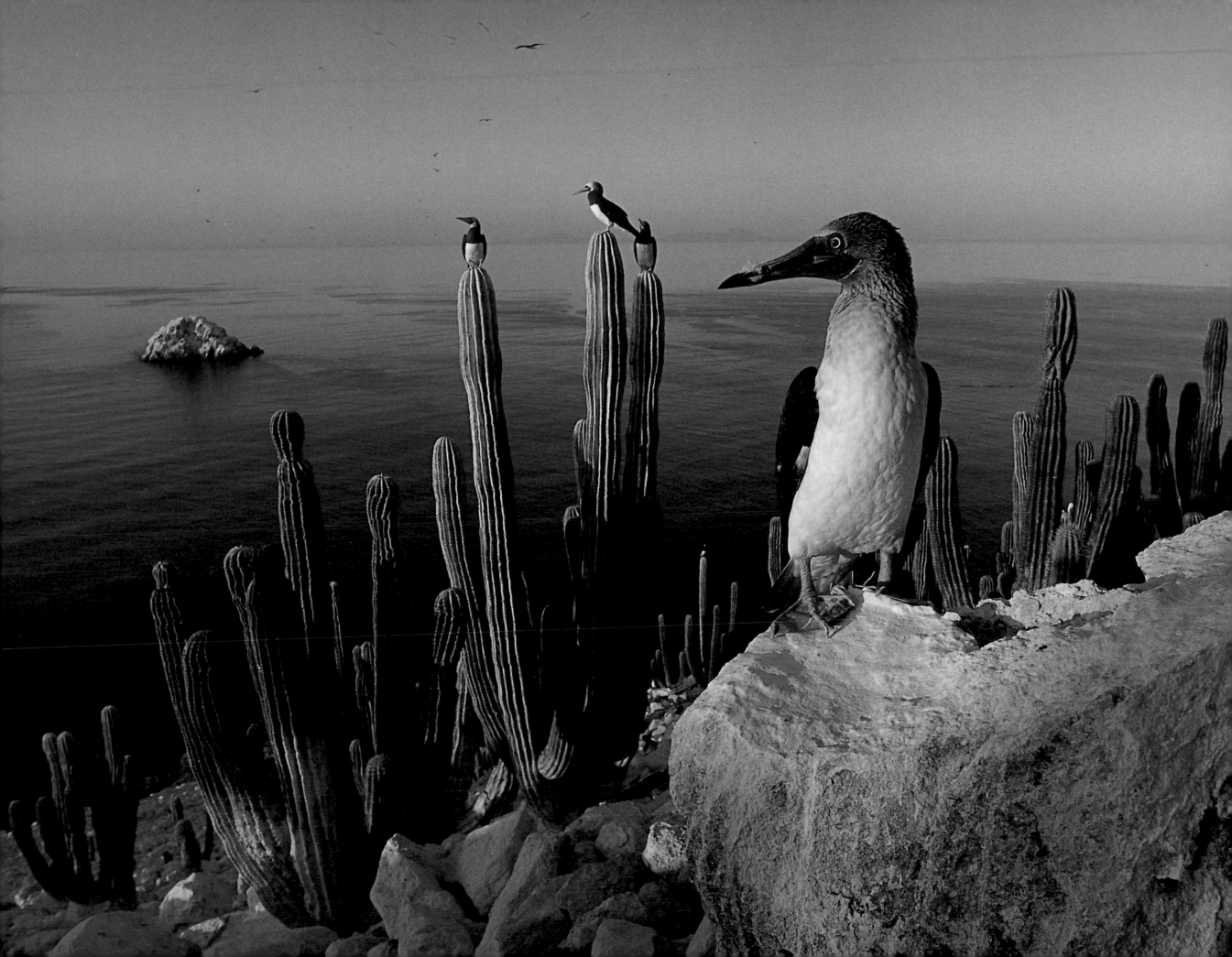

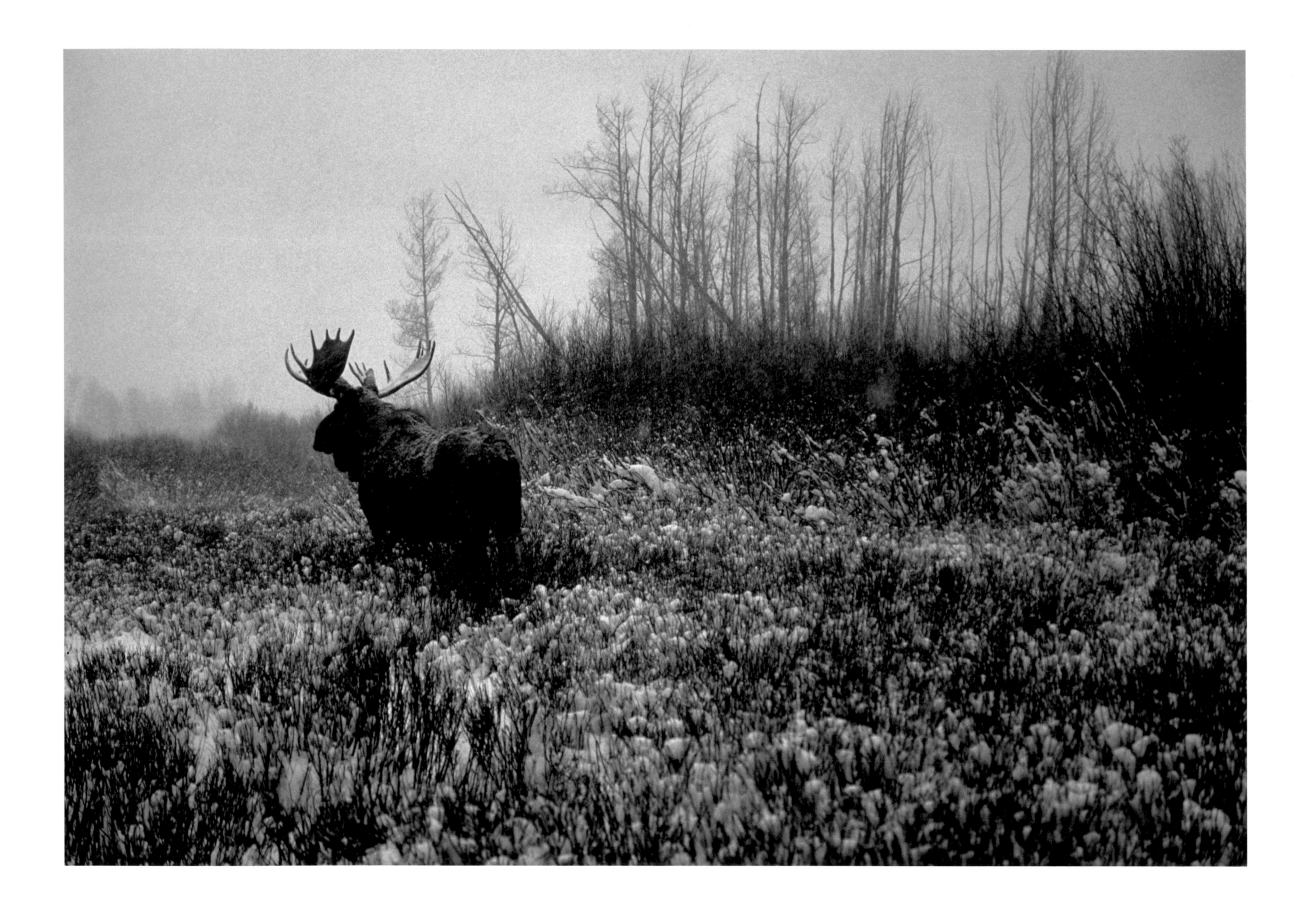

THE FOREVER LAND
Yellowstone/Grand Teton Region
Photographer: THOMAS D. MANGELSEN

*In the barest of terms, here was a high country with a hard winter climate,
carrying fair numbers of hoofed animals and their predators.*

FRANK FRASER DARLING (in Ann and Myron Sutton, *Yellowstone: A Century of the Wilderness Idea*, 1972)

This is the clockwork of nature: To be a wild thing, thriving on the million-year voltage of evolution; to wheel and ride the corkscrew upsurge of strong lift within a mountain-top thermal, knowing it will lead to success in the hunt.

Look to the flight of the bald eagle: Hanging on the ragged edge of a stall, feel your edge feathers flutter as you bank and swoop through blue-black giddy heights, lord of all you survey.

Now, plunge from the thin cold of altitude straight down, down toward the river, a sunlit crystal vein to feed the wild country. A last sure thrust of wings, then strike! with razored talons into the crisp flesh of the mottled salmon you saw from a mile high.

As surely as the sun tracks through the Wyoming sky today, tomorrow, and forever, you are guided in the act by the certainty of uncertainty: All things evolve and change in order to ensure survival. All things end and begin again.

As the eagle is to humans an embodiment of power and grace, so is the Greater Yellowstone Ecosystem (GYE) an icon for preservation of wilderness. The GYE extends across Wyoming, Idaho, and Montana to include Yellowstone National Park, Grand Teton National Park, seven national forests, two national wildlife refuges, federal, state, and extensive private lands. It is one of the most intact, pristine temperate-zone ecosystems in the world and recently, through reintroduction of its native predators, is again a refuge for the array of wildlife species the American Indian once knew and revered.

Today, Yellowstone the park and Yellowstone the conservationist ideal have become symbols for how a nation might step back from its headlong manifest gluttony long enough to look around, take a breath, and declare: "These lands must endure."

America's first national park, Yellowstone was already famous in the lore of the West when it was born by act of Congress in 1872. Yellowstone National Park was an expression of our willingness to learn to love and respect the world and its future generations of human inhabitants. When it became a park, seeds were sown that would bear the fruits of environmental sensitivity, conservation, and ecology around the world.

The entire ecosystem is a surpassingly beautiful land of dynamic mountain ranges, pristine lakes and vast, dense forests supporting a rich and diverse panoply of plant and animal species, all suffused within vapors of primordial steam. It has mountains, rivers, big open meadows, waterfalls, and the spectacular erosions of the Grand Canyon of the Yellowstone, carved by the Yellowstone River. In winter a cold, heavy blanket of snow combined with fog and hoarfrost in thermally active regions create a magical, spiritual atmosphere. In summer, its moderate climate and big blue skies attract millions of visitors.

For Americans in particular, Yellowstone's venerated Old Faithful and other geysers and their attendant court of thermal attractions are an icon of the ultimate nature vacation destination. For generations, families have packed up their belongings to drive over the vast continental network of highways and spend a week or two getting "away from it all" —and back to what is important.

Yellowstone has always been a natural focal point for dialog and implementation of land management policy to answer that nagging question: How can we best protect our natural world from ... ourselves? Thus, it is an arena where factional political battles are still vigorously engaged. Wealthy and powerful landowners, conservationists, cattle ranchers, game hunters, commercial tourism industries, animal rights and recreational interest groups, geologists, biologists, and other parties dedicate millions of dollars and prodigious effort to "put things right."

*On the opposite page,
as the breeding season nears its end,
a bull moose remains alert to his
harem of cows hidden in the willow
thickets nearby. When snows deepen
the bull will join other males
to winter, while the cows and calves
will find their own areas.*

Like its eagles, like the magma that runs hot just beneath its emerald and ochre landscapes, Yellowstone glides on, tossed and tumbled as ever by currents of struggle and change. And as the Yellowstone experiment evolves, so evolves our skill at stewardship of Gaia.

A LIFE IN THE FIELD
The actual exposure of the film can be almost anticlimactic.
Tom Mangelsen

Tom Mangelsen hears a shrill reet, reet, reeeet! and raises his binoculars. It is late spring in the beautiful Lamar Valley, here at the northern reaches of Yellowstone National Park, Wyoming, U.S.A. Winter has made its comeback gambit: fresh snow lies everywhere beneath the turbulent cloudscapes of a changing season. But harsh cries of spring are in the air.

Again he hears the shrill call. Finally he spots the mating pair of kestrels among a grove of cottonwoods. The most successful of all falcons, kestrels thrive throughout North America, Europe, Asia, and Africa in woodlands, grassy steppes, and heartlands from sea level to altitudes as high as 4 600 meters.

This day, the pair has its talons' full taking care of business, which right now means warding off predators and starting a new family. As Tom watches the raptors working their nesting territory, a male swoops down on a pretender to his throne. With a furious thrusting of wings, he sinks his talons into the breast of the branch-crowding intruder, launching the entangled pair into thin air.

Mangelsen, a celebrated wildlife photographer and cinematographer (BBC's 1994 Wildlife Photographer of the Year) whose career bliss derives from creatively expressing the complex intricacies and enduring beauty of wilderness, views the skirmish with fascination.

"I watched defender and interloper plummet to the snowy ground, the defending male on top and in control. Once the intruder accepted a subordinate role, the defender released him and away he flew."

Minutes later, a larger, more formidable foe, the red-tailed hawk, lands in the grove. Far from being intimidated, the male kestrel sets upon the hawk with a well-calculated series of dive-bombing, screeching attacks. Away flies the hawk.

Meanwhile the female hunts for a suitable nesting hole in the trees. Over a period of several hours, Tom watches as the male, between turf battles, busily attends to the needs of the female. Dropping down to catch field mice in the snow, he presents them to the female. Frequently, as if his "to do" list isn't full enough already, the female calls to him to mate. Only then does he get a brief rest, then back to work. And we think we've got stressful lives.

"It was during one of these periods of rest, when the male was looking at the female and yawning," he remembers, "that I made my favorite bird image. It was a stark scene, with the wintry white sky, the dead tree limbs covered with snow, and the two splashes of color of the birds. It reminds me of my most inter-esting days in the field, those special, unexpected times that make wildlife photography such an extraordinary experience."

CONFLAGRATION CLASSROOM
Fire is a common and frequent element in the ecological setting of the Rockies; thus, … it is not surprising that many plants and animals are specifically adapted to [fire's] periodic occurrence.
George Wuerthner, *Yellowstone and the Fires of Change* (1988)

Every school-age American child over the last century or so has absorbed the essential facts about Yellowstone National Park: It is the first and oldest national park in the world. It is one of the largest parks in the lower 48 states, covering more than 810 000 hectares and touching the states of Wyoming, Montana, and Idaho. It has the largest concentration of geysers and hot springs in the world, foremost of which are the world-famous eruptions of Old Faithful.

Throughout that eighteenth- and nineteenth-century drive to completion known as manifest destiny —America's consolidation of its coast-to-coast expanses into one great national territory—, the young country's western reaches remained mostly primitive, savage lands. Trappers, scouts, pioneers, and settlers encountered a daily fare of breathtaking mountain and prairie vistas overflowing with a broad diversity of animal, plant, and human inhabitants.

What made Yellowstone truly singular in the context of those times was its spectacular geothermal oddities, a wonderland of otherworldly geysers, hot springs, fumaroles, hot pools, azure lakes, and the hell-blasted hues that make up a true volcanic landscape.

Over time, as vast expanses of the American West went from untamed wilderness to territory to state, Yellowstone's importance as a wildlife sanctuary became even greater. The animals found in the park today remain a cross section of Rocky Mountain fauna: moose, bighorn sheep, grizzly bear, elk, bison, mule deer, black bear, pronghorn, coyote, mountain lion, beaver, trumpeter swan, eagle, osprey, white pelican, and many more.

The Greater Yellowstone Ecosystem (GYE), an area of 7.3 million hectares, is in fact home to a greater number and variety of wild animals than any other place in the U.S. outside Alaska. And even after 128 years of Industrial Revolution, world wars, economic booms and busts, and massive urban and suburban over-paving of wilderness, 99 percent of Yellowstone Park is still undeveloped. It remains by all measurements, past and present, a true wilderness preserve.

As a model for the evolution of ecosensitive management of natural lands, Yellowstone remains a proving ground as well as an ongoing classroom where trial-and error is often the teacher. Well-funded organizations devoted to studying and managing the entire ecosystem continue to inform a growing global consciousness as to how huge wilderness areas can effectively be made available to vast numbers of visitors with minimal negative impact on the natural order.

Yellowstone was the first jewel in an American system that has grown to 369 national parks, millions of hectares of wilderness, recreation areas, battlefields, and historic sites. The GYE remains the largest relatively-intact ecosystem in the lower 48 states. Only vast Alaska has more pure wilderness.

Even so, effective wilderness management against the constant pressures of civilization has its setbacks, mistakes, and devastations. In 1988, Yellowstone taught us all a new lesson: An unusually dry year on top of more than a century of overzealous prevention and control of forest fires in the ecosystem paid off in a series of immensely destructive blazes that choked the skies from May 24 until September 11. More than 365 000 hectares of watershed were damaged. Bordering towns, settlements, park buildings, and homes were threatened and many structures were lost. There were countless more animal deaths and greater destruction than would have been the case had fires simply been allowed to burn themselves out, as throughout prehistory.

When the summer of smoke was over, a ghostly black devastation extended over nearly half the park. Responding to the hue and cry of public and government, the park system made effective changes in fire-management policy. Wilderness fires would be allowed to burn unhindered, unless started by humans or directly threatening human developments. More efficient techniques for putting fires out quickly, learned through often heroic effort and trial during the fires, would be adopted.

Forest ecosystems of the Northern Rocky Mountains include not just trees, but grasses, flowering plants, and animal species that have evolved together into a complex matrix of interconnectivity that in fact anticipates the occasional wildland fire. Ecosystems where lightning strikes are common evolve to survive through sublime adaptations such as pine cones that only sprout after being exposed to the searing heat of forest fires and aspen root networks that remain safely below ground, sending up shoots that grow into dense new stands of trees.

Nature works best when we leave it alone.

CALLED TO THE WILD
Humankind has not woven the web of life. We are but one thread within it.
Whatever we do to the web, we do to ourselves.
All things are bound together. All things connect.
CHIEF SEATTLE

Park managers, legislators local and national, ecologists and conservationists have learned a lot over the years, but old habits and faulty but entrenched "knowledge" die hard. In the 128 years of Yellowstone's park status, conservationists and hunters have continually locked horns over predator vs. prey controversies.

"Even Yellowstone was not immune from the notion that removing predators was good for everybody," says Tom Mangelsen. Federal programs for predator "control" resulted in drastic drops in numbers or outright extermination of the wolf, lynx, grizzly bear, mountain lion, and other mammals. The resultant rise in ungulate populations in turn overtaxed the resources of the area.

Tom has seen groups with local agendas from outside the park grapple with the larger visions of ecosystem balance. Farmers and ranchers are allowed to kill or trap predators attacking their livestock, and are handsomely compensated by the government. Even so, the entrenched and prevailing emotion among these groups toward grizzlies, mountain lions, and wolves seems to be hatred. Killings in open defiance of the law are not uncommon. "They still see these animals," says Tom, "as their born and sworn enemies."

Some "guides," for $3,000 and up, turn radio-collared dogs loose to sniff out and tree mountain lions, while the guides and their clients wait in four-wheel-drive pickup trucks. When the radio receiver indicates the dogs are looking up and have treed a cat, the clients move into the woods for the kill shot. Ah, the thrill of the hunt.

On a cheerier note, nature writer Cara Blessley describes a more progressive approach to dealing with predators that is gaining acceptance among ranchers in the region.

"Ranchers are learning to embrace and work with nature. Some programs encourage ranchers to use dogs to protectively herd livestock when predators approach. The predators soon learn that domestic animals are anything but easy prey and leave them alone. Ranchers, in turn, much like organic farmers, can then market their products as 'predator friendly' beef."

When passionate commitment meets a barricade, it finds a way over, around or through it. New concepts, knowledge, and energies must be brought to bear. Tom, as an advocate for movements such as the recently successful reintroduction of wolves to Yellowstone, finds himself spending a fair amount of his time in political activism. He would rather be out in the field, but believes it's important and part of his responsibility to write letters to fish and game departments, local and national political figures, and anybody else with influence or of potential support who might answer his call to action on behalf of persecuted species such as the mountain lion.

"We're trying to close down the hunt on mountain lions in Wyoming. Of a quota of 295, a total of 170 have been killed in just three months. There may be somewhere in the area of 60 mountain lions that have home ranges in the Grand Teton mountain range, but no one knows for sure because they are so elusive and difficult to count. Killing mountain lions makes absolutely no biological sense."

Here as everywhere else in the world, interspecies dependence is the

lynchpin of ecological balance. Pull one link and the whole chain writhes like a dying snake. After wolves were exterminated from Yellowstone, the elk population that migrates throughout the GYE quickly grew to epidemic proportions. The carrying capacity of the land was overrun.

"Wildlife managers for years have talked ad nauseam about the need to manage our wildlife because of the lack of predators that man has exterminated. Now some of the predators like mountain lions and grizzlies are returning, and they want to kill them off again. The Wyoming Game Commission can't wait to see the grizzly delisted so they can reopen hunting season on the bears for 'Wyoming sports enthusiasts,' as the commission describes them."

"This last year, the mountain lion became low predator on the totem pole. In the grand tradition of man's general fear of predators, hunters kill them out of all proportion to their threat." Tom cites an historical perspective: there has never been a mountain lion attack on a human in Wyoming history. "Only 14 people in the last 100 years have been killed in all of the United States. Meanwhile, game managers like the Wyoming Game and Fish Department say there is an over-abundance of elk in Teton Park, which is the only national park in the U.S. that allows hunting." "So why," asks Tom, "are we killing mountain lions?"

He knows that mountain lions, like most predators, instinctively do a vastly superior job of culling weak, sick, and old animals from the herds. "Hunters with guns usually take prime bulls and cows, leading to species degradation."

In similar fashion, hunters typically kill older male and female mountain lions, leaving the young to starve or, if old enough —14 to 18 months— to fend for themselves. It is a losing scenario. "It's been shown that killing mountain lions may exacerbate the threat of lions to humans. Killing off old males leaves their established territories open to younger cats, who may cause a temporary surge in the population. They haven't learned how to hunt the large elk, so they turn to smaller game like deer, rabbits, pets —and livestock. It's like a human town with no parents, and the kids run amok: Inexperienced animals are always more likely to get into trouble with humans."

He singles out the existing law against shooting females only if their cubs are with them. "The stupidity of that is mountain lion cubs don't hunt with their mothers! It's difficult enough for a female to stalk a deer without her cubs screwing things up. So they stay in the den, the female gets shot, the cubs slowly starve to death. Female lions are pregnant or raising cubs at least 75% of the time, so shooting an adult female means any of her cubs from infancy up to 18 months probably won't make it. Those that do survive fit the profile of a potential problem animal in human-inhabited areas. It's cruel and inhumane. For every female mountain lion that dies, two to four cubs will die too. With two to three thousand more elk than the land can carry, it's absolutely amazing they're still allowing the killing of mountain lions."

Compassion comes hard when fear replaces balanced judgment.

On the opposite page,
bison plod over deep snowdrifts
in Yellowstone Park's Hayden Valley
on an endless forage for grass buried
beneath the snow.
Bison leave the higher meadows
in winter and gather in open
meadows near thermal areas
or along streams or rivers like
the Yellowstone, where less snow
and protection from the wind make
feeding easier.

FEAR OF TEETH AND CLAWS
Only two things are infinite, the universe and human stupidity,
and I'm not sure about the former.
ALBERT EINSTEIN

Fear and avoidance of predators is hardwired into our DNA. Lions and hyenas are still locked in a blood hatred that goes beyond the logic of day-to-day survival, and is as old as the golden grass of Africa. Humans, too, often mindlessly destroy predators they fail to understand or appreciate.

Yet humankind's predator paranoia has never had much foundation in reality. If anything, wolves and mountain lions, like the perennial "problem" bears of Yellowstone Park, become a threat only after they learn to associate people with easy food, through ever-deepening human encroachment into their territories.

Once, not so long ago, only humans outnumbered the wolf in the Northern Hemisphere. Estimates range as high as 750 000 wolves in what is now the United States, and millions around the world. Today, the numbers are shocking: 50 000 in all of Canada, 4 000 to 6 000 in Alaska, and fewer than 2 000 in all the rest of the U.S. In human terms, such fervid extermination is called genocide —a practice for which we have demonstrated a remarkable talent.

In January of 2000, a U.S. Federal appeals court ruled that wolves reintroduced into Yellowstone and other northern Rockies wilderness areas in 1995 and 1996, could remain. The ruling covered the first 66 wolves over the five-year program, a seed group that has now grown to more than 300 animals. In the words of the ruling, "This decision helps to right a critical ecological balance that has been missing for nearly 100 years. Every wolf in Yellowstone is four-footed proof that the Endangered Species Act (of 1972) works."

A footnote to illustrate the ongoing realities and setbacks inherent in raising ecological sensitivity is the story of Wolf No. 10. Captured in Canada, he was fitted with a radio collar for eventual release into Yellowstone. Soon after his arrival in Rose Creek he became affectionately known by various names: "Arnold," "The Big Guy," or "The Pride of Yellowstone."

Introduced in an acclimation pen to a beautiful black adult female called "Natasha," the pair were quickly observed to walk side by side in perfect stride and sleep with their bodies entwined. It was a perfect match.

Just one month after the mating pair was released into Yellowstone, Arnold was shot, skinned, and beheaded. Investigators deduced another tragic sidenote to the drama. Apparently Natasha tracked his scent, discovered his remains and, confused and agitated, hastily dug a makeshift den right in the snow beside her mate.

Instincts eventually took over, and she left the den only in time to deliver her eight pups in the deeper safety of the forest.

A man named Chad McKittrick was quickly tracked down and sent to jail for the killing of Wolf No. 10. He was the first person ever to be charged with the murder of an endangered wolf.

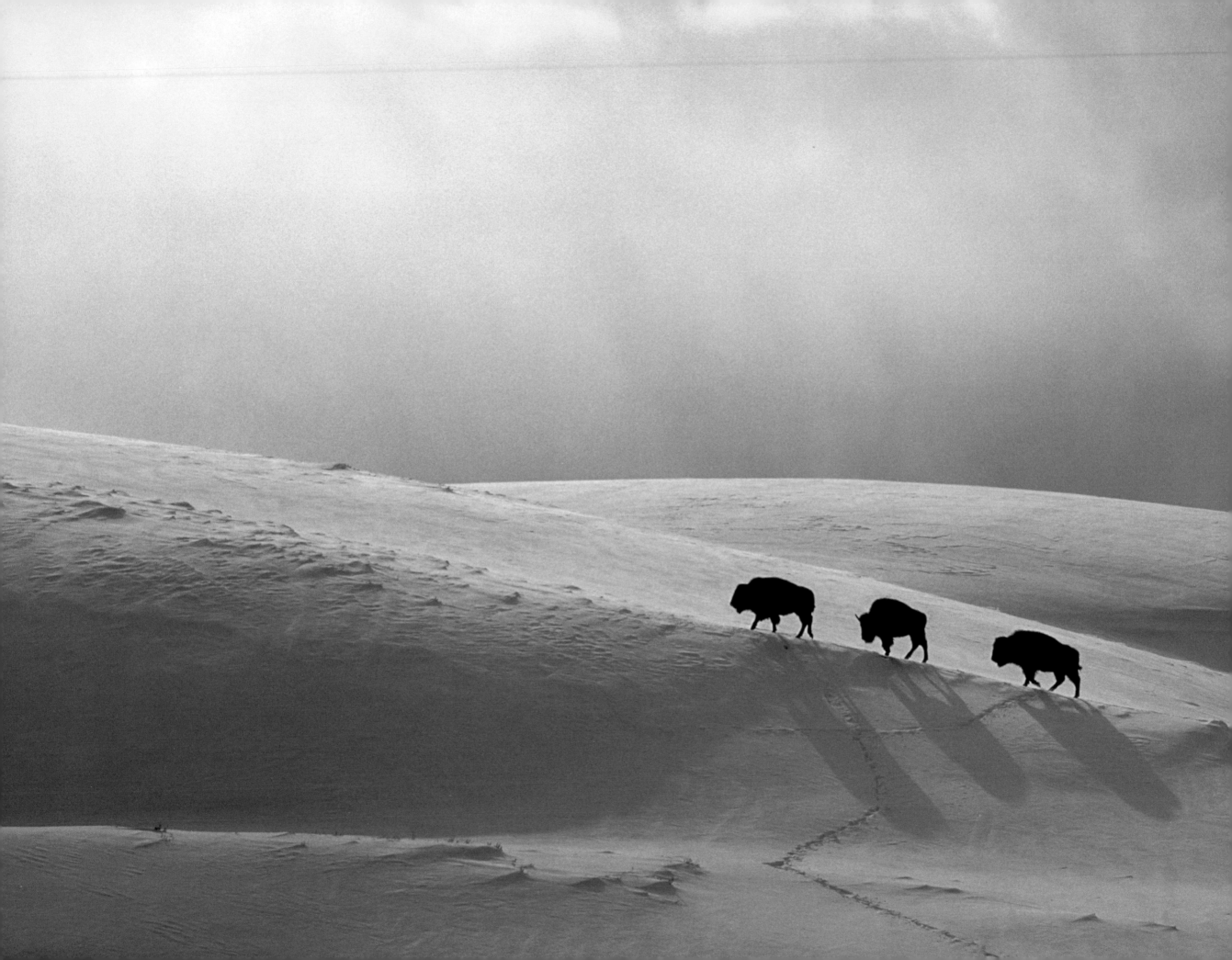

The force of law takes time to work changes in behavior, but change can occur and people will learn —one way or another.

THE WAY THINGS ARE
I realized I couldn't wait for the sun to shine for dramatic lighting, that animal activity went on whether it was raining, snowing, or blowing.
TOM MANGELSEN

In his forays into nature around the world, Tom has learned that animals embodied the very mood of the weather in their positions and appearance. "They also tended to be less concerned about me if their activities were strongly influenced by the weather. There was a big difference between a bird sitting on a limb in bright summer sunshine and the same bird hunkered down on a frozen branch with its feathers puffed up in twenty-below-zero weather." Scenes such as kestrels mating in wintery cold weather are what sets Mangelsen's work apart from many of his colleagues. "When people look at a photo and know it's one of mine, then I feel good. My work ties the animal to the landscape, to its own environment, to the season."

Tom's passion for wilderness conservation goes way beyond simply protecting his primary source of income. By photographically advocating for wildlife, he brings their world into the human consciousness. "If I can get people to feel something close to what *I* feel when I see a great gray owl or a loon, then it's that much easier to convince them we need to protect these animals."

He knows there's no way a picture will ever take the place of the actual sounds and smells and the way the night wind can call your soul. "The best you can do is to get close through the visual sense: it's the one we depend on most. You hope when someone looks at a picture of swans flying across the Yellowstone River, they can imagine the sound of their trumpeting echoing off the water."

The next step is to take action. "Increasingly, people ask me: 'How can I help?' or say 'I have a friend who's an attorney,' or 'I'll put some money toward stopping the killing of bison in Yellowstone or saving the mountain lions.' It's those responses to my photography that gives me some optimism that you can make a difference."

THE LONGER VIEW
In three words I can sum up everything I've learned about life: It goes on.
ROBERT FROST

There is a butte in Yellowstone's beautiful Lamar Valley, eroded by eons of wind and water. Like a natural history museum diorama, the eroded sedimentary sides of the landform, several hundred meters high, tell a fascinating story of ongoing volcanic activity from ancient times to the present.

In layer after layer of fossilized rock, petrified remains of entire groves of trees are clearly visible. During ancient volcanic eruptions, these groves were catastrophically inundated by pyroclastic flows of gas and hot volcanic ash several meters deep. The truncated tree trunks died where they stood, along with the flora and fauna they hosted. In time, the uncovered upper portions of the trees decayed into the new soil as a fresh grove of trees took root and grew. In a few hundred years, the restless earth erupted again, burying the new grove.

So it went, for tens of thousands of years, another enduring clockwork to mock the brief pretensions of humankind.

The 1988 Yellowstone fires left behind a blackened landscape of nearly 400 000 hectares. Park officials wondered if visitors would avoid the park for years. Instead, attendance continues to grow. Surveys showed that the people are not so herdlike as often thought. They are eager to learn that fire, like ice, like wind, like glaciation and erosion, birth and death, is a natural part of life on Earth. They come to see its works upon the land, to understand, to accept.

Yellowstone's thermal regions betray a formidable secret: the entire area is a gigantic volcano. Temperatures under the ground are 30 to 40 times higher than any other place in the world. Only a few places in the ocean have similar hot spots, but Yellowstone is the only one on land.

Someday, it is going to blow. The only question is, "When?"

Geologists and volcanologists peg the cycle of major cataclysm at every 600 000 years or so. It has been 600 000 years since the last big one. We might be at the tail end of the cycle, or just beginning a new one. No one knows for sure.

Every 20 000 years or so, smaller eruptions, on the scale of the 1980 Mount St. Helens explosion, take place. It has been 70 000 years since the last "little" blow in Yellowstone.

The Earth informs us of our temporary hold. We are footsteps in beach sand, prey to the seas of time. By viewing with our hearts and minds the lands and animals that share our short time here, we can for a while choose forgetfulness, and so leave the greater cycles of fire and brimstone to the gods.

But eventually the flip side of the Moebius strip of compassion and awareness calls us to the longer view. With great and ironic poignancy we realize that all of us, animals and plants, burn so briefly through the long night of the universe. And when we act on behalf of nature, of all life, we shine like the stars.

On the opposite page, Lamar Valley is famed for its sightings of grizzly bears and, since 1996, wolves. The undulating hills of the Lamar Valley play off light and shadow of passing thunderstorms in summer and snow squalls in the winter. Open, rolling terrain and the absence of trees make for an ideal spot to watch the greatest wild creatures of North America.

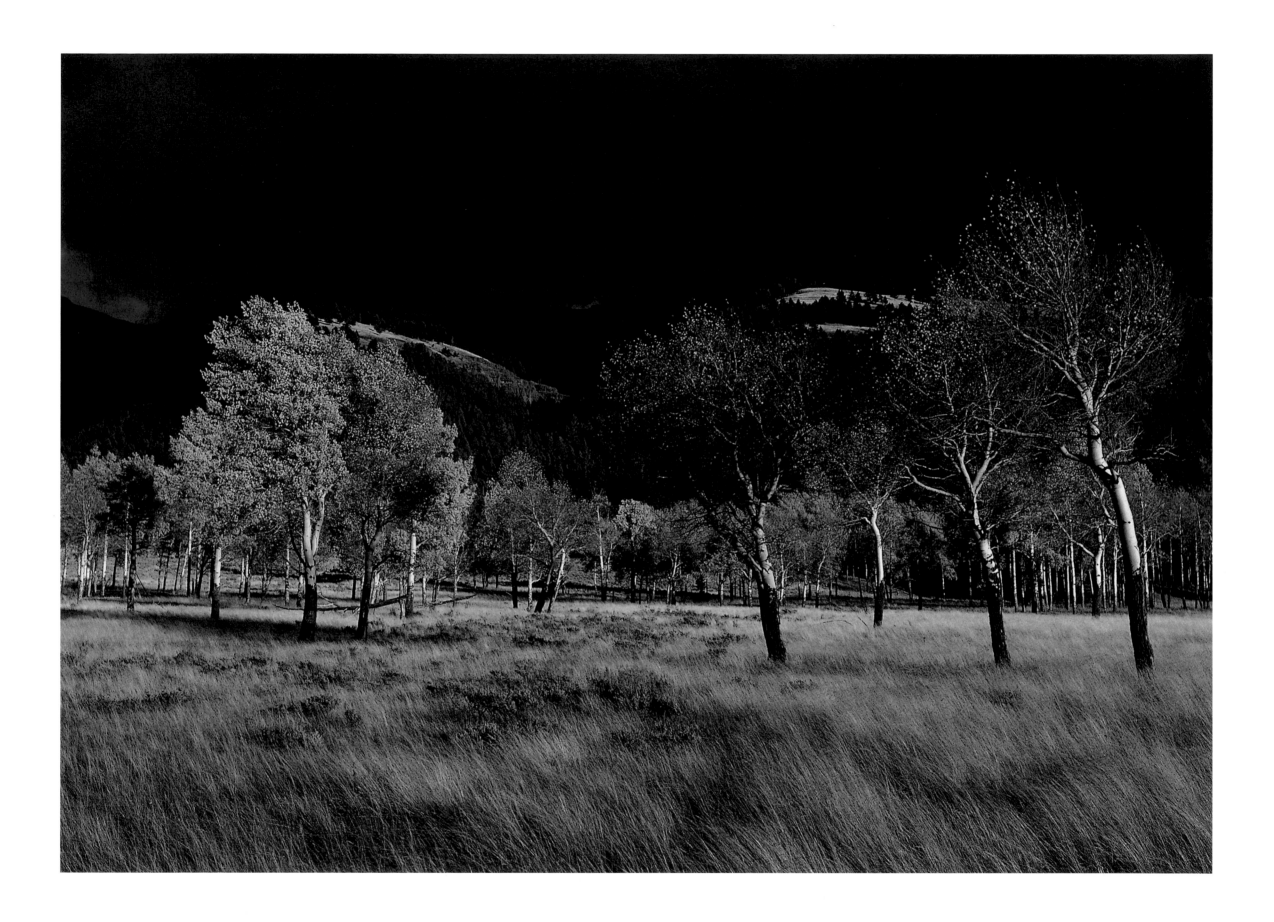

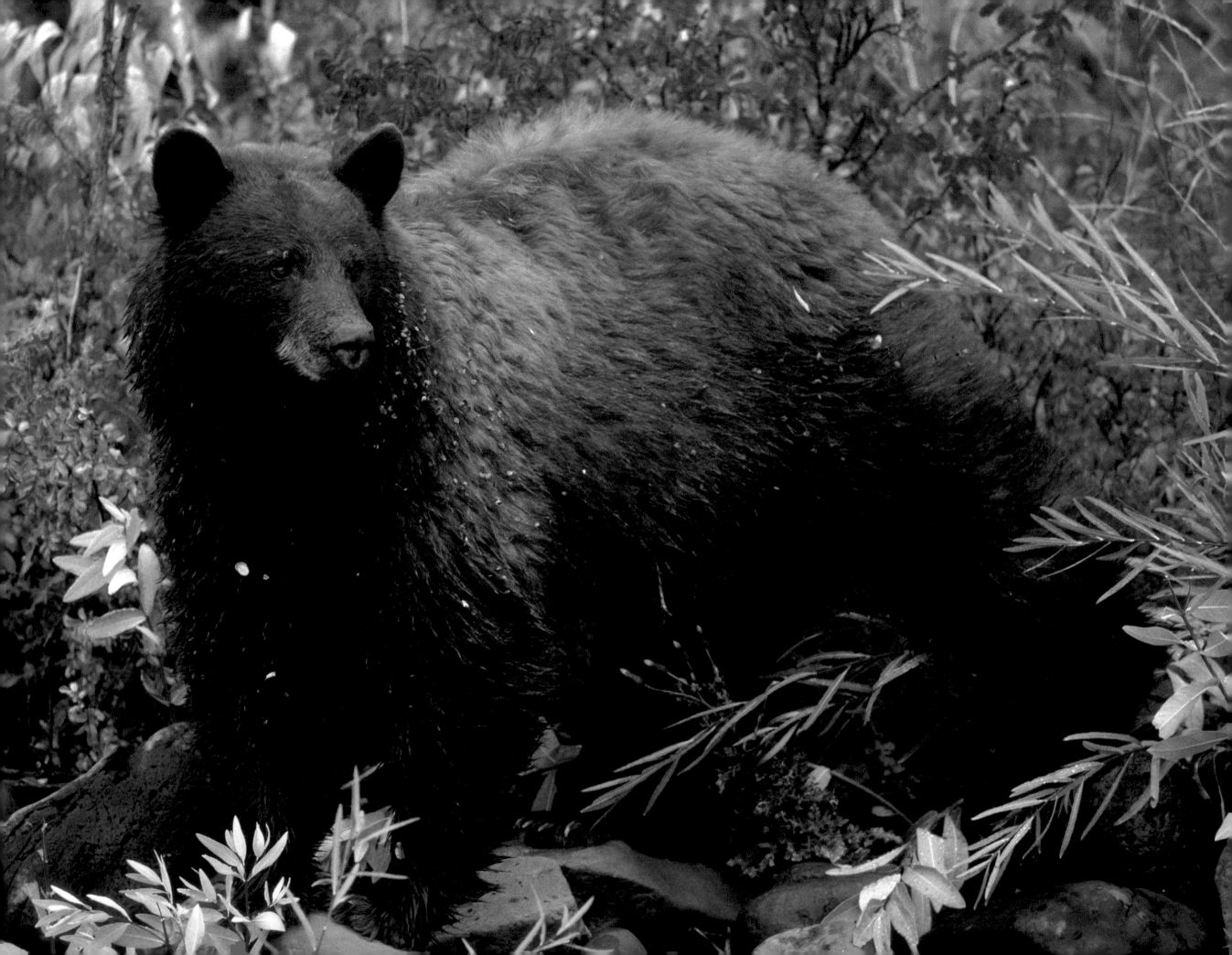

On the opposite page,
a small cousin of the grizzly, the black bear is found throughout the United States
in forested mountains. Its color ranges from black to cinnamon to nearly white.
Unlike the grizzly, the black bear is skilled at climbing trees.

Below, early autumn is a fervent gathering and storing time for chipmunks that make their home
in the Northern Rockies. Here, in Yellowstone National Park, snow may fall as early as September, signaling that
the onset of winter is not far behind. The least chipmunk hibernates, usually much later
than the Eastern chipmunk, and has been known to climb trees to sun itself as temperatures drop.

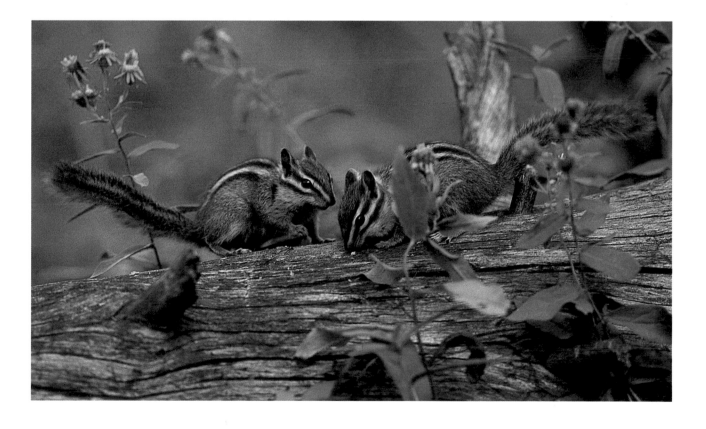

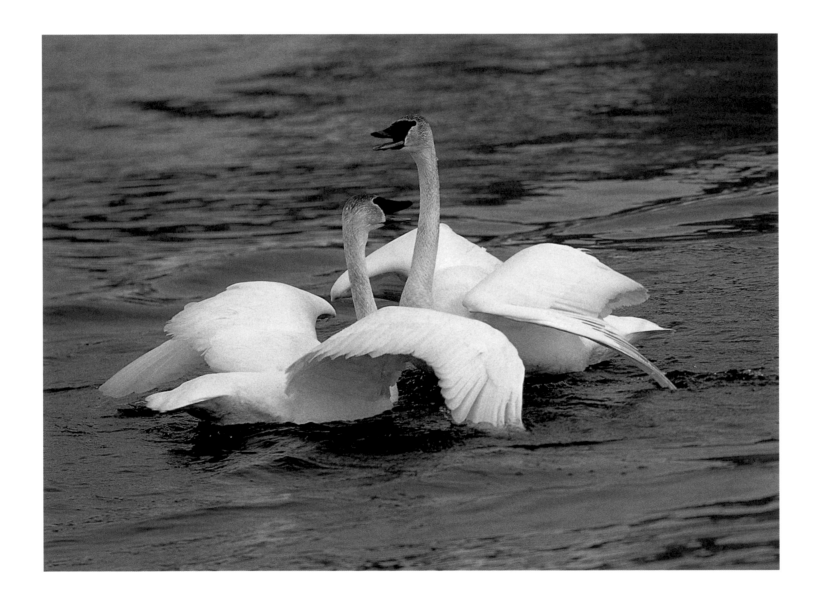

Every spring, before the snow has melted away from the valley floor of Jackson Hole, trumpeter swans begin their annual mating ritual. These swans are monogamous and mate for life, and every year reestablish their pair bond in a beautiful and elaborate dance of wingbeat and the swaying of necks. In one exchange, they take turns pumping their necks up and down, an act which bonds the two birds in their search for a nest site at the beginning of the breeding season. At the present time, a debate ensues as to whether a hunt should be opened on trumpeter swans, mainly because these birds are often mistaken by hunters to be snow geese. Most wildlife biologists and conservationists, however, believe that such a hunt is unethical, unnecessary, and immoral, given the previously threatened status of this species of waterfowl.

On the opposite page, as winter slowly freezes the high waterways of the Rocky Mountains, trumpeter swans begin to congregate on the few remaining open ponds. These large waterfowl require a long expanse of open water for their takeoffs and landings. In severe winters, they will migrate out of their mountain habitat and winter briefly in lower elevations.

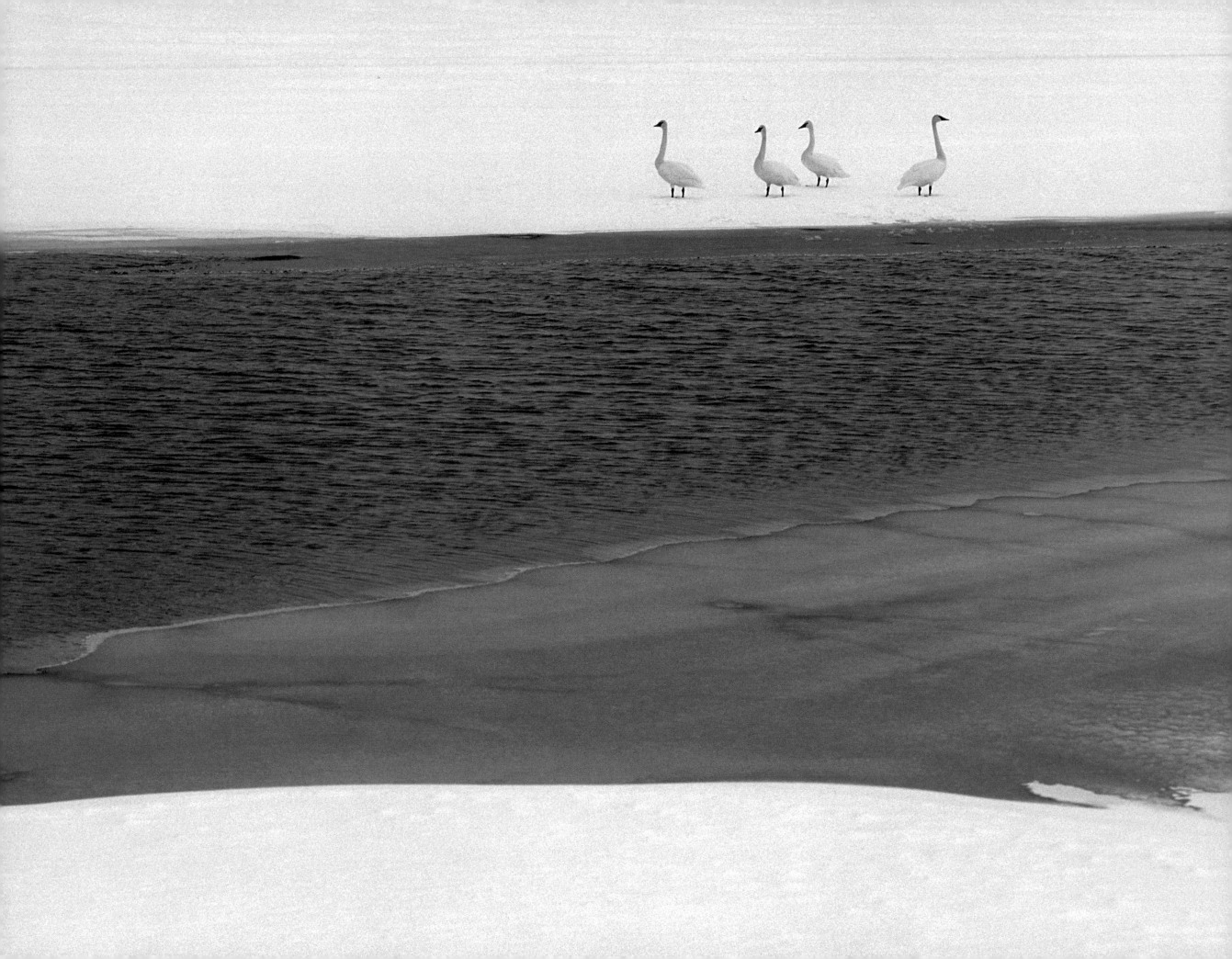

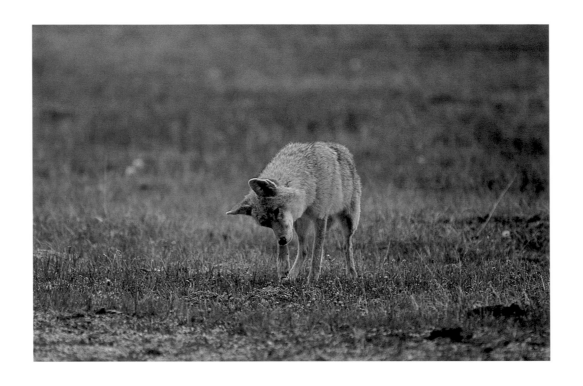

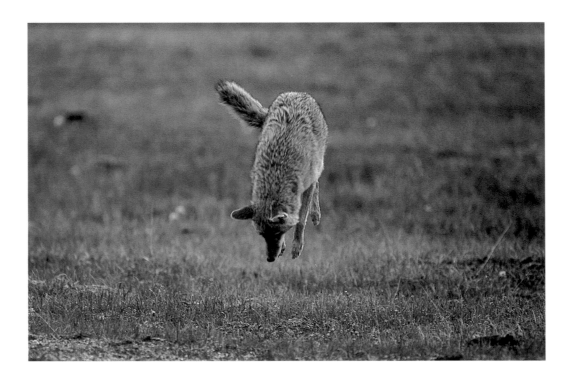

Honing in on its key food source, the meadow vole, this coyote employs
its signature hunting technique. Once it senses its prey, the coyote freezes,
then springs into the air to pounce on its unsuspecting meal.

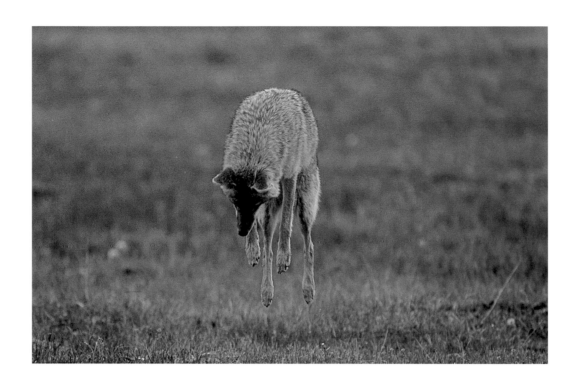

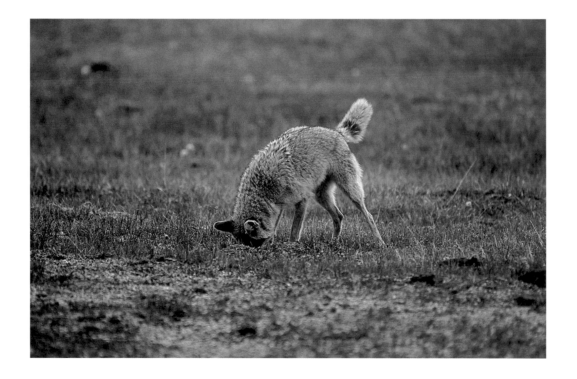

Coyotes are an important link in the food chain:
they control rodent populations that may quickly mushroom
given the absence of this prairie trickster.

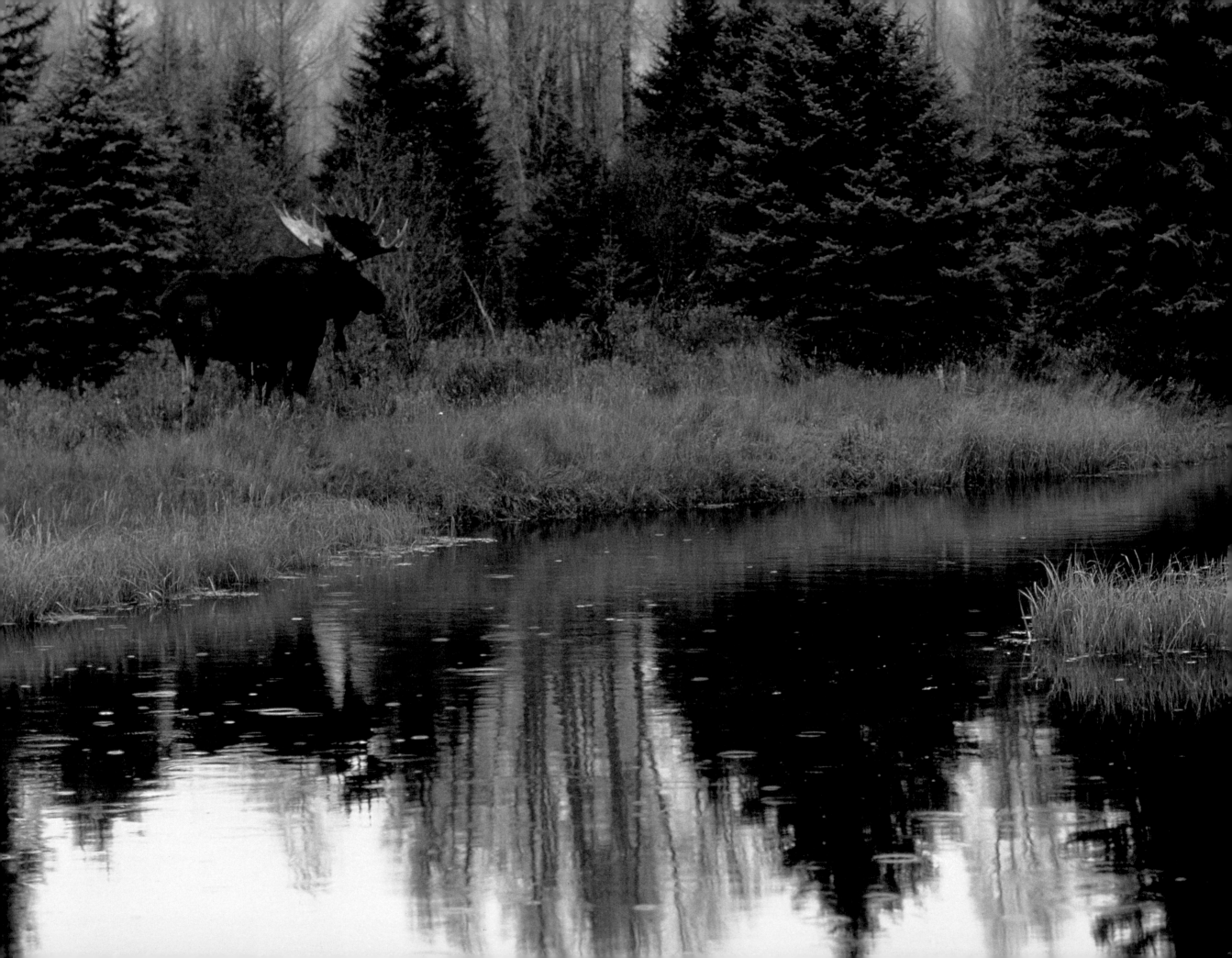

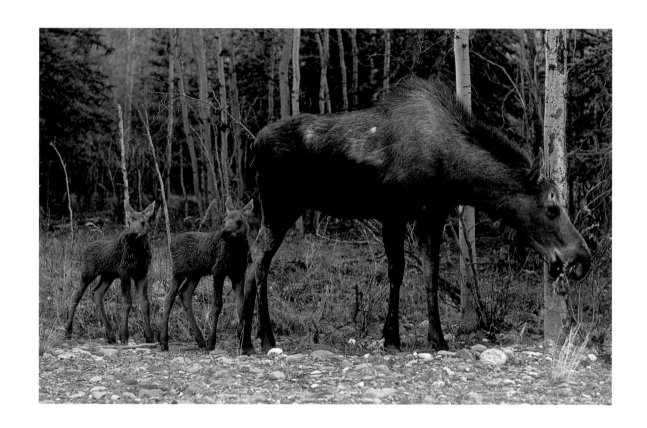

On the opposite page,
almost hidden by lush vegetation and steady rainfall so typical of autumn,
a lone bull moose forages for food around a beaver pond.
Constructed on a tributary of the Snake River, the lodge will serve as a home
to the industrious mammals all winter. Autumn is the season of the rut for both moose
and elk. While moose are nearly silent during their courtship,
the sound of bugling elk is a sure sign of fall,
echoing throughout the valley for a few weeks every year.

Above, with winter at her back, a mother moose brings her newborn twins out of the forest
to discover the plentiful world that awaits them.
During the fruitful summer months, a full-grown moose consumes an average
of 27 kg of willow twigs and leaves each day. Young moose are under an almost constant
threat of wolves during this time of year. To protect her young,
the mother moose will stand over her calf and face off the wolves.

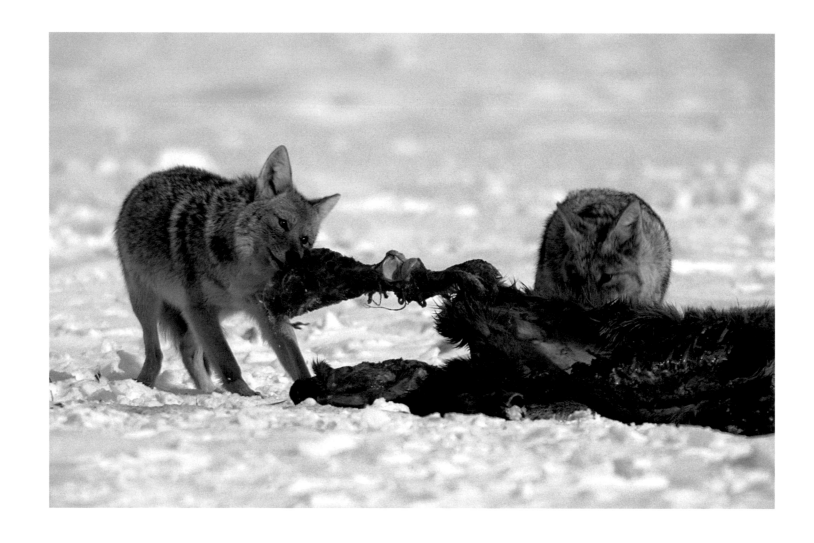

The National Elk Refuge outside Grand Teton National Park is the smallest piece of federal land in Jackson Hole, Wyoming.
With its robust population of wintering elk and bison, and the variety of winter wildlife from wolves to coyotes, trumpeter
swans to mountain lions, it is frequently compared to Tanzania's Serengeti.
Coyotes are some of the most common mammals found in the National Elk Refuge, where they hunt for mice and voles
tunneling under the snow and scavenge for remains left behind by predators.

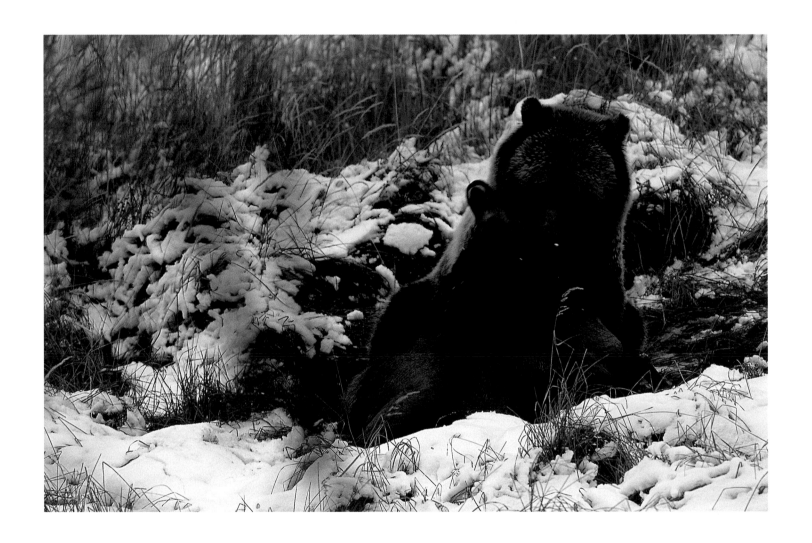

Grizzly bears are the great symbols of the Rocky Mountains, where their survival as a species has endured and triumphed
under the Endangered Species Act. Once persecuted like many of the other predators of the American West,
such as the mountain lion and wolf, remaining populations of grizzlies have made a gradual but successful comeback
in many parts of their original range. Thanks to the pioneering efforts of bear biologists and twin brothers
Frank and John Craighead, the grizzly was preserved before its extinction in this region, unlike the wolf.
Today, Yellowstone National Park is one of the prime "islands" of grizzly bear habitat,
where these great bears will remain forever protected.

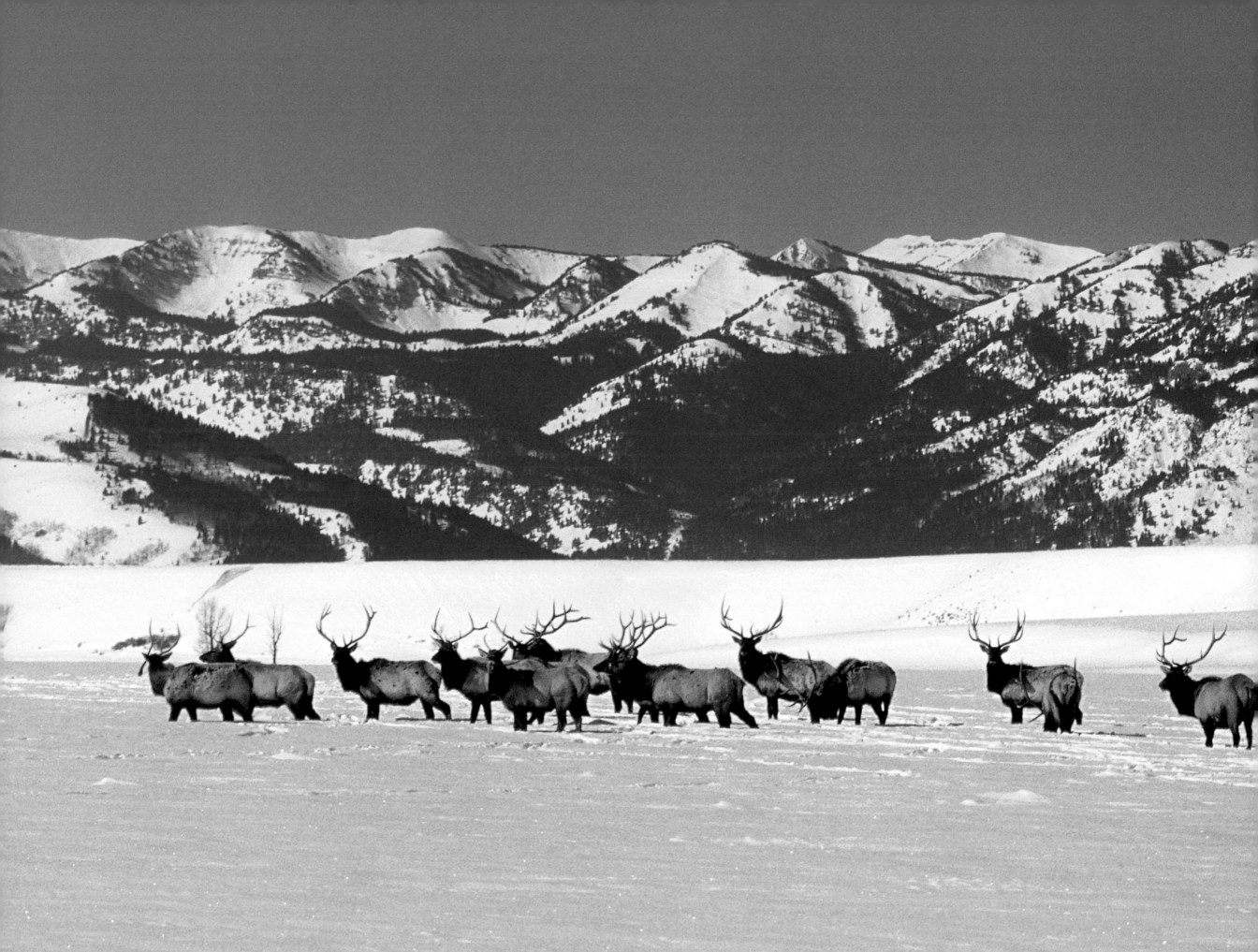

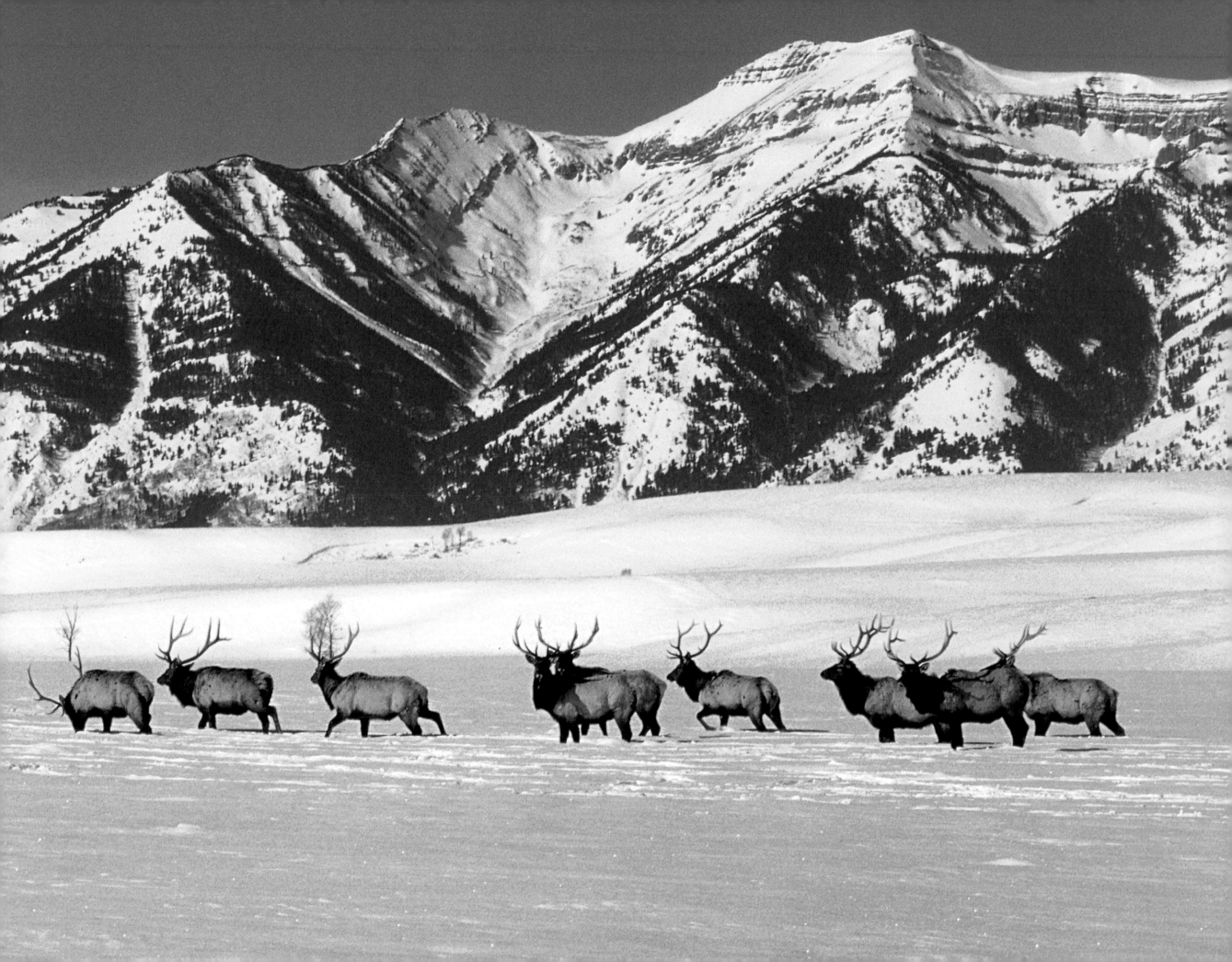

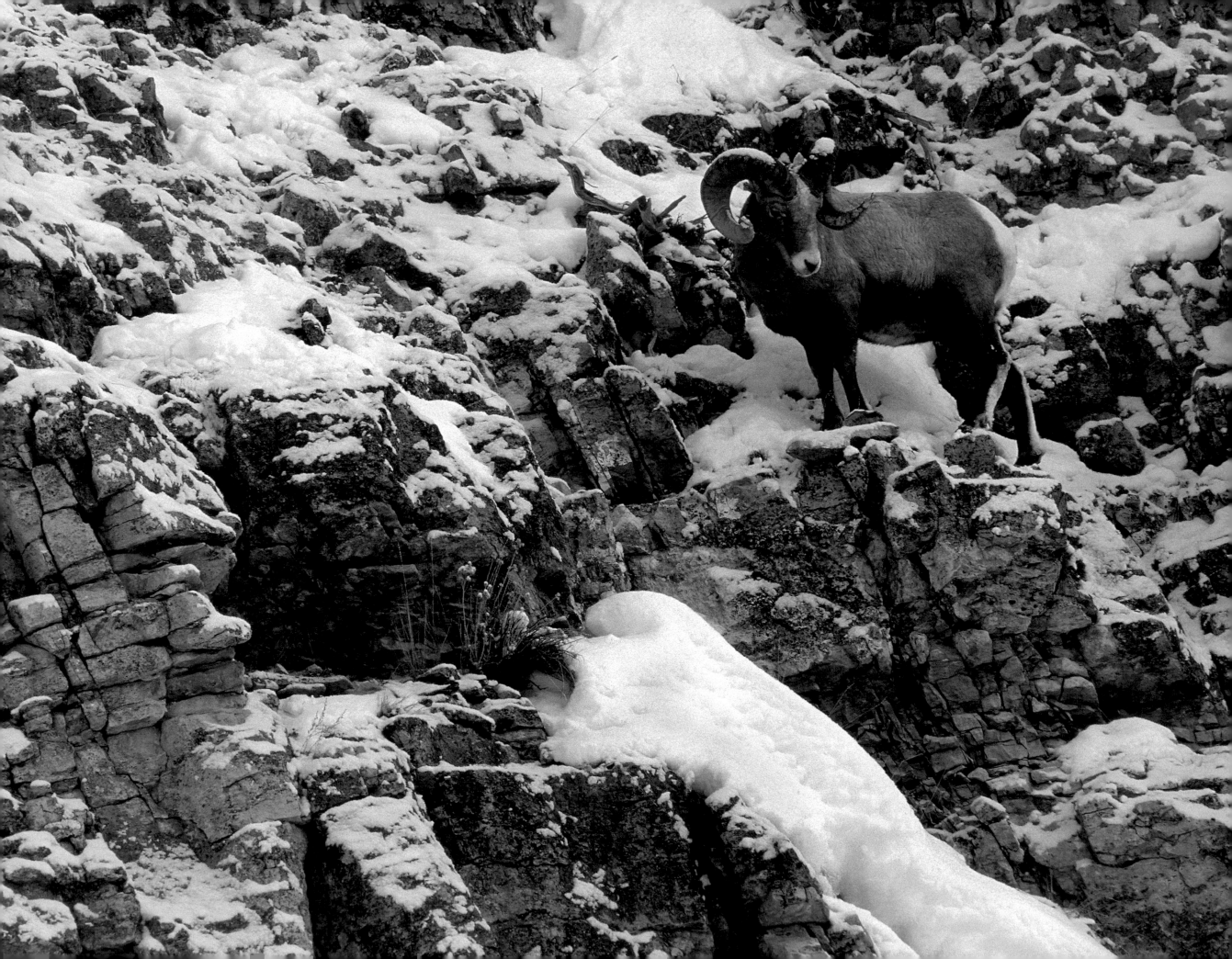

On pp. 40-41,
gathered below the southern Teton Range, a herd of bull elk band together at sunset to pass the night.
By this time of year, the rut has passed, and pregnant elk as well as females with young
occupy their own space in the Refuge. The Rocky Mountain elk are the most numerous of the four varieties
of this ungulate, the most polygamous deer in North America.

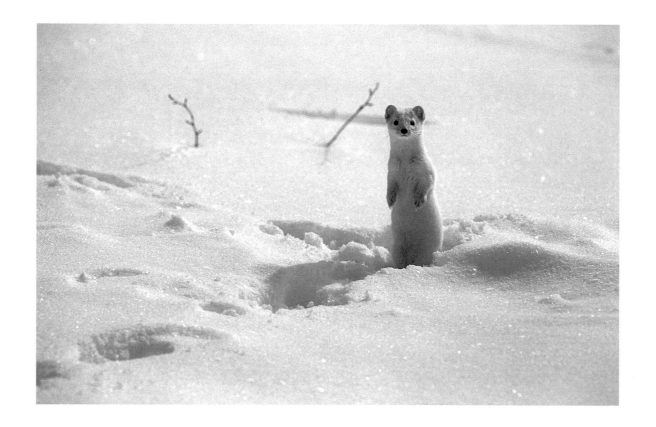

On the opposite page,
with hooves that are hard on the outside and soft on the inside, Rocky Mountain bighorn sheep are well-equipped
to navigate the loose shale and limestone cliffs that are typical of their habitat. The Rocky Mountain bighorn sheep
is just one variety of this adaptable species. Others that share its genus, or family, are the California bighorn
sheep and the Dall's sheep of Alaska.

Above, each fall, the short-tailed weasel sheds its rich, brown fur for a white winter coat to blend with the snow,
and it is then often called an ermine. In winter, it feeds mostly on mice caught beneath the snow.
The fearless ermine is a common sight darting in and out of woodpiles and around cabins as it hunts.

On pp. 44-45,
sailing across open waters, a family of trumpeter swans takes advantage of the ample submergent vegetation
that grows year round in the Yellowstone River. Warm springs keep this river running throughout the winter.
A favorite place for trumpeter swans, the Yellowstone River begins in Yellowstone Lake
and travels north out of the park through Montana until it runs into the Missouri River.

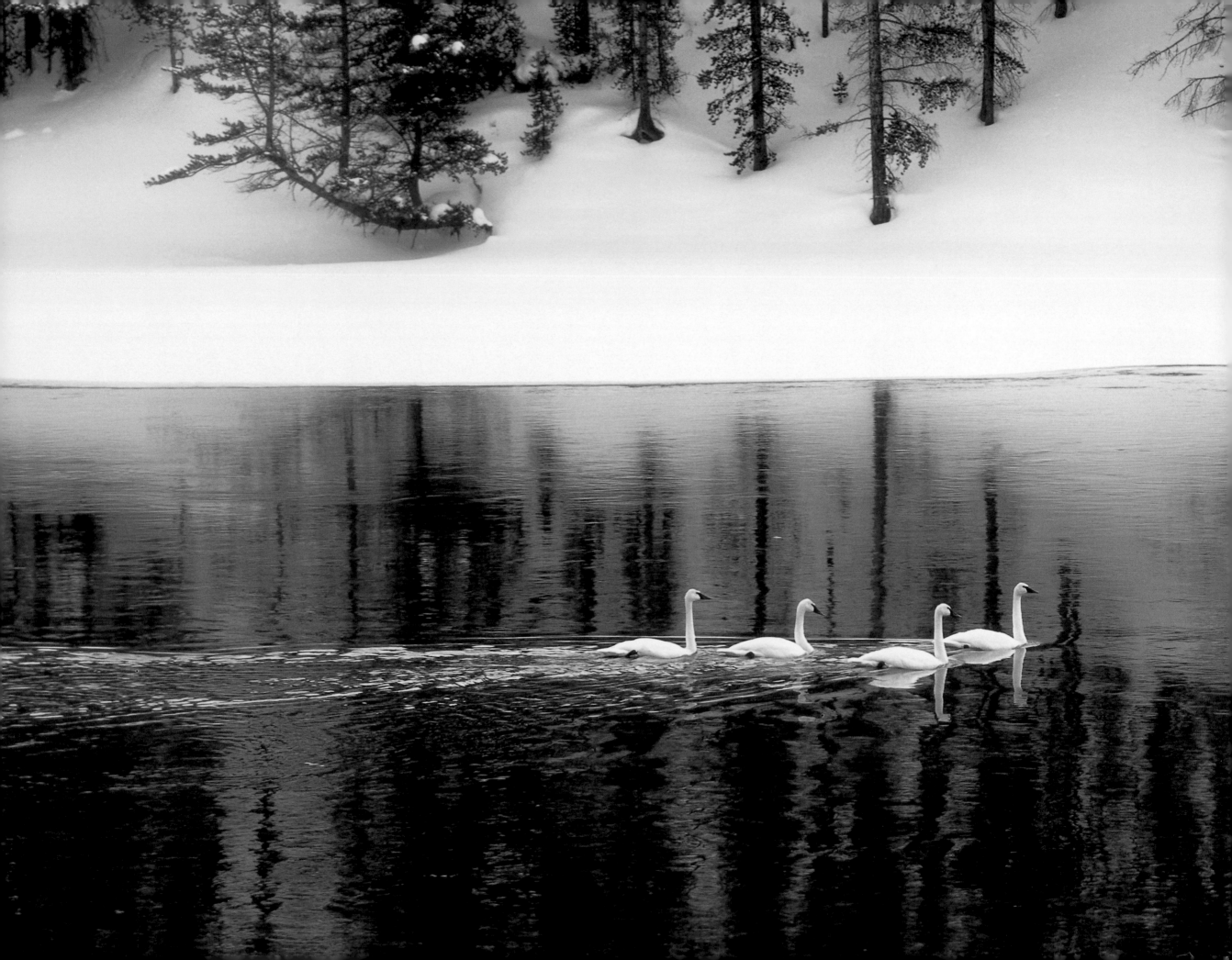

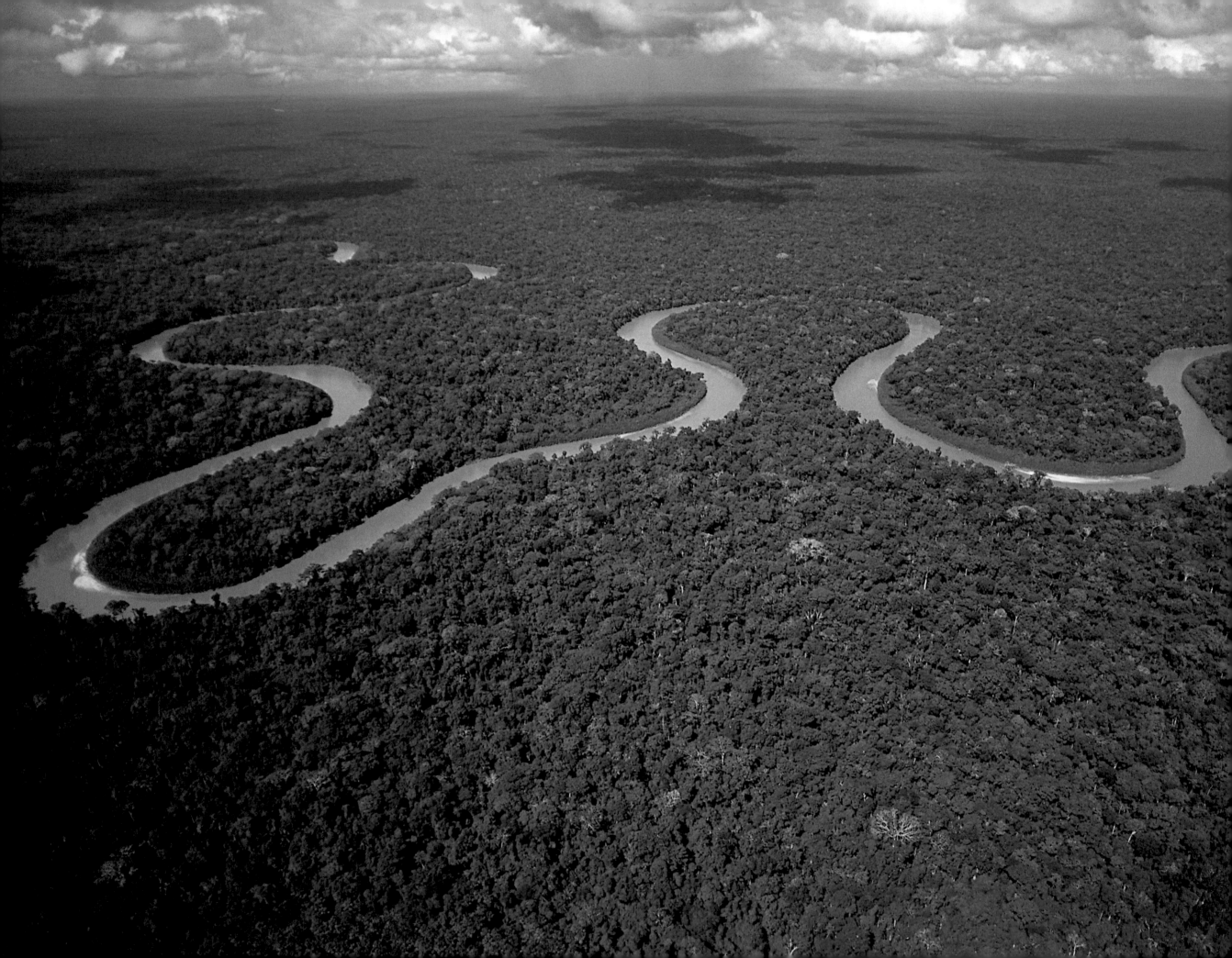

THE SERPENTINE REALM
Manú / Tambopata-Candamo / Madidi Region
Photographer: ANDRÉ BÄRTSCHI

The Indians say that creation is not finished in the Amazon.
God will wait until the end of man to complete his work.
From the motion picture *Fitzcarraldo*

This moving ocean of green-brown muddy water, this great broad snake of a river, undulates like a living thing through the dense lowland rainforests. Above, cottony eruptions of clouds boil down endless sky streets, exploding into mighty storms that flash heat lightning to the distant billowing horizon, then quickly collapse and die. By dawn and dusk, vaporous sky blues soften sun fire into smiles of amber, soft coral, and violet.

Always and everywhere, there are the whistles and chirps and shrieks of birds, the buzzing of insects and, now and again, the night growl of the jaguar, the screeching of capuchin monkeys.

In brooding counterpoint to the eternal flow of the river, an endless choking density of trees seems to murmur an invitation: Enter. Become part of me. Know Gaia.

So seductive is the call of jungle and river, human tribes since before the spoken word have lived for tens of thousands of years within its labyrinthine refuges. It has served in the time of humans as a home of abundant sustenance and dreams of empire, and a dark theater for danger and sudden death. The Incas and rubber barons grew their empires here, then vanished. Modern conquistadors wearing hard hats, carrying chain saws and gold pans, come again, with new dreams of wealth and avarice. Indifferent, the river slithers and carves through the red clay alluvial topsoil; the trees and understory grow and cover everything real and artificial; life continues.

In southeastern Peru's Manú National Park and Biosphere Reserve and Tambopata-Candamo Reserved Zone, the pristine rainforest and its full complement of life endure as they have for 75 million years within the greater immensity of the Amazon Basin.

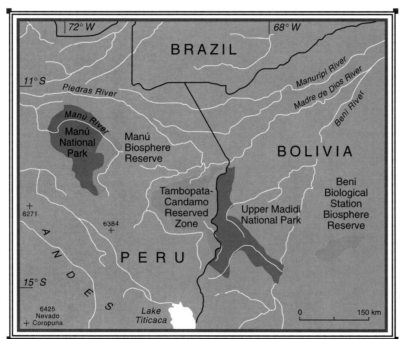

DESTINY'S CALL
You must be the change you wish to see in the world.
MAHATMA GANDHI

There is a harmony that sings of soul when we walk the right life path. No matter how challenging the environment or difficult the work, hours fly by. At the end of the day, sleep is untroubled, whatever tomorrow may bring.

For Swiss photographer André Bärtschi, following his bliss means spending long stretches of solitary time deep within a pristine tropical forest, often with only his thoughts and camera equipment for company. "Since my very first encounter with the rainforest, I always feel a sense of peace and happiness within it. I am completely overwhelmed by the 'greens'; the shapes and varieties of the luxuriant vegetation and the tremendous size of the canopy trees."

From his extended visits to rainforest ecosystems over nearly 25 years, he has come to know many of the animal voices and the messages in their calls. "I have learned how to look beyond the green walls to find the cautious forest-dwellers for my photography. But even so, it is not always possible to spot the hidden jaguar. It is knowing I am in his home range that motivates me —and provides that steady thrill."

Chosen 1992 Wildlife Photographer of the Year by *BBC Wildlife* magazine, André enjoyed a growing reputation as he took advantage of any opportunity he could to spend time in Manú, Tambopata-Candamo, and other lush, riverine ecosystems.

"The stark contrast between our modern human world we call civilization and the splendor of a pristine tropical rainforest," he says, "draws me to distant places. To discover the complex interactions of the plants, animals, and humans that share the rainforest: that is my principal goal."

In bringing back living images of beautiful creatures within their natural

On the opposite page,
the Pinquén River meanders through
the seemingly uniform structure
of Manú's primary lowland
rainforest. However, in the green
universe there are probably millions
of species, most of them still to be
discovered. In this area also roam
groups of nomadic Mashco Piro
Indians who have never been
in contact with the outside world.

environment along with pictures revealing the destructive forces aligned against them, he lights the way to a paradise that still remains largely unknown.

EDENS OF THE MIST
Once a woman asked her three children if they intended to use their fangs and claws to eat human flesh. Two nodded yes; the mother yanked out their teeth and claws. She pulled the nose of one; he became the anteater. She stuck the claws and fangs on the head of the second. He became the deer. The silent third child was left alone. He became the jaguar.
Machiguenga Indian myth

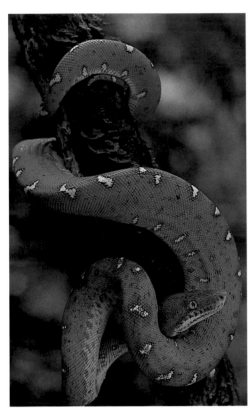

One of the most beautiful snakes in the Amazonian rainforest is the emerald tree boa. In fact, it is my favorite among all the snakes, but during so many expeditions I found it just twice. Unfortunately, encounters with humans often end fatally for emerald tree boas, because they are mistaken for highly-poisonous emerald forest pit vipers.

48

Like beating hearts, southeastern Peru's Manú National Park and Biosphere Reserve and Tambopata-Candamo Reserved Zone (part of which was incorporated into the 325 000-ha Bahuaja-Sonene National Park in 1996), and their sustaining river environments, nourish the most species-intense ecosystems in the world.

Manú, at nearly 19 000 km^2 the largest virgin tropical rainforest biosphere reserve on Earth, lies at the furthest tip of the upper Amazon, 160 km from the Inca ruins of Machu Picchu.

A few kilometers to the east, newly created Tambopata-Candamo, nearly as large as Manú at roughly 15 000 km^2, shares with its sister park what is likely the richest profusion of biodiversity in the world. The tantalizing list includes more than 2 000 varieties of flowers which get plenty of company from more than 1 000 bird, 1 200 butterfly, and 150 dragonfly species alone! On land and in the rivers and oxbow lakes, or *cochas*, more than 100 species of mammals and 125 of amphibians, almost 100 species of fish and hundreds of insect varieties round out the Eden-like profusion of biota.

The context of "Reserve" takes on added importance when you realize that more than a dozen species from the Tambopata region alone, including the jaguar, ocelot, harpy eagle, giant armadillo, and giant otter, are included in major threatened species lists such as the World Conservation Union's *Red Data Book* and CITES Appendix 1 and 2.

In human terms, Manú and Tambopata remain among the most sparsely inhabited and undeveloped rainforest areas in the world. Several distinct tribes of sometimes-hostile Indians, devastated in the last 100 years by contact with the white man, prefer infrequent contact with outsiders.

The floor of their rainforest home is a fragile entity, ironic considering the myriad species it nourishes. That's because its nutrient base comes primarily from the decaying biomatter of the forest canopy and understory growth, not from the ground. Even the 46-m trees of the canopy don't sink their roots very deep into the hard clay soil. Instead, they evolve sturdy buttressing root systems that work their way across the surface for scores of meters, providing a sta-

ble foundation. Otherwise, there would be no canopy at all: the trees would too easily topple.

NIGHT SOUNDS
Fear is that little darkroom where negatives are developed.
Michael Pritchard

Hearing things at night in the jungle can be a very different experience than hearing things by bright light of day.

"Everything is completely different at night," says André. "When there is no moon and no light, you feel very small. You have one sense left: hearing. So you start thinking; and bad thoughts sometimes come into your head. "

André finds the most threatening rainforest sounds come, not from nocturnal animals slinking or slithering about, but from the weather and its potential for sudden catastrophe.

"When there is a thunderstorm at night, you feel suddenly quite helpless. If you are camped near a river, you can be flooded. In daylight, this is not a problem; you can leave. At night, you can not see where you should go. It gives you a very weak feeling."

In his visits to Peru and other locations in the New World tropics, André has learned to respect the myriad dangers of the rainforest.

"But I like being exposed to nature. You become a part of this mysterious world, and with a little experience, you quickly learn not to take undue risks. Usually the biggest danger is your own ignorance." He knows people are more likely to come to harm from the rather unromantic fall of a heavy tree limb than by poison arrow, snake bite, piranha attack or jaguar pounce.

Case in point: never camp next to a big tree.

"The rainforest floor is littered with dead trees and large branches. In heavy winds the biggest trees sometimes fall over. The rainforest is very dynamic; things are always falling down."

Once, working in the "kitchen" of an expansive campsite with his wife Cornelia, they heard a huge crash. They looked to find an enormous branch had demolished a tent just across the trail. Anyone inside would have likely died.

Still, André has seen how people like to exaggerate the dangers of the rainforest. "There are no elephants or lions or other dangerous wildlife except poisonous snakes, and bites are fairly rare. Snakes are often found around campsites, so it is wise to look where you step or put your hands. Generally they are not very aggressive —unless you step on them or disturb them."

One night, André and Cornelia were sleeping when an alarming noise sat them bolt upright. "It was like a big paw, hitting the roof of the tent and scraping down to the ground. It happened over and over, right beside our heads."

"We had to find out what it was. I crawled outside with a flashlight and saw this giant female toad, with a male on her back. "They were mating and trying to

jump at the same time," André remembers with a laugh, "but they kept hitting the tent and slipping down, jumping and slipping down, over and over." He breathed a big sigh of relief and went back to bed. Just another night in the rainforest.

EARTH THE MOTHER
*I have spent several months a year in the Manú for 22 years in succession, and yet there are numbers of creatures I have never seen —mammals, birds, reptiles
Even my Machiguenga friends have never seen some of these animals.*
JOHN TERBORGH, Co-Director, Duke University Center for Tropical Conservation

To many people, the word "rainforest" conjures up images of steaming lowland jungles crawling with poisonous reptiles and man-eating predators. In fact, although both Manú and Tambopata-Candamo encompass their share of the great Amazon River Basin lowlands, their boundaries also encircle a representative cross section of climatic zones that reaches all the way up to the steep, cold reaches of the eastern Andes Mountains.

The reserves include three broad but distinct climatic zones that drop from nearly 4 000 m down to around 300 m. They are the *puna*, cloud forest, and lowland rainforest.

Puna describes the cold, tundralike, high-altitude steeps of the Eastern Andes mountains, with their pale yellow ichu grasses, deep blue lakes and llamas, huemul deer, and cavy (a guinea pig relative of the giant lowland rodents, capybara and agouti).

The ethereal cloud forest gets its name from a climate zone that begins at the top of the perpetual clouds and runs from 3 500 m down to about 2 500 m. Tangled groves of stunted trees shrouded in fog provide a home for epiphytes such as dripping tree ferns and orchids. Spectacled bears and lavishly-colored birds including the famed orange-red cock-of-the-rocks bring welcome color to this gray world of eternal mists.

Manú's lush lowland rainforests, fed by the ever-winding Madre de Dios and Manú rivers, are home to an astonishing diversity of wildlife. Designated a UNESCO World Heritage Site and Biosphere Reserve, it is also listed as one of World Wildlife Fund's Global 200 ecoregions. More and more tourists visit the region every year —and they come to see the animals.

Visitors are rarely disappointed as local guides in 9-m motorized riverboats lead them to exciting encounters with animal species. Joining the 1.8-m-long giant otter and black caiman alligator are a long list of exotic creatures they hope to see: the stealthy, spotted jaguar, ocelot, puma, tapir, capybara, anteater, and sloth; 13 species of primates including the red howler monkey, black spider monkey, woolly monkey, dusky titi, and emperor tamarin; several species of piranha; and more than 1 000 species of birds —an astonishing 10 percent of the Earth's total.

Only about 20% of Manú, within a 49 000-ha parcel called the Reserved Zone, is open to outside visitors, and the Peruvian government protects it by requiring permits. The heart of the park remains off limits to all incursions except the natives who have always lived there.

As in Manú, ecotourists come to Tambopata to explore its floodplain, transition, and terra firme forest biota. One of the biggest draws is the world-famous macaw lick, or *collpa*. On an almost daily basis, several dozen large blue and red macaws gather with hundreds of other brilliantly colored parrots at a vertical, 40-m riverbank to nibble away at its exposed clay. Ornithologists believe the birds eat the clay for its minerals or to counteract plant toxins from their diets.

Bird sightings in the region border on the spectacular: a world record 331 species were recently seen and heard in one day by a single party hiking the trails and paddling a river canoe.

NEED TO KNOW
Tambopata is the perfect place to remember once more that nature does not belong to us. We belong to nature.
Rumbos Online, Peruvian Internet travel magazine

Native rainforest tribes are rarely a threat to outsiders, but outsiders can unintentionally, and severely, threaten animal populations. Without proper education in the sensitivities of specific species, as André learned from his interest in the endangered giant otters, populations can be driven off or even die out.

"I first heard about Manú and Tambopata in 1977," says André, "while I was working in the Zurich Zoo. I very much wanted to see this healthy population of giant otters. At that time, there was no tourism, but I managed to get a permit for myself and some friends. We traveled all over the region with a park guard for several weeks."

While there, he got his first glimpse of the sleek predator that is hovering on the brink of worldwide extinction. "Manú has one of the largest giant otter populations in the Amazon, yet there are only about 70 to 80 left. Scientists worry if there are enough to make a comeback."

Like the cheetah of the Serengeti, this fanged carnivore may possibly have been forced by environmental pressures into so much inbreeding that it could now be genetically vulnerable to being wiped out by a single communicable disease.

Things have changed dramatically in the quarter century since André Bärtschi first saw the giant otter. Ecotourism is growing rapidly, but with it have come problems. "Well-managed tourism is necessary to balance increasing human populations with the need to protect Manú and Tambopata. You can't just close off an area and leave it only to the scientists. But everybody has to learn how to do it right."

André believes one path to successful tourism lies in establishing human-animal interface guidelines, based on input from specialists and animal groups.

The funny-looking leaf frogs are nocturnal, slow-moving insect hunters. Most species —such as this Phyllomedusa vaillanti— stroll the canopy during the year, but in the rainy season they descend close to the ground to mate and breed on leaves overhanging temporary pools in the rainforest.

"The giant otters are a good example," says André. "I spent time with a scientist making a years-long otter study. He discovered how tourists were having a negative impact on the otters."

When tourism operators, ignorant of how the animals display their sensitivity to intruders, encouraged tourists to get too close to the animals in their oxbow lake habitats, the otters fled or became too stressed to properly care for their young, threatening entire generations.

"The scientist discovered how extremely sensitive the animals are to human disturbance. When otters approached, making a snorting sound, it was a warning to humans to leave. But people thought they were being friendly!"

Once the scientist shared his insights, tourist paths along the lake's shore were relocated and viewing platforms were established to reduce the pressure by boat traffic, and to give the otters a bigger comfort zone. More secure, their numbers have stabilized.

"It is very important," says André, "for tourism businesses and conservationists to work with specialists; not just with park authorities, not just with tourism experts, but with scientists who really know about the specific behavior of mammals, birds, and reptiles. That is one way the area can be used for tourism without harm."

He laments another challenge that would seem to be a boon: the money tourism brings with it. "The big profits are made by the tourist agencies, but often not enough goes to the local people. But we also have to recognize that natives and local people work for awhile, earn some money, then buy chain saws and go into the rainforest to cut down trees to sell."

"There are so many opinions of how to do things the right way. Park management has improved. When the people are trained very well, when they are paid better, they can identify more with the need to contribute to the well-being of the area. But tourism and harvesting of sustainable resources is a complicated problem, with lots of potential for corruption, in this remote area with so few roads."

THE HUMAN LANDSCAPE
I hope that native people, typically looked upon as backwards and uncivilized,
can be seen instead as sophisticated naturalists in their own right,
able to teach us a great deal about the environment in which they live.
GLENN SHEPARD JR., PBS online

Humans are no less colorful inhabitants of the Manú/Tambopata rainforest environment than the plants and animals. A broad and diverse array of Indian groups has long called the region home. It is currently theorized that, like their northern cousins, many of South America's indigenous peoples originally came across the Bering land bridge between ice ages, perhaps 40 000 years or more in the past.

In the lowlands a variety of tribal cultures live in harmony with nature, if not always with each other. Far from primitive savages, these are people who know the land and can teach Western man many lessons in how to reap its constantly regenerating bounty. Schooled from birth to become skilled hunters, they are also perceptive foragers for medicinal botanicals of great potential value to Western society.

The Machiguenga of Manú are known for their friendly, sometimes even playful interactions with outsiders —once their trust has been earned. The Yora/Yaminahua avoided contact with outside Peruvian societies until the 1980s. Fierce marauding warriors and restless nomadic hunters, they are known for their raids on villages. Descending without warning, they pillage food crops and steal tools, weapons, and even craftworks, presumably because they have not developed the ability to provide similar goods for themselves.

Industrial man had a large part in prolonging the traditional isolation of the Yaminahua. When rubber barons murdered, enslaved, and brutally exploited large numbers of natives in the nineteenth and early twentieth centuries, they fled deeper into the jungle.

Even today, oil platform workers and loggers in certain areas of the region are on constant alert against attack from natives with bows and arrows, who sometimes appear wearing industrial hard-hat helmets stolen from earlier raids.

THE BALANCED VIEW
There are no passengers on spaceship Earth. We are all crew.
MARSHALL MCLUHAN

"As a wildlife photographer I try to document the undisturbed beauty of tropical nature, but also the devastating effects of its systematic destruction." And wherever humans and nature intersect, André has seen that well-managed protected areas can advance the cause of conservation without imposing hardship on the people. But so often, crafting effective management is an incredibly complex, routinely frustrating endeavor.

And when super-wealthy, exploitative corporations such as Mobil or Shell Oil uncover vast natural gas reserves, as they have in the Candamo and Camisea watersheds, conservationists sometimes feel like throwing in the towel.

The Peruvian government needs energy desperately for its economy to grow. But extracting mineral resources is forbidden in national parks. Therefore, political compromises must be made —such as what happened with Tambopata-Candamo. Originally on track to become a national park, most of the important parts such as the entire Candamo Watershed remain only a Reserved Zone for the immediate future, even as the gas pipeline begins its link-by-link march to the cities beyond the western Andes.

Finally, factor in the waning but still detrimental remnants of a gold rush in the Tambopata Watershed. Now weigh such economic temptations against the natural desire of indigenous peoples to improve their living conditions and enjoy

On the opposite page, one morning after a rainy night, as I was walking back to my camp in the midst of Manú National Park, I suddenly noticed something large moving through the rainforest understory: a jaguar was clambering onto a fallen trunk where he laid down with his back towards me. First it seemed that he didn't notice me, probably because the damp leaf litter muffled my footsteps.

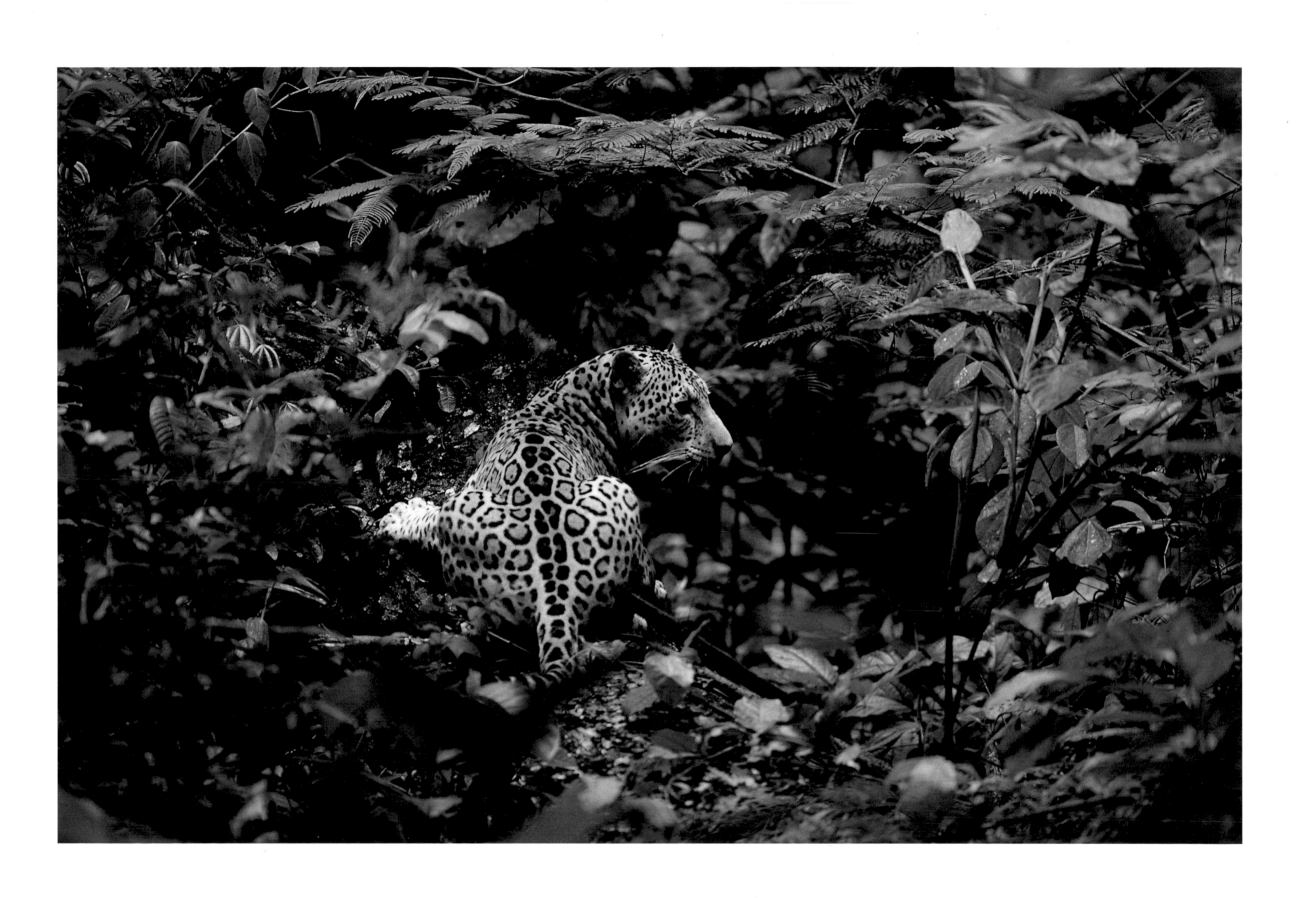

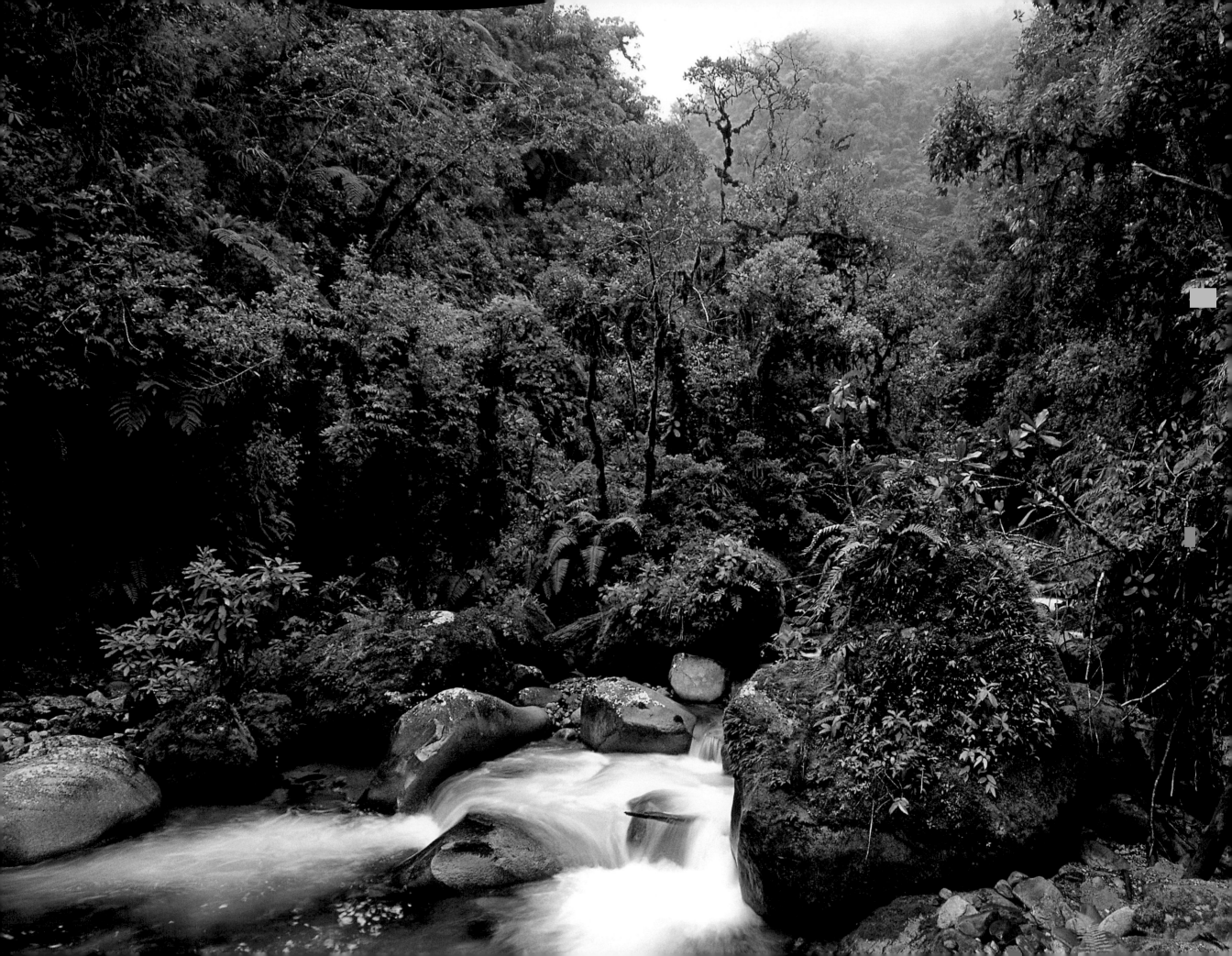

the fruits of industrial civilization. How do you explain the value of protecting a "biosphere" to a father and mother of six hungry children?

In seeing the intricate tangle of all the players, each promoting his or her own agenda, André has come to realize that the only solution lies in communication and cooperation. All parties must work for effective management that takes the long view: a global conservation ethic within the context of compassionate provision for all a nation's peoples.

A WALK ON THE PATH OF TOMORROW

Renewable yearly harvests of Brazil nuts, rubber, marketable fruits and other rainforest products can potentially employ more people and create more revenue over the long run than can other models of development —most of which (assume) the rainforest's permanent destruction.

KIM MACQUARRIE, *Peru's Amazonian Eden: Manú*

In recent times, the civilized world has come to view with alarm the massive logging of Amazonia and the destruction of its diverse and fertile ecosystems. In the last 100 years, more than half of all the world's rainforests have been cut down. By 2040, world population is projected to double. When you do the math, you wonder how the forest will survive.

Perhaps the most damaging influence on the Peruvian Amazon began in the 1960s. Peasant colonists or *colonos* began to flock to the rainforests from Andean and coastal regions. The Peruvian government, figuring exploitation of rainforest resources would help ease their land hunger while also improving defense of national sovereignty in remote border regions, offered free land and financed construction of highways. The doors of the frontier were flung open to the *colonos* and industrial development of oil, gas, rubber, and logging.

Conservationists and ecology scientists know that once the trees are gone, the rainforest soil has little left to offer: less than 5% of the rainforest is even suitable for growing. In Europe, 75% of nutrients are in the soil, 25% are in the trees. In Amazonia, the reverse is true: 90% of nutrients are vegetative; only 10% are found in the clay soils.

A supreme irony: here lie the most luxuriant forests on Earth, rooted in the midst of what are essentially nutrient badlands. So as elsewhere, when Peruvians can't see the forest for the trees, they cut them down, bankrupting all their children's green futures.

A good example of programs that seek to find a way out of the dilemma is the new Ese'eja Ecotourism Project in Tambopata. It looks to build businesses that are profitable and that benefit the local Indians and their biospheres.

Founded on a 20-year contract between the native community of the Ese'eja people (who live in a 10 000-ha protected zone bordering the Reserve) and ecotourist company Rainforest Expeditions, the project funnels 60% of the operating profits to community members. They also have equal decision-making powers in all project stages.

The first phase of the project is a 24-bedroom ecotourist lodge opened in 1998. Because of the shared ownership philosophy of the enterprise, the Indians realize they are owner-partners, not employees. Programs to teach English, tour guiding, and service skills are in full operation. Even opportunities for higher education are in the offing.

Families with members involved in the project have seen dramatic increases in their annual incomes. They are learning that, while a felled money tree needs decades to grow back —if it is able to grow back at all—, paying tourists will continue to come, for years and years, just to see such places of astonishing natural beauty.

Humans of all shapes and colors are clever animals indeed, and the Ese'eja are no exception. For years, they regularly raided eight large harpy eagle nests, located within their village grounds, for ceremonial feathers. When the tourists came, willing to pay money just to see the eagles, the Ese'eja quickly realized they would do better over the long run if they became the eagle's protectors.

Before long, the partnership concept got its first test: an Ese'eja guide stepped forward and stopped a road construction crew from cutting down one of the harpy eagle's nesting trees.

Through such encouraging parables, may we find a resurgence of hope that the Manús and Tambopatas of the world will survive to teach us how we can save our beautiful world and all its green Edens.

On the opposite page,
the frequent rains (up to 6 m annually) support the mysterious and intriguing cloud forest,
which ranges in elevation from 1 000 to 3 500 meters. Unión River, Koshñipata Valley, Manú.

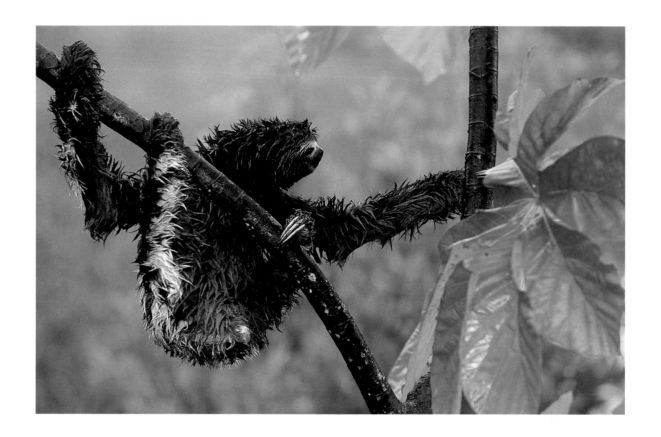

Three-toed sloths spend much of their lives sleeping and foraging high in the canopy,
where they are nearly impossible to spot. They feed on leaves of numerous species of trees,
but they enjoy plenty of cecropia leaves. After a heavy rainstorm I was scanning the cecropia trees
along the river, when I spotted this soaked three-toed sloth. He was descending from the tree,
probably to get rid of the countless cecropia ants.

On the opposite page,
shrouded in the mist of dawn, the enchanted rainforest realm along the Chalalán Lake in lowland
Madidi National Park entices us to go in and try to discover some of the countless mysteries it holds.

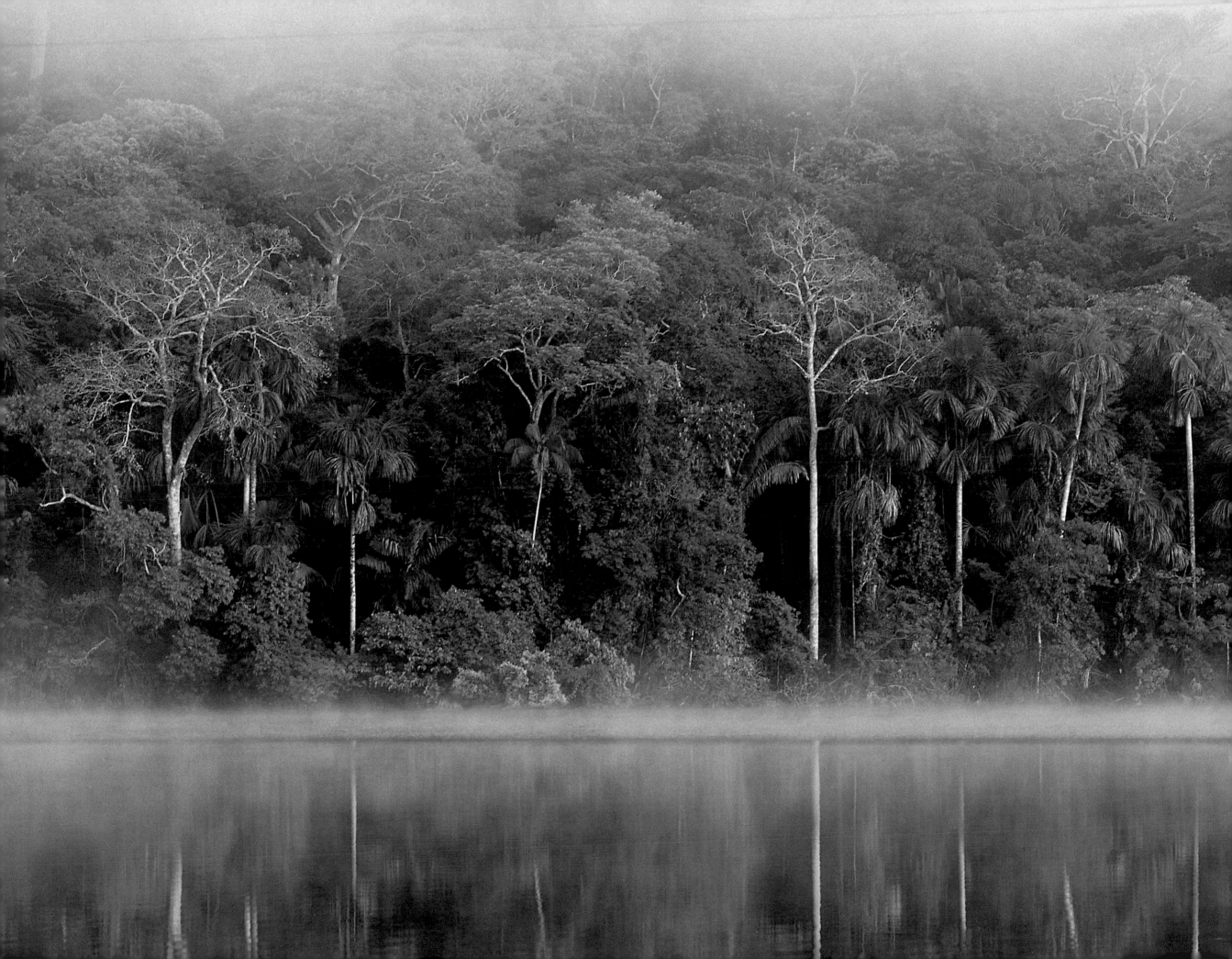

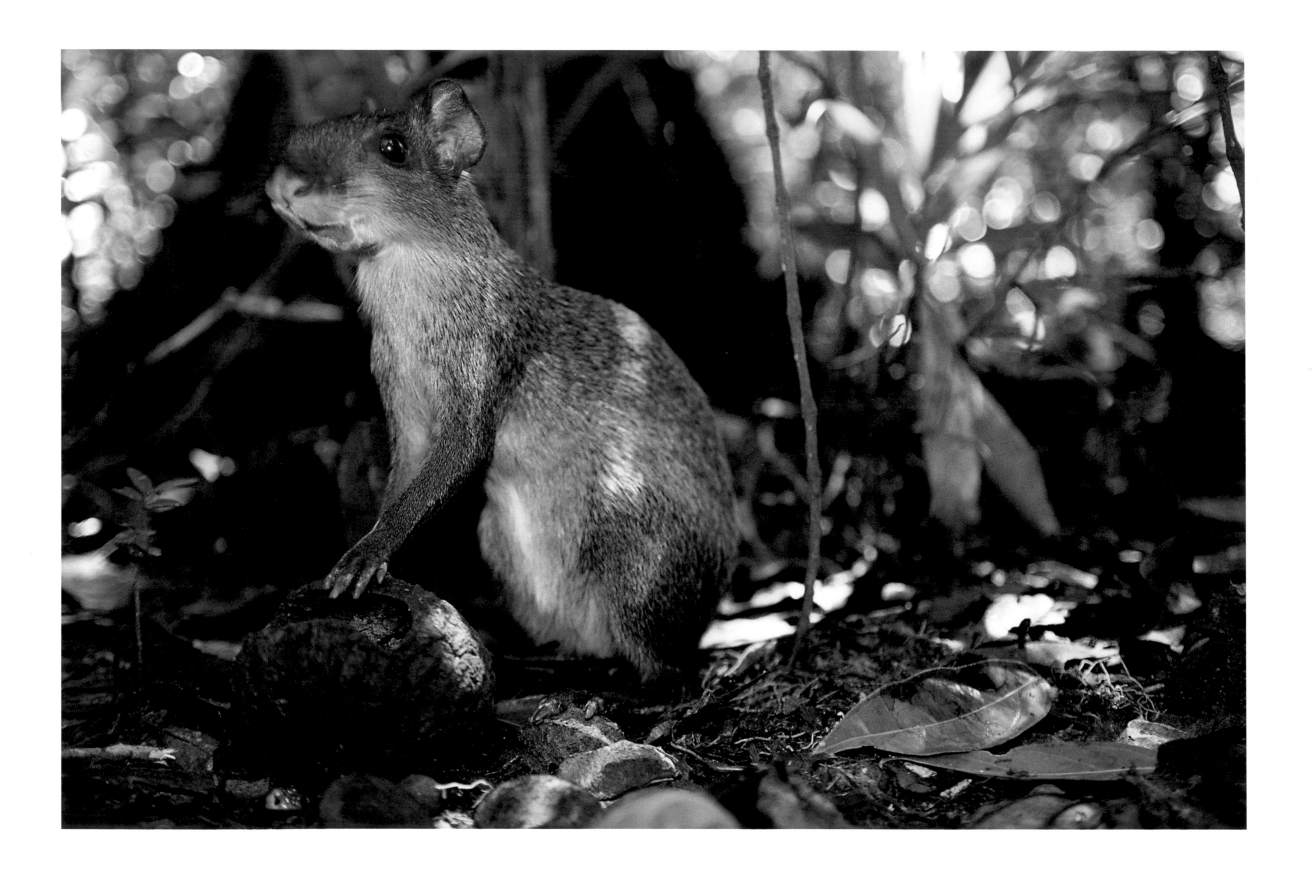

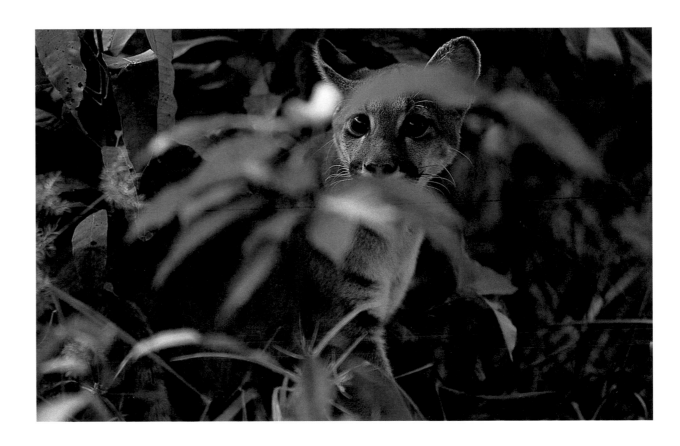

On the opposite page,
the small agouti and the giant Brazil nut tree have one of the most unexpected yet important relationships
in the Amazonian rainforest. This rodent, about the size of a domestic cat, is an expert at opening
hard-shelled Brazil nut pods. It usually eats a few nuts right on the spot and burries leftovers for later
consumption. Some of the cached nuts may be forgotten and finally will sprout into new Brazil nut trees.

Above, growing up as a "sweet little pet" at a settler's hut along the upper Tambopata River,
this juvenile puma has a very uncertain future. Soon, with sexual maturity the cat's supposed tameness will
fade away and tragedy will culminate for her. Her fate began when hunters illegally killed
the puma mother and sold her kitten to the farmer for a few cents.

Cocks of the rocks are among the most spectacular birds of the Andean cloud forest. The males with their
brilliant orange-red plumage gather at traditional leks, for much of the year, to display and to attract
the attention of females. Away from such display grounds, the cocks of the rocks are difficult to observe
as they are quite shy and usually live along remote mountain slopes.

On the opposite page,
an explosion of color and sound erupts as a large group of red-and-green and scarlet macaws take to the air
from a clay lick along a remote river in Manú National Park. In the Amazon, many of the birds
and mammals that eat leaves or seeds have been observed eating clay. The seeds and leaves of many tropical
plants are rich in toxic compounds, so the widespread snacking on clay appears to allow macaws
and other animals to eat such poisonous foods.

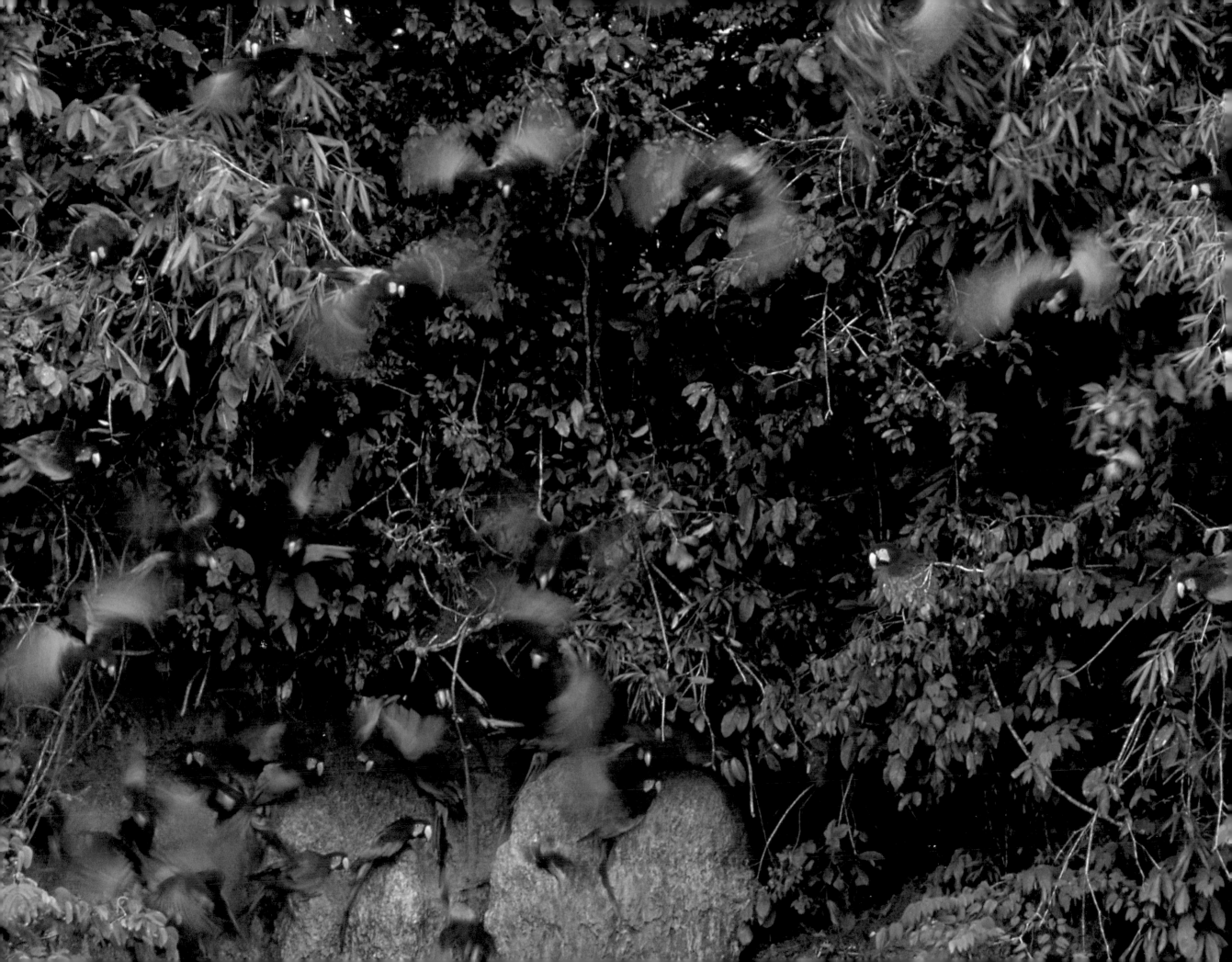

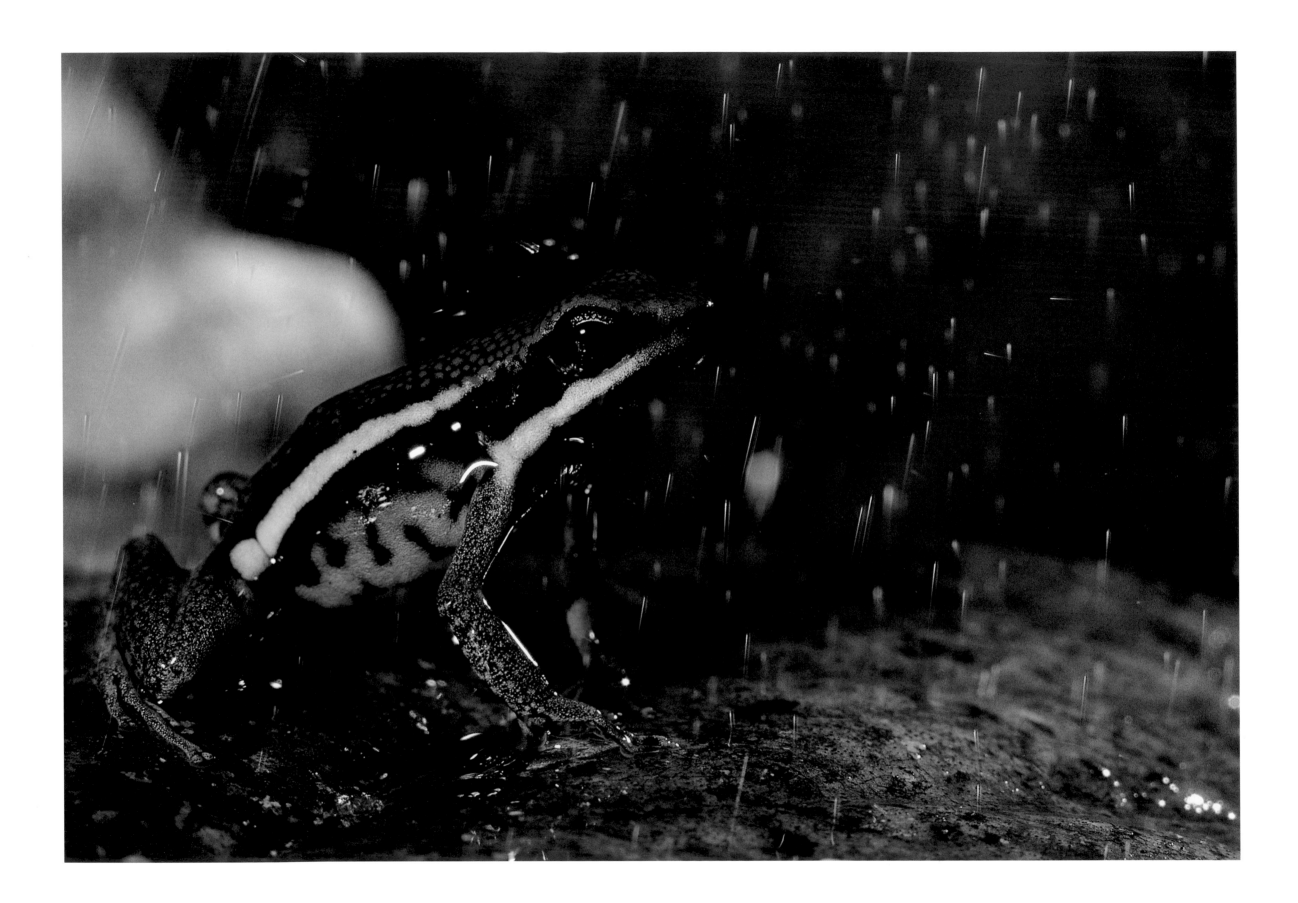

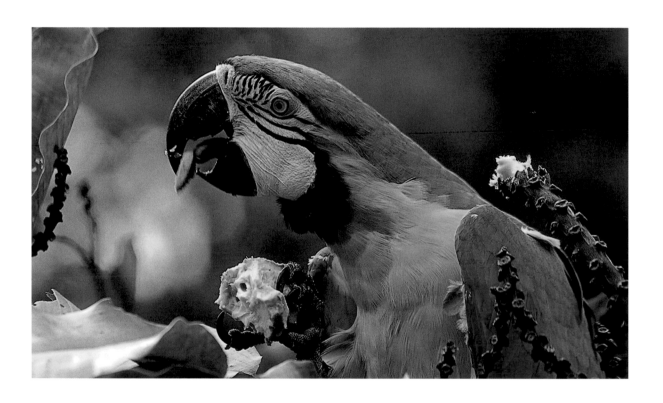

On the opposite page,
the only location of this poison-dart frog on the planet lies within the region of Manú.
I found this brightly-colored male calling amidst the leaf litter beside a small stream
one morning when it started to drizzle. He is calling either to mark his territory or to attract a female.

Above, a blue-and-yellow macaw does not wait for the Brazil nut pod to ripen and fall.
It perches on the crown of the emergent tree and feasts on the still soft-shelled developing nuts.

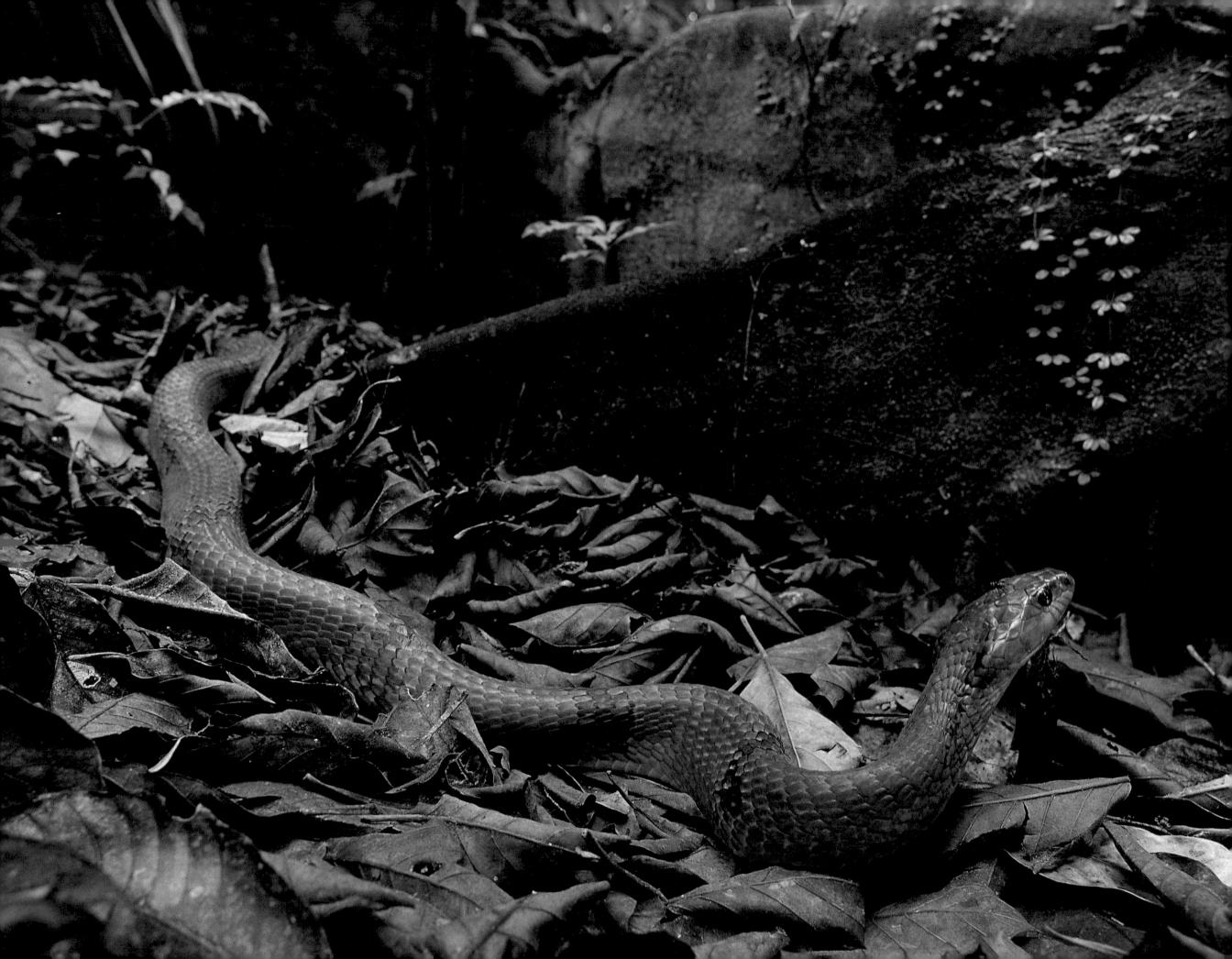

*On the opposite page,
the diurnal toad-eating snake is not dangerous for humans, but exhibits impetuous behavior
when disturbed. It flattens its neck and body and strikes loudly, hissing.
The snake devours the largest frogs and even poisonous giant toads,
which tend to inflate their bodies when faced with danger.
However, some elongated teeth in the upper jaw may disinflate the blown-up prey
and help the snake swallow it.*

*Above, I have always had a special interest in frogs. The variety of colors,
shapes, and behaviors is amazing, and there is a tremendous diversity of species
along the eastern slopes of the Andes, where herpetologists
discover new species whenever they explore a new area.
The skin secretion of this two-colored leaf frog is used by Panoan Indians,
who introduce the dried secretion mixed with saliva into the blood stream
through deliberate skin lesions. As a result, the natives experience pain
and gastric distress, but then feel energized and refreshed.*

The silhouette of a tree-dwelling tarantula appears on a palm leaf beside my tent
as the light pours through the canopy gap. This was a relatively large Avicularia species,
about the size of a small hand. Though they are called bird-eating spiders, they feed mainly
on insects, and look a lot more dangerous than they are. I'm always happy
to find them around my campsite.

On the opposite page,
the most ancient gardeners of the tropical forest, the leaf-cutting ants,
carry pieces of leaves down from a canopy tree.
The fragments of leaves, and sometimes flowers, are used as a medium
to grow fungi to provide the ants with food.

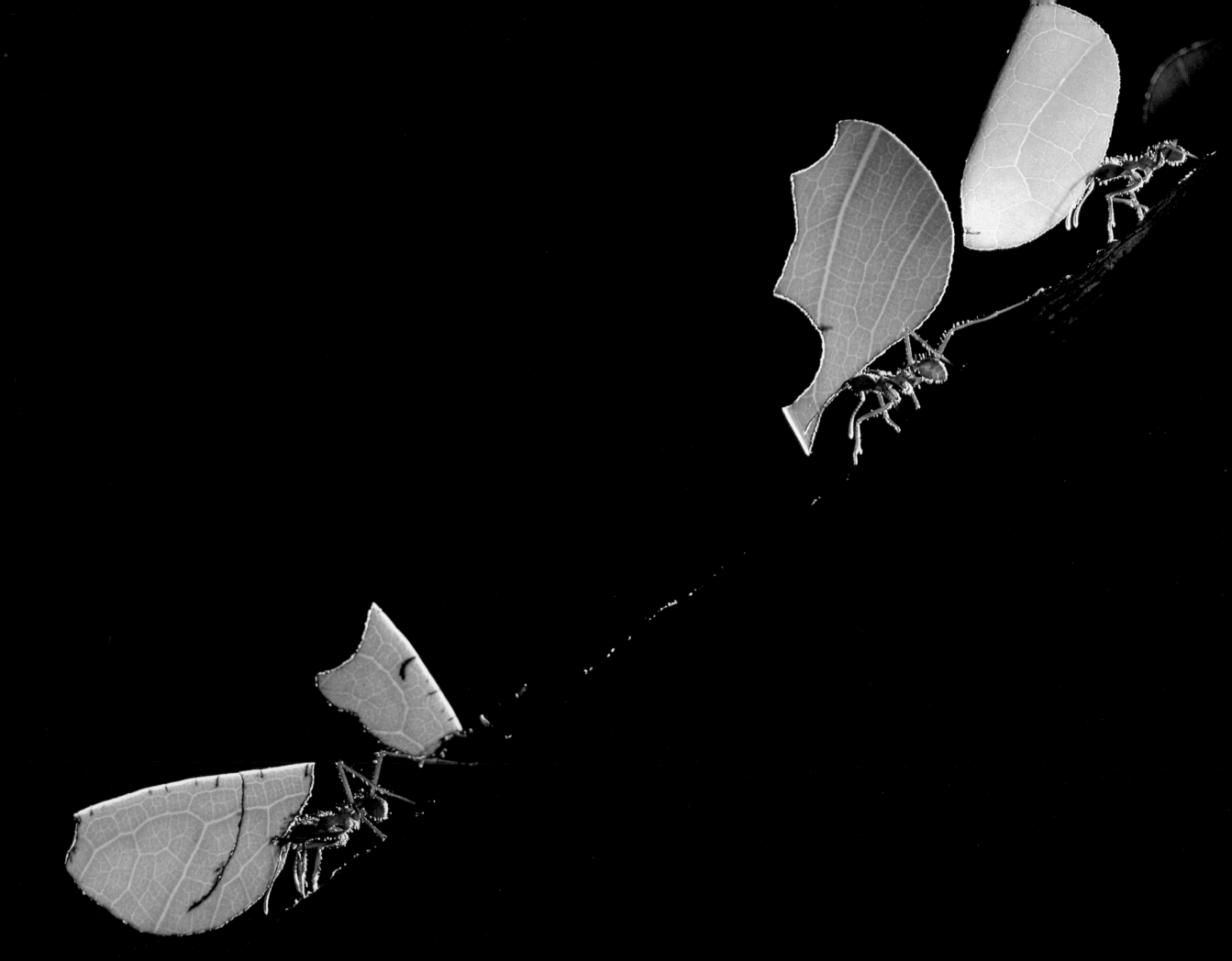

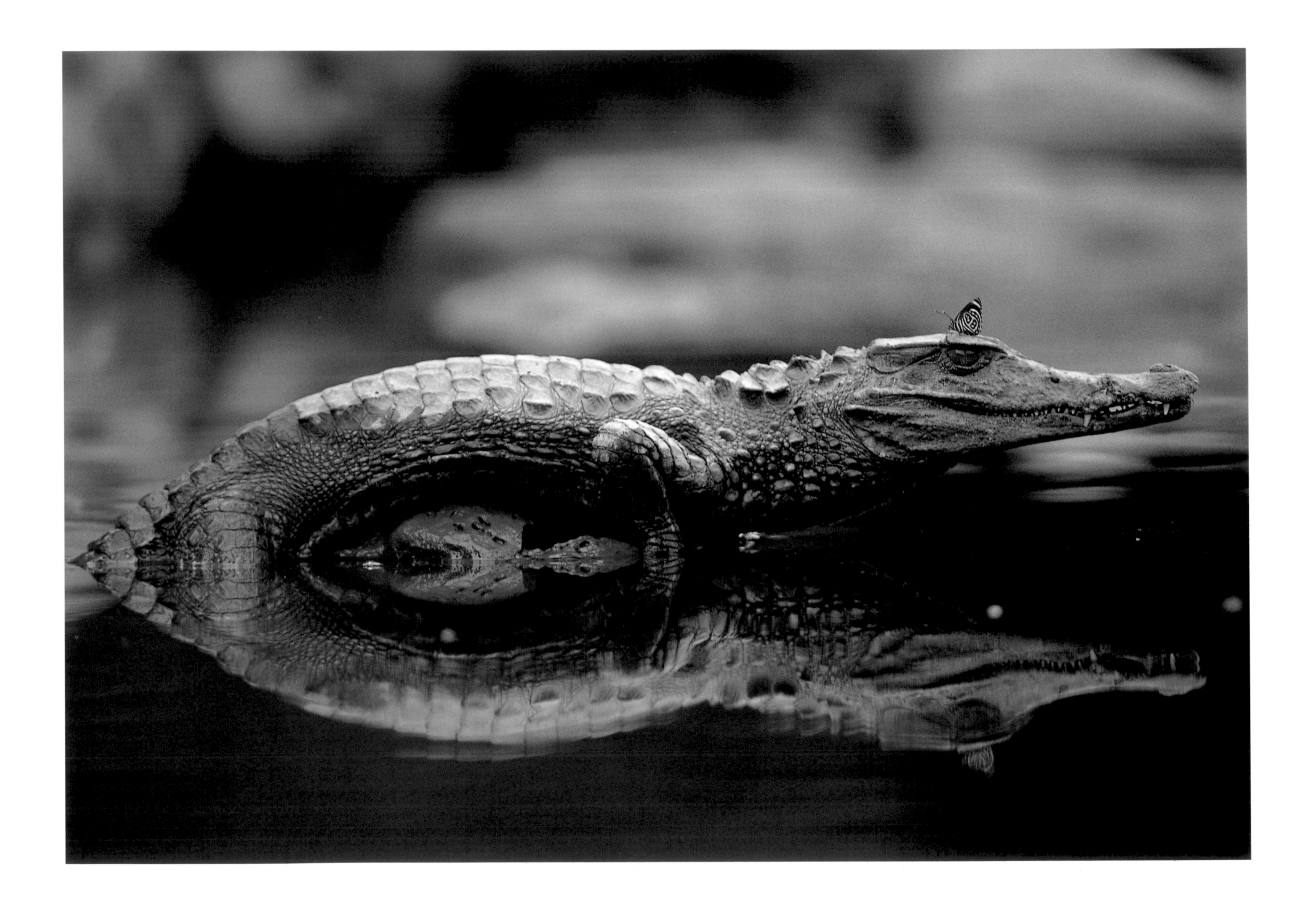

On the opposite page,
a Schneider's dwarf caiman was basking on a rock on the shore of the Távara River,
when a nymphalid butterfly fluttered into the scene and dipped down to sip salty fluids
from the caiman's eye. Sadly, the apparent unspoiled serenity of this image
may be shattered in humans' search for oil. The Peruvian government has excluded
the immensely important Candamo-Távara Watershed from the new national park
scheme, due to its probable mineral deposits.

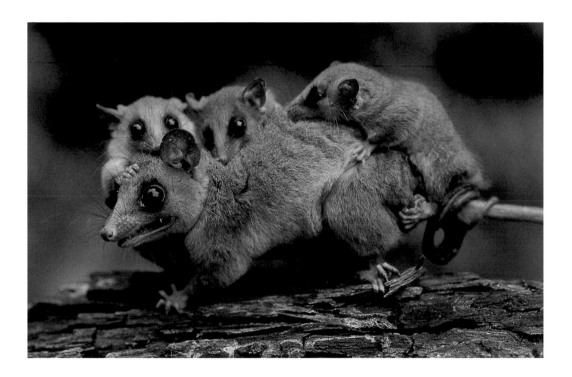

This nocturnal marsupial, a mouse opossum with weighty offspring on her back,
decided to spend the day hidden in a basket full of fruit at my rainforest camp.
In the morning, unintentionally I frightened her while preparing breakfast.
Hissing and threatening with an open mouth, the heavy-laden mother left the camp
and disappeared up a tree.

It was a fascinating experience to observe the family group of giant otters while they all hunted
for fish in one of Manú's oxbow lakes. After a while, the leading female approached
my canoe at the lake's edge to within just a few meters. Protesting with loud snorts —their warning
sound—, she wanted to drive me away, as she would try to do with any potential enemy.
Carefully I retired and the giant otters continued hunting along the shore.

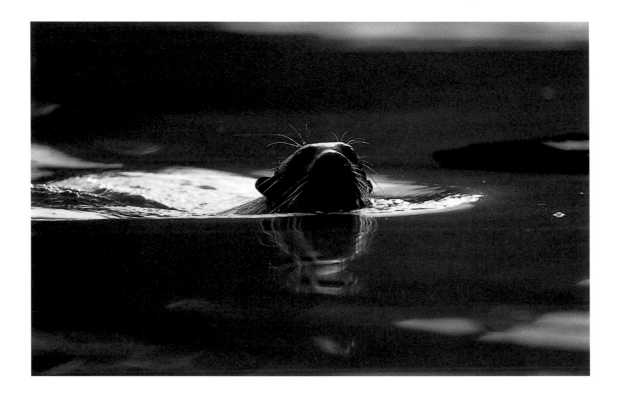

On the opposite page,
tapirs, the largest mammals in the Amazon Basin, have a natural craving for clay
and will travel miles to feed at a clay lick, to which they will regularly return. One night this big
male tapir was drinking the mineral-rich water after devouring big amounts of clay
from the bank behind him. The camera on the tripod was very close to him
as I triggered with a radio control from my hide. The muddy water did not affect the well-protected
camera, but it heavily splashed onto the expensive wide-angle lens as the tapir rushed by.

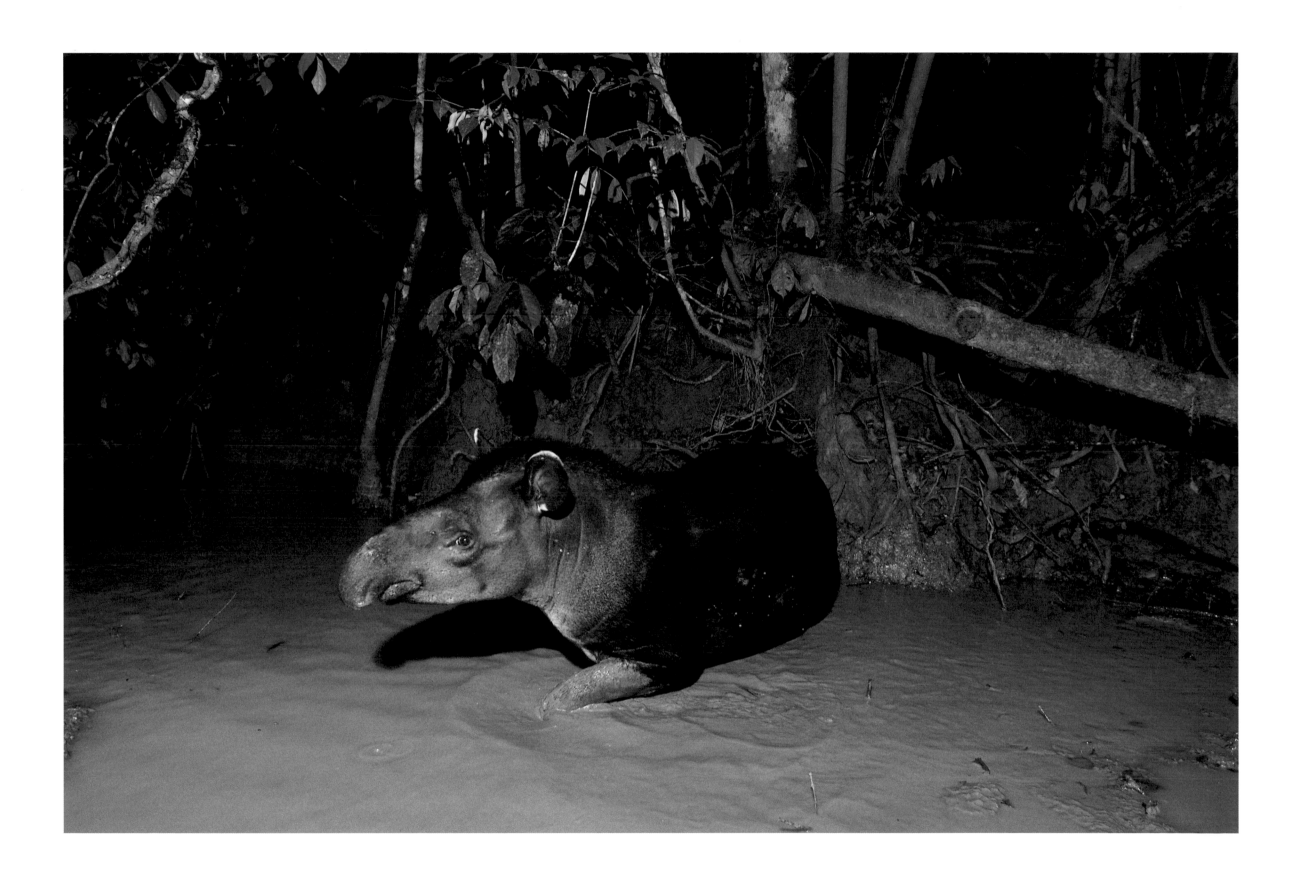

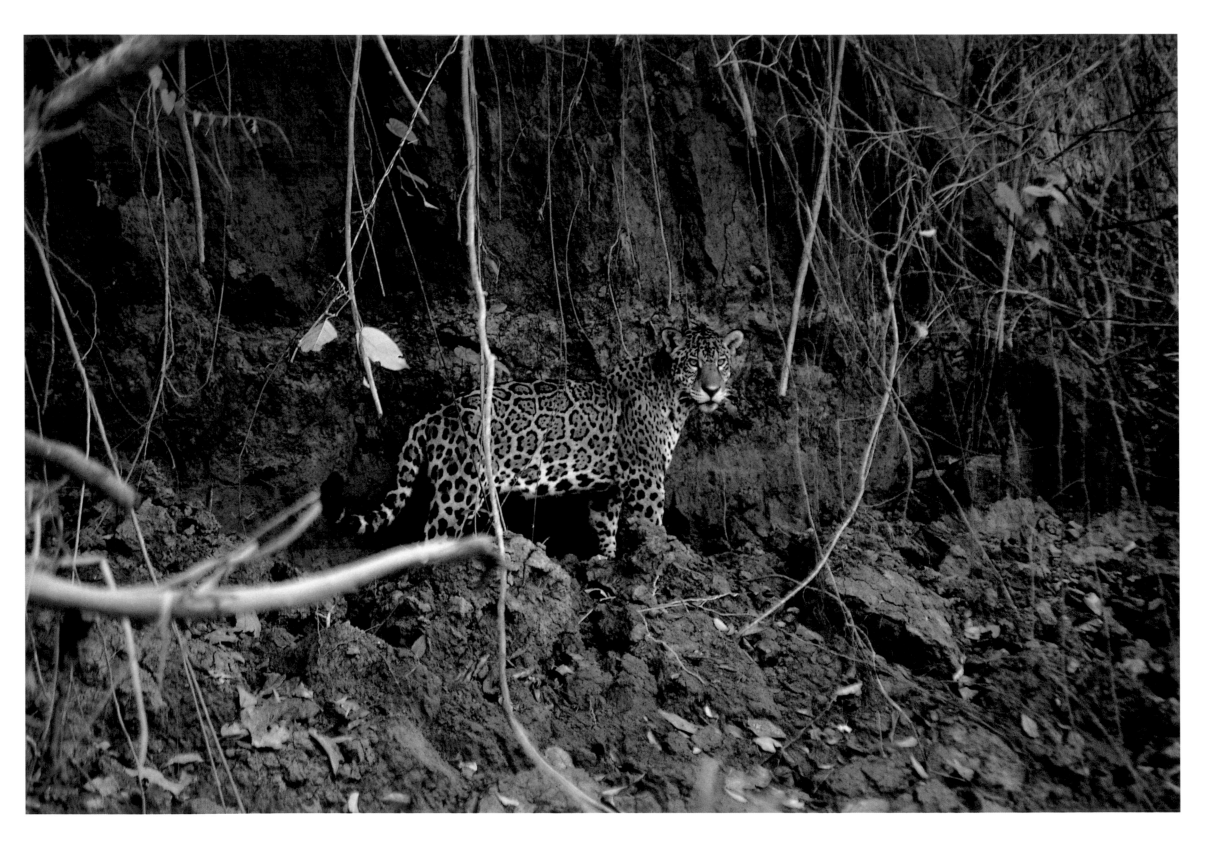

I spotted this male jaguar as he prowled along the Manú River where he probably hoped to surprise a capybara, caiman, or other riverine prey. We carefully approached in our inflatable boat to within less than 15 m before the big cat moved away very slowly and finally disappeared into the rainforest. Such close encounters with jaguars are not very rare in places as Manú and Tambopata, where no hunting pressure existed for many years.

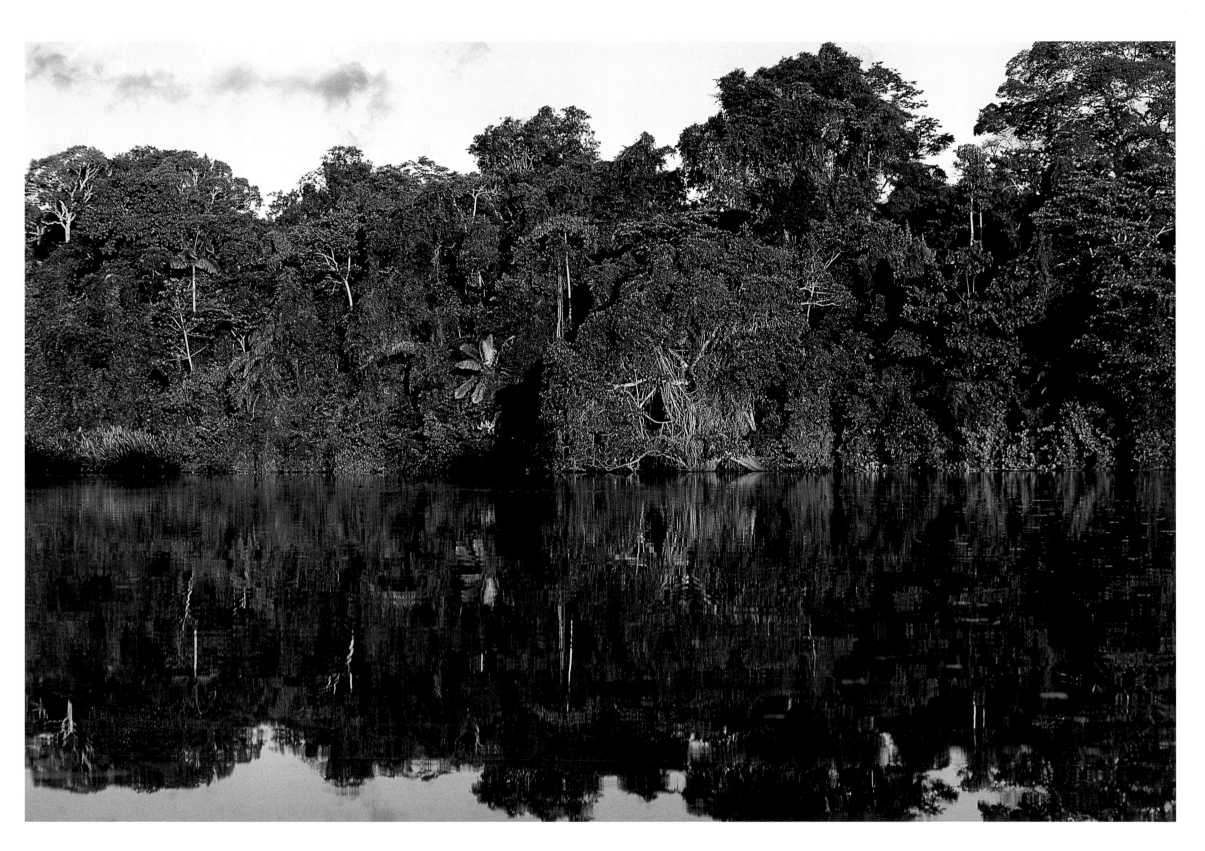

Meandering rivers carve the land, forming oxbow-shaped lakes or cochas *where river channels are cut off and isolated. Here the lowland rainforest is mirrored in the still waters of Cocha Cashu, the site of Manú's world-famous biological research station, built in 1970. With their extraordinary abundance of life, Manú's remote oxbow lakes and the surrounding rainforest make ideal sites for investigations into tropical ecology.*

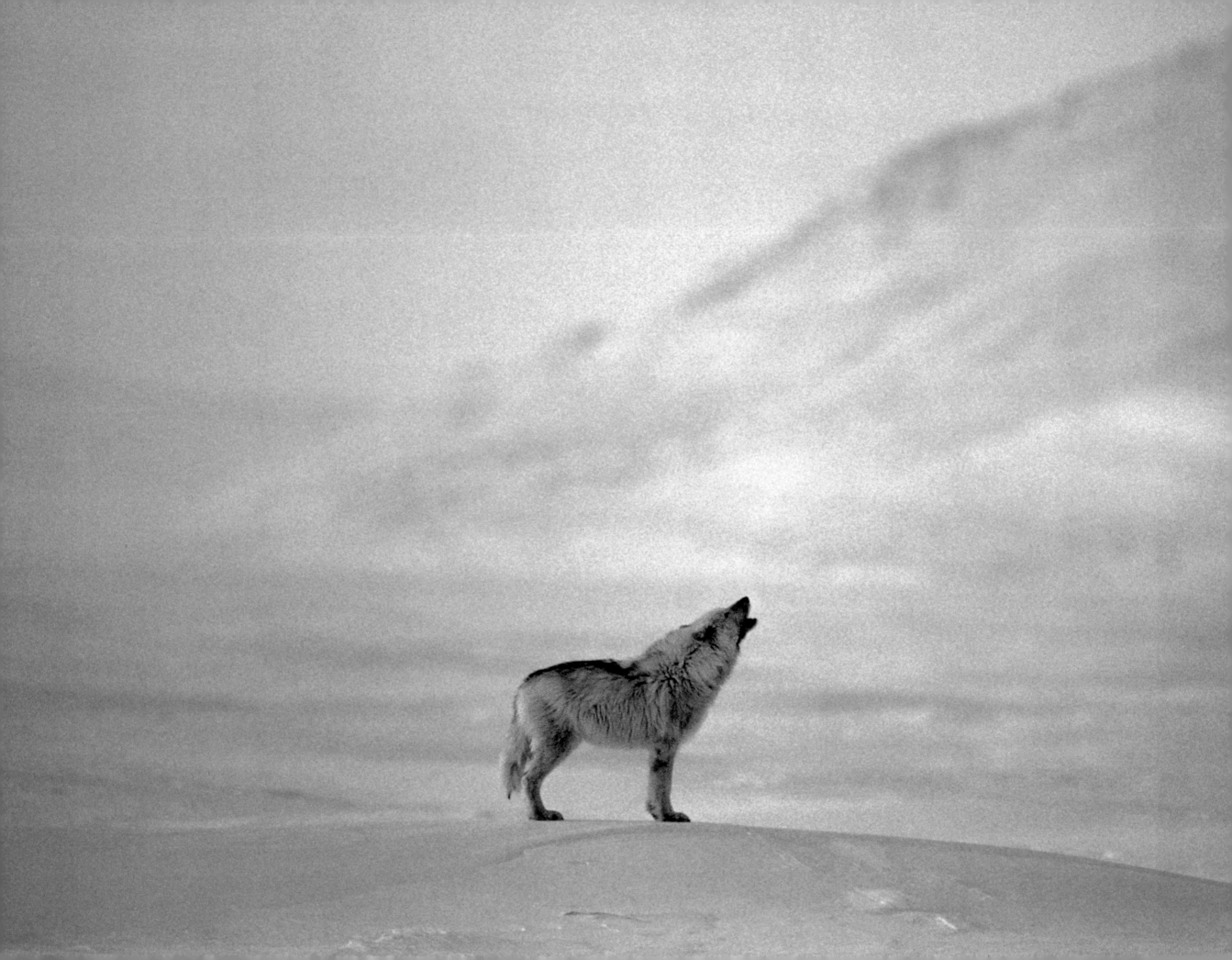

THE IVORY DESERT
Quttinirtaaq, Ellesmere Island
Photographer: JAMES BRANDENBURG

I tramp a perpetual journey … each man and each woman of you
I lead upon a knoll / My left hand hooking you round the waist /
My right hand pointing to landscapes of continents …
WALT WHITMAN, *Leaves of Grass* (1855)

It is a dreamland of desolation. For all but a few months in summer, everything is white, white, white: a rolling polar desert of ice and blowing snow punctuated here and there by sharp, craggy mountains and their many tongues: inexorable, syrup-slow glaciers licking down the valleys and fjords toward Arctic seas.

Riding the stark yin/yang shift from eternal night to eternal day that marks the seasonal wobble of our planet's polar regions, this immensely beautiful, unbelievably harsh land at the top of Canada's new Nunavut territory is so inhospitable to life that only a handful of plant and animal species can survive here. Even humans have tried to live on Ellesmere, only to be rebuffed by changes in climate that dramatically reduced the land and marine animal populations so vital to their own survival.

A vast and seemingly empty land, you won't find a respectable tree or city for 1 500 kilometers in any direction. With no forests or ground cover, the daily play of life and death between herbivore and carnivore takes place on an eternally bare stage.

Prey animals have a doubly tough existence. In the dark of winter night, musk-oxen, Peary caribou, Arctic hare, and collared lemmings must endlessly paw the icy edge of existence for their sparse forage while keeping one eye cocked for predators. In turn, the survival of the carnivores —Arctic wolf, Arctic fox, weasel, and polar bear— rises or falls on their prey's success at finding enough food.

In spring and summer, as the temperatures warm, the set becomes more

and more colorful, but the actors play the same parts, eternally, and so it goes in the natural world.

This is Ellesmere Island, western neighbor to Greenland, tenth largest island in the world. The northernmost landmass of the North American continent, it has often served as an ideal jumping-off place to the North Pole, just 770 km from its northern coasts. Famed explorer Robert E. Peary made many quests from Ellesmere in his passion to be first to the North Pole. Expeditions continue today, ranging in tone from serious scientific expeditions to frivolous gaggles of well-heeled jet-setters, out for a recreational lark.

Even with modern technology, the climate of the Arctic Circle presents a brutal challenge to all life. When you walk here, you go arm in arm with sudden death, where eternally dark winter nights, sudden, severe storms, winds, and temperature drops to –57°C can quickly steal the life from the careless or ill-prepared.

The 800-km-long island holds a convoluted topography of sharp-toothed mountain ranges inlaid with numerous deep fjords. Substantial ocean sounds, frozen bays, 1-km-thick ice caps, and vast regions of ocean pack ice create a dramatic coastal environment that runs thousands of kilometers.

Highlands, tundra, and hundred-km reaches of barren, expansive plains wear wavelets of crinkly-dry, wind-drifted snow and perennial ice stretching to all horizons. In summer, 21°C warmth imbues the bleakness with a heathery green vibrancy, punctuated by poppies and other wild flowers, insects, and migratory birds, in higher and lower elevations alike.

In the vast and open lands of Ellesmere, life has evolved in a unique way. Just as in the Galápagos, human presence has been so minimal over the millennia that animals have not learned to fear us.

Factor in the low-angle sunlight that reigns from late spring through late

On the opposite page,
the wolf howl is one of nature's most
haunting sounds.
When one is separated from the pack,
howling is used to stay
in touch. It is also a means
of warning other packs not to intrude
upon their territory.

summer, that "golden-hours" hue photographers prize for its rich, warm patina, and you know two of three reasons why Jim Brandenburg heard destiny call him to Ellesmere Island.

The third was the white wolf.

BROTHER TO THE WOLF
You must have … a place where you can simply experience
and bring forth what you are and what you might be.
JOSEPH CAMPBELL

He is the hunter, hunting the hunter. In patient pursuit, he scans the barren taupe and green distance for signs of the pack. Though he hasn't slept in more than 24 hours, he can't miss this.

Jim Brandenburg is living the dream of a lifetime.

Far from the madding crowds of civilization, his thoughts roam back to the Minnesota prairie, his boyhood home. Gazing into that kindred emptiness had raised a nameless craving deep within him. Happily immersed in Ellesmere's echoing vastness, that early, mysterious hunger is finally being satisfied.

For hours now, he has excitedly dogged the tracks of the white wolf across the rocky expanses. The long-distance ability of wolf packs to keep up a steady, loping gait of 10 km per hour, for hours at a time —they often range 60 km and more on a single day— makes keeping close in his tottering all-terrain vehicle a bumpy, gradually losing affair.

He has seen neither hide nor hair for some time of the pack he has come to know so well that he has given them names: Buster, Mom, Scruffy, Midback, and more. But that's what knowledge, the confidence to follow hunches, and good tracking skills are for; all traits Jim shares with the pack in its hunt for food.

The hierarchy of the wolf pack is worked out at a very young age. Ritualistic body language often times can tell you which is the dominant animal.

There's something more at work, too: Jim is never afraid to trust his inner voice. "As a photographer, I allow myself to be guided by intuition. My best images come from an emotional relationship to my subject, and rarely from calculation."

In months of fieldwork, Jim has observed and filmed aspects of the wolves' complex social structure, hunting tactics, and care of their young that few humans have witnessed, much less recorded in such comprehensive detail.

It is 1988. Over two decades and more than 1 000 published wildlife images from around the world; only the wild wolf has eluded his camera. "From dozens of fleeting encounters, I made only seven photos of wild wolves in all those 20 years. None had the aesthetics of a great photo." With a gentle chuckle, he adds, "You could get better wolf pictures at a zoo."

Ellesmere is a bit like a zoo. Here, the wolves are so accustomed to his pres-

ence that they often ignore him. He has had to make wolflike warning huffs to keep the friendly intruders from dragging off sleeping bags and food.

In their highly-evolved social structure, in the affection and family-like activities of play, in their coordinated pack hunts, Jim has found a lifetime's photographic and spiritual bounty.

A DELICATE BALANCE
… he pointed his nose at a star and howled long …. And his cadences …
voiced their woe and … the meaning of the stiffness, and the cold, and dark.
JACK LONDON, *The Call of the Wild* (1903)

Through Ellesmere's winter palaces of murderously cold permafrost valleys, through its summer realms of mosquito-plagued, untrammeled highlands, *Canis lupus arctos*, the beautiful white Arctic wolf, roams virtually unchallenged in its supremely adapted struggle for survival.

In every other ecosystem on Earth, the wolf is rarely encountered in the open, for good reason. Around the world, wolves have been the objects of systematic and centuries-long campaigns of annihilation. They have learned the hard way that human beings must be avoided. Only on Ellesmere is the animal inclined, through innocence, to give humans the benefit of the doubt.

Perhaps wolves tolerate humans because they are not genetically wired to hunt two-legged animals, only the four-legged kind. That's good news for humans, but bad for musk-oxen and the other ungulates and small-fry prey of Ellesmere.

For the wolf, taking a musk-ox is a crowning triumph of sophisticated teamwork in which attackers can quickly become victims from a mortal hoof kick to the head or a horn hooked deep into the belly. In the game of life, the cards are stacked, as always, against the animal that blinks first.

ON THE HUNT
Only one who bursts with Enthusiasm do I instruct;
Only one who bubbles with Excitement do I enlighten.
CONFUCIUS

Jim crests a gentle rise, raises binoculars, and finds the wolves. He senses an intensified purpose in their beeline trot for the next ridge. Goosebumps pop on his arms. Although he can't see any other animals, he believes their prey must be nearby.

He is deeply fatigued from lack of sleep, yet intuitions and long experience tell him to move —now! Gunning the little ATV, he races off on a tangent, hoping to reach the wolves' destination before they do. He jounces across the spongy tundra, praying for this chance to film a scene few have witnessed and none have recorded —the full array of cunning teamwork, individual courage, and savage decisiveness required for the taking of a large prey animal by a wolf pack.

Where winter wolves bark amid wastes of snow … far from the settlements ….
The enormous masses of ice pass me, and I pass them….
WALT WHITMAN, *Leaves of Grass* (1855)

There are few landscapes less hospitable to life than this island. Beneath translucent cerulean skies and storm clouds alike, the weather-worn ridges and sawtooth mountain ranges of the coasts are transected by numerous steep-walled finger valleys and fjords laden with glaciers. Framed by these coastal highlands, wide, open-range expanses of continuous permafrost run for scores of kilometers.

Only a handful of hardy species can make it here: musk-oxen, wolf, Arctic hare, Arctic fox, lemming, weasel, and Peary caribou. Polar bears haunt the coasts in search of seals, their favorite prey. Even this fearless carnivore steers clear of a wolf pack. As elsewhere around the world, bears and wolves have learned it is wiser to avoid each other.

In the eternal freeze/thaw/fracture of the high Arctic Ocean pack ice, several marine mammals thrive: killer whale, walrus, seal, white beluga whale, and the unicorn-tusked narwhal. The Arctic char, similar to trout or salmon, is often praised as the best-tasting fish in the world.

A rich and welcome panoply of some 30 species of birds add their music and color to the great open spaces. Some are migratory during the warmer months, the rest survive the dark winters to stay year-round. Species include king eider, rock ptarmigan, Arctic terns, ivory gulls, snowy owls, snow buntings, gyrfalcons, Arctic loons, ruddy turnstones, northern fulmar, plover, hoary redpoll, red knots, and the long-tailed jaeger.

The Arctic tern, with its black head, sharply-angled wings and long, pointed twin tail, makes a 38 000-km round trip every year to Tierra del Fuego and back: the longest migration of any animal in the world.

Botanical life ranges from abundant multicolored lichens to grasses, sedges, and the ubiquitous tundra ground cover. Poppies and purple saxifrages add welcome color, while the ground-hugging Arctic willow, technically classified as a tree, fails to rise as high as a clutch of spring poppies.

Insects live even on Ellesmere, but in slow motion: the woolly caterpillar that takes a year to metamorphose from egg to moth in North America takes 12 or more years to mature here. Bumblebees and mosquitoes come out in warmer months. Life finds a way in Ellesmere as everywhere else on Earth, but it is not an easy life.

DANCES OF DEATH

Once a wolf, always a wolf.
AESOP

Off to his left, Jim spots the pack. Again he marvels at the steadiness of their gait over uneven ground even as he wishes his own bouncy ride was smoother.

He rolls over another hill and there, a kilometer ahead, is a musk-ox herd.

He dashes onto a rise, close enough to film the imminent drama, and sets up his gear just as the pack trots into view.

With almost workaday casualness, the wolves trot straight for the herd. In a pas de deux as old as time, the musk-oxen sidestep and shuffle into a defensive circle, haunches jammed together at the center, their phalanx of curving horns brandished towards the interlopers.

The wolves charge and feint around the animals, hoping to frighten a calf or a weak animal into bolting. Jim films it all, flushed with excitement as the ungulates shift in unison while individuals thrust and parry with their horns. In a surprisingly short time, the wolves deduce that these are healthy and determined animals. Breaking off the threat rather than waste energy in a lost cause, they return to their single-file traveling gait and head straight for the next ridge. Prey 1, Wolves 0.

Before long, they come upon another dozen musk-oxen grazing in low, boggy ground —a poor footing for defense. This group has three calves. Again, Jim hurriedly sets up equipment as the prey animals hustle into their instinctive defensive ring, calves huddled in the center. As before, the wolves skillfully harass the musk-oxen, but the ungulates hold their ground.

But then, just as the predators give up and turn to leave, the musk-oxen, perhaps overstressed by the wolves' intimidation on this untenable ground and too dimwitted to realize they are home free, pick the worst possible time to bolt for higher ground. The wolves instantly whirl and chase them at top speed. The stampede grows wilder as wolves bite at the legs of the fleeing musk-oxen. Suddenly, Jim finds himself directly in the path of the melee. He ducks as the herd rushes straight at him, breaking at the last second to flow past on either side.

One wolf sinks its fangs into the flank of a calf, separating it from the bolting herd. A second calf is pulled out, but its mother charges the wolves with maternal fury. White blurs scatter everywhere, long enough for this young one to regain the herd and safety.

When the musk-oxen stop on high ground to regroup in defense, the pack abandons the attack to race back down the hill and finish off the doomed calf. The hunt, 17 hours old now, is finally a success. Soon, bellies distended with kilograms of meat, the meat hunters and their human companion head for home.

Arctic hares are precocious in that when they are born, they are quite soon mobile and not as dependent upon the mother as other animals.

THE SCYTHES OF EXTINCTION

Things are not what they seem. Nor are they otherwise.
Lankavatara-sutra

Survival above the Arctic Circle is ever a day-to-day ordeal. But recent climate changes have wreaked new havoc on Peary caribou and musk-ox populations.

Peary caribou, closely related to European reindeer, are elfin creatures of white fur, mottled backs, and scraggly little horns that resemble withered tree branches. Robert E. Peary and other explorers nearly wiped out the entire Ellesmerean population by slaughtering them for food to sustain several expeditions over a number of years. Almost a century later, the hapless ungulates have not fully recovered —and global warming patterns have locked away the animal's forage beneath impenetrable layers of packed snow and thicker-than-normal ice.

Caribou are not the only threatened species. Whole herds of musk-oxen have been found far out on the pack ice between Ellesmere and Greenland, frozen upright where they stood in a failed search for new grazing ground.

In recent winters, as much as 85% of the Peary caribou population may have perished. And Inuit populations, allowed by their own Nunavut government to engage in subsistence hunting, may bring musk-ox and caribou herds to the brink of extinction. White wolf populations may follow, unless they can learn to survive on Arctic hare, lemmings, and weasels: slim fare compared to a 660-kg musk-ox calf or a 880-kg Peary caribou adult.

DAY'S WORK, DONE
The strongest impression remaining with me after watching the wolves ...
was their friendliness toward each other.
ADOLPH MURIE, *The Wolves of Mount McKinley* (1944)

Racing back the 55 km to the den, Jim is ready to film the reunion of the pack with those who stayed behind. Before long, in the empty distance kilometers away, he hears the discordant keening chorus of the hunters, announcing their return. The mother, a guardian adult, and the pups jump up, tails wagging. The pack arrives and gets a happy reception. Each pack member soon disgorges part of its ballast of musk-oxen meat to feed the puppies and nonhunting adults at the bottom of the hierarchy.

Jim films it all, but before long, weary hunters four-legged and two settle into their respective hollows, one of earth, the other of nylon and goose down. Time for a richly-deserved rest.

On the opposite page, the polar bear is at the peak of the food chain on Ellesmere Island. They have been spotted swimming hundreds of kilometers offshore from Ellesmere Island.

TOURISM AT THE TOP OF THE WORLD
There are not many places you can go in the world with that much
totally pristine real estate.
JIM BRANDENBURG

Why would you create a park in a mostly unpopulated, frozen wasteland? One word: people. Throughout Ellesmere's fragile permafrost areas, vehicle tracks, temporary structures, and even footprints may last decades. Parks Canada felt control was needed to minimize damage from future tourism. Opponents said the very scourge the park was designed to prevent would be exacerbated by the resultant increase in visitors.

Parks Canada, in reaffirming its official ethos that maintaining the unimpaired ecological integrity of lands forever was good for flora, fauna, and human beings, won the day. In 1988, Ellesmere Island National Park Preserve was born.

By right of sheer longevity, the Inuit people have recently reclaimed considerable dominion, along with a billion-dollar settlement from the government of Canada, over their ancestral hunting lands. Nunavut is the new Canadian territory created from the division of the Northwest Territories, and includes Ellesmere Island.

With the change, the new name is Quttinirtaaq National Park, Inuktitut for "top of the world." The park's 39 348 square kilometers embody the topography, climate, flora, and fauna typical of the rest of the island.

The park's highest point is Mount Barbeau, at 2 600 m. South of this "nunatak," so-called because little of its peak protrudes above the ice cap, lies Lake Hazen, an Arctic thermal oasis flourishing with life. The largest freshwater lake north of the Arctic Circle, it is 80 km long and lies in a basin that captures reflected solar radiation from the nearby Grant Land Mountains, creating a thermal oasis with an atypically hospitable clime. The remainder of the park is a polar desert.

Some 4 000 years ago, nomadic Paleo-Eskimos crossed Ellesmere Island to keep their musk-oxen food supply within reach as they ranged across northern Canada. Europeans first came to Ellesmere Island with the British Arctic Expedition of 1875-1876. A base was established at Fort Conger in 1875 by the crews of *H.M.S. Alert* and *Discovery*. Numerous sled journeys were made inland and east across the sea pack ice to Greenland.

Today, Ellesmere is populated by a scant 400 or so humans, of which 147 live in the south of the island in the Inuit settlement of Grise Fiord. The remainder staff military and scientific research stations.

Ellesmere's nearly pristine purity could change as overuse by park visitors and oceanic industrial pollutants drifting north from Europe infiltrate the region's delicate ecology. Well-versed in the harsh conservation lessons of older parks around the world, Quttinirtaaq's management is watching tourism closely and may someday impose a restriction quota.

A GIFT
Indeed, I believe that wolves possess a kind of spirit we can only begin
to understand through our emotions.
JIM BRANDENBURG

Two days before his final departure from this wonderful island of ice and snow, Jim decides to photograph close to the den. Perhaps, he thinks, he'll get his first shots of the trove of this year's puppies, for none has yet ventured into the open since their birth.

The adults, curled up and resting a hundred meters away, watch as he

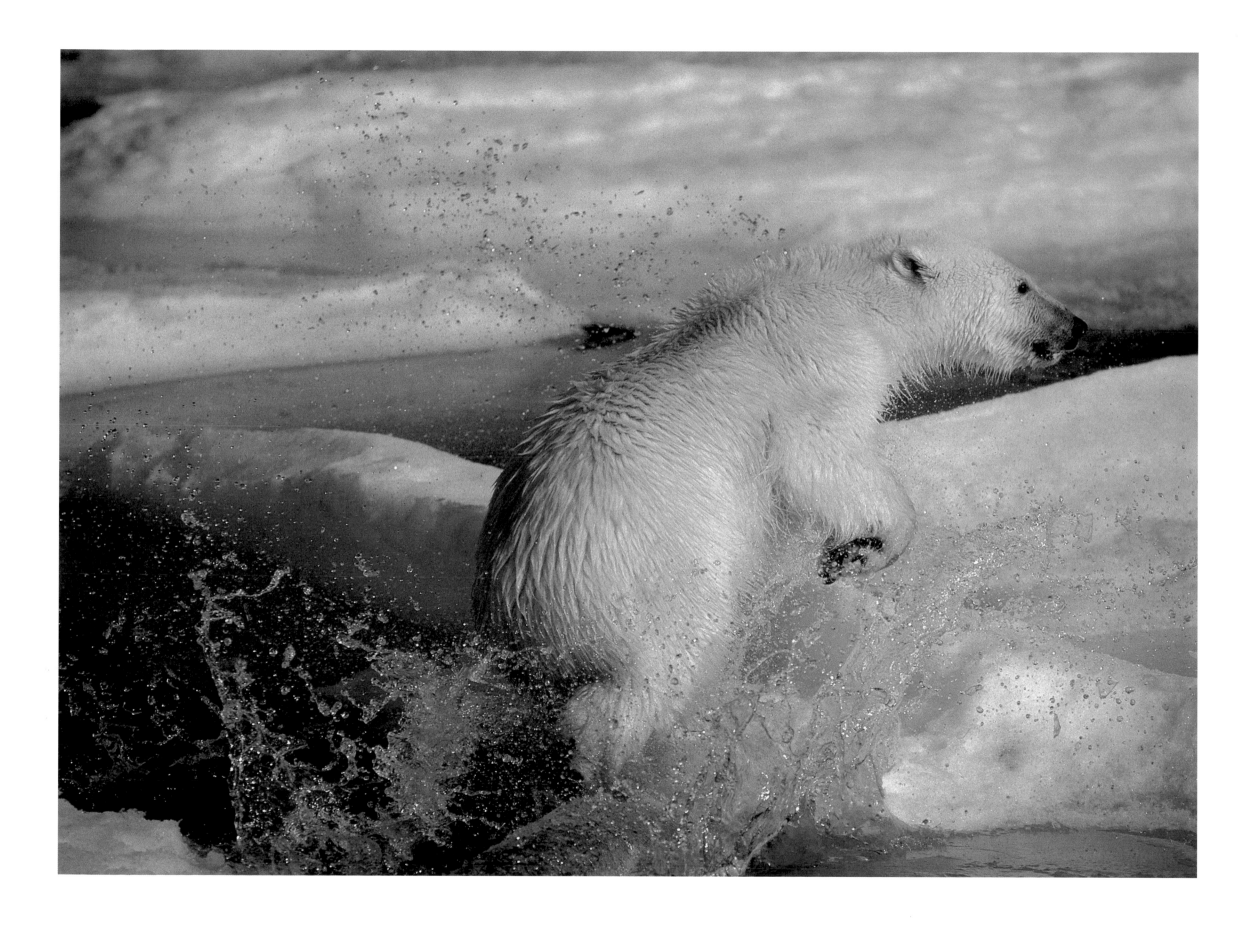

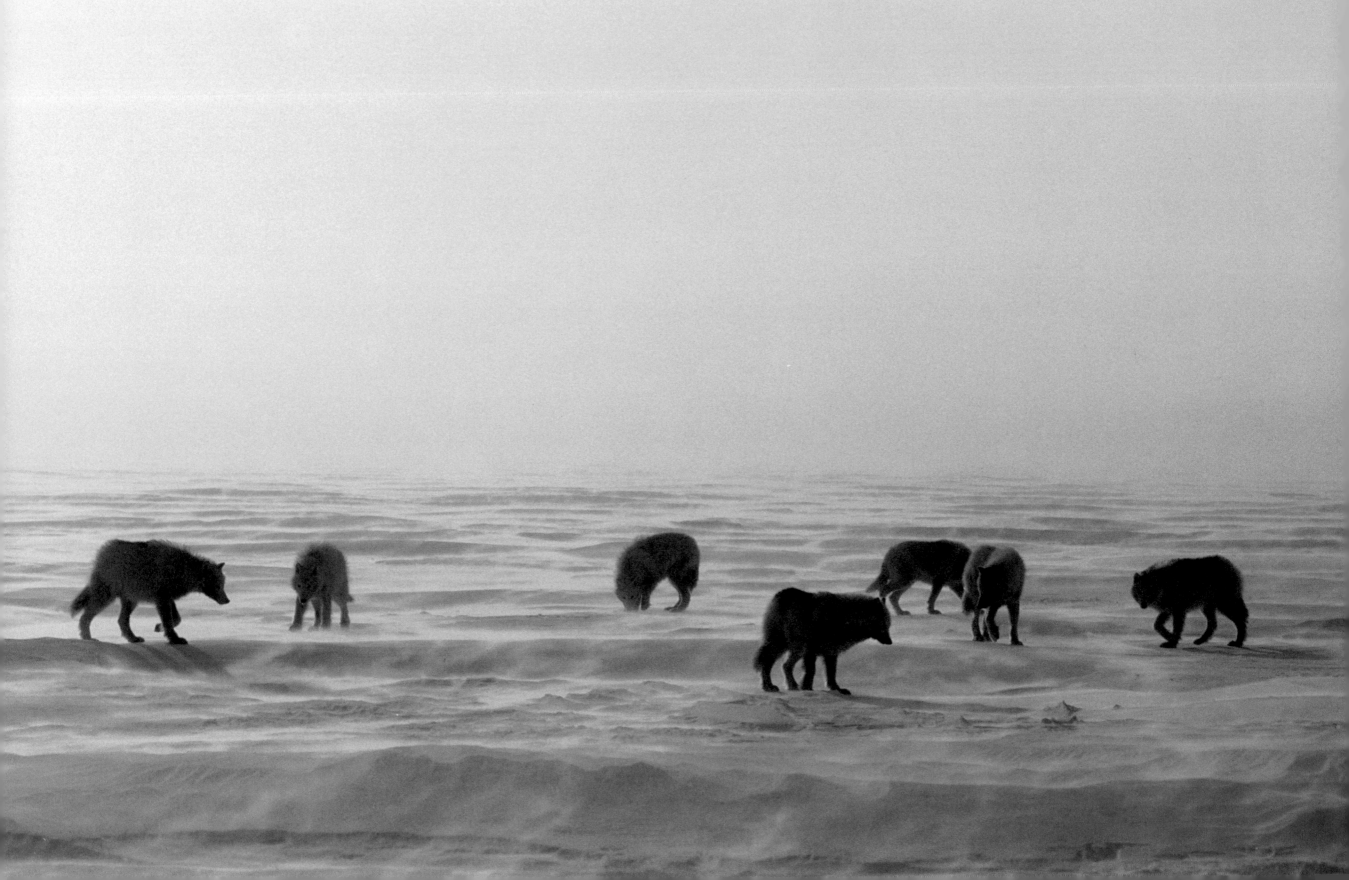

approaches the den with cameras, tape recorder, and flashlight. The mother, far from alarmed, wears an expression that seems to say, "Well, you've never done this before."

For a moment he hovers near the entrance, heart pounding, then decides it's now or never. He drops to all fours and slowly crawls inside. He knows the pack could descend on him at any moment to tear him to pieces. Intuition and trust tell him that won't happen.

Crawling forward down the narrow passageway redolent with the sweet smell of puppy fur, he finds a tight ball of four puppies, constantly squirming against each other to stay warm. One pup senses Jim the intruder and growls, instinctively asserting dominance at just three weeks of age.

Jim gratefully makes the most of his five minutes of unchallenged photography. When he leaves, Mom saunters over, sniffs the entrance, then crawls inside to make sure the puppies are okay.

THE LAW OF THE HUNTER
There are, of course, several things … more dangerous than wolves.
For instance, the stepladder.
J. W. CURRAN

Even in today's increasingly ecosensitive political climate, even with the growing global influence of animal rights organizations, wolf pelts still bring good money and government bounties, and that encourages wolf hunting. The reverential regard aboriginal peoples once held for their spirit brother has thus degenerated into just another threat to yet another animal species. In Grise Fiord, the small Inuit settlement at the bottom of Ellesmere Island's coast, pelts can bring $300 apiece. Not surprisingly, there is a paucity of wolves and other large game within a 65-km radius of the Inuit hunting town.

One wonders how many sacks of flour, cans of soup, televisions, hunting rifles, and snowmobile parts can be bought with the pelt of a beautiful white wolf that has survived everything nature could throw at it … except the abstract appetites and lethal tool-wielding efficiency of the human being.

In his book *White Wolf*, Jim Brandenburg offers a point of view that may help us understand the predatory mind-set. One day, he witnessed the cold-blooded shooting of a wolf that had inadvertently strayed into an Inuit camp. Remembering with irony an identical scene, when a hapless Arctic hare had hopped over a hill to blunder right into the middle of a lounging wolf pack, Jim reflected on the significance of the shooting. "There was nothing bloodthirsty or 'macho' about the Inuit killing the wolf; it seemed instead to reflect a characteristic of hunting people that those of us who live in relative technological comfort may have trouble understanding."

The law of the jungle —kill or be killed— is as immutable at the top of the world as everywhere else.

THE LONE WOLF
There were times that I felt I was placed on this Earth to do that story.
JIM BRANDENBURG

Jim surveys the dimming autumn landscape of Ellesmere Island. When we have fully lived the best of our dreams, he thinks, we are wise not to ask for more. But wisdom can lie heavy on the heart.

He loads the last bundle onto the plane. Something makes him look up. There, sitting with quiet mystery at the other end of the runway are the whole pack … including the pups, especially the pups, which had yet to venture more than a kilometer from the den.

The mother has brought them the entire 9.5 kilometers.

Jim Brandenburg scrupulously avoids the trappings of self-importance, though his artful creativity, humanity, and plain old hard work have earned him wealth and worldwide fame. He prefers to seek and settle into his natural place within the larger spinning wheel of all life. Yet at this moment, he cannot entirely deny himself the minor hubris of an upwelling joy. Perhaps, just perhaps, the wolves have indeed come to say goodbye.

He stands, profoundly moved, watching the watchers. He knows he will never see them again.

Linked across the distance, the gulf between man and wolf disappears. They quietly regard each other for long seconds, remembering.

The impatient pilot calls to Jim. One last glance, then time to climb aboard. The twin Otter's engines roar. The metal bird lurches down the runway, reaching for the sky like a long-tailed jaeger.

Through the window of the banking plane, Jim sees the pack one last time, heads raised as if to howl, following his flight.

The white wolf brother has gone. Long live the white wolf.

On the opposite page,
a wolf pack can be very efficient
in detecting the scent and tracking
the prey that left it. The wolf can
smell a million times better than
humans. The pack doesn't always
succeed, however, and often times
will go for days without eating,
a real challenge for an animal
in such a cold climate which requires
lots of calories to survive
and stay warm.

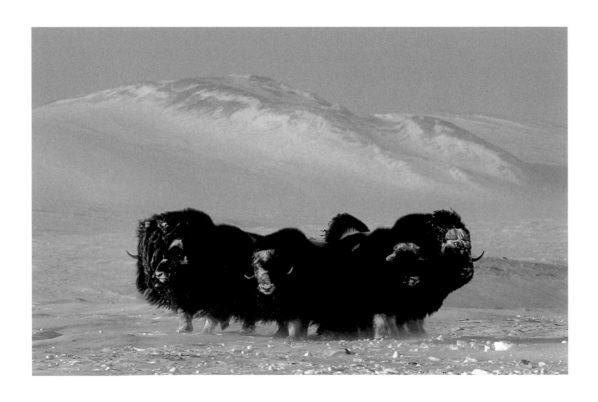

Musk-oxen roamed the tundra with the woolly mammoth.
The defensive circle that they have adapted may explain one of the reasons
for their long-term survival.

On the opposite page,
wolves travel great distances in their search for food.
It is not uncommon for a 80-km journey to be made.

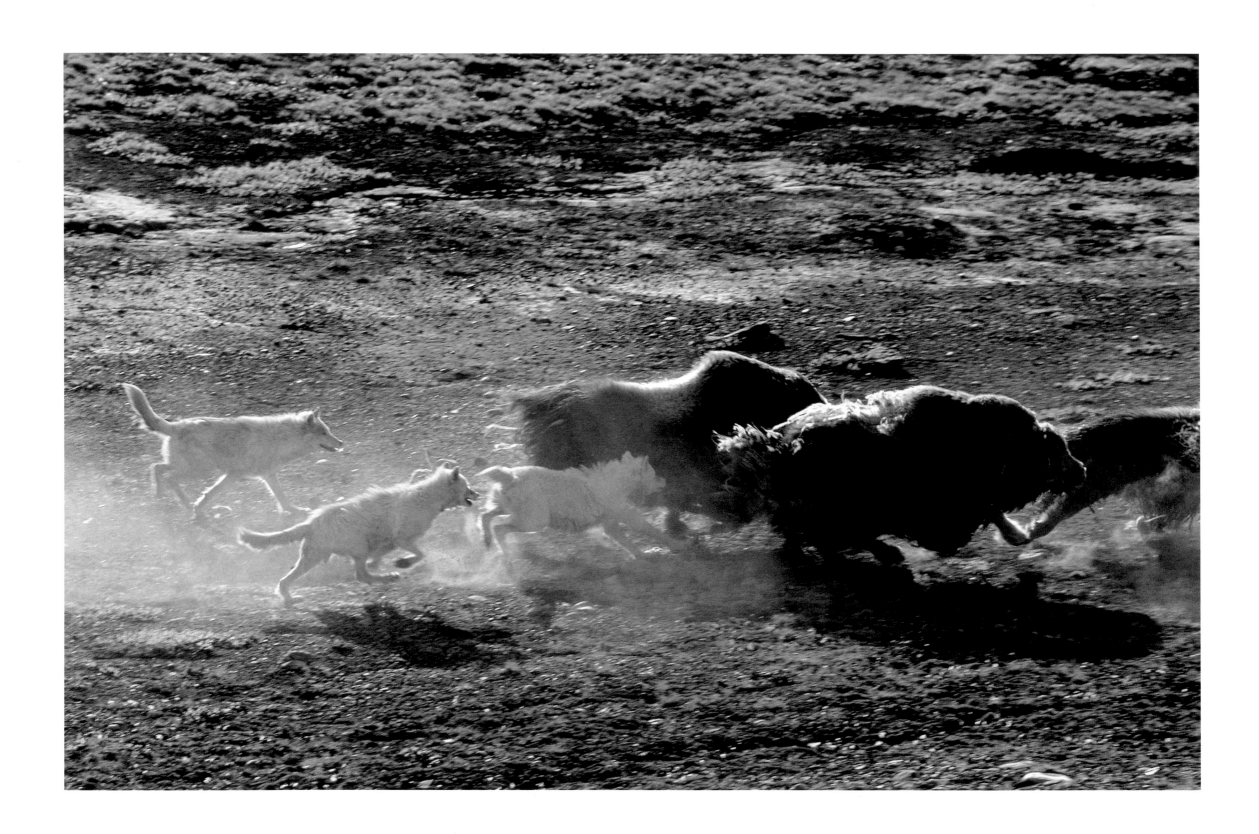

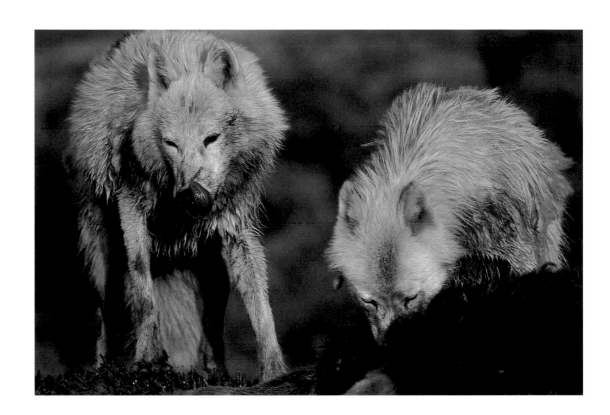

On the opposite page,
the wolf pack sizes up the musk-ox herd. Like a military strategy,
wolves often times have a plan of attack. In this case the plan worked, as some members
of the pack give chase. The alpha male in the lead and the alpha female second,
other members of the pack circled around and were waiting
as the musk-oxen were driven into the trap. Most of the time,
wolves are unsuccessful when attacking prey and can easily get injured.

Above, wolf society is based upon a hierarchy of the alpha pair and lesser ranking members
of the pack. The alpha pair always eats first after a kill,
with other pack members eating in descending order of their position.

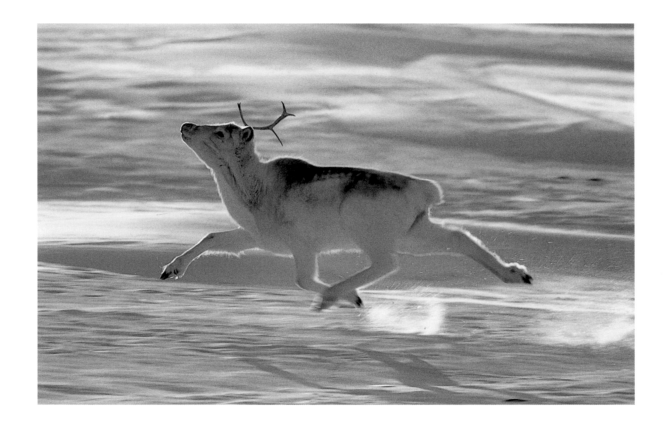

The Peary caribou has changed its form from the barren ground caribou to a much smaller
and whiter individual for better adaptation to the high Arctic. They have recently edged closer
to extinction because of climate change. Instead of typical snowfall,
freezing rain encrusts the tundra food source and is greatly affecting the population.

On the opposite page,
the 5.5-kg Arctic hare is an important food source for the wolves of Ellesmere Island.

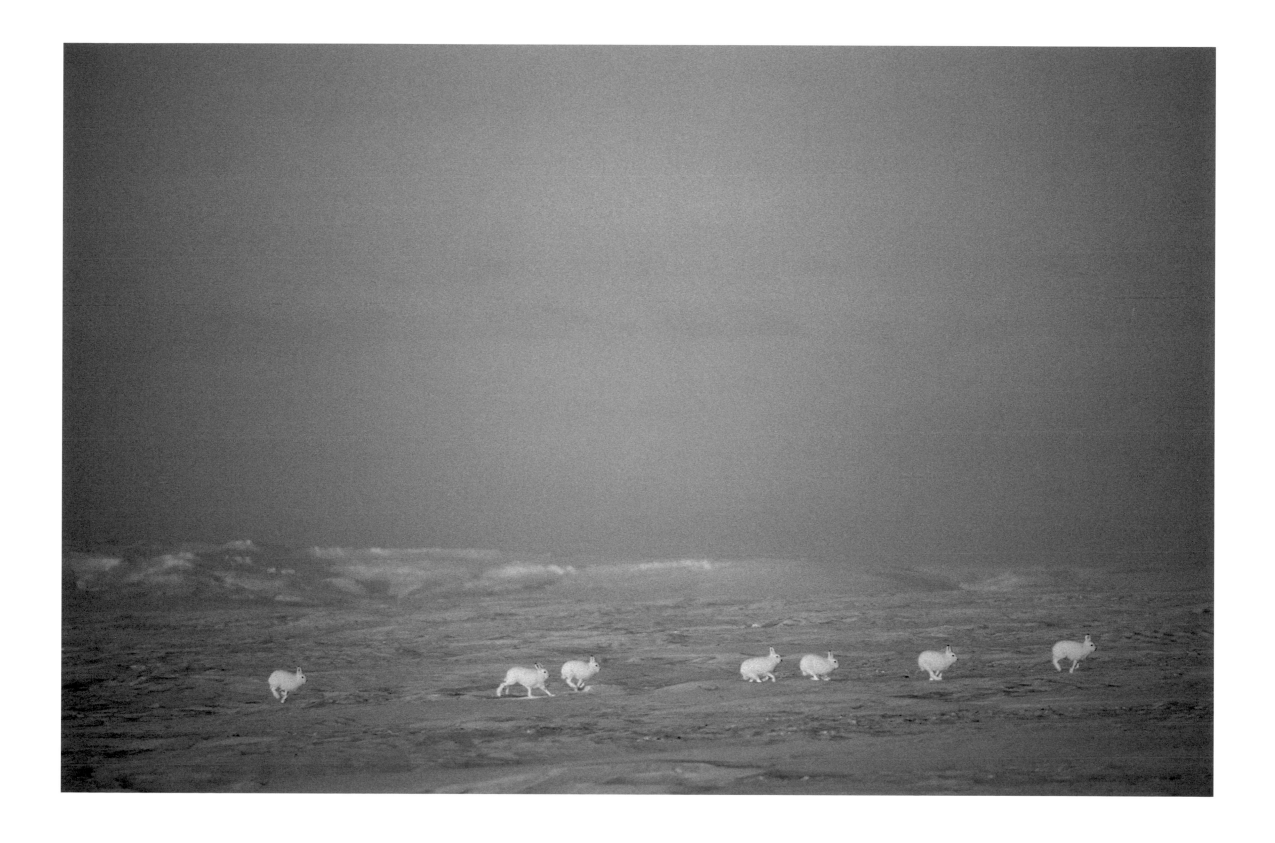

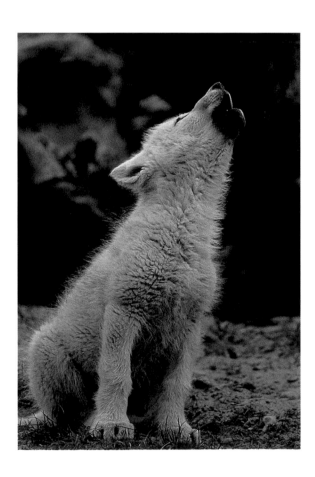

The vocalization of the wolf starts at an early age
and is an important aspect in keeping the pack cohesive.

On the opposite page,
Scruffy, the baby-sitter of the pups, stands atop the sandstone outcropping
that served as the pack's centuries-old den.

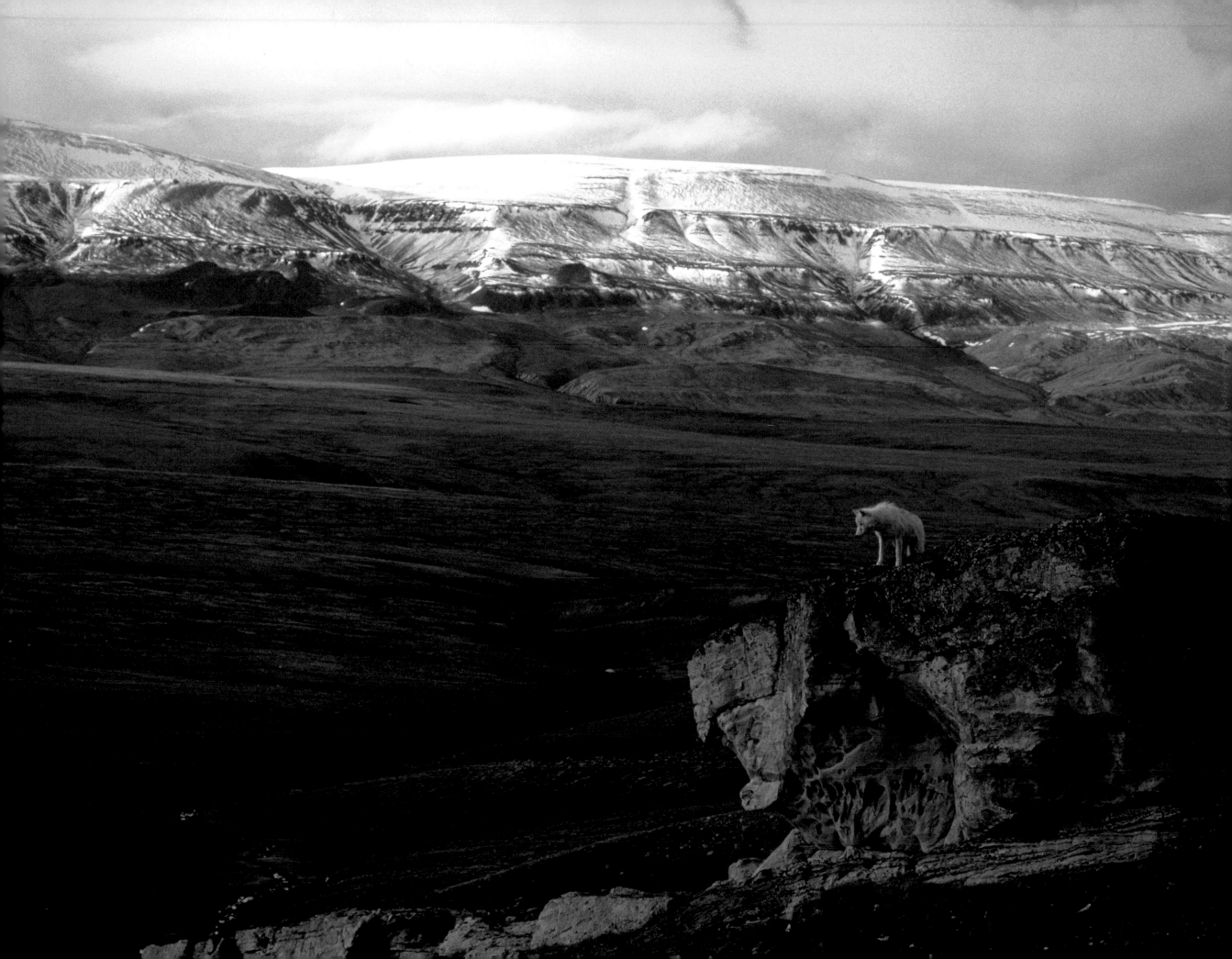

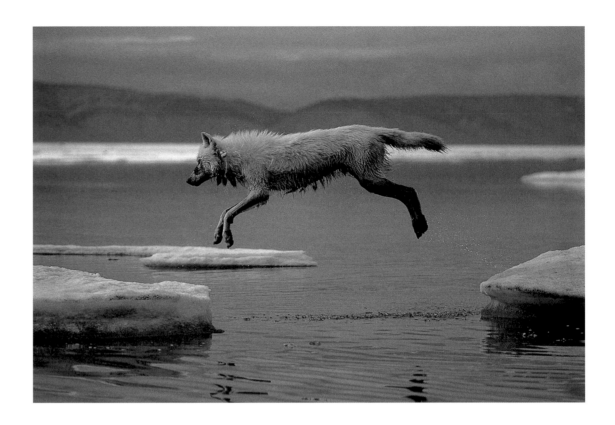

On the opposite page,
this was a rare situation in the high Arctic, to have such a safe and comfortable den site
excavated beneath a huge sandstone boulder with permafrost just below the surface
of the Arctic tundra. Digging a den is usually impossible, but in this case they were able
to excavate where the boulder sat on the surface. Evidence has shown this den site
is hundreds of years old. Frost covers the walls but the young Arctic wolf pups have a thick
coat of protective fur. Even though the pups were only a couple of weeks old,
they showed evidence of rank within the litter.

Above, the alpha male showed his leadership and confidence by often taking the lead
in exploring nearly inaccessible locations. Here, Buster jumps from one floating platform
to another looking for morsels of sea life washed in from the Arctic Ocean.

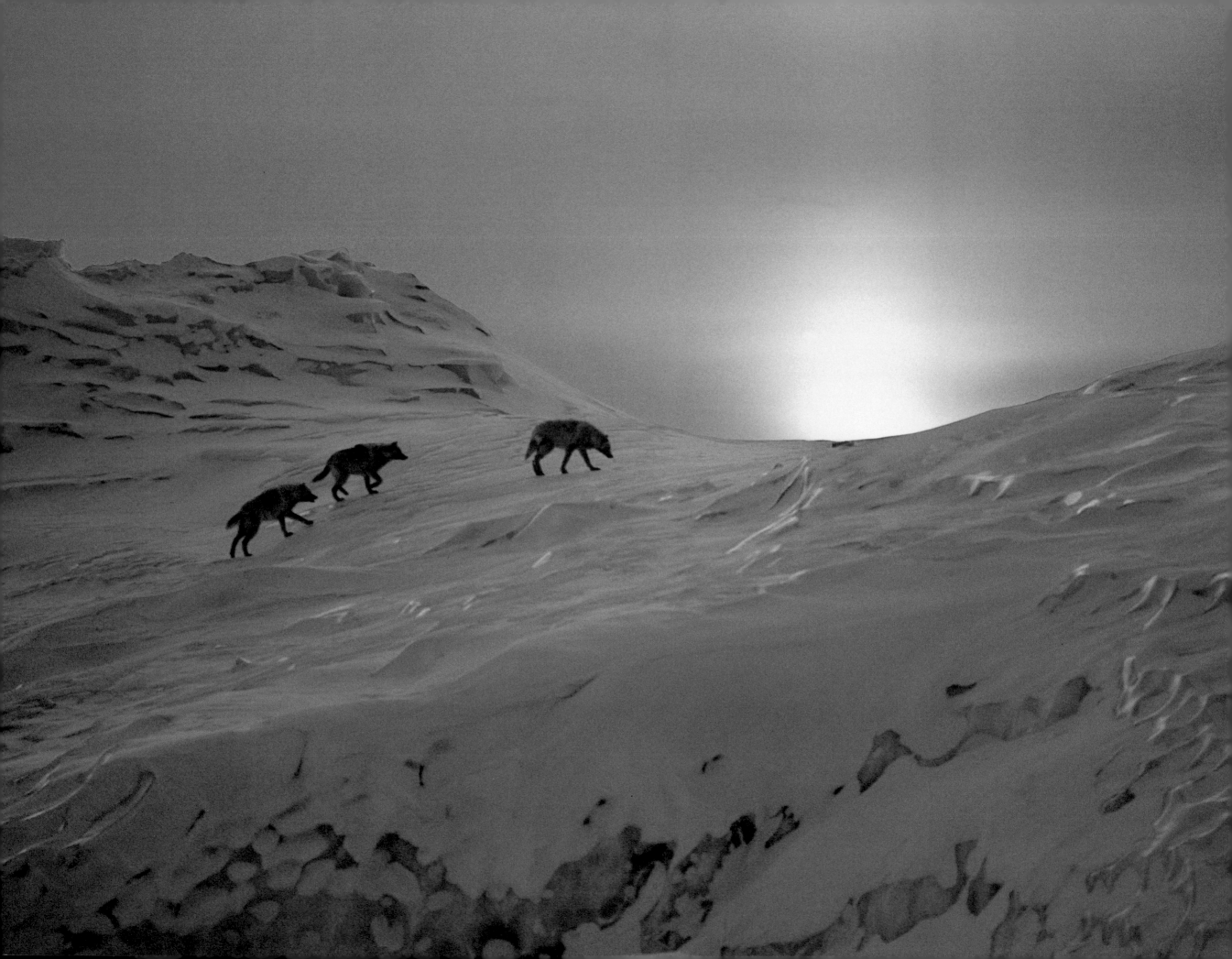

On the opposite page,
in March, the sun comes over the horizon,
leaving Ellesmere Island a wash in beautiful pink light.

Above, these wolves spent much time
climbing frozen-in icebergs in a bay in the Arctic Ocean.

THE ENCHANTED ISLANDS
Galápagos
Photographer: TUI DE ROY/Minden Pictures

*The archipelago is a little world within itself …. Seeing every height crowned
with its crater, and the boundaries of most of the lava streams still distinct,
we are led to believe that within a period geologically recent
the unbroken ocean was here spread out.*
CHARLES DARWIN, *The Voyage of the Beagle* (1909)

Imagine this world, a Lost World if you fancy, a group of islands born in fire and steam and smoke in the middle of the great blue-green Pacific Ocean. In time, the new lands grew hospitable to life-forms of an astonishing breadth and complexity, and something more: 75 percent of the species of indigenous land birds and 97 percent of the bizarre reptiles and mammals found on the Galápagos exist *nowhere else* on Earth. Visualize them now as a rosetta stone laden with secrets waiting to be deciphered, poised on the edge of history to dismantle forever the errant, lofty preconceptions of science and religion regarding the dominant species: humankind.

Such a place was the Galápagos Islands in the early nineteenth century. Like a spray of cooled lead, the archipelago spreads across the eastern Pacific, some 1 000 km west of the South American nation of Ecuador, to which it belongs. More than 100 islands and smaller islets and rocks make up the chain, all formed of extruded magma oozing from the slow, grinding collision, perhaps five million years ago, of three immense suboceanic tectonic plates.

Dressed in level shorelines and mountainous interiors culminating in high central craters, the remote islands are geographically and biologically distinct from the vastly older Gondwanaland, that primordial landmass from which the continents emerged and drifted into their present locations.

Galápagos was blessed by a convergence of cool and warm ocean currents that over time ensured a steady supply of nutrients to its marine, air, and land animals. Here, creatures evolved along distinctly diverse paths from their mainland counterparts. Clues as to the actual mechanisms underlying how biospecies adapt to their environments were written in their strange shapes and behavior.

In time, Charles Darwin, the great evolutionary thinker, made his epic 1835 voyage into history aboard the mapmaking British frigate *H.M.S. Beagle*. His higher purpose, to expand and support emerging views on evolution, found a fertile ground in the untrammeled ecosystems of the Galápagos where everything —geography, biology, and the Darwinian intellect— came together as if divinely orchestrated.

On islands isolated from the mainland and, significantly, from each other, a kaleidoscopic array of climatic zones and ecosystems and their unique animal and plant populations gave Darwin a perfect opportunity to observe and deduce the link between each island's ecology and its effect on the evolution of its biota.

The core of his hypothesis formed around the finches. By establishing that all 13 varieties spread among the islands had evolved along unique paths from a single South American finch species, he articulated the concept of evolutionary branching now known as adaptive radiation. His book, *On the Origin of Species…*, changed our understanding of the webwork of life, and our place within it, forever.

DARWIN'S CHILD
*… it is the only way of living I could ever imagine: away from human artifice,
breathing the freedom of the denizens of the world's wildest places.*
TUI DE ROY, *Galápagos: Islands Born of Fire* (1998)

She kneels rapt at water's edge, studying the movements of a huge, antediluvian sea tortoise with a child's daily supply of inexhaustible wonder. The time is 1958,

*On the opposite page,
living their entire life
along the barren lava shores
that are their home, marine iguanas
settle down together to conserve heat
as the sun sets and the cool sea
breeze sweeps over the land.
Fernandina Island.*

a time of innocence and ecological purity in the Galápagos Islands. Among the wild and still-unspoiled landscapes of her home, Tui De Roy is learning in daily lessons a life-shaping truth: that animals are not only a joy to watch, but also inform a vital, instinctual link between ourselves and the natural world.

Tui's maturation into a world-renowned nature photographer and writer was spawned by her own familial process of natural selection. Her Belgian parents, resolved to escape the crush of rampant industrial growth and pollution of a rebuilding, post-World War II Europe, bundled up two-year-old Tui and moved to Galápagos, where they would remain their entire lives.

Naturalists who reveled in the many opportunities for research, the De Roys took to the Enchanted Islands like a blue-footed booby to water. Tui, whose father was also an amateur photographer, became a painstaking and fastidious dabbler in film emulsions at his side. In the deep, red glow of a filtered kerosene lantern, working with their scant supply of cherished photo chemicals, paper, and flashlight-lit enlarging equipment, she learned to develop black-and-white photos of "my beloved pelicans and iguanas."

Happily lost and forever found in paradise, her long equatorial days were spent rowing her little boat, scampering through dense mangrove thickets in search of warbler and night heron nests, and wandering the beaches and rolling green highlands in journeys of joyful discovery. A century earlier, Darwin had walked these same volcanic shores and slopes, to marvel and wonder at the curious plants and animals.

LIFE ZONES

Considering that these islands are placed directly under the equator, the climate is far from being excessively hot; this seems chiefly caused by the singularly low temperature of the surrounding water ... very little rain falls ... but the clouds generally hang low. Hence, whilst the lower parts of the islands are very sterile, the upper parts ... possess a damp climate and a tolerably luxuriant vegetation.
CHARLES DARWIN, *The Voyage of the Beagle* (1909)

The Galápagos enchantment casts a magical spell over casual visitor and researcher alike by virtue of its discrete climatic and biological diversities. There are four main ecosystems, specific to elevations from sea level to the tops of the highest volcanic peaks on the larger islands.

The arid lowlands (the islands get rain for a brief period every year, and some years almost none) are typically dotted with open cactus forests. Moving higher in elevation brings you to subtropical forest regions. Higher still and you find a moist, dense forest, where the prevalent clouds shroud the slopes. In the highest upland reaches, treeless areas display a rich tapestry of ferns and grasses.

Even though the archipelago's fragile ecosystems are under mounting pressure, they retain as much as 95 percent of their original biodiversity. Compare that to popular island retreats like Hawaii and Polynesia, where

50 percent of animal species and native flora have disappeared forever. Paradise is not lost ... yet.

A SHORT PRIMER ON NATURAL SELECTION

This is where my instincts were honed and my spirit roamed free for nearly four decades. This is where I became who I am, where the present sometimes melds with eternity.
TUI DE ROY, *Galápagos: Islands Born of Fire* (1998)

Darwin's observations in the Galápagos established once and for all that the engine of evolutionary change runs on a very simple principle: rock and blood are eternally intertwined. Change the environment through flood, tectonic calamity or shifting food supplies, and creatures and plants must change as well —or go extinct.

Over time, animals and plants become increasingly specialized to their home environment, as seen in shorebird species with different leg lengths that feed only at specific tidal depths. Thus, species also evolve in a way that, in effect, allows them to weave their thread of survivability into the larger matrix of all life-forms, reducing competition and making coexistence possible.

The wondrous evolutionary classroom that is Galápagos remains in session to this day. In the 1970s, a devastating drought on the small islet of Daphne Major reduced dramatically the number of edible seeds. The medium ground finch native to the island preferred smaller-sized seeds, but these grew increasingly hard to find. Larger seeds became the prevalent food source. Since larger finches with bigger beaks had less trouble cracking the larger seeds, they survived while the smaller birds died off. Even though the overall population declined, the surviving population evolved to an average larger size. Welcome to natural selection in action.

STRICTLY FOR THE BIRDS

One day I had a heavenly revelation: I would use a camera as the ultimate tool to record every species in the islands ...
TUI DE ROY

Tui's inspiration to photograph every nuance of the birds whose Latin names she had memorized in her adolescence was a fitting beginning for the girl of the Galápagos. She looks back with bemused appreciation at that heady vow, acknowledging the passion of innocence that drove her to become the committed nature photographer, writer, and naturalist she is today. From her first article for *Audubon* magazine at age 19, Tui has broadened her reach to dozens of publications, lecturing the world over, and several books, including *Wild Ice: Antarctic Journeys* and her latest effort, *Spectacular Galápagos*.

At the core of her lifework is an abiding love of the natural world. "Yet on my own, I have never had the intense dedication to simply observe nature for

On the opposite page, peaceful neighbors, a sea lion cools off in a salty pool where a group of greater flamingos perform their synchronized courtship dance unperturbed. Surprising encounters between varied Galápagos animals are normal in an ecosystem that knows few predators. Rábida Island.

12 hours, hanging from a tree branch in the Amazon rainforest or freezing in Antarctica," Tui confesses. "Photography is my excuse for being out there. Give me that extra bit of purpose that comes with trying to get a good photograph of something I care about; that's the difference. "

THE LEGACY OF PRIMAL PLACES

The Galápagos archipelago, like all island environments, was able to sculpt the evolutionary shape of plants and animals because of its freedom from the stresses and contamination of complex continental ecosystems and sophisticated predators. Species evolved in step with each island microhabitat. The chain became a million-year dance of life and death, of adaptation and renewal, to

rhythms in the Earth as old as time. Like all pristine realms that rose from barren, boiling rock, they remind us that the life-force needs no more than the amino acids of creation applied to the canvas of sun, sea, sky, wind, and soil to paint its wonders and miracles.

THE HAMMER OF MAN

Part of the kit and baggage of the global traveler is an inevitable education in the interconnectedness of everything in the world biosphere —and the legacy of human decimation of ecosystem after ecosystem that plagues it.

Tui has had to accept that the Galápagos Islands will never be the same. More than 16 000 new immigrants have crowded onto islands which, in her youth, barely supported mere hundreds. Tourists numbering 60 000 and more come every year to experience its strange and wonderful life-forms. Others clamor to immigrate and prosper from the new wealth that comes with tourism. Under such pressures, no ecosystem remains pristine.

Today Tui, who has lived in New Zealand for nine years now, compares the unsettling feelings that come from return visits to Galápagos with looking at faded films of a previous life that seems as if someone else had lived it.

"This isn't quite home anymore. I'm not as tuned into the throb of the islands. Many things have altered the chronology of life in Galápagos, since nature is always in flux; I've missed whole chapters since I left; it leaves you feeling somewhat disconnected."

"In the early '80s, Galápagos was still considered too special to tamper with. But in the last decade or so, people, cars, boat traffic; you can actually smell the exhausts out on the sea. I grew up used to that pure ocean air, so I find the new pollution purely offensive."

Perhaps it hurts most when she sees what looms ahead with unhappy portent for Galápagos. "This was the one place everyone assumed, because of its importance to scientific research, would be protected forever." She still wants to

A pair of red-footed boobies engage in graceful courtship postures while building their nest in a Croton shrub. They feed on flying fish in the tropical waters to the north, returning to land only to nest.
Wolf Island.

believe that her beloved isles will endure in relatively unspoiled condition. Yet, as in so many other pristine areas of the world, there is increasing pressure from all sides.

"THE SOUL OF THE GALÁPAGOS IS LEAVING ..."

Today I look to the sea and see the same purposeful destruction of resources that occurred so many years ago with the whalers and tortoise-gatherers who took the resources of the islands. We know, know full well, the damage that can be done ... the fact is that the soul of Galápagos is leaving ...
GODFREY MERLEN, Galápagos resident

The Galápagos archipelago, spawning place of modern evolutionary science, international whale sanctuary, UNESCO World Heritage Site, and one of the most strictly managed natural areas in the world, would seem to be a model of how a pristine, isolated biosphere might thrive in modern times. But in recent years, the once-unthinkable has begun: *The Enchanted Islands* have suffered from too much humanity.

As always, the threat begins and ends with people, who introduce foreign animals and plants, deplete the Galápagos land and marine ecology through poaching and illegal fishing, and generally (and sometimes with open hostility) resist all efforts at preserving the pristine nature of the islands.

A glaring example is the discovery in the late '90s of 500 sites on beaches and coves that bear signs of illegal camping and extended use by fishermen. The scarce mangrove forests that Tui De Roy once explored on western Isabela and Fernandina are the only habitat for the rarest species of Darwin's finch, the tool-using mangrove finch. Yet fish-camp dwellers cut trees to hide their illegal equipment, filter telltale smoke, and provide fuel for cooking-pot fires that directly endanger the bird.

The continuing shortfall of funds for conservationist programs and lack of a strong, well-enforced legal conservationist presence only compound the damage.

The Charles Darwin Foundation (CDF), a nonprofit organization dedicated to promoting conservation, education, and scientific research in the islands, considers the invasion of alien biota as the number one challenge in Galápagos, and urges Ecuador's government and the Galápagos National Park Service to adopt a hard-line strategy to reverse it.

Yet the rigorously managed Galápagos National Park, which oversees 97 percent of all the island's surface and Marine Reserve, faces daunting obstacles. CDF notes the particularly harmful effects of goats, pigs, cats, rats, and dogs, as well as some 300 introduced plant species, numerous insects, and unknown diseases on island habitats.

On Isabela Island alone, 100 000 goats have proliferated, denuding the vegetation and causing a heavy die-off in the giant tortoise population there. A detailed goat-eradication plan has been prepared, but is tagged at eight million

dollars over five years —*if* the funds can even be raised. Clearly, prevention is far better —and cheaper— than cure!

Factor in contentious debates among local inhabitants and up to the halls of Ecuador's government over the preferred eradication methods, a pressing need to educate the ever-growing and often rebellious population on the vital importance of conservation in farmlands and towns where pollution is a runaway threat, and a largely unheeded call to return zero population growth to the human population, and you can see why further research, commitment and, above all, money, are desperately needed.

THE COMPLEXITIES OF SAVING PARADISE
The shark's head was out of water and his back was coming out
and the old man could hear the noise of skin and flesh ripping on the big fish
There was only the heavy sharp blue head and the big eyes and the clicking,
thrusting all-swallowing jaws
ERNEST HEMINGWAY, *The Old Man and the Sea* (1952)

Tui sees the sharks moving on Galápagos. She regards a recent round robin of leadership coups in the government of Ecuador as another setback in the prospects for funding and enforcement of the Galápagos Special Law, passed in 1998 to expand and protect the Galápagos Marine Reserve.

"Everyone is hellbent now on getting at the Galápagos resources," she says with unrestrained dismay. "Fishing companies flying Ecuadorian flags are owned and operated by big Asian companies. Like fishing fleets around the world, they've vacuumed out their coastal resources and don't have much left to work with."

The Special Law has been openly defied by the mainland fisheries. Even though boats have been confiscated, fines have been mere slaps on the wrist. Big fisheries leverage big money and influence against the very organizations mandated with giving the law teeth.

"I'm afraid if people think conservation efforts have no hope of winning in the end, money from around the world will dry up. There are so many competing causes."

She cites a world perspective in which ongoing marine resource depredation has led to exhaustion of once-abundant populations of anchovies in Peru, the Patagonian toothfish in the southern oceans, the bluefin tuna, and many more species. "Now those same industrial fleets come to Galápagos to reap its rich marine system. I almost feel it's unrealistic to say it's possible to stop it. But you can't just give up."

The Ecuadorian government, says Tui, presides over an "extremely proud country" with a long historical tradition steeped in fishing as a main source of agricultural revenue. "The fishing industry has deep roots into the government."

More disturbing is her assessment that eradication of feral animals and plants is a huge task that will take years to accomplish. "They may never get rid of the rats and cats. Right now the goats on Isabela are a main target of a high-tech, multi-year, multi-million-dollar project, the biggest of its kind in the world. Meanwhile, the goats continue to strip virgin territory. It'll be a long ecological pull to return the flora to what it once was."

And what do you do with 100 000 dead goats? "There are many starving people it could feed. But the logistics of moving that meat to market would cost its weight in gold; it's inconceivable. Killing them and leaving them is a practicality since Isabela is a roadless volcano. There's just no other practical way."

She adds that removing 100 000 animals from the soil they have denuded of a considerable amount of biomass might make it impossible for the land to regenerate. By letting the goats decompose where they fall, much of that nutrient base will return to the earth.

Answers don't come easy in paradise today. But not all the news is grim.

RAYS OF HOPE: THE LOGISTICS OF CARING
The Galápagos giant tortoise almost went the way of the dodo bird,
the elephant bird of Madagascar, and the moa of New Zealand.
TUI DE ROY

When you consider the depressing legacy of the human flood that inundated earlier Edens from Hawaii to New Zealand to Madagascar, there have been surprisingly few extinctions of animals in Galápagos. The giant tortoise, an iconic symbol of the islands the world over, is still there, though its numbers were so savagely depleted it was recently on the teetering brink of extinction.

Each island has its own type of tortoise. Tiny Española, south and east of the archipelago proper, supported tens of thousands of the large saddleback variety as recently as the mid-1960s. Once goats were introduced, they quickly grew to 40 000 in number. The saddlebacks died off so rapidly that only one male and 13 females remained of the entire original population.

In a heroic effort worthy of a Hollywood movie, environmental activists rushed in to save the day by rounding up all the tortoises on Española for a captive-breeding program at Darwin Research Station. They received a surprise bonus: another male tortoise from the San Diego Zoo. In pens built in the same climatic zones as their ancestral home, the eggs incubated and thrived. Once the hatchlings grew hearty enough, they were reintroduced to the island. In early 2000, a celebration marked the thousandth baby turtle successfully hatched.

Similar programs are under way. Another hatching project seeks to preserve and restore the land iguana. Fences will help keep feral animals from destroying endangered plants, such as the handful of surviving *Scalesia* forest

When draught brings food scarcity to the island, the little vampire finch of the northernmost islands, an inventive member of the endemic Darwin finch tribe, plucks at the base of a nesting masked booby's tail feathers, drinking the resulting blood. Wolf Island.

vegetation on goat-plagued Santiago Island and the *Floreana flax*, rediscovered in 1997 and long thought to have gone extinct. Aggressive programs to control rats and cats near the nesting areas of breeding birds also promise regeneration of threatened species.

Where humans care —and mobilize—, miracles can happen.

HOME AGAIN, HOME
If we can't save Galápagos, what hope is there left anywhere?
Tui De Roy

We return to the place of our childhood adventures, to find it is not the home we remembered.

"It's still me though, this place," says Tui De Roy. "Nowhere else on Earth do I feel quite the same close and intimate contact with nature. Other places are exciting, full of mysteries, but here is … intimacy. It's like the difference between good friends and a lover."

The bus ride from the airport at Barla to where her mother still lives —her father is laid to rest in the volcanic soils of his adopted paradise— takes an hour. In the drive up the lee side of the island, she instinctively responds to subtle signs in the flora and what they tell her about the weather in the year she's been away.

"There are a million little messages springing out everywhere. When it's been real moist atmospherically, the lichens hanging from the branches of trees in the upper dry zone get lush and long. In rainy years, they rot and fall off. If it's been a warm year, they're brighter. Splits in banana leaves speak of lots of wind. The color of the sea tells me how rich the marine upwellings have been. And if the boobies fish in flocks, I know there's a good food supply in the ocean."

"We think we're intelligent, sensitive, in charge of our environment. The superior species. If we want to prove it's true, we have no choice but to keep the most wonderful parts of our world. The Galápagos Islands embody, more than anything else, that higher spirit that we like to think we have in us. History so far is not bearing me out."

She reflects for a moment, then concludes, "If we can't use that as the best excuse ever to save these places, then what have we got? What's our spirit worth?"

On the opposite page, showing off their bright breeding plumage in synchronous flight, a flock of courting greater flamingos circles above the salty pool where they will nest. Dormant silvery palo santo trees stand in leafless backdrop during the dry season. Santa María Island.

GAIA
When you journey into nature, you develop a feeling for it. In time, no matter where you go, it becomes one place: only the actors change …
Pablo Cervantes, nature photographer and writer

The scope and commitment of a conservationist philosophy goes beyond saving microscopic shrimp from destruction by megacorporations, or ensuring lots of "cute" mammals will survive to delight us on our ecovacations to exotic locales. Preservation of pristine environments is important for the ultimate survival of our planetary biosphere. Championing that cause also helps us remember to pledge allegiance to Earth first, and all other abstractions —political, religious, and ethnic— second.

Galápagos and its sister regions around the world urge us to return to a kinship with the living Earth. By acting on this principle, we serve notice on the mangrove-burning fishermen, the short-sighted poacher profiteers, the sharkfin hunters, the giant-tortoise slaughterers, and the big-boat fisheries that they are in for a battle, on every hallowed ground. We begin humbly, by first choosing to consecrate that gentle ground in our minds and hearts.

To journey to the Galápagos Islands, if only in your imagination, and behold the value of a palm-sized sea tortoise, newly hatched, scrabbling its adorably clumsy way out of an earthen hole in search of the sea, is to cradle and cherish your own umbilical connection to all of life. Through your mother and father and back into antiquity, through your mate and children and forward into eternity, you are a link in the same helix of life that binds all generations of living things, past and future, each to the other.

Imagine this fragile miracle of a baby tortoise resting in your hand. See how it moves with instincts passed down through natural selection for millions and millions of years. Marvel as its little lungs draw life from the same humid ocean breeze you breathe. Think of it as no less precious than your own beloved child. By so doing, you pay homage to its right, equally with yours, to live in harmony, not in subjugation, upon this Earth.

Now, let the battle cry begin to swell in your heart. And let it include the name "Galápagos!"

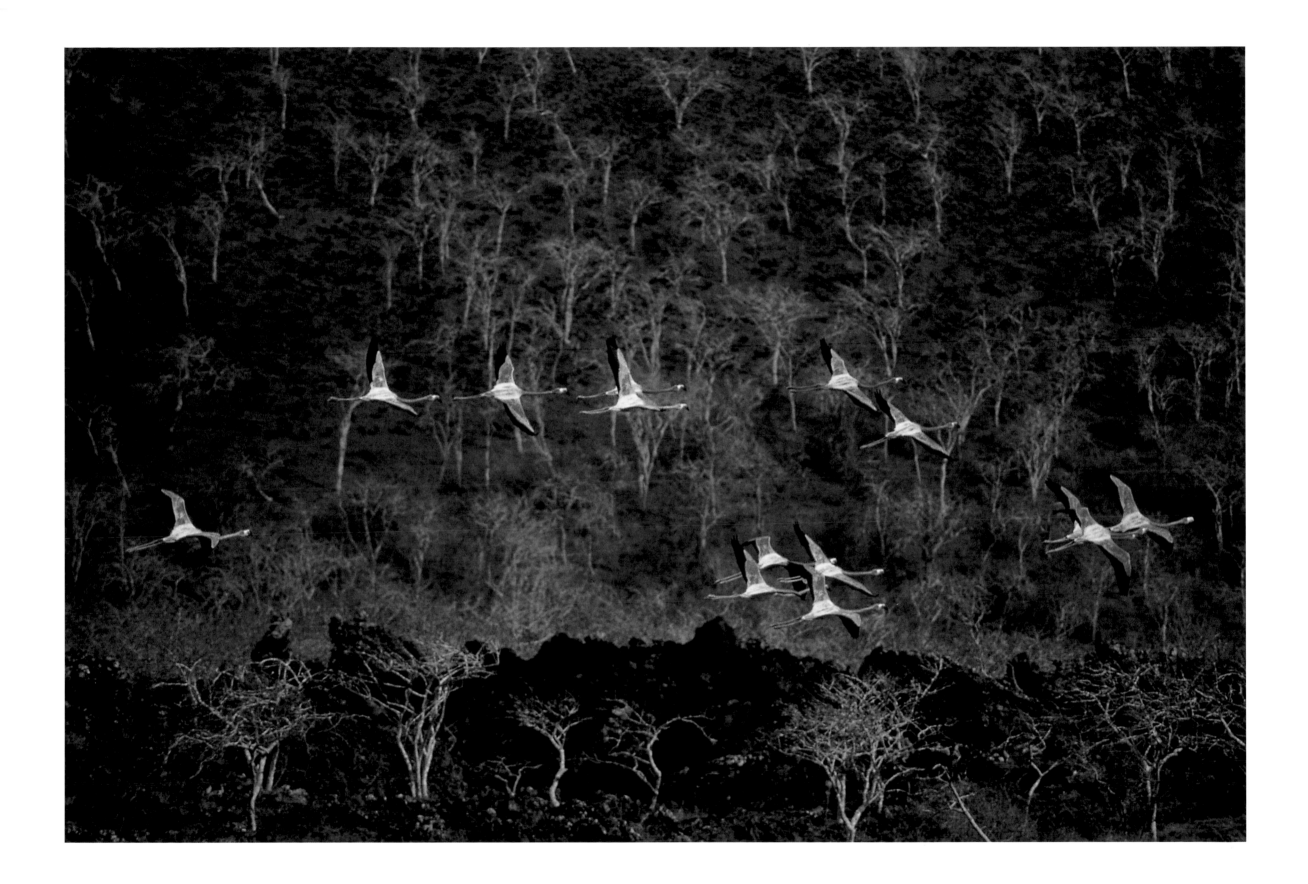

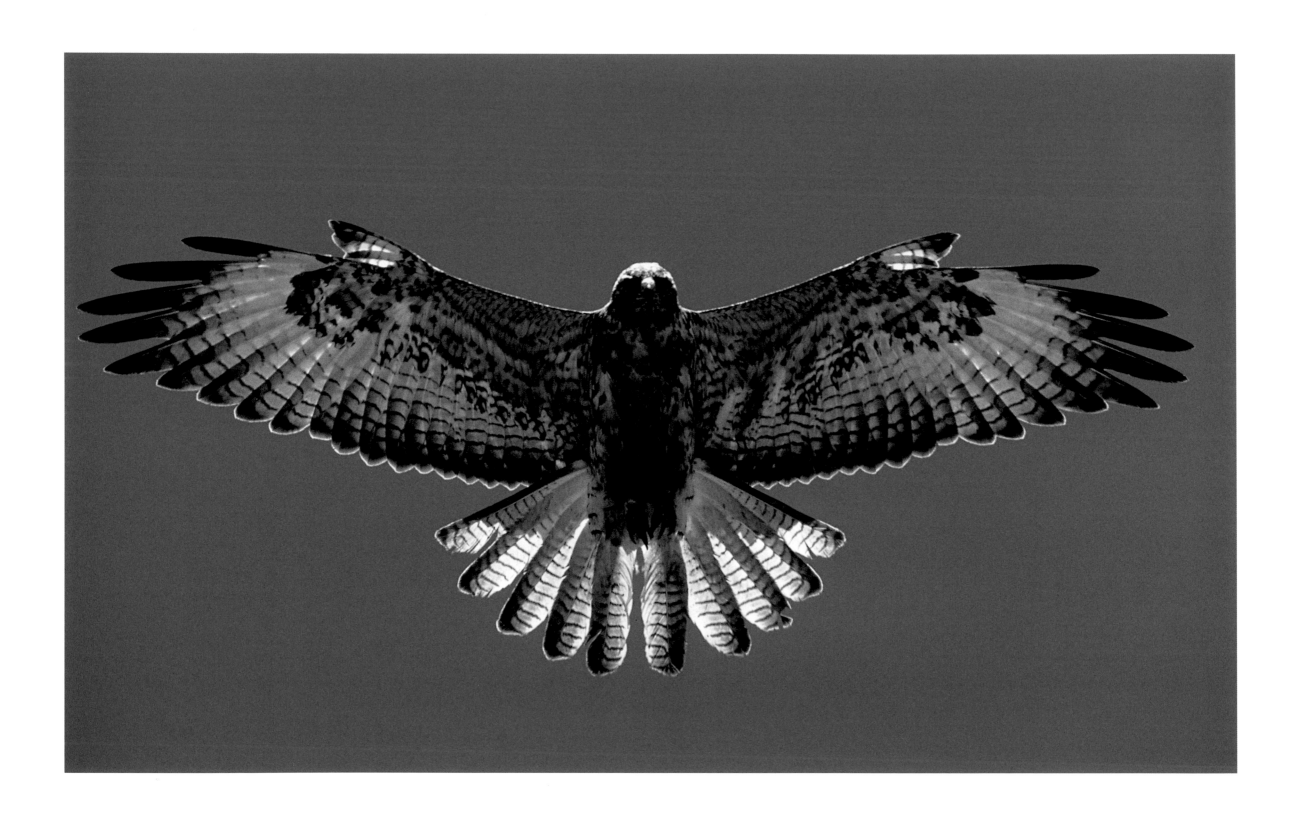

On the opposite page,
with no fear of humans, a curious Galápagos hawk hovers
close overhead for a better look at the strange biped below.
Fernandina Island.

Above, a male great frigate bird inflates his spectacular
courtship pouch to attract the attention of passing females
overhead. The air-filled balloon loses its bright color
and shrivels up completely outside of the breeding season.
Genovesa Island.

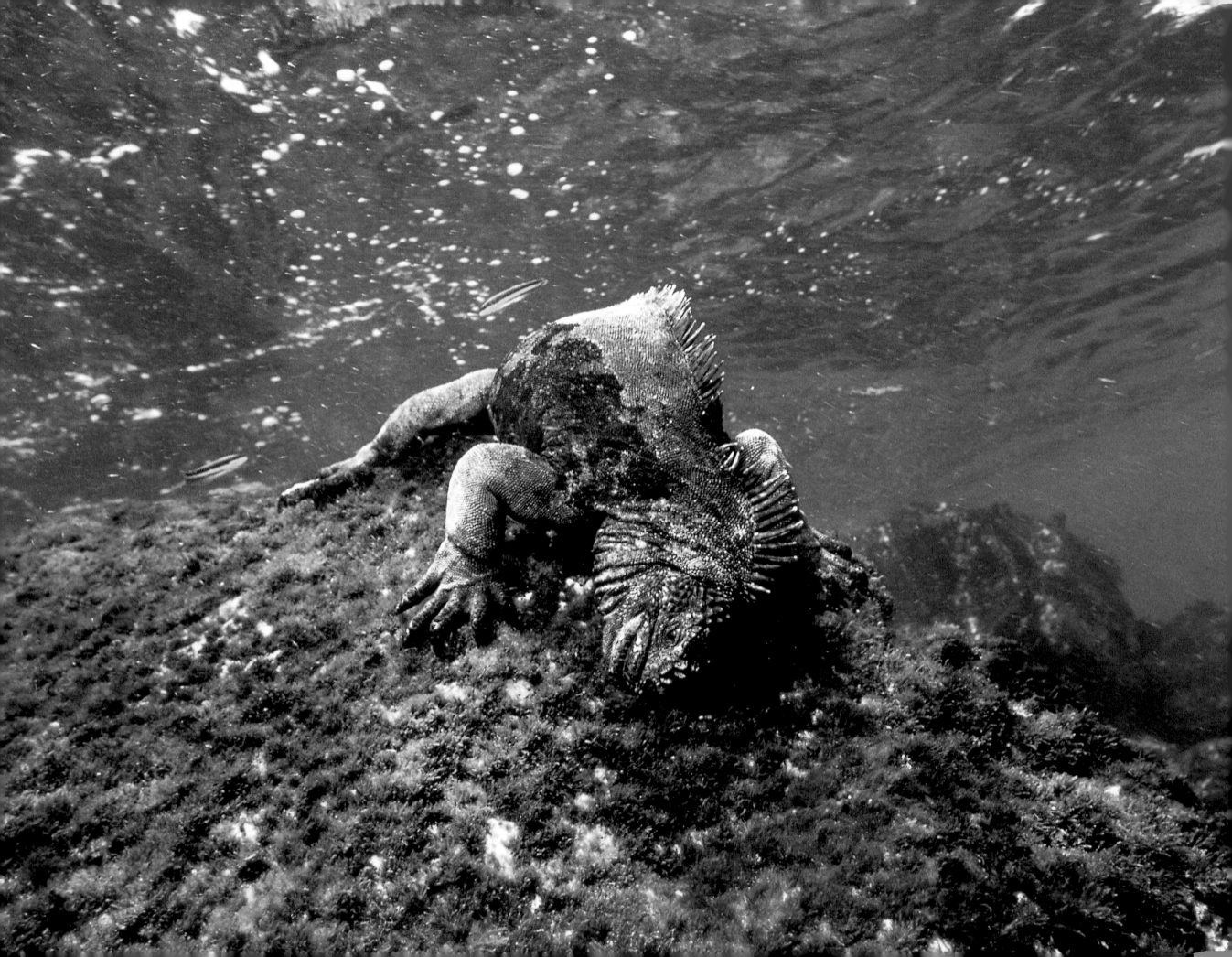

On the opposite page,
it is an incongruous sight to watch a marine iguana grazing algae
on the seafloor, unhurriedly scraping the tender growth with its specialized teeth while
small fish dart around to pick up exposed marine life.
Santa Cruz Island.

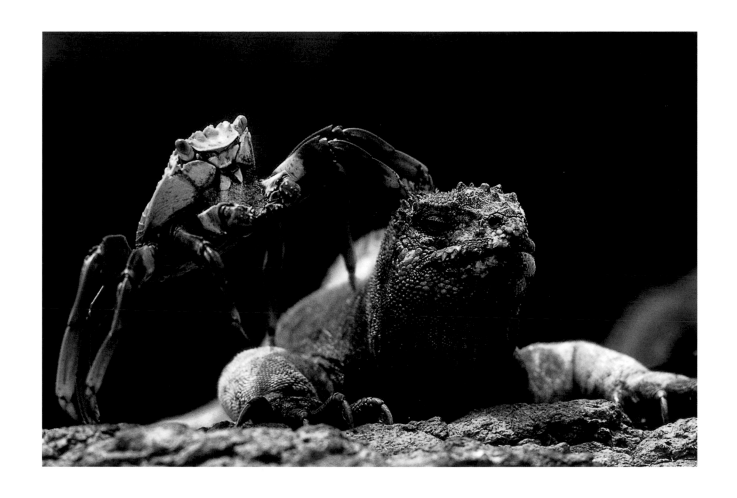

Above, a large Sally Lightfoot crab wanders slowly over
the back of a placid marine iguana, carefully picking small pieces
of shedding skin from the reptile's back. The iguana is more preoccupied with defending
its small seasonal breeding territory against intruders,
advertising its dominance with bright breeding colors which fade
during the rest of the year. Española Island.

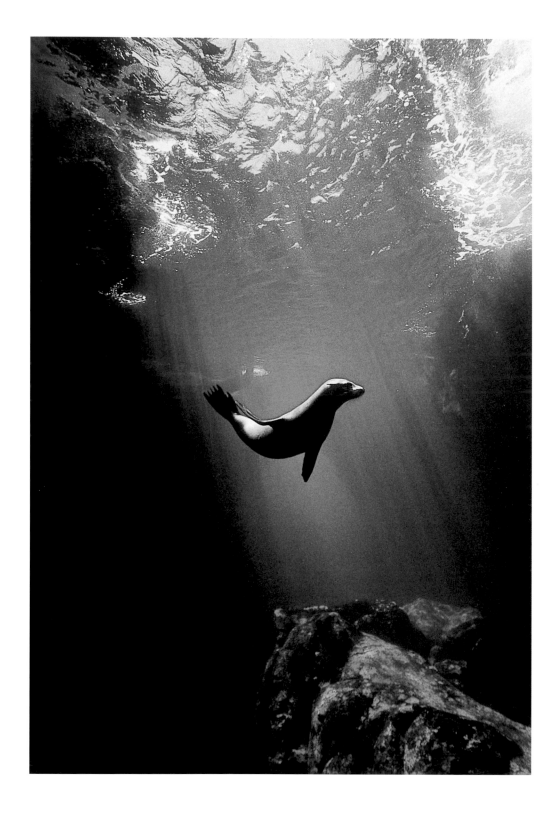

Like the free spirit of Galápagos that he represents,
a young sea lion dances in his weightless underwater world
inside a sun-spangled sea grotto.
Seymour Island.

On the opposite page,
the purple hues of dusk mingle with the deep red glow
of graceful lava fountains issuing from a recently awakened vent
on the flanks of Cerro Azul Volcano.
Escaping gas spews lava "bombs" high into the air,
forming growing spatter cones where they fall back
on the ground and cool. Isabela Island.

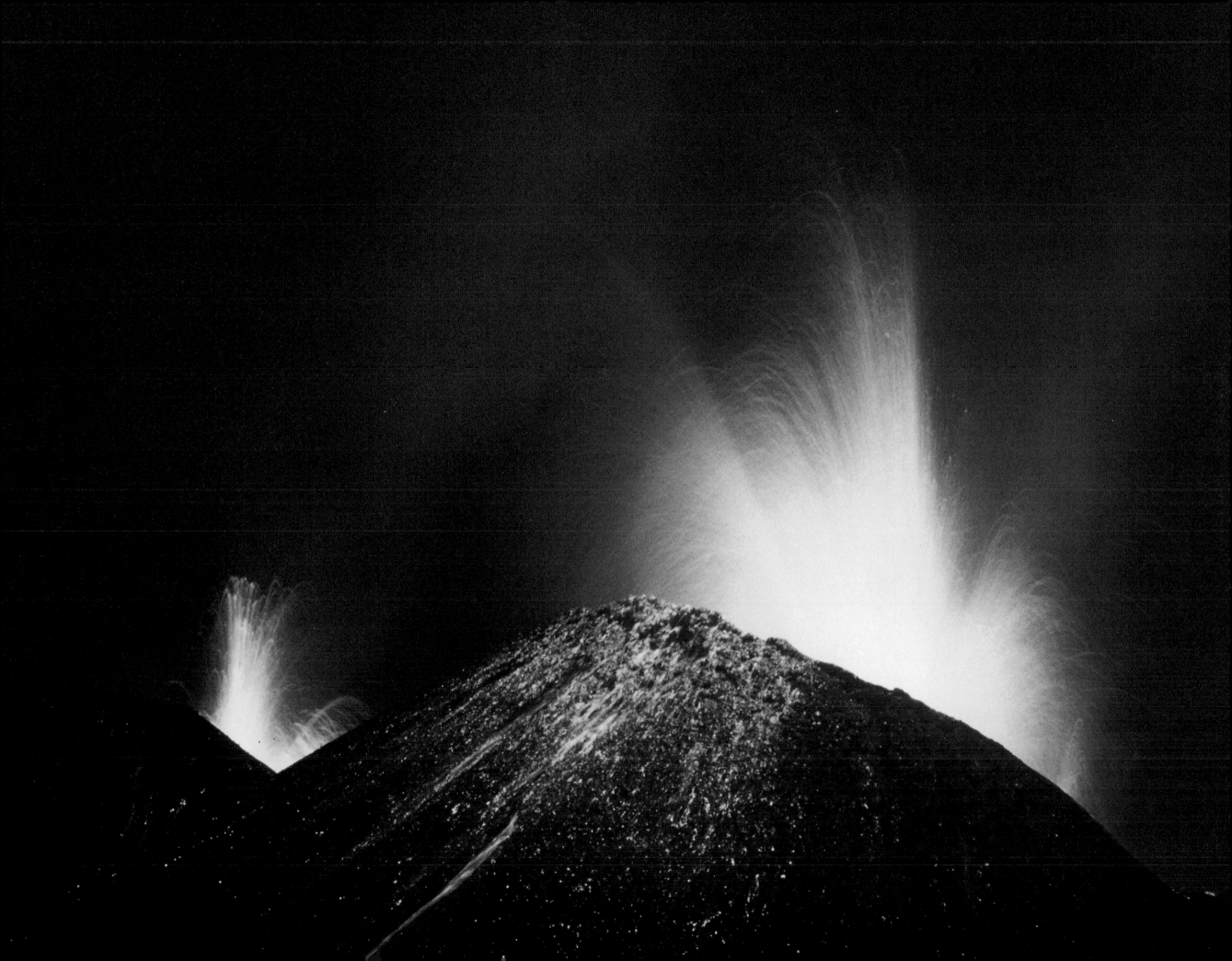

Marine iguana grazing on algae in wave wash at low tide.
Academy Bay, Santa Cruz Island.

On the opposite page,
marine iguanas sit stoically as billows of steam rise where fresh lava pours
into the sea. Not understanding the danger from the volcanic activity,
they simply face into the sun as they would normally do to cool off.
Many iguanas were killed by this volcanic eruption, during which time
a new shoreline was formed.
Fernandina Island.

On the opposite page,
the dominant land predator in the Galápagos food chain,
an endemic hawk preys on a young marine iguana only hours out of the nest.
Galápagos hawks may prey on birds, lizards, and insects, and even feed
on sea-lion placenta when the marine mammals are giving birth.
Fernandina Island.

On the right, hunting by day in the shady understory of cool,
moist highland cloud forest, a short-eared owl settles briefly on a mossy
branch with a freshly-killed introduced mouse before heading to its nest
hidden in the thickets. The owls are diurnal only on islands where they have
no competition from hawks.
Santa Cruz Island.

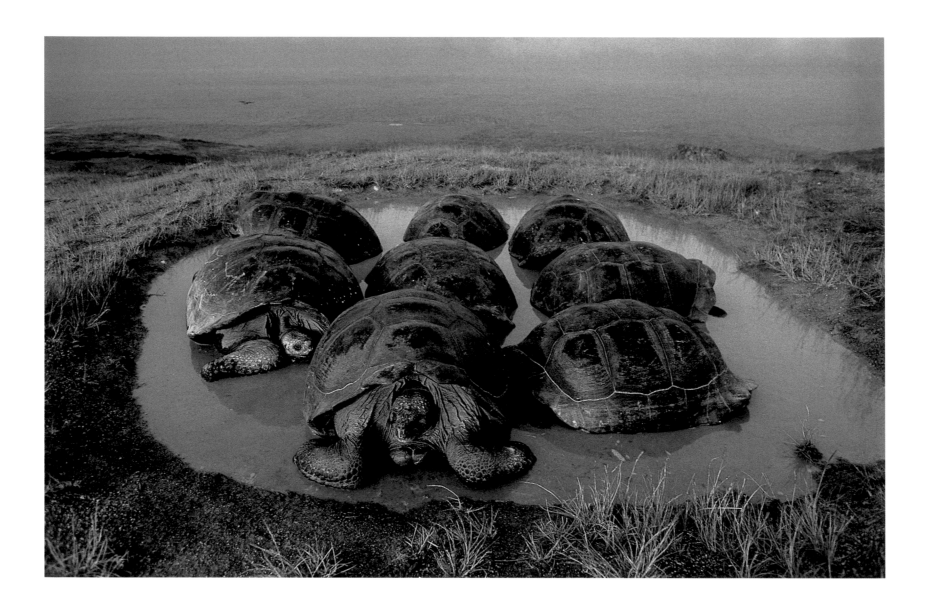

During the rainy season on Alcedo Volcano, a group of large male giant tortoises crowds into a small rain puddle at the end of the day
to wallow in the warm mud for the night, helping them get rid of troublesome ticks in the process. Isabela Island.

On the opposite page,
living on one of the world's most active volcanoes, a Galápagos hawk perches on the edge of a 5-km wide caldera,
whose floor dropped down 600 m 30 years ago and whose lake disappeared since this photo was taken. Fernandina Island.

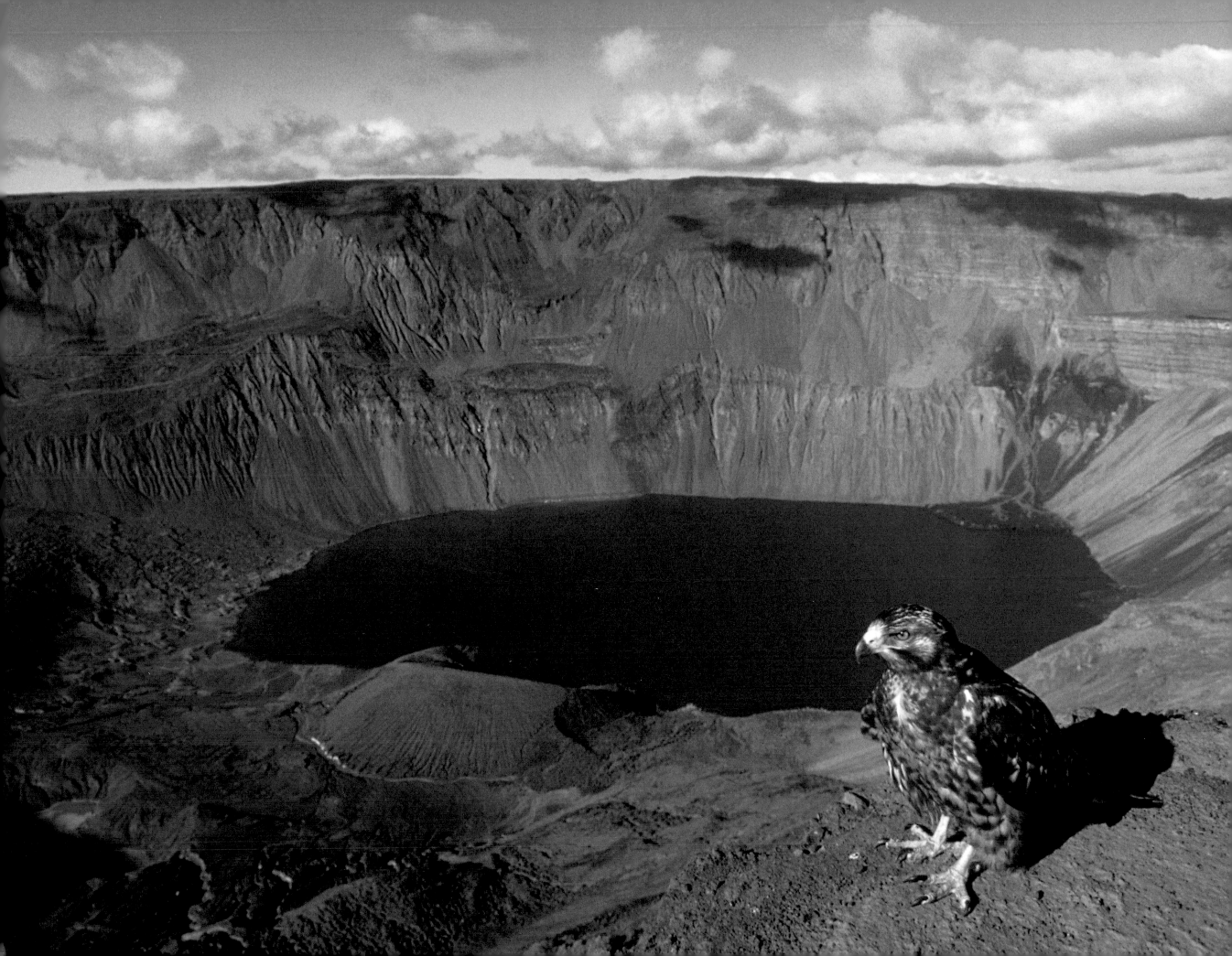

As the day cools and sunset colors tint the damp sea sky, a male magnificent frigate bird brings back one last
twig to the nest where the female will arrange it securely in order to lay her single egg.
Ranging far over the ocean for food, it may take the pair 18 months or more to raise just one chick.
Seymour Island.

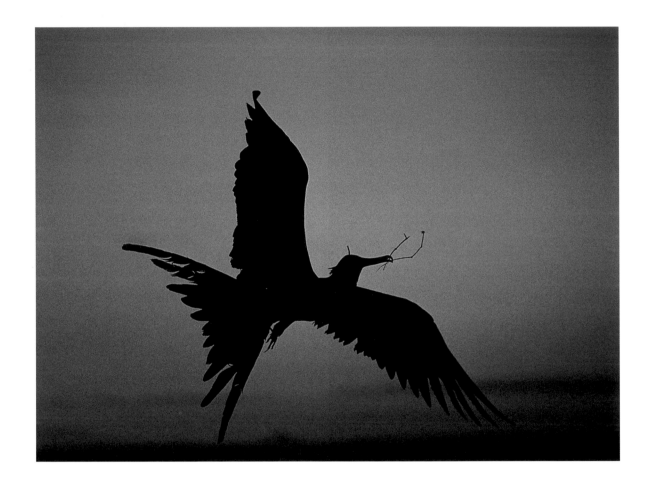

On the opposite page,
the cool, upwelling waters of the Cromwell Current contrasting with warmer air above create some of the most
spectacular sunsets along the western edge of the archipelago. Nestled in Elizabeth Bay is little Mariela Island,
whose dormant palo santo forest is silhouetted against the evening sky. Isabela Island.

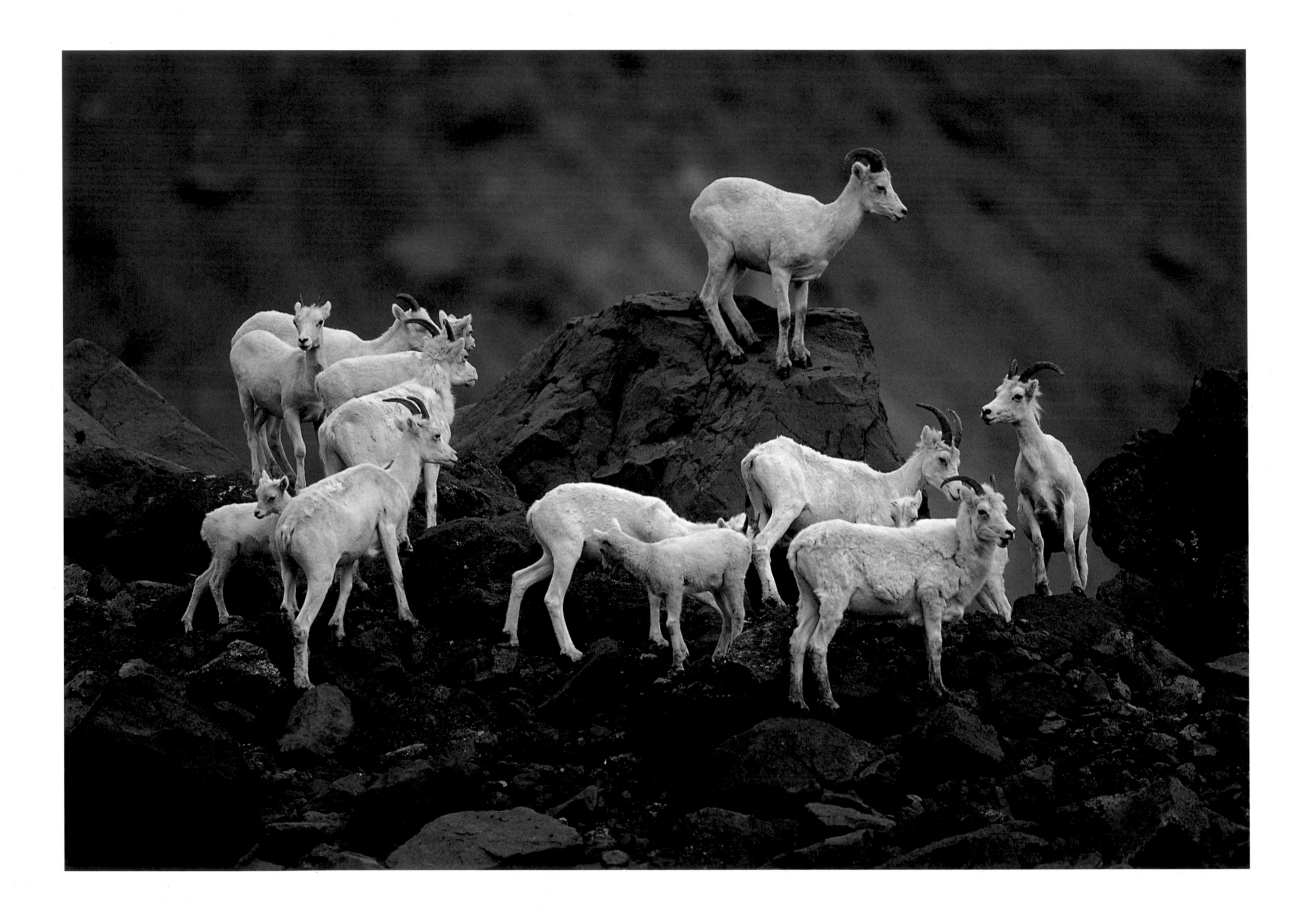

THE LAST GREAT FRONTIER
Denali Region
Photographer: ART WOLFE

This is the land that reminds you just how small you are. And where better to begin than with the focal point of its magnificence: the eternally snow-white, rugged pyramid of a mountain massif called Denali?

Americans love *big*: big cars, big business, and perhaps most of all, big sky country. But this is ridiculous. You stand at the bottom of Denali and look up ... and up —and still you can't believe it. Your senses tell you Denali (officially Mt. McKinley) is the highest mountain on Earth. Mt. Everest may reach a higher elevation, but Denali starts its steep climb from a much lower base elevation, rising 5 486 m to its 6 194-m summit, the highest peak in North America.

On a clear day, Denali is visible 400 km away. It stands as a beacon and undeniable symbol of the ultimate in big country and big ideas; in this case, the idea that a massive pristine wilderness can be preserved in its original state.

Native Athapaskan for "The High One," Mt. Denali anchors a 1 040-km-wide curve of high peaks called the Alaska Range that arcs across south-central Alaska. The range makes its own weather, blockading moist, warmer coastal air masses from bringing moisture to the vast, frigid tundra prairies and forests of the central interior.

The high-altitude jet stream has been known to dip down below the top of Denali's twin peaks, boosting the ground wind velocity in Denali Pass to an unsurvivable 320 kph. Any living creature caught out in such a hellish gale would literally blow away and simultaneously flash freeze in seconds.

As big as the mountain and its impact on the eye and climate are, Denali is but one player in a landscape of giants that lend the 49th American state its rugged identity. Some superlatives properly frame its geographic magnitude: Alaska is one fifth the size of all the lower 48 states combined; has 17 of the 20 highest peaks in North America, half the world's 5 000 glaciers, three *million* lakes, and 3 000 rivers (10 of which are at least 480 km long, and one, the mighty

Yukon, flows almost 3 200 km); and supports the most varied and abundant population of wildlife in all of North America.

Set like a diamond into this immense expanse of open land is Denali National Park and Preserve. Named for the mountain, the original Mt. McKinley National Park encompassed 769 000 ha of virgin Alaskan tundras, taiga forests, glaciers, lakes, and mountains.

With the passage of the Alaska National Interest Lands Conservation Act in 1980, hundreds of millions more hectares were set aside in 11 national parks and preserves. Denali was tripled in size to almost 2.4 million ha and its original dimensions redesignated as a wilderness area.

But Denali and its environs have more to offer than mere scale. In each of its challenging climatic zones, life finds a way to survive. Even in the microecosystems that exist within a few centimeters of the surface, life is plentiful —as the first-time visitor finds out in a hurry.

HUMBLE IN THE PALM OF THE WORLD
People often ask me to name my favorite place in the world. Often I start to answer Antarctica ... then I pause, and remember: it's Denali —the last week in August.
ART WOLFE

Art Wolfe is not exactly having the time of his life.

It is 1975. This is the young photographer's first visit to Mt. McKinley National Park. He and a friend have timed their arrival based on Art's familiarity with his native Pacific Northwest weather, where August is the prime season of the year.

Now, standing at the park entrance opposite the train station, he looks into the great green wilderness with a sense of foreboding. It is snowing. The wind is blowing —hard. And it's getting really, really cold.

On the opposite page, a herd of Dall lambs and ewes traverses a rocky slope within Denali's Alaska Range. During the summer months, the sheep separate into herds along gender lines: the ewes and lambs congregate apart from the rams. As the rut season approaches in late fall, the herds gather together.

Oh, yes: the only road into the park —a 150-km-long ribbon that dead ends 27 km from the northern foot of Mt. McKinley— is closed. Welcome to Alaska.

"We have no means of transportation except our feet. We shoulder our packs and head up the road." After 8 km of strenuous uphill trekking, Art is more than a little intimidated. "Everything is so big, so foreign to me. It's getting colder, windier, and we're tired —but we have to keep moving."

With the head-down determination that has made him one of the most prolific and successful nature photographers in the world today, Art leads the way for five more kilometers until a patch of young spruce trees offers promise of shelter from the worsening storm.

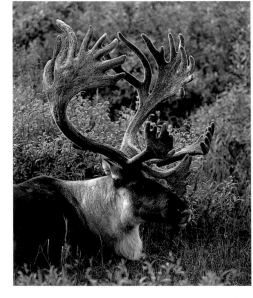

"We pitch camp and settle in, and these really amazing winds start howling." When the gale yanks young spruce trees right out of the ground, the men check their maps. "In August it's still light outside. We locate a canyon on the map that offers an escape route to what should be a less windy area. We break camp and hike down in, but by now the winds are almost overpowering."

As they descend into the narrowing throat of the canyon, Art realizes they are caught in a venturi effect: the wind, squeezed by the canyon walls, increases its force. "We turn around … and literally can not stand up. We have to go on hands and knees to get back out!"

Finally, they regain the chaos of the wind-whipped black spruce forest, which doesn't seem so bad now, and pitch camp again. By morning the storm breaks. Sunlight peeks promisingly through the parting clouds. As they hitch a ride up onto the tundra plateau, Mt. Denali shows itself for the first time. Art looks up in reverent awe. "That mountain absolutely took my breath away."

"So when people ask what is my favorite location, I have to say Denali. It was the first place I actually felt completely overwhelmed by nature."

WHERE THE CARIBOU WANDER
No one knows where the wind moves, or the caribou.
Native Athapaskan saying

On those heart-squeezing mornings when the sky is clear, sunlight turns the white enamel line of the sawtooth Alaska Range into a jagged rim of heavenly fire. Deep, cold blue sky takes on the breath of reflected warmth, to brighten the dusky browns, greens, and russets of summer tundras below.

The single highway happily winds across the open plain, following the base of the foothills. Unadorned —no billboards or streetlights allowed—, it is the only transgression against the immensity of untracked open space. In winter, the implacable whiteness of the mountains will descend to conquer the lowest levels of tundra. Then, the highway will be a black thread in an oceanlike undulation of blinding glare.

Caribou are the New World's most northerly member of the deer family and the only North American deer to carry antlers in both sexes. They are prodigious migrators; populations of caribou that inhabit the Arctic tundra may travel 1 000 km between their summer range in the north and wintering range in timbered areas. Those in milder climes may simply move to a lower elevation in winter.

116

But now, color holds court in the lowlands. Across the shoulder of Polychrome Pass at Stony Hill Overlook, orange Arctic poppies and green sedges bring welcome hues to the thawing lands. Spring has gone as quickly as it came —Denali throws off the rigors of winter for just three months: June, July and August— and nature is making up for lost time with a profusion of tundra flowers.

The tundra carpet is the coldest of all biomes. "Tundra" comes from the Finnish *tunturia*, or treeless plain, and thrives in permafrost zones of low temperature and little precipitation. The weather-making Alaska Range creates the perfect environment by denying all but about 305 mm of moisture per year north of its ethereal battlements.

Cloud-woven sunlight and shade throw a patchwork upon the endless land. The tourist season is in full sway. More than 500 000 visitors arrive, mostly between May 1 and September 15. There is only one lodge within the park proper, at Kantishna—just the way Charles Sheldon would have wanted it. A New York adventurer and big game hunter, Sheldon was instrumental in securing park status for Denali in 1917.

There are more caribou than people in Alaska. One million roam the wilderness in 30 distinct herds, always moving in search of food: lichens in winter and a variety of estival plants across the summer tundra.

Animals remain the main event for most visitors to America's Serengeti, and Denali does not disappoint them. As for the nature photographer, there can be no finer experience than to be far from the clattering din of civilization, camera at the ready like a painter's brush.

CATHEDRAL DAYS
I found myself above the fog. Denali, immaculately clear, towered above me, its lower slopes crossed by a thin band of pink vapor, the sky above it pink, yellow, gold, crimson, of ever-changing color tones.
CHARLES SHELDON

"There's something … infinite about the place. It's in the air; a feeling that goes to the bottom of your lungs when you take a deep breath," says Art.

Educated in art and an avid painter, he remembers the visual impact of his first visits. "Everything was green, beautiful, so pleasing to the eye. I made a short trip to Fairbanks and returned to find the tundra had exploded into the golds and reds of fall. In two days! Things just happen fast up there."

One morning, Art and his assistant were up before sunrise to climb the Cathedral Spires, just west of the park, in search of Dall sheep. Scrambling like goats themselves up the steep, sharp edges of ridge rock country, surveying the tundra plains and taiga forests far below, they heard a noise, a footfall in the loose gravel behind them.

"Our hearts stopped. We spun around, and towering over us was this huge rack of antlers. A big bull caribou was staring down from a couple of

meters away. He walked calmly around us and continued on down the slope."

Before long, Art saw a grizzly bear on the tundra below, with three roly-poly cubs in tow. Not long after, they came upon a bull moose and his cow in the forest. "Later, on the Teklanika River, I photographed a couple of porcupines. And then a family of Arctic foxes!"

By the time the campsite came into view, the photographer was ecstatic. "It was a seminal day in the maturation of the artist. I finally comprehended what Denali was all about. Here was a place I could really learn my trade. I promised myself on the spot I would come back over and over and over."

Throughout his long and successful globe-hopping career, Art Wolfe has kept his vow: he has returned to photograph the wilds of Denali more than any other place on Earth.

THE WHOLE OF NATURE
A human being ... experiences himself ... as something separated from the restThis delusion is a kind of prison for us Our task must be to free ourselves from this prison by widening our circle of compassion to embrace all living creatures and the whole of nature in its beauty.
ALBERT EINSTEIN

The Dall sheep, that magnificent icon of high mountain fastnesses, is supremely adapted to its Denali haunts, where as many as 1 000 live. The only wild, white sheep in the world, they are handsome animals. You can tell their age by counting ridges that grow on their magnificent, curling, cinnamon-colored horns: five rings means five years old.

The gray wolf roams Denali and much of Alaska in small packs. Like Ellesmere's white wolf, they are highly sociable, team-oriented in the hunt, and show little fear of humans. Moose, caribou, Dall sheep, and small mammals have all felt the lethal fangs of the far-ranging wolf.

If you come across a white-crowned sparrow or robin in the lower 48 states and Mexico, you feel humbled at the reach of their delicate wings. Birds from many southern lands return to Alaska every spring. A recent DNA study of Wilson's warblers in Denali Park proved that the hardy travelers migrate all the way to highland areas near Tegucigalpa, Honduras!

The feather-footed willow ptarmigan, Alaska's plentiful state bird often jokingly dubbed the "Alaskan chicken," joins other avian members of the biosphere: the long-tailed jaeger, a graceful kite of a bird, soars overhead in search of lemmings, voles, mice, and ground squirrels. Marsh hawks, short-eared owls, ducks, and mew gulls inhabit areas south of the Alaska Range where warmer temperatures and lakes prevail.

Arctic foxes are always on the hunt, especially for the white Arctic hare. In the rivers and lakes, cod, flatfish, and trout are abundant. And then there is the sockeye salmon, that great actor in one of life's most dramatic performances.

When flushed red with the spawning urge, they fight their way upstream by the thousands to lay eggs and die.

Waiting to cash in on the salmon run is the huge, ambling mammal that prizes the fat-rich skin of the fish above all other foods: the great grizzly bear.

LESSONS IN THE FIELD
In nature there are neither rewards nor punishments —there are consequences.
ROBERT G. INGERSOLL

One day in Denali, Art and his photo assistant are hiking up a broad canyon in the back country, kilometers from the road. He has seen caribou on higher ground that he wants to photograph. As they move briskly up a flat gravel riverbed, his companion notices a grizzly bear high up on one of the flanking hills, a good 1.5 km away.

Art tells him not to worry, but as they press on, his friend keeps tabs on the big brute. A couple of minutes later he tells Art the bear is watching them.

"Relax," Art repeats, "he's too far away to bother us."

A few moments later, his friend, sounding frightened, says, "He's coming toward us!"

Art turns to look but the bear has disappeared.

"Where is he?"

"Not up there, stupid," his friend cries, "down there!" Art follows the pointing finger to see the bear in full gallop down the hillside. The big grizz has covered half the distance —in just two minutes.

The men freeze, watching as the big mammal crashes down the steeper tundra, through a line of willows lining the edge of the river basin, then out onto the gravel and now *straight toward them*! There is no obstacle to hide them, no place close enough to run from an animal that moves twice as fast as a man.

As luck would have it, Art remembers the M80 firecracker in his backpack that someone gave him just days before. "This was the only time I had ever carried any kind of animal protection in my life."

The bear is coming on fast, just a hundred meters away now. The men can hear its huge paws pounding the ground, see the sprays of gravel it kicks up. They frantically try to light the firecracker, but the damn *wind*! The wind keeps blowing the matches out!

Closer the grizzly hurtles: fifty meters, forty, still at a gallop, he'll be on them in five seconds and in desperation Art strikes the last match he's got time to try and he's using his jacket as a wind shadow and *What if it doesn't light!* and then it catches, the fuse sputters and *Yes!* in one fluid motion he throws it straight at the onrushing bear, praying it will not be a dud, praying the noise will scare the big brute, wondering where he can run ... it's too late, it's not going to

Ever watchful for predators, a pair of Arctic ground squirrels stand at the entrance to their burrow and survey their territory. Their burrows are up to 20 m long and it is there that they hibernate living off their fat reserves for 7 months from October to April. They may store food, ranging from seeds and roots to insects and eggs, in their burrows but they don't seem to utilize it until they awaken in April.

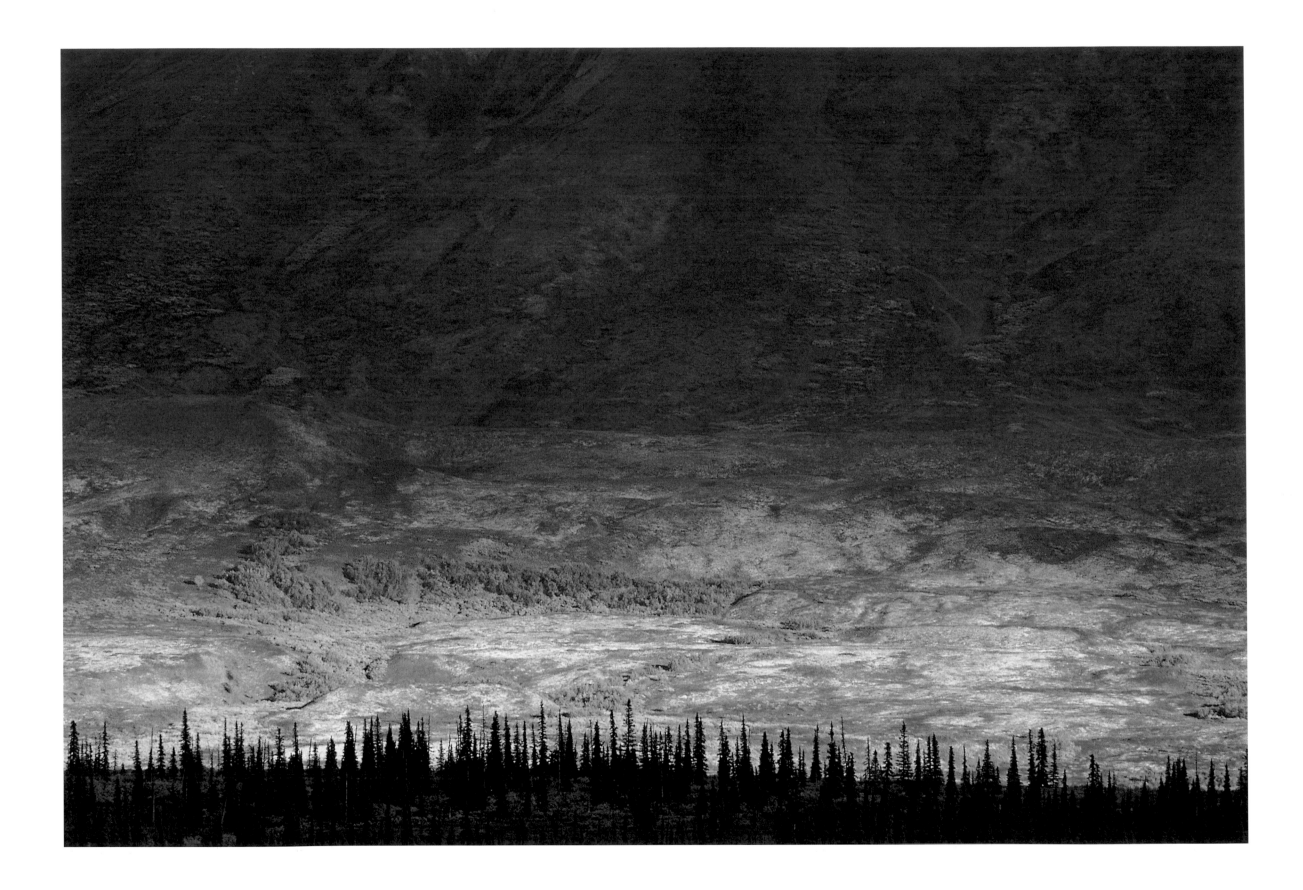

go off! and CRACK! it explodes right in front of the bear and the bear stops! It stops dead in its tracks! and rears up on its hind legs, just 12 m away, but it's turning its head to follow the echoing sound around the canyon walls, it's confused and then ... then it drops back down on all fours, *Thank God!* and spins furiously to gallop away at full speed in the exact same direction from which it came.

It takes quite a few minutes for the men to recover. Maybe, Art thinks, it mistook them for a caribou. Maybe it was just in a bad mood.

"He was a three-year-old. The park rangers call them 'rascals' because they're so unpredictable. They've left their mother, are low man on the bear-society totem pole, and get ornery and like to stir up trouble, just like juvenile delinquents."

"Maybe he would have stopped when he saw we weren't his usual dinner. Maybe not. Thank God for that M80."

MAN AND PARADISE
Nature can not be commanded except by being obeyed.
Sir FRANCIS BACON

Perhaps 25 000 years ago, perhaps much longer back than that, migratory humans came across the Bering Land Bridge from Asia to settle and reap the lowland bounty of Denali's caribou, sheep, and moose from spring through fall. They preserved berries for winter, netted fish, and gathered edible plants. As winter cold set in, they migrated to lower, warmer river-valley elevations.

They called themselves Athapaskans, or simply "people." The Alaska Range formed a natural buffer, spawning a variety of cultures. By giving the ancient Koyukon name of Denali to the park, the government sounds a promising note in what may yet become a song of repatriation and new respect for ancient ways.

Perhaps other names will also be restored, their meanings more widely shared: Oonyeeh Tilaah Dinh —where the blackfish run in season; Ts'ilhyaan Dinh, place to hunt polar bears; Nannugvik, lake of the fat whitefish; Ts'atiyh Dinaa Dakk'onh Din, where a forest fire burned the hill to the river.

And by holding on to colorful phrases from the state's more recent, wild and woolly Gold Rush past —Flapjack Island, Skull Cliff, Coffee Can Lake, Hell Roaring Creek, Sore Finger Cove— perhaps we can also choose to wrap a place in the cloak of all its human history, embracing both our triumphs and painful lessons as we move forward.

CHAPTERS IN A LIFE
I came where the river ran over stones; my ears knew an early joy. / And all the waters of all the streams sang in my veins that summer day.
THEODORE ROETHKE, "The Waking"

Photographers work hard. They often must endure, unsheltered, the worst that nature can throw at them. Sometimes they tramp for miles, for days, and never get the shot they came for.

"When you go to an area that doesn't have Denali's abundant life and grandiosity in the landscape, you have to work harder to make those little neurons in your brain come up with a good image," says Art from the perspective of three decades and a monumental body of photographic work.

"But in Denali, even rank amateurs come away with great shots all the time —yet that doesn't take away from my joy in working there. I would much rather not work as hard anyway."

Few nonnatives know Denali better than Art Wolfe. "Each time I return for a shoot, whether for a week or a month, I remember specifics based on my trips there; I have a very good memory for my photos, even though I've taken so many. So when I come around a particular stand of trees, I'll remember that in 1979, there was a fox den just over that bank. Over time, all the memories turn pleasant —even if I was shooting in a blinding snowstorm or a plague of mosquitoes."

"It's like visiting a part of your life. Every little bend in the road carries a personal story."

BENDS IN THE ROAD
I would feel more optimistic about a bright future for man if he spent less time proving that he can outwit Nature and more time tasting her sweetness and respecting her seniority.
E.B. WHITE

In the years since Art Wolfe discovered Denali, it has gone from a raw and seldom-visited wilderness to an increasingly popular destination spot. Hotels and commercial developments continue to grow just outside the main gate. Tour buses run more frequently. Alaska's cadre of conservative politicians press the federal government to loosen or reinterpret laws to allow more economic and recreational development in the parks and preserves.

There is constant agitation to increase snowmobile access to more areas of Denali; grant oil and mineral exploration leases; build more roads, lodges, and even a railroad inside the park; allow the return of wolf hunting from airplanes in the misguided view that moose and caribou game herds will increase; permit more air traffic over the Denali core wilderness; allow more landings on glaciers; issue more mountain-climbing permits; and on and on it goes.

It's enough to give a dedicated conservationist a headache.

The 1971 and 1980 acts that codified the expansion of Alaska's protected lands made allowances for snowmachines, motorboats, and airplanes in Alaskan parks and wildlife refuges for "traditional activities" such as hunting, fishing, trapping, and traveling to and from villages —*if* those activities occurred before the laws were passed. Establishing exactly what that ambiguous wording actually means fuels the ever-shifting battleground between environmentalists and their equally-dedicated foes, spurred on by those who moved here to escape the increasingly conservationist regulations of the lower 48 states.

On the opposite page, as a nature photographer, I delight in photographing wild animals. However, it is usually the landscapes I feel much more connected to and I often choose landscapes that are vignettes of a greater whole. Such is the case in this image. I have brought attention to the undulating shadows, the interplay of light and dark, and the fall colors; all these elements have combined to create a more moody and memorable picture.

The National Parks Service holds fast to its prime directive: the purpose of a national park is to protect habitat and wildlife first, then provide use and enjoyment of those lands to people *only* as it is compatible with the first purpose.

There are never easy answers, only action, reaction, and —we can hope— inspired resolution. Denali and all of Alaska's protected areas belong to the animals, but also to the people of the world, not as a playground but as a cherished representative of the living soul of our planet.

WHY WE LOVE NATURE
We feel a kinship for the eagle and the bear. The culture of conservation holds a commonality between all living creatures. To know more is to care less about the differences between nationalities ... races ... species.
ART WOLFE

"We are animals, which is why we are intuitively drawn toward animal life. They share this planet with us." Art has seen some changes come to Denali National Park and Preserve. "Still, it is a great model of how a park can be run, even though there are some nasty politics being played in the state."

He worries that the much-lobbied road proposal from the west to Kantishna, if pushed through, will compromise the most delicately beautiful area around nearby Wonder Lake that his forebear, Ansel Adams, immortalized half a century ago in black and white.

"The entire scene will change there. If that happens, there is no going back. So I agree with the park's stand on keeping development to an absolute minimum. Let's keep those sightseeing visitors on the buses: it works on behalf of the animals, and that's what it's supposed to be all about."

...AND PROMISES TO KEEP
We can't help being thirsty, moving toward the voice of water.
JALÁLUDDIN RUMI

Denali presents the best face of nature preservation to a world thirsty for beauty and reassurance. In the haunting warble of the loon, the dance of veils of the aurora borealis across a night sky, the black silhouette of the caribou against a deep golden twilight, life plays its greatest symphonies and all seems right again with the world.

"When I show slides from Denali and share my experiences, people smile and laugh, relax and seem to be renewed. It gives them hope to know the entire world isn't getting paved over after all."

Photographers who have traveled around the world the last 30 years have a unique perspective: they have seen too many pristine ecosystems slipping, slipping away. None can speak of any wild place that has reversed the trend and returned to its wild state. It's too late for that now.

So when Art Wolfe, who's been about everywhere in the natural world there is to go, casually comments that the occasional "rusty old mining camps" will eventually "disappear into the land," we can indeed harvest hope.

Here, he is saying, here in Denali, the standard of preservation seems to be holding. Here the rack and ruin of civilization will give up its gains, will fall away. Here, the grizzly bear, the gray wolf, the willow ptarmigan and vole and ground squirrel, the first green comma butterfly of spring may yet prevail.

Here, we can gift our children with these simple words: "Go to Denali. Go see how God meant the world to be."

On the opposite page,
I spotted this set of caribou antlers glistening in the sun approximately two kilometers away. The white antlers stood
dramatically apart from the bright autumn colors. I used a 20-mm wide-angle to show both the antlers in full, as well as
the environment I found them in.

A bull moose passes through a grove of black spruce and brilliant ground vegetation
in full autumn color. The large bull epitomizes strength and virility as he approaches
the rut season, when his strength will be challenged by other bulls in the region.

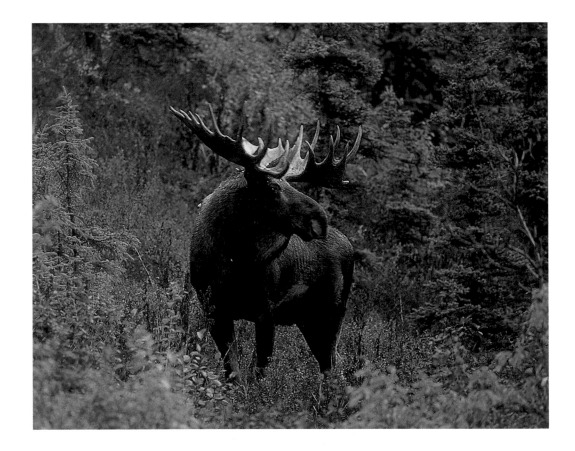

On the opposite page,
rainbows are relatively frequent sights within the open terrain of Denali National Park,
especially during the months of July and August when sun and showers are common
companions. The summer rains keep the rolling vistas of the tundra a vibrant green.

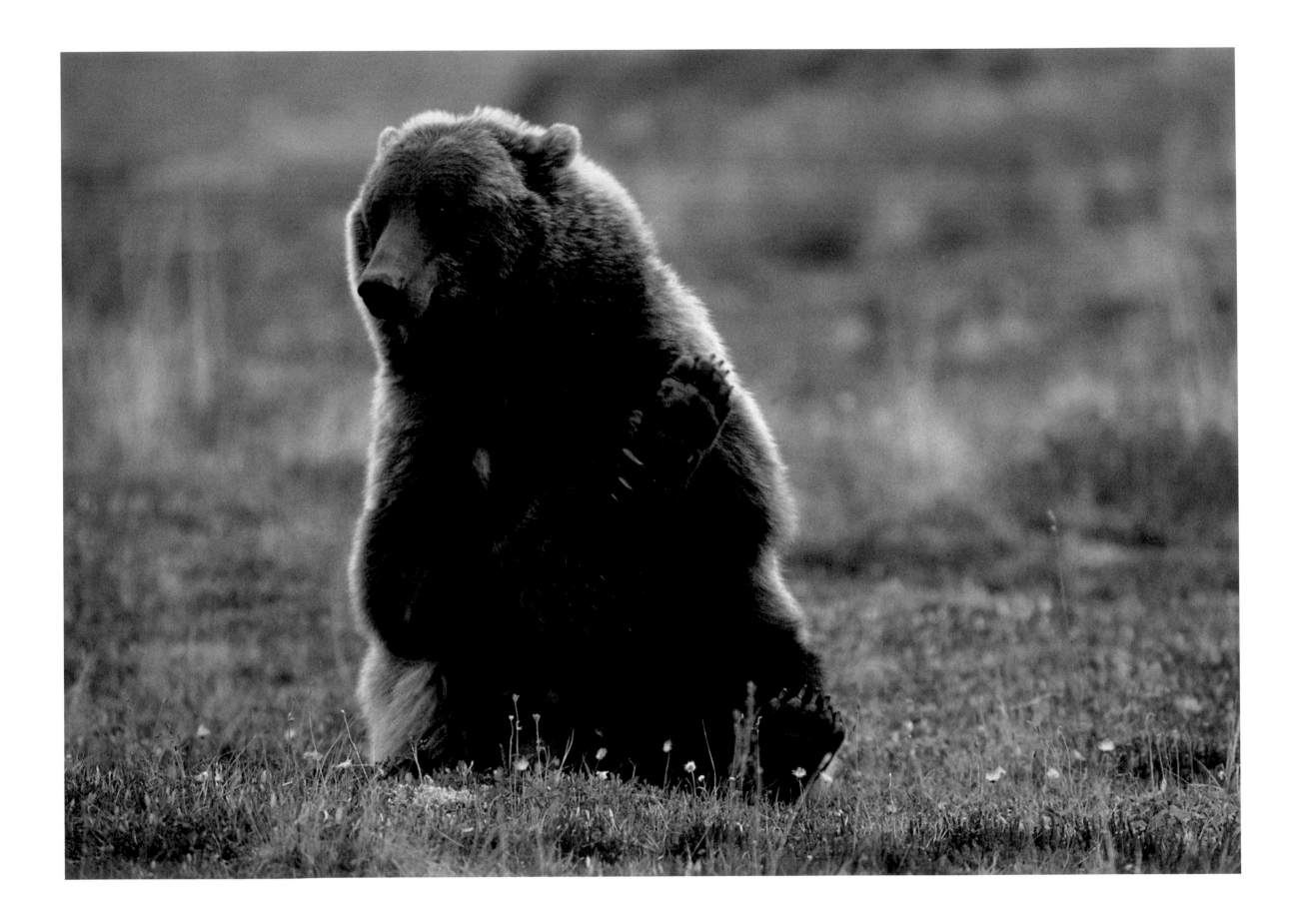

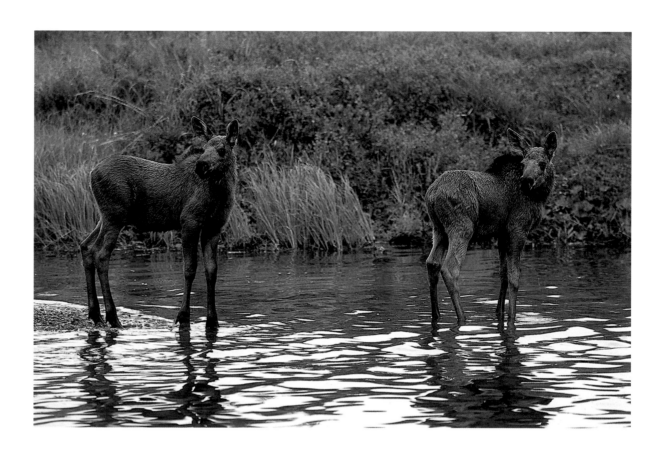

On the opposite page,
grizzlies are omnivorous; they eat a great variety of food, including a massive quantity
of berries that ripen in the fall in Denali National Park. For hours they will dig after Arctic
ground squirrels, as well as chase moose calves and old caribou. Striking a rather comical
pose, this grizzly briefly stops for a scratch.

Above, in July, moose calves are still rather small, but at this stage they are very
rambunctious. Their mother was feeding on submerged vegetation at the edge of Wonder Lake
while they chased each other around.

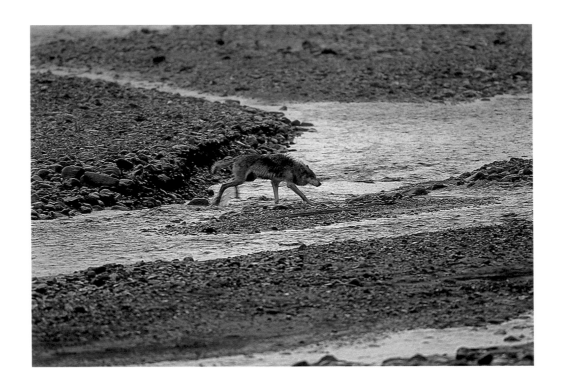

With groves of willow
and soapberries growing along their banks
to attract moose and caribou,
rivers are prime hunting grounds
for wolves. It is also easier for wolves to travel
along the open river sandbars.

On the opposite page,
a caribou is dwarfed by the foothills
of the Alaska Range.
Sweeping views epitomize the open country
of Denali and this is one of the reasons
why wildlife is so regularly seen.
There are few forests to hide their presence.

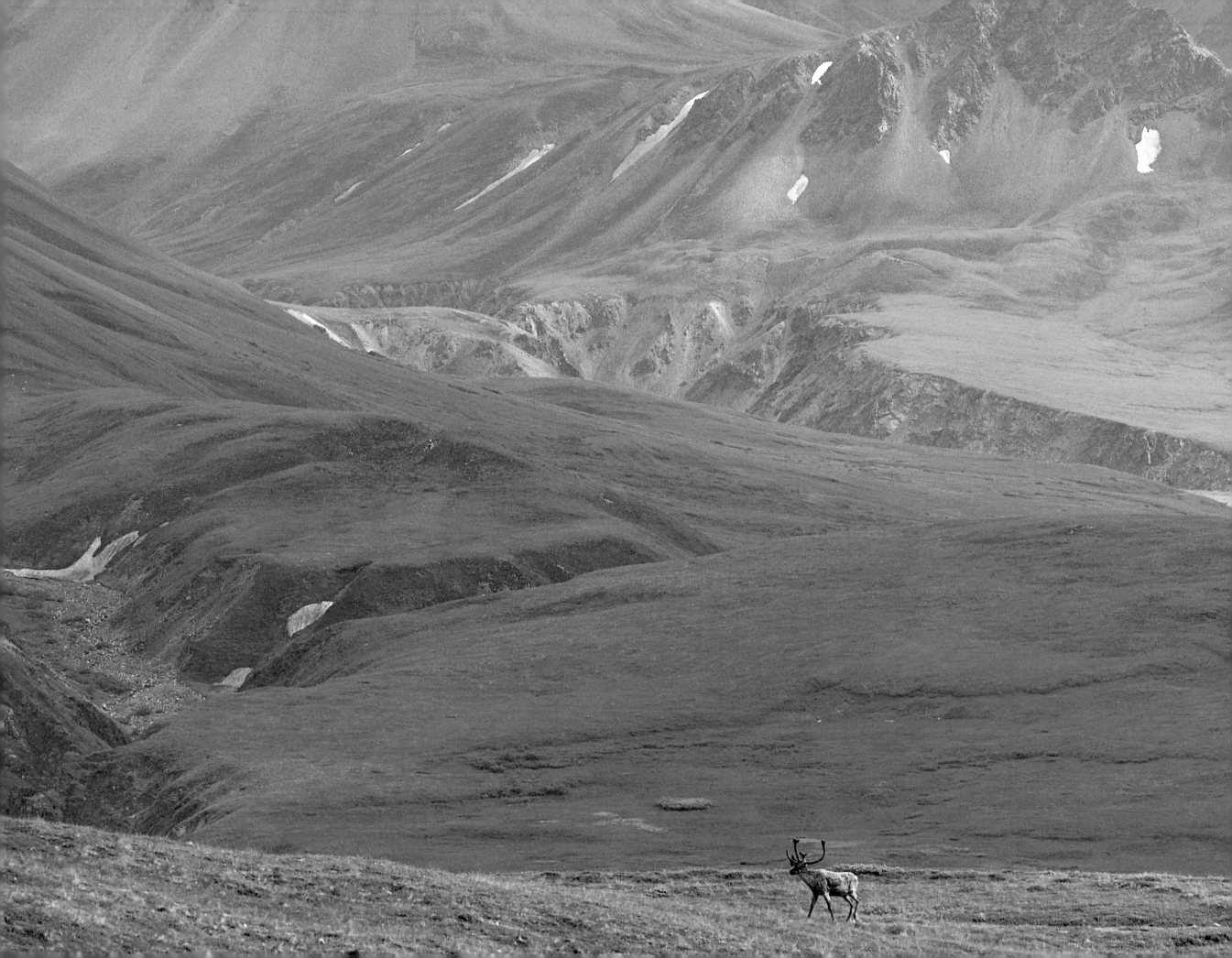

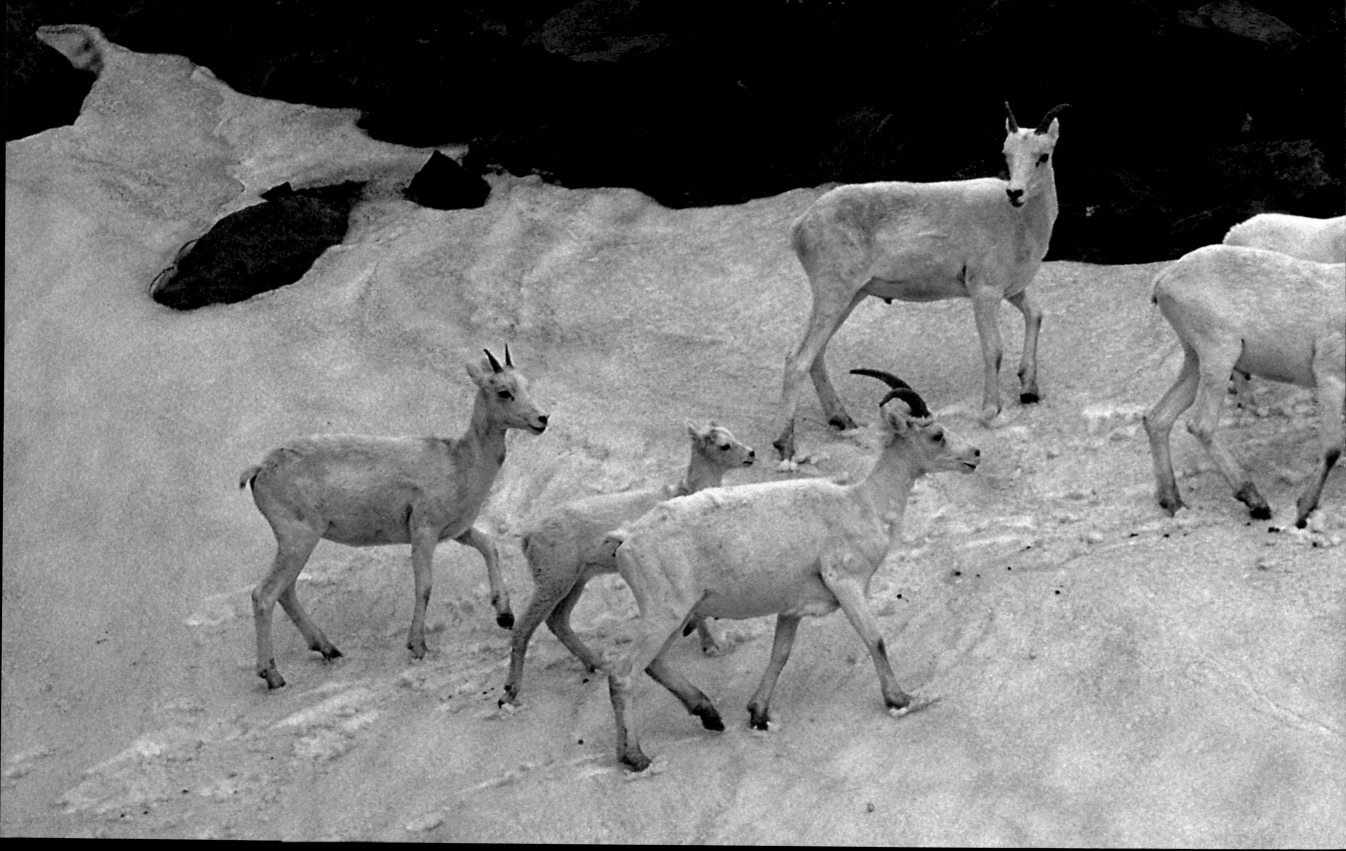

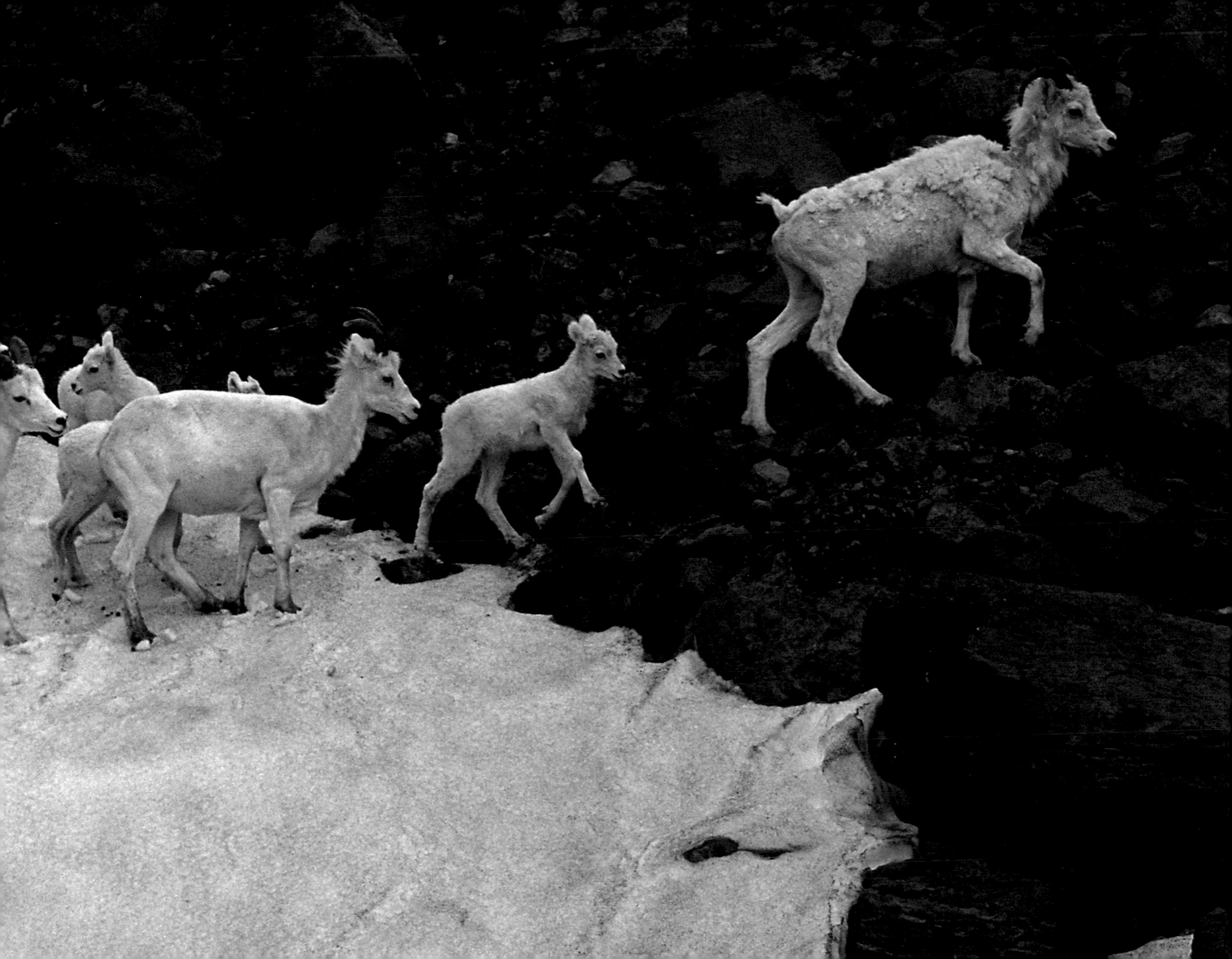

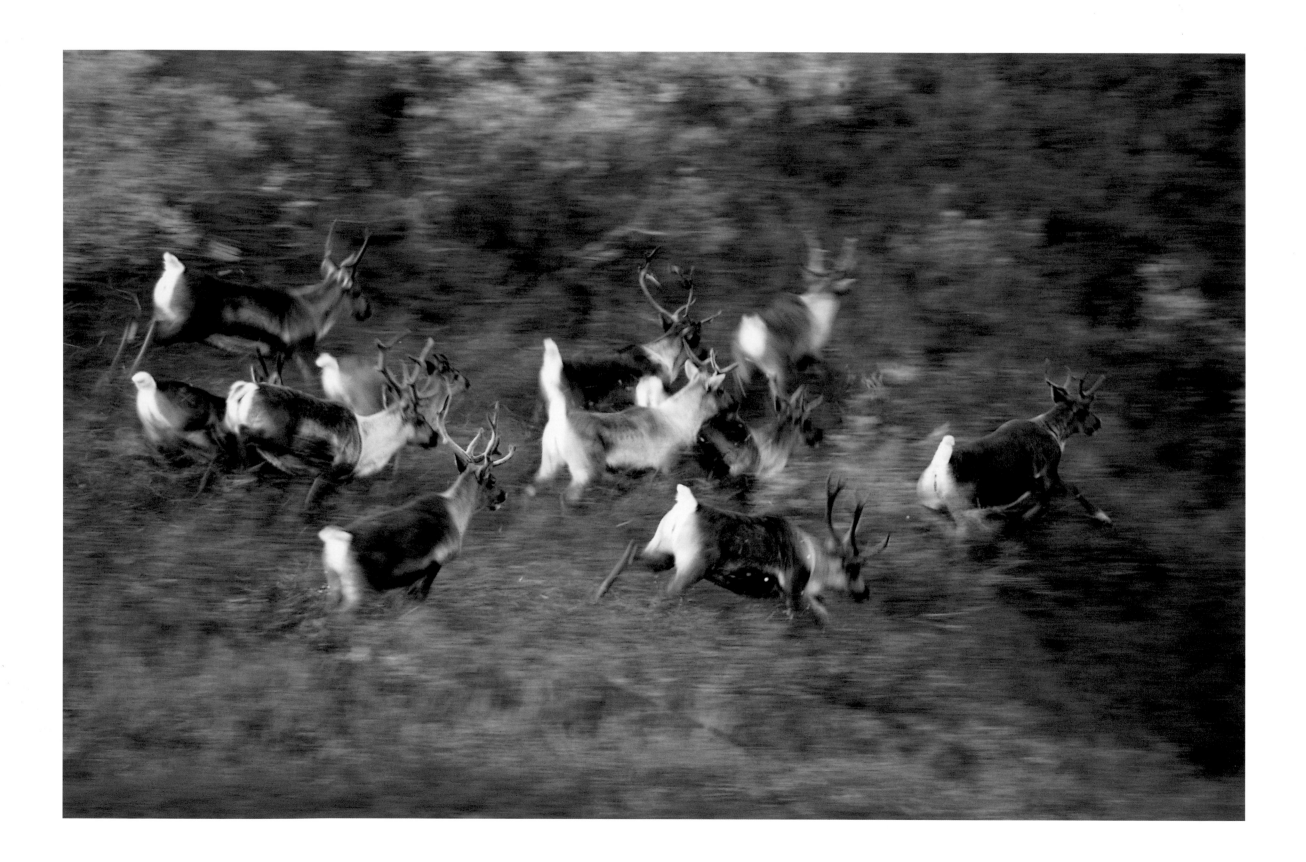

On pp. 128-129,
during the long summer months, the ewes and lambs separate from the rams.
In the late fall they come back together for the rut season. Here, they cross a snow patch
in the foothills of the Alaska Range. Rarely approachable elsewhere, the sheep seem to know
that within the confines of Denali National Park they are safe from hunters.

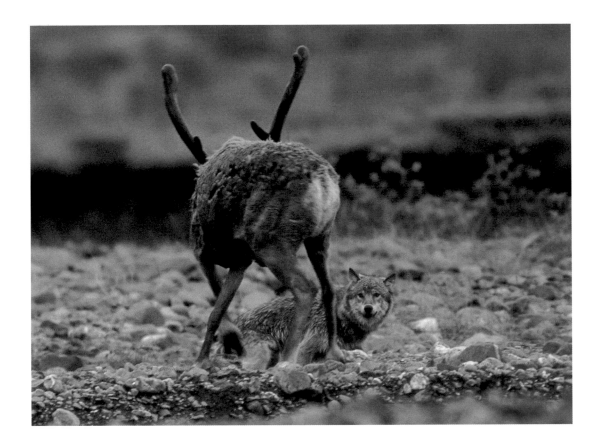

On the opposite page,
often I deliberately lengthen the shutter speeds of my exposures to create a more graphic sense
of motion. This image of a caribou herd is one of my favorites; the sudden appearance
of a grizzly had alarmed them and off they went.

Above, a brief confrontation between a single female wolf and a bull caribou ends in a draw.
Often wolves challenge their prey's strength. If the animal appears weak, the wolf will attempt
to take it down. After an hour, the wolf thought better of this encounter
and the two parted ways.

An Arctic ground squirrel stands brazenly
in front of its burrow. Arctic ground squirrels are preyed
upon by grizzlies, foxes, and golden eagles;
consequently, they are very cautious. In this particular case,
though, with its burrow at its back, it felt comfortable
as I photographed it.

On the opposite page,
one of my favorite photographic moments is when
I spent a brief time with this Dall ram overlooking
the Teklanika River Valley. This was one of the first times
I was able to photograph an animal where the landscape
was just as important as the animal itself.
The ram seemed to be enjoying the scenery as much as I was.

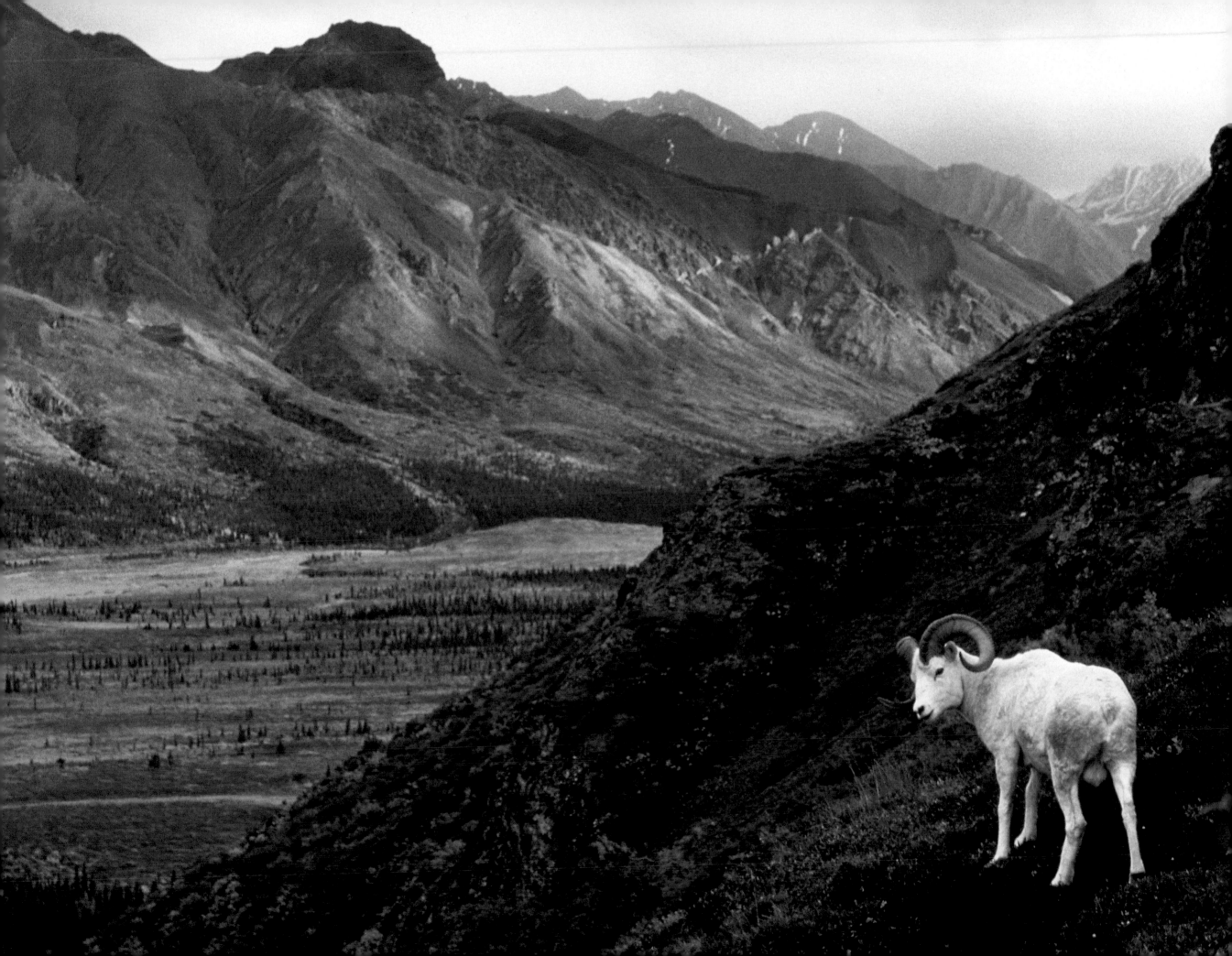

On the opposite page,
the mountains of the Alaska Range are renowned for their rugged inaccessibility.
The Cathedral Spires are an isolated group of jagged granite peaks near the border of Denali National Park.
Very few climbers have attempted the Cathedrals, since getting to the base of the mountains
presents a major challenge in and of itself.

On the right, a pair of Dall rams rest near the summit of Igloo Peak. Dall sheep become remarkably
relaxed when protected within parks. The sheep rarely venture far from the steep cliffs,
especially when wolves are present.

On pp. 136-137,
Denali rises 6 000 m above the surrounding lakes
and tundra and punctuates the Alaska Range with its massiveness. During the long summer days,
a photographer has to get up early or stay up late to capture the beautiful pink alpine glow that bathes
the mountain on clear days.

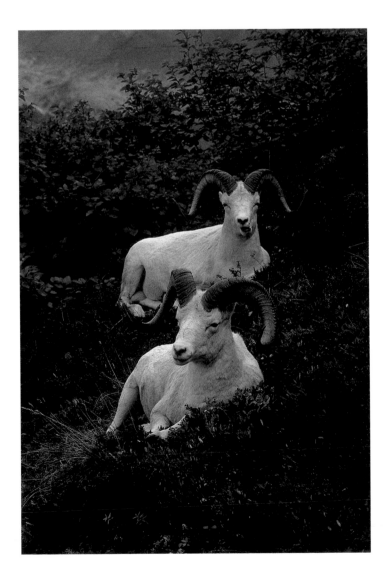

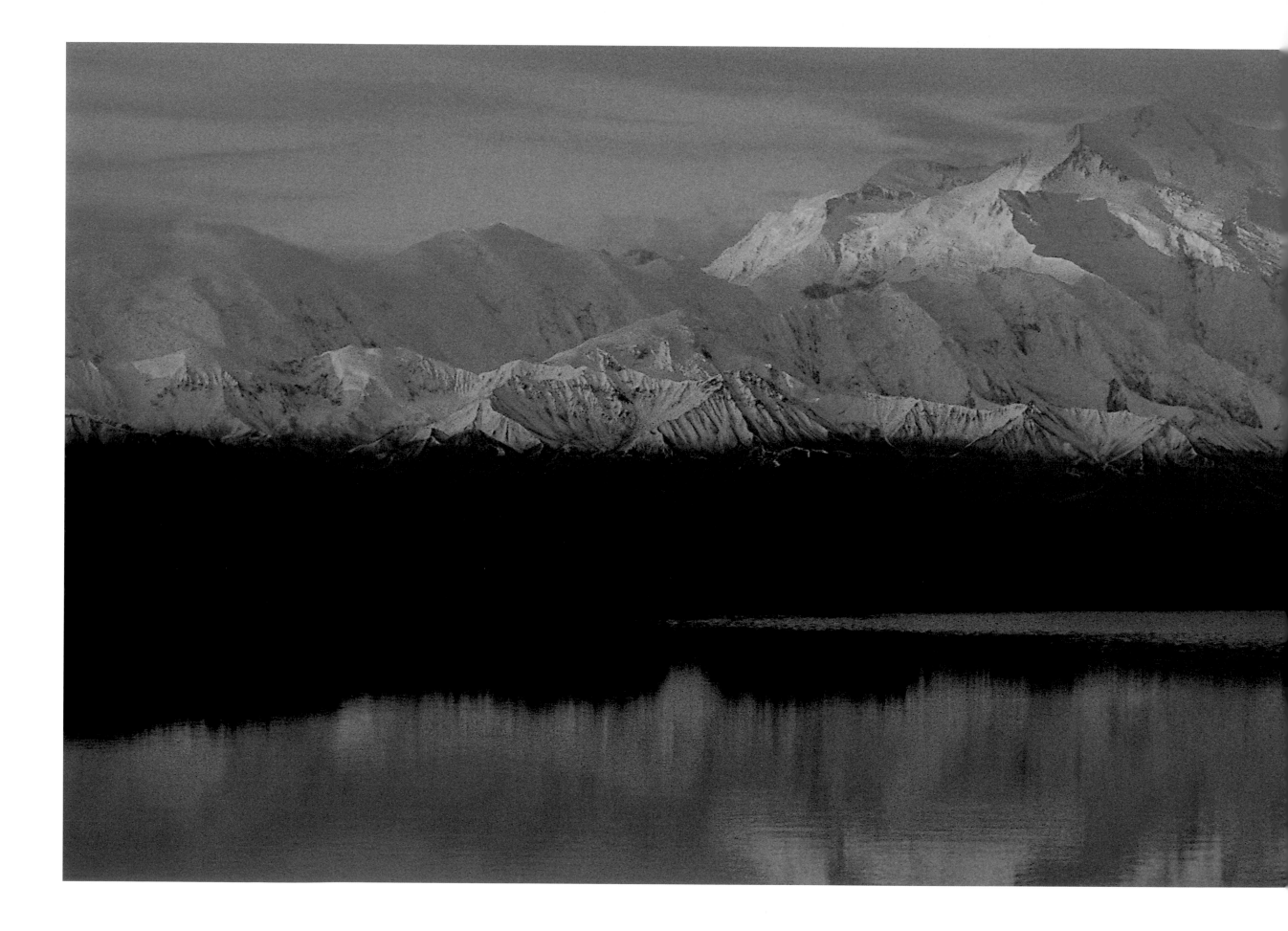

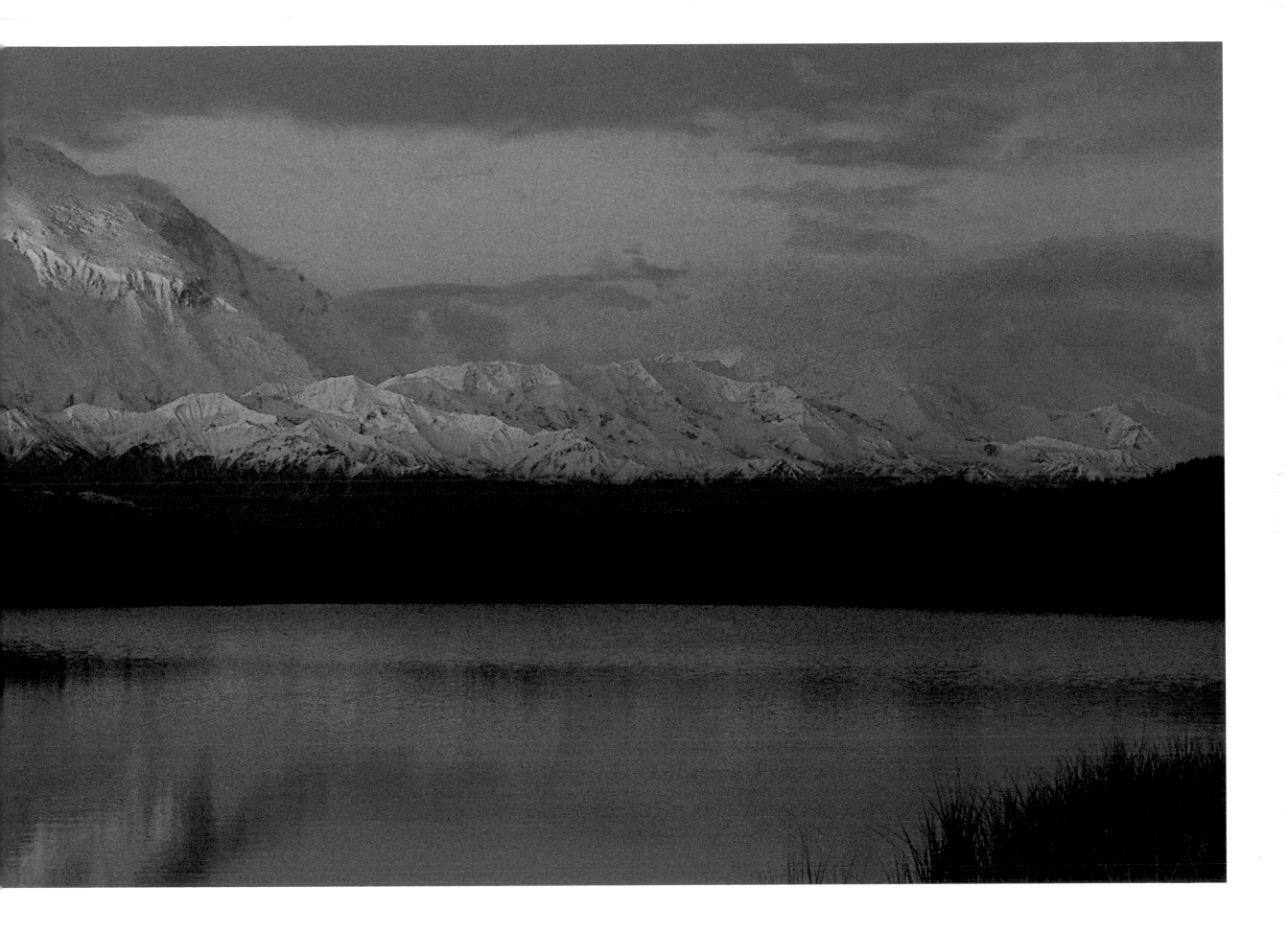

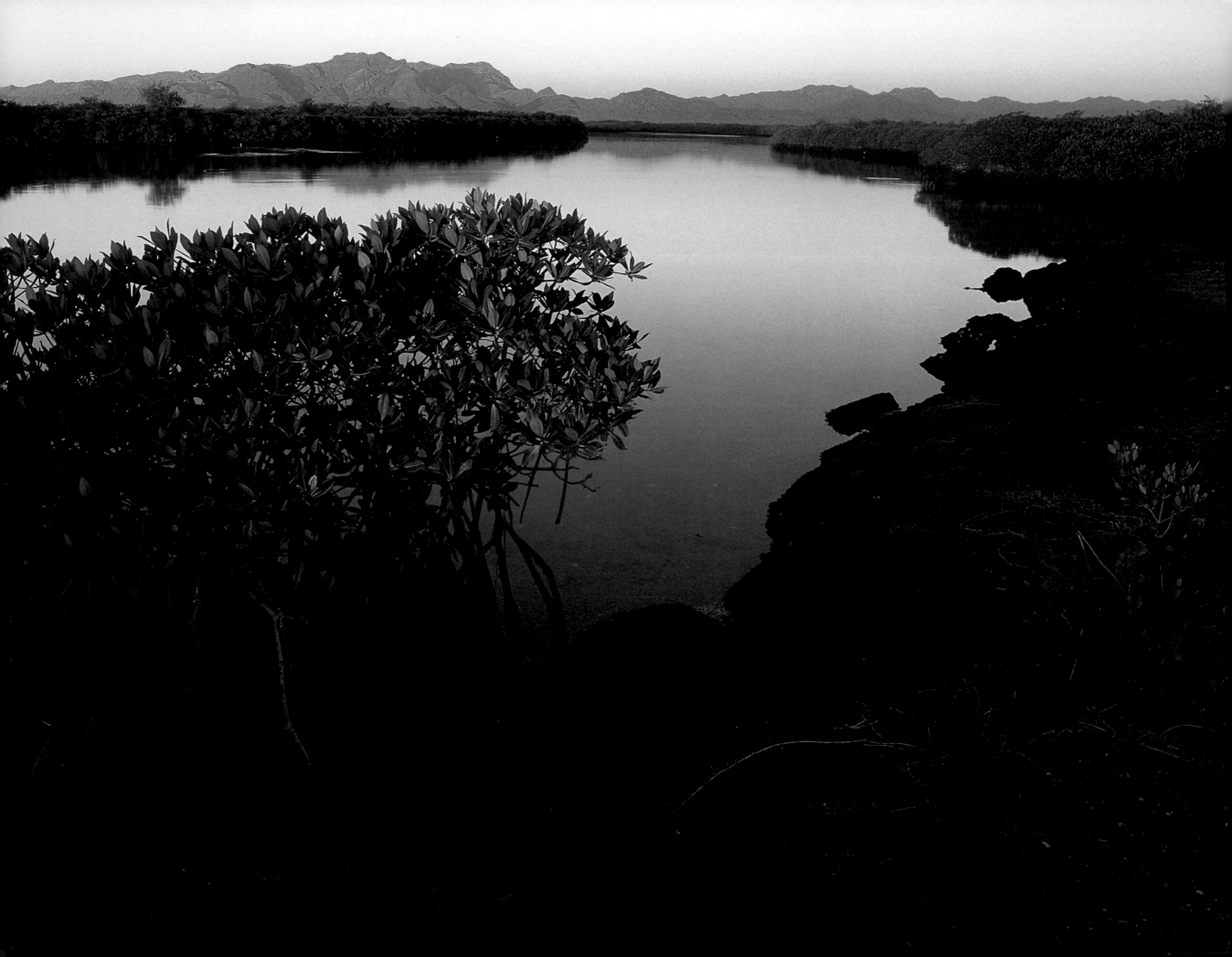

SANDS OF THE DESERT SEA
El Pinacate, Sonoran Desert/Gulf of California
Photographer: PATRICIO ROBLES GIL

*Before we take to the sea, we walk on land Before we create,
we must understand*
ERNEST HEMINGWAY

Like the flying fish, skim low across the water. The air is hot, though the morning sun is yet a bright orange disk on the smooth glass plate of the Gulf of California, or Sea of Cortés. On the water, the sharp line between the lightening blue sky and the dark shadows of the island's ragged mountain is a sensuous, undulating snake.

Three immense grey-green phantoms levitate up from the deep, arc to the surface as one, and exchange lungfuls of air in quick, hissing puffs. The humpback whales bend back into the water, to run silent and deep along their migratory track.

Sea lions bask by the hundreds below the slanted-strata gray-brown cliffs stained with white seabird guano. Many struggle awake, barking to greet the day. An old, sick bull pants limply on a rock near the water. The heat will mercifully finish him today. Meters away, beginning the journey down the other side of life's Moebius strip, a just-born pup squeaks at his mother as birds peck at its discarded umbilical cord.

This is Tiburón Island, the Gulf of California's "Shark Island," at dawn. It is a desert biologist's dream place, one of the few examples of pristine desert plant and animal life that remains in all of Mexico.

Across the short gap of water now, to the Sonoran Desert mainland, go! Fast and furious, fly like the hot night winds that blast across the Gulf in summer. North, along the eastern coastline of the northern Gulf of California, to marvel at the sharp demarcation between emerald waters and sun-blasted beige, caramel, brown, and charcoal rock and sand. And what is that black, black smear on the golden desert, like a huge gunpowder-blasted ground?

Swoop closer to the nightmare of cinder cones, lava flows, and huge *maar* craters that anchor a strange desert of ebony sands and mountains, dark as the crow's feathers. Yet this Stygian hellscape of unbearable heat, endless and inhospitable, entices with a vibrant galaxy of bright, lime-green cholla cacti and springtime flowers.

El Pinacate and Gran Desierto de Altar Biosphere Reserve is its name. One of nature's harshest realms, it is a highly valued and protected area for scientists, biologists, archaeologists, and any tourist brave enough to venture forth upon its fire and brimstone terrain.

Pull up now, higher, to see all the Sonoran Desert lands, from Pinacate north through the basin and range topography that runs across the border into Arizona and its protected Organ Pipe and Cabeza Prieta refuges, south into the massive sand dunes of Gran Desierto, then back toward the riparian, estuarine, and marine areas of the northern Gulf of California.

Considered together, these millions of hectares of protected lands form a vital part of one of the world's most biologically rich warm deserts.

THE ETERNAL SCHOOL
*Fainthearted animals move about in herds.
The lion walks alone in the desert.
Let the poet always walk thus.*
ALFRED VICTOR VIGNY

"Every human being, at least once in his or her lifetime, should go to one of these places," says Patricio Robles Gil, photographer, artist, conservationist, writer, publisher, world traveler, and —in the way he ties all these talents and devotions together— a devout friend of the Earth. He is thinking right now of a walk he took one late evening on Tiburón Island.

On the opposite page, Conca'ac, a sacred place of the Seri tribe, is the highest mountain on Tiburón Island. Each new day, at dawn, its peaks are inflamed as the sun rises.

"It was too dark to photograph any more, so I was just walking to relax, looking for stone arrowheads." He heard a noise and turned to see that infamous trickster of Indian lore, the coyote. "He was not afraid of me. He walked carefully in a wide circle around me, then moved in closer. I am tall, so I sat down to make him more comfortable. He came closer, closer, finally sniffing at the stick I was holding, just thirteen centimeters from my hand."

The coyote moved back out to make another circle around him. Patricio was careful not to show him his back, but the animal never made a threatening gesture.

The twilight communion between human and canine lasted perhaps 10 minutes. It left Patricio with an appreciation for how sublime a simple experience in nature can be. These times can help us find our sense of place in the universe.

"We are baptized by these experiences. Henry David Thoreau said, 'In wildness is the preservation of the world,' and for me that means encounters with animals. Things like that change you; you will always want to go back afterward."

Patricio loves the desert as a place to feel free, far from the crush of the cities. "Deserts are places where you walk and see, in the rock formations, the passing of time."

And the hourglass is everywhere: the desert growth blooms, then fades away; sun-blasted extremes of sand, rock, and mountain formations speak to the ages; petrified lava rivers and volcanic craters tell tales of Earth's violent past. And then there are the cloud ships, sailing desert skies.

"The sunrises and sunsets are out of this world. The stars speak so quietly to you, sometimes. On Tiburón, it can get very windy around Christmas, and the sky gets very clear."

One recent holiday season found him on Tiburón Island again, looking for desert bighorn sheep. He has always been drawn to wild sheep and has sought them out in Alaska, Canada, Mexico, Europe, and Asia. "In a way, they symbolize for me the wild, wild places that are so hard to get to. They are like the monarchs of the mountain."

Perhaps, too, in the high, wide solitude of the desert bighorn, he sees an echo of his own struggles in conservation. As founder and driving force behind Agrupación Sierra Madre and Unidos para la Conservación (United for Conservation), two environmental organizations based in his native Mexico, Patricio must at times lower his head to ram at the doors of private companies and fight against public apathy.

"In one way or another for the last 30 years, I have been involved with conservation of nature, first as a hunter, when I traveled with my father and brother throughout Africa, Mexico, and the U.S., and then as a photographer. In look-

Cardons, or giant cacti, and brown boobies seem to blend together to form a single being; by the hundreds, their silhouettes contrast against the slopes of San Pedro Mártir Island, and are like old companions shaping the presence and character of the Gulf of California.

140

ing at all these wonderful things, I saw what we have ... and what we are losing."

He's not about to let it go without a fight.

THE BIG DESERT VIEW
We need to erase the idea of border, and stop being so provincial.
DAVID KIDD, 1994 Director, Chamber of Commerce, Ajo, Arizona

The Sonoran Desert, North America's third largest, runs from the California-Nevada border south several hundred kilometers to the tip of the Baja California Peninsula, east across the Gulf of California to the desert mainland of Mexico's state of Sonora, and north into Arizona. Two thirds of the Sonoran Desert lie within Mexico.

Combine the Sonoran Desert with the nearby Chihuahua Desert to the east and the Mojave of southeastern California, and you have one of the largest primarily intact arid ecosystems in the world, rivaling Africa's mighty Sahara and Asia's high, vast, cold Gobi.

In seeking to protect the major essence and biodiversity of the Sonoran and Gulf of California ecosystems, the Mexican government set aside several areas and afforded them its highest legal protection: that of the *biosphere reserve*. Equal in status to a wilderness area in the United States, the protected areas of the Mexican Sonoran Desert now total more than 2 400 000 hectares: an area almost three times as large as Yellowstone National Park.

The U.S. takes up the challenge on its side of the border with two other large protected areas. There is also a movement in the U.S. Congress to incorporate the entire American Sonoran Desert into a gigantic Sonoran Desert National Park and Preserve —an idea that is embroiled in controversy.

But the protective umbrella already in place in both nations energizes the overall goal of conservation for the region. The Nature Conservancy, World Wildlife Fund, and UNESCO commit time, money, and energy to support the concept of managing a massive desert region within the context of sustainable human habitation —and that's no small task.

To meet the challenge, the International Sonoran Desert Alliance was formed to encourage an ongoing, trinational dialogue between the U.S., Mexico, and the indigenous Tohono O'Odham peoples that live on both sides of the historically contentious border.

Arizona's Organ Pipe Cactus National Monument was established in 1937 and preserves 133 000 hectares of Sonoran Desert as part of the National Wilderness Preservation System. It is named for the organ pipe cactus, a cousin of the fascinating old timer, the saguaro. The senita cactus and elephant tree decorate the hot desert home of the high-climbing desert bighorn sheep, endangered Sonoran pronghorn, and lesser long-nosed bat.

Near Organ Pipe is Cabeza Prieta National Wildlife Refuge, established in 1939 and running nearly 150 km along the Mexican border. The 139 000-ha pre-

serve was created primarily to protect the desert bighorn sheep. Hiking or driving in the Cabeza Prieta adds an unusual nuance to the normal desert risks: visitors must first sign a release with the U.S. Air Force, since the Camino del Diablo road into the refuge passes right through the Barry M. Goldwater Air Force Bombing Range. A camper truck was once mistakenly strafed with bullets —as if the desert isn't dangerous enough already.

When you combine both parks with the Tohono O'Odham Reservation, the Air Force Range, the El Pinacate and Gran Desierto de Altar, and the Upper Gulf of California Biosphere reserves, which were designated several years ago, the region forms the largest contiguous area of protected zones in all the Americas.

More than just an impressive geopolitical entity, the region is home to 750 plant species, or one third of all the flora of the entire Sonoran Desert. Factor in the 62 mammalian, 400 avian, and several dozen reptilian and amphibian species, including the desert pupfish, endemic Upper Gulf porpoise, Yuma clapper rail and totoaba fishes, and you understand why Mexico ranks fourth in ecosystem diversity in the entire world.

Tiburón Island, the largest island in the marine life-rich waters of the Gulf of California, was settled hundreds of years ago by the slender, beautiful Seri Indian people. The mountain island and its tall, supplicant saguaro cactus, ironwood, deer, bighorn sheep, and reptiles are now protected as part of the Gulf of California Islands Flora and Fauna Protection Area. Its 120 000 hectares of coarse sand and shell beaches and vertical terrain, and the deep, cool waters off its coast make it an important area for fishing, diving, wildlife watching, and hiking, as well as for ecological and historical research.

Tiburón's hauntingly beautiful Gulf of California environs contain one of the most globally significant marine ecosystems on Earth. The long, narrow gulf reaches south more than 960 km from the Colorado River Delta to the tip of the Baja California Peninsula.

But, as always, in setting aside large ecosystems for preservation, a price must be paid. On Tiburón Island, it was paid by the Seri. Forcibly banished from their arid island home in the 1950s and compelled to live in a squalid settlement on the mainland, the few hundred Seri had to adapt, and adapt quickly —or face cultural extinction.

ANCIENT WAYS, MODERN WORLD
I always want to be in the wild taking pictures.
I know how "to sell" our natural resources.
PATRICIO ROBLES GIL

Patricio has used his Unidos para la Conservación to help the members of the Seri Indian culture find new sources of income. Although they are forbidden to live on Tiburón, they retain ownership of its resources —a vital key to their welfare.

"We developed a program where the price of a bighorn desert sheep hunting license is determined through auction, and 80% of the proceeds go to the Seri and the preservation of their habitat."

The current population of 500 bighorns grew from the mere 20 introduced to the island in 1975. They thrived in the ecosystem thanks to its plentiful forage and lack of predators.

Some criticize the program as the Seri version of a casino; auctions have brought license fees of 200 000 U.S. dollars from wealthy hunters. Distribution of funds to the 160 families of the Seri is proving to be a problem. Every one in the community has different ideas of how it should be spent. Still, a cultural center, fishing boats, water supplies, and support for their elders are dramatic improvements for an indigenous community in desperate need.

Conflict is nothing new to the Seri, who have battled conquerors for more than 500 years. A nomadic hunter-gatherer culture that fished, hunted, and gathered desert plants, the Seri found a fortress haven on Tiburón. Not about to become domesticated farmers, they instead raided mainland ranchers and colonists well into the nineteenth century.

"When I began working with the Seri," says Patricio, "I could see they were smart at dealing with the white man to get what they wanted. They are sometimes difficult to work with, but I think they will succeed. We want to train them to manage their natural resources. Our positive approach is changing to some extent the way they view things."

The tribe is proving to be clever and adaptable. "Just 50 years ago," says Patricio, "they were nomads. Now they sell their resources in global markets, things like uniquely beautiful baskets and ironwood sculptures. As ironwood becomes more scarce, because other people are producing their ironwood designs faster, some turn to sculpting in stone. They are smart, these people."

Call it survival of the fittest —Seri style.

THE GALÁPAGOS OF MEXICO
To see a world in a grain of sand and heaven in a wild flower, /
Hold infinity in the palm of your hand and eternity in an hour.
WILLIAM BLAKE

The Gulf of California is known worldwide for its biodiversity and wonderfully varied ocean/river delta/desert landscapes. Its rich ecosystem includes lagoons, marshes, marine beds, mangroves, and swamps. Transitional realms between the fresh waters of the Colorado River Delta and the saltwater inland sea offer riparian wetlands, scrub brush, sandy desert, and coastal dune sheets.

Within the wetlands, nesting habitats for endemic and migratory animal

After a storm, it is wonderful to witness the display of aromas, forms, and colors of desert flora. It's like a great party, an invitation for our senses. No one ever knows how many years we will have to wait before it is time for another celebration like this one.

141

species like pelicans, cormorants, gulls, and ospreys abound. But the region has its share of environmental challenges, as always directly attributable to the encroachment of humankind.

Patricio Robles Gil calls the islands of the Gulf of California the "Galápagos of Mexico" for their bountiful marine biodiversity. The title evokes a darker kinship with the Ecuadorean archipelago: the marine resources of the Gulf of California, from shrimp to sea cucumbers to sharks, are seriously threatened by large-scale Mexican fishing fleets and small-time poachers alike.

Sea turtles have been nearly harvested out of existence to feed the bottomless appetite of the Asian market. Illegal activities such as overnight camps set up to harvest shellfish, octopuses, shells, and lobsters are all too common throughout the threatened waterway.

But the dark clouds over Baja have a silver lining. The 934 756-ha Upper Gulf of California and Colorado River Delta Biosphere Reserve was created by the Mexican government to deal with overfishing and urban contamination from dwellings, industry, and agriculture. It is working to protect the region that ranks in the top one per cent of the world's biologically richest ocean areas.

One clear action is the government ban on commercial fishing, a traditionally profitable industry, to prevent the destruction of shrimp beds within the Reserve. In the Baja shrimp-fishing village of Puerto Peñasco, the bright blue and white paint of the boats is giving way to angry orange rust. And the shrimp are rebounding.

Not too far north of the turquoise waters of the northern Gulf of California lies the place no one knows —yet. Only about 5 000 devoted ecotourists, hikers, scientists, and students of desert biology visit El Pinacate every year. But the numbers are growing, and therein lies the tale.

SACRIFICES LARGE AND SMALL
I come like Water, I and like Wind I go.
EDWARD FITZGERALD

"The first time I went to El Pinacate, there were no game wardens or rangers," Patricio remembers. "You could hike all the way to the top of the mountain. You felt as if the place belonged just to you."

"Pinacate is unique to Mexico. We have rainforests, but not like South America's. There are bigger mountains elsewhere. But nothing matches the Sonoran Desert. It is a confrontation between sea and desert, water and cactus: a fabulous mix."

"The saguaro cacti seem to have moods that remind you of people. I'm always making pictures of them, and some are quite humorous." To the Tohono O'Odham Indians, until recently called Pápagos, saguaros are as expressive and vulnerable as humans. In their language, they use the same word for "saguaro" and "people."

Saguaros can live more than 200 years and grow 15 m tall. They don't even

On the opposite page, for millions of years, the sediments dragged from the canyon of the Colorado River have been deposited in the Upper Gulf of California. Due to strong ocean currents and winds, these fine sands have come to form the Gran Desierto de Altar. Only the volcanic massif El Pinacate was able to stop the long journey of these sands.

flower for the first time until they are 50 years old or so, when they are still but a meter high. "And when they bloom," says Patricio, "it is amazing. Sometimes at night, you can not sleep, there is so much fragrant, sensual pollen in the air."

But he knows to never let his guard down in the desert. In this environment intrinsically lethal to humans, with less than 127 mm of rainfall per year, temperatures soar above 50°C, and near the black sand and volcanic shards, can reach nearly 80°C! "If you get lost here, you die. It is that simple."

In the last five years, a permit system has been adopted for the El Pinacate Reserve. "You can't leave the roads anymore," says Patricio with tangible regret. "If you want to stay overnight, there are more permits. Sometimes you feel as if you were in a very large zoo."

Yet he is all too aware that on our increasingly crowded planet, wilderness must become more intensely managed to survive at all. "It is an unhappy fact of life, but there are no alternatives: it is the only way to protect these places."

Even with government Reserve personnel in the area, beer cans, illegal charcoal-firing pits, and general trash are found on the slopes of the crater called Elegante, a magnificent, gigantic *maar* nearly two kilometers in diameter. Poachers, cactus thieves, cinder miners, and loggers of ironwood trees —critical to the health of senita cacti and an important component of the Seri Indians' economic livelihood— largely escape apprehension.

"Of course, we need to preserve biodiversity and natural phenomena. When more people see wilderness and natural areas, they want to get involved, and that can help conservation throughout the world."

"But to be honest, I wish I didn't have to share any of it with anybody. I go out there partly to be alone. When you are in Africa now and a wonderful lion is mating with a lioness, and a Land Rover full of tourists spots you and races over, it ruins this beautiful moment you have waited for perhaps all your life."

"Still, we have to keep at it. We have to do the best we can to paint those pictures of wild places, to fill the heart of the world, to help them to care."

THE FIRES OF ETERNITY
… warblers flew to me and touched my face, a badger trotted up and sniffed my boot, coyotes sat watching me walk by, an antelope paced for a mile. In complete silence and isolation, it was like what walking on the moon must be.
JULIAN D. HAYDEN, *The Sierra Pinacate* (1998)

El Pinacate is named after a beetle which defends itself by standing on its head to spray noxious fumes. Over the millennia, uncounted hundreds of volcanic cones, vents, and *maars*, in a core area of 2 000 km², spewed their own host of fumes skyward: black pumice, rock, sand, and ash. Eighteen massive calderas and 10 *maars* dominate the landscape that has been volcanically active for five million years.

Maars in particular are a scientist's delight. Perfectly round holes in the

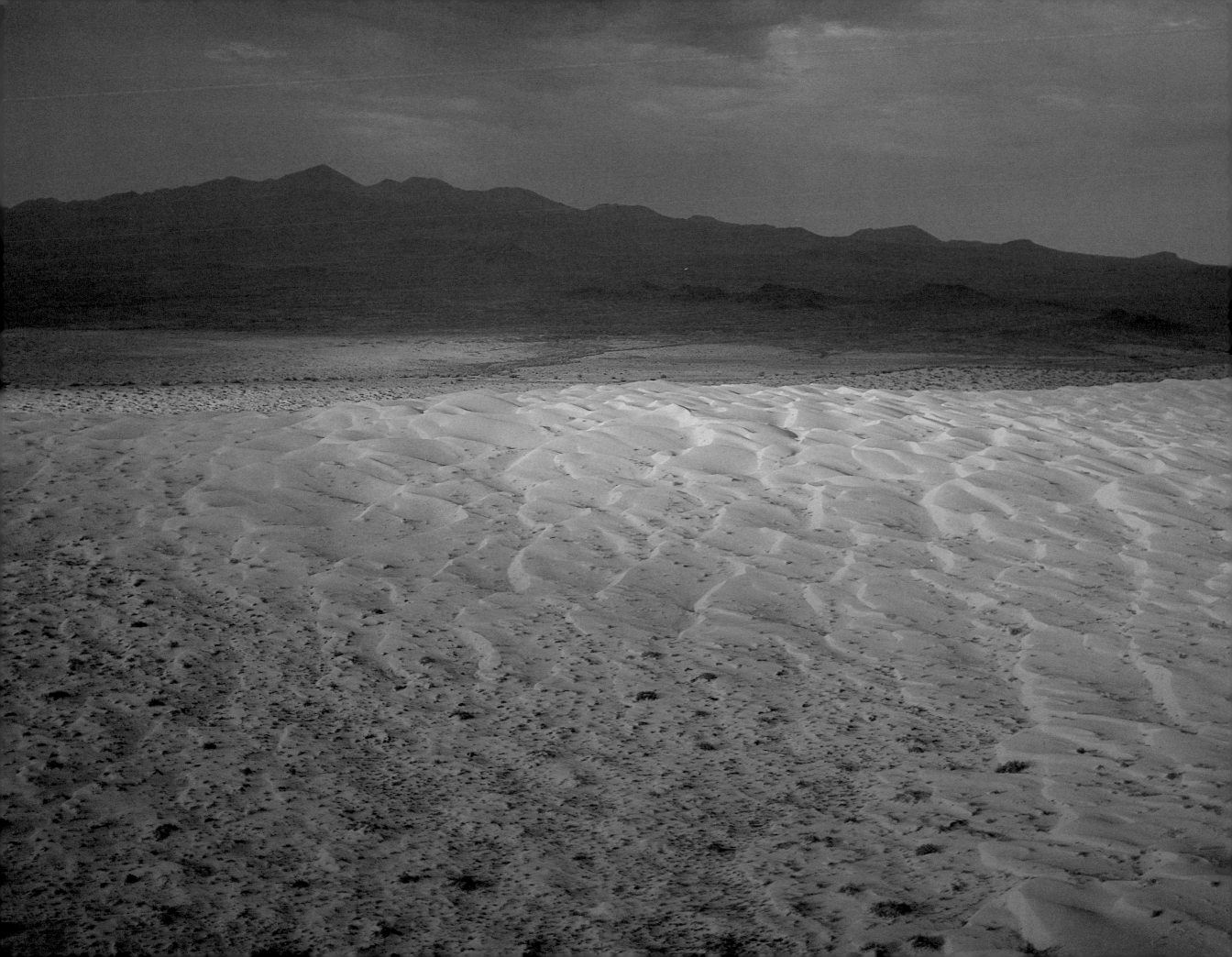

ground as wide as 1.6 km in diameter and up to 240 m deep, to early Spanish conquistadors they appeared to have been made by meteors. Modern volcanologists speculate that the low-rimmed craters were created when underground magma flash-heated groundwater, building pressure until the superheated steam blew with the force of an atomic bomb.

In many places, immense lava flows solidified into congealed rivers of black stone. In the dark caverns of basalt formations, thousands of bats nest, feeding on pollen and nectar from the sentinels of the desert, the saguaros. In some places, expanses of flat stone called "pavimentos" seem to be the work of a lost race of ancient craftsmen. But nature is the sculptor. Millennia of sand-blasting winds have inexorably worn down the rock surface into spectacular geometric formations.

There are days in the Pinacate when the heat is so relentless, the rocks themselves are fragile as glass. Walking across stretches of broken lava that crunch under your feet like pottery shards, you hear first a hissing sound, then a loud "clack!" as they break into pieces. Geologists call the process *thermoclastic*. For the visitor, this living landscape is more likely to conjure up thoughts of demons and the fires of eternity.

The black desert abruptly gives way to 4 000 km² of peach-beige sands that rise to form the massive dunes of the Gran Desierto, or Great Desert of the Sonora. As impressive in scale as the sandy seas of the Sahara and Arabia, they began as silt from the Colorado River. Funnel winds from out of the southern Gulf of California blew them up the largest dune sheed on the North American continent.

Rain is rare and difficult to predict. But when it comes, the world itself takes a deep breath, and sings out a chorus of Sonoran Desert color: sand verbena, dune sunflowers, saguaro flowers, desert lilies, and more.

On the opposite page, symbols of the Gulf of California, pelicans wait patiently, and they are well aware of the great riches of the waters in which they live. They are creatures that seem to have come from worlds lost in time.

HOME IS THE HUNTER
The best and most beautiful things in the world can not be seen or even touched —they must be felt with the heart.
HELEN KELLER

Patricio Robles Gil knows his roots, though he hasn't taken a game animal since he was a young man. The same stealth, patience, and persistence so vital to the hunter must be summoned for successful wildlife photography.

"One time I was on a cliff, glassing the mountains to find sheep. I saw three rams on the other side of a dry riverbed, on a mountain facing me. I snuck up on them, but didn't actually see them until I was 12 m above them. I moved very slowly to keep from scaring them away —it took me forty minutes just to position the tripod, sit down, and aim the camera."

He takes great pride when he can move close without alerting an animal that depends on its senses for survival. "You feel this thing inside of you. It reaches back to your ancestral roots."

Another time he came across a saguaro vibrant with red pitahaya blossoms. "It was one of the first of the season. It was very hot so I knew everyone, all the animals, would be thirsty and would come to this saguaro to eat the pitahayas, that are like an ice cream treat for them."

Donning camouflage gear, his intuition was rewarded when a pair of quails arrived to peck away at the fruits.

"Sometimes you forget in this desert environment that almost any detail can become a great moment —any little event. I had been chasing pictures of quails for many years. You just never know when you wake up what you're going to shoot that day."

"Photography puts me out in the wild world where I love to be. Sometimes it's late and you're very tired. But you push these things away. You go further and work harder to get the picture. Photography helps you be what you want to be."

And there is no better tool to bring the story of wilderness to society. "I really like to show people these places. My pictures tell a little about me —but much more about what I like that is out there."

THE TERRESTRIAL IMPERATIVE
Solitude is the beginning of all freedom.
WILLIAM O. DOUGLAS

There is something to be said about an ecosystem so harsh, its plants work hard at being antisocial. Consider that most common ground-cover plant, the ubiquitous sagebrush of the Mexican and American deserts.

Sagebrush and other desert flora manufacture toxic substances in their leaves and parts, a process known as *allelopathy*. When the leaves fall, their toxins in effect sterilize the soil, inhibiting any other type of seedling from taking root. The bitter taste also deters grazing animals.

In our ever-more-crowded world, we practice a human form of allelopathy by going to deserts like the Sonoran. By ourselves or with a few friends, in wilderness we find space to stretch our limbs, fill our lungs with clean air, and bathe our eyes in the endless, timeless beauty of our living planet, Gaia. In open space, there is survival.

Along the dune sea, the inland ocean, the desert island, the blasted Pinacate volcanoes, we come back to the one truth that vibrates the core of our being: we each make our own journey, children of our paradise world, sailing in its shelter through the deep, black void.

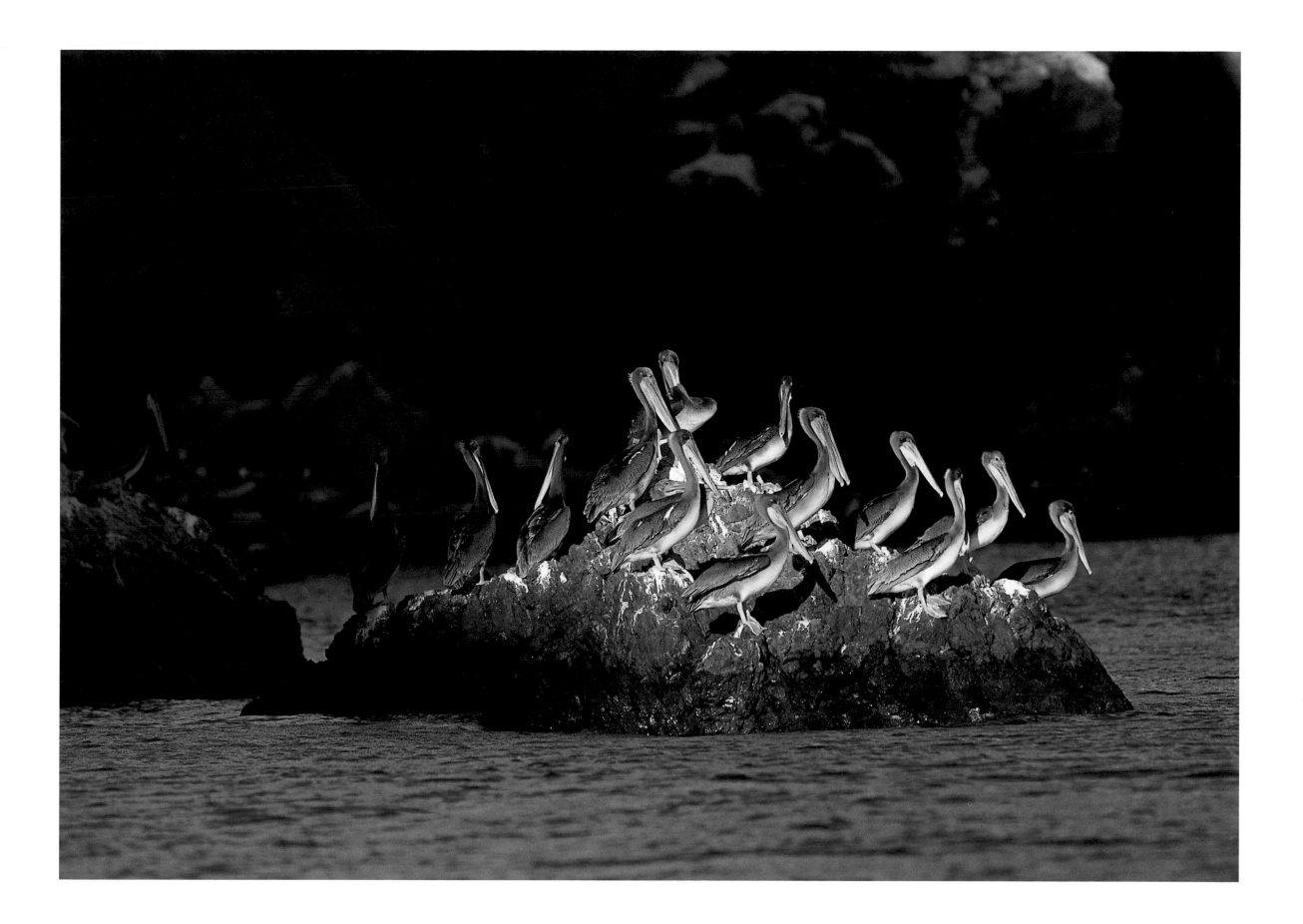

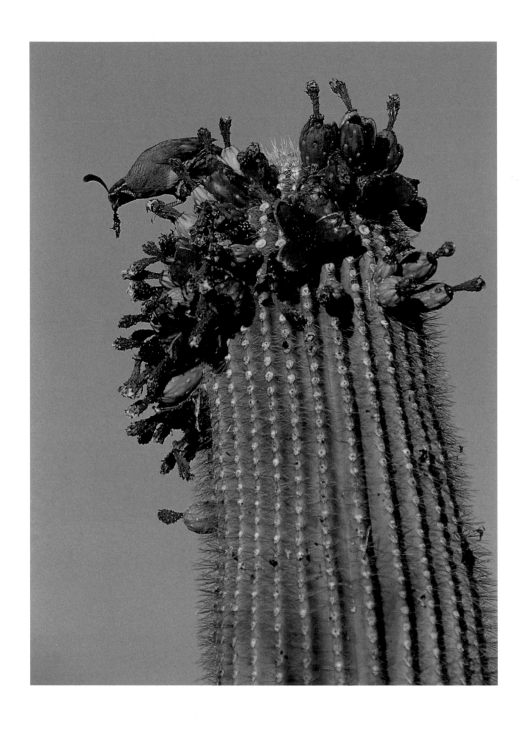

Unmistakable creatures, young saguaros stand strong,
threatening the heavens. The sun and the wind make them tough,
and their shapes change. Wiser for this, their "arms" speak to us:
they have given flowers and fruit, tastes and life to the thirsty desert.

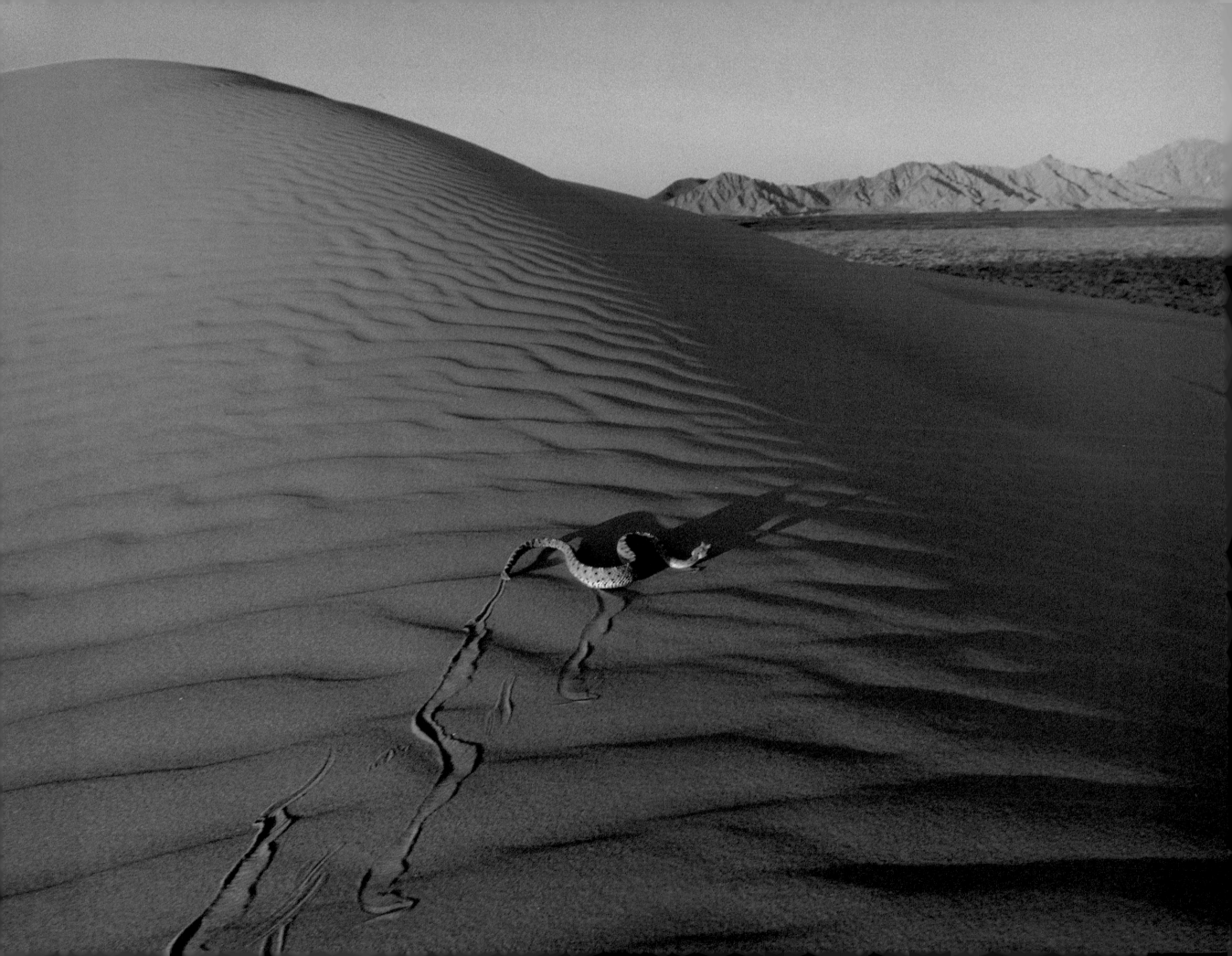

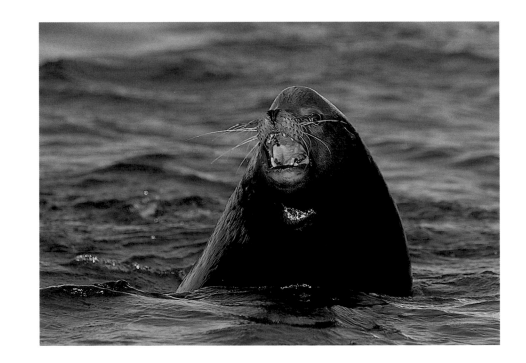

On the opposite page,
on the dunes of the Gran Desierto de Altar,
the sidewinder rattlesnake moves along supported
by only two points and traces its unmistakable winding path,
silently taking its shadow along with it.

Above, San Pedro Mártir Island has one of the largest populations
of sea lions in the Gulf of California. They are accompanied
by thousands of seabirds which are attracted there to breed.
Day and night, the birds and the mammals interact;
and only the powerful bellowing of the male sea lions provides
a backdrop for this great humming.

In the summer, El Pinacate is a veritable inferno:
the soil, covered with black rocks, absorbs the heat and
hares use their long, beautiful ears to refresh themselves
with any passing breeze.

On the opposite page,
step by step, day by day, tortoises have witnessed a world
that was lost in time. Their future on this planet will depend
on whether we allow them to continue to "go about their way."

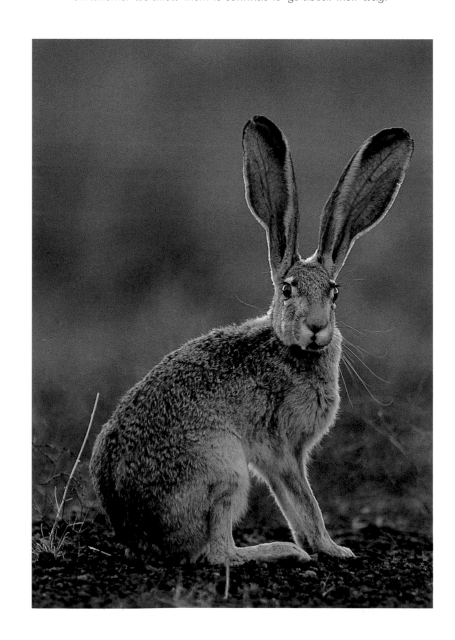

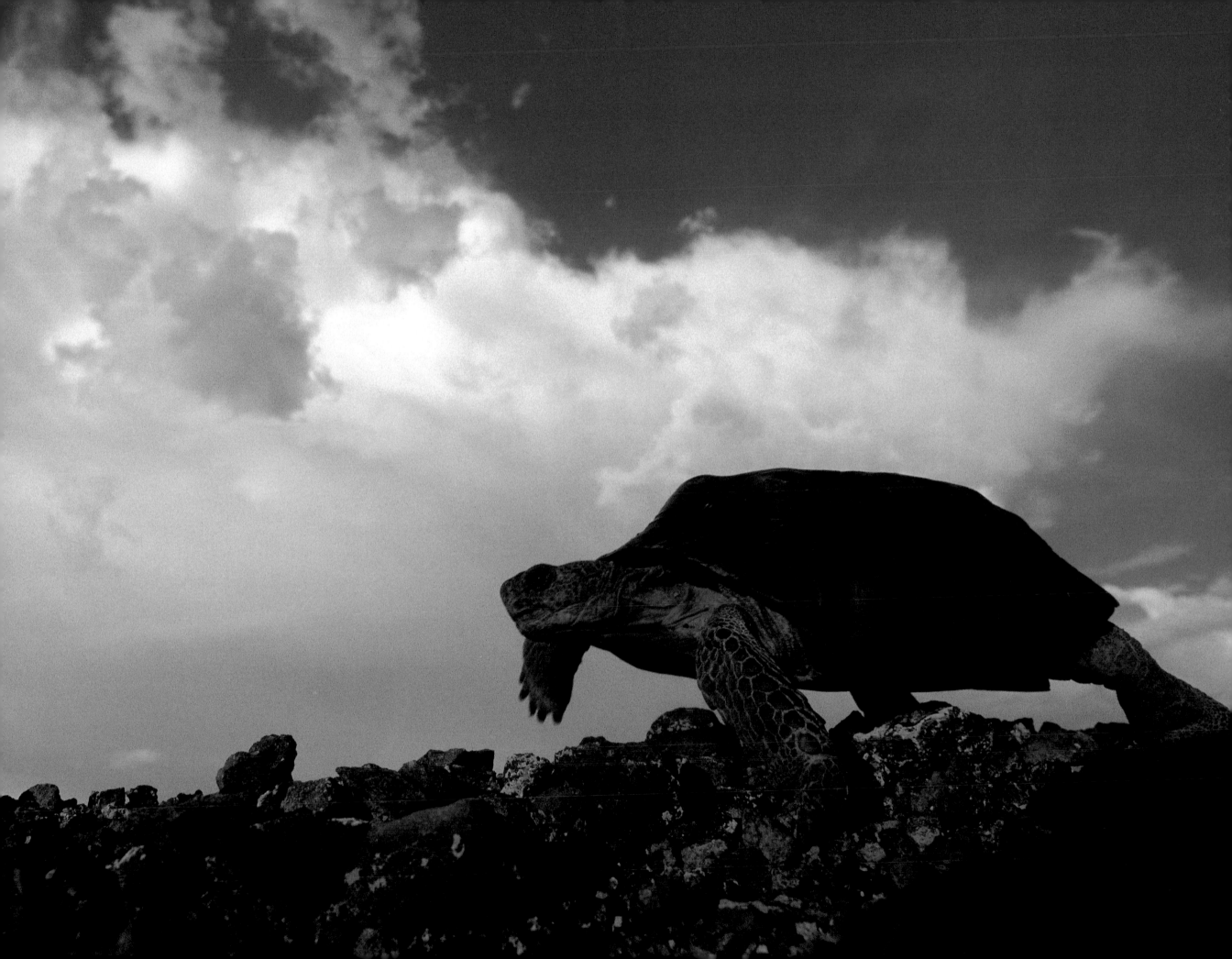

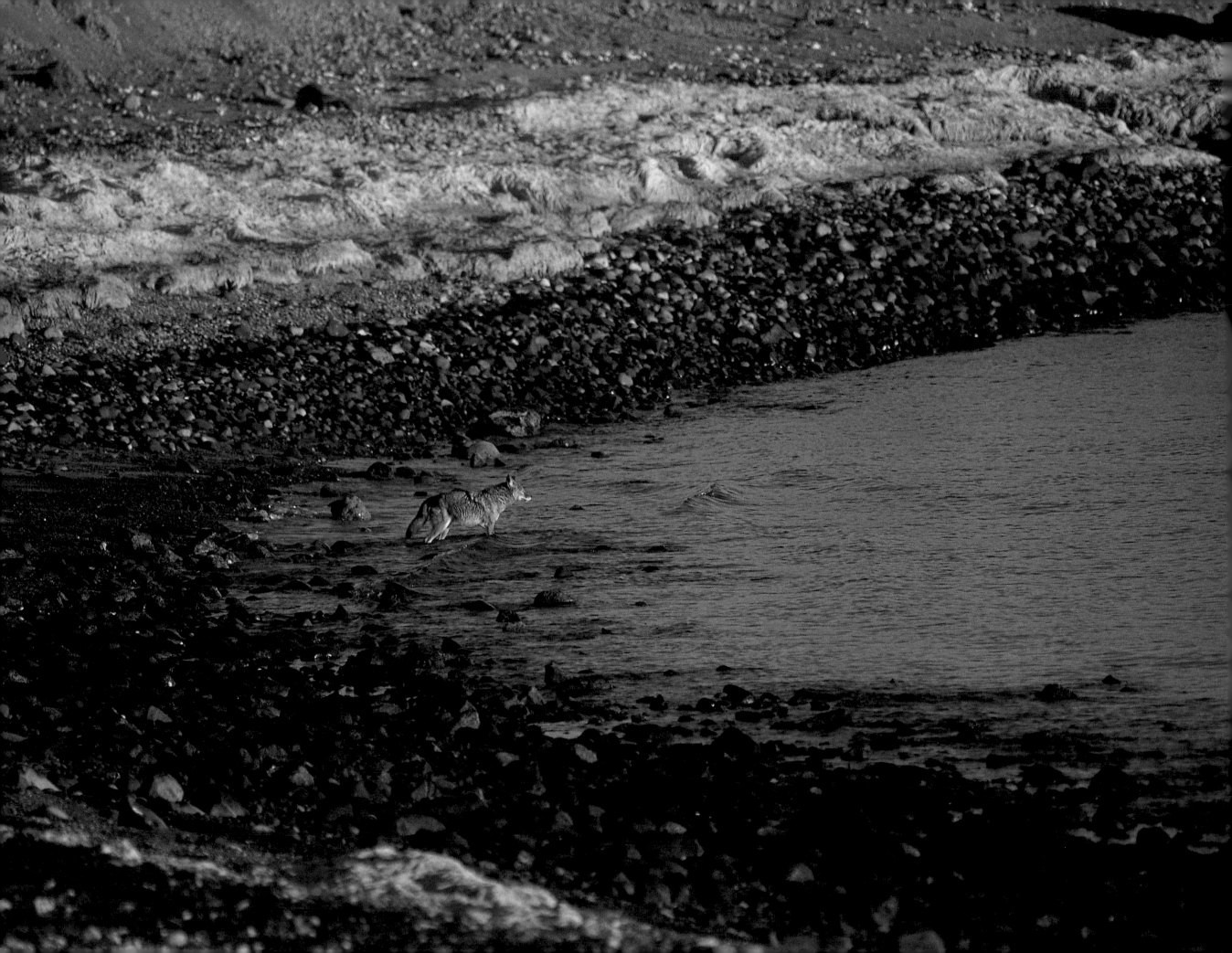

On the opposite page,
always on the prowl, coyotes patrol the coasts of Tiburón Island.
For a minute, this one ventured into the water and gazed absently
towards the horizon. So then I imagined that in its search,
its mind was traveling to other lands, to other worlds.

Above, shorebirds, little soldiers that come in big armies,
cover and go up and down the beaches and rocks of the Gulf of California.
The seasons come and go, and with them, the tides.

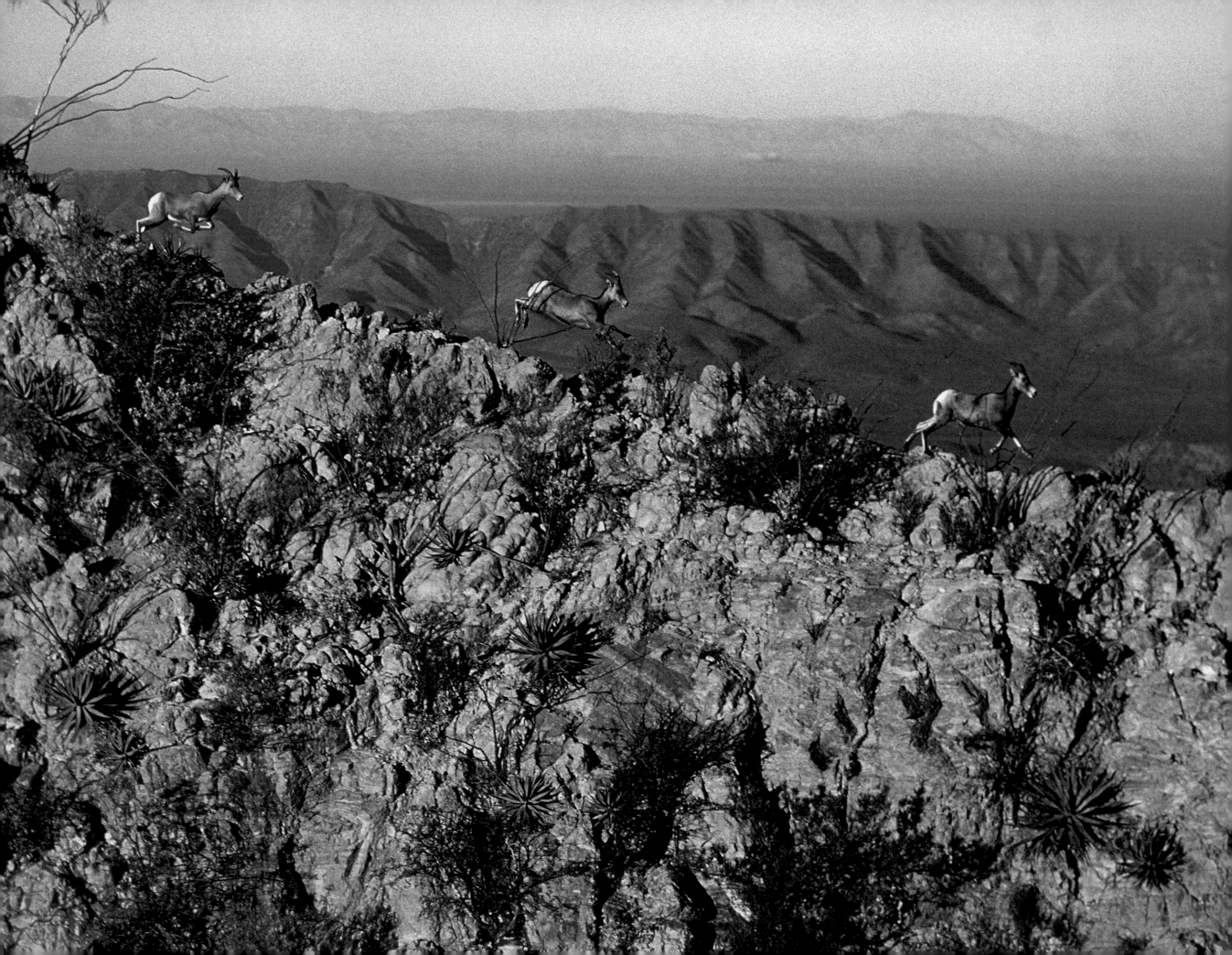

Landscapes of bare sierras, desert sierras; rugged cliffs overlapping the blue mirage
of the Gulf and Baja California; paths where the swift desert sheep runs,
reaching for the skies to embrace the sea.

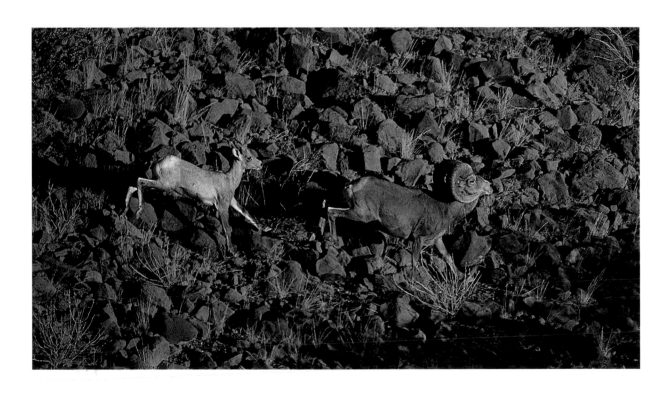

Forests of giant cacti, bold guardians surround the volcanic shield of El Pinacate.
In winter, its slopes come alive with different colors, and rain has moistened
its burning soil. The desert awakens; all of a sudden, it has become a garden.

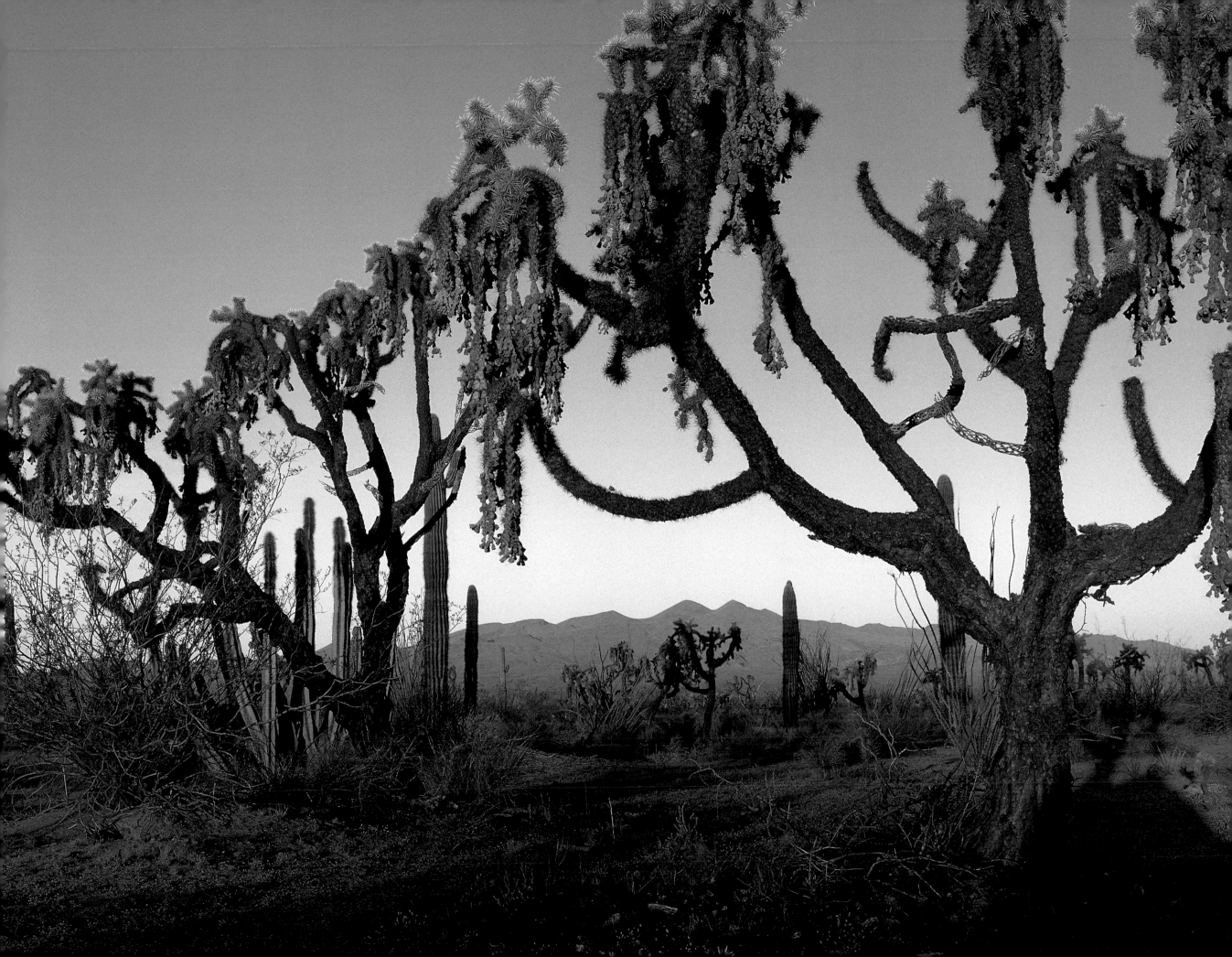

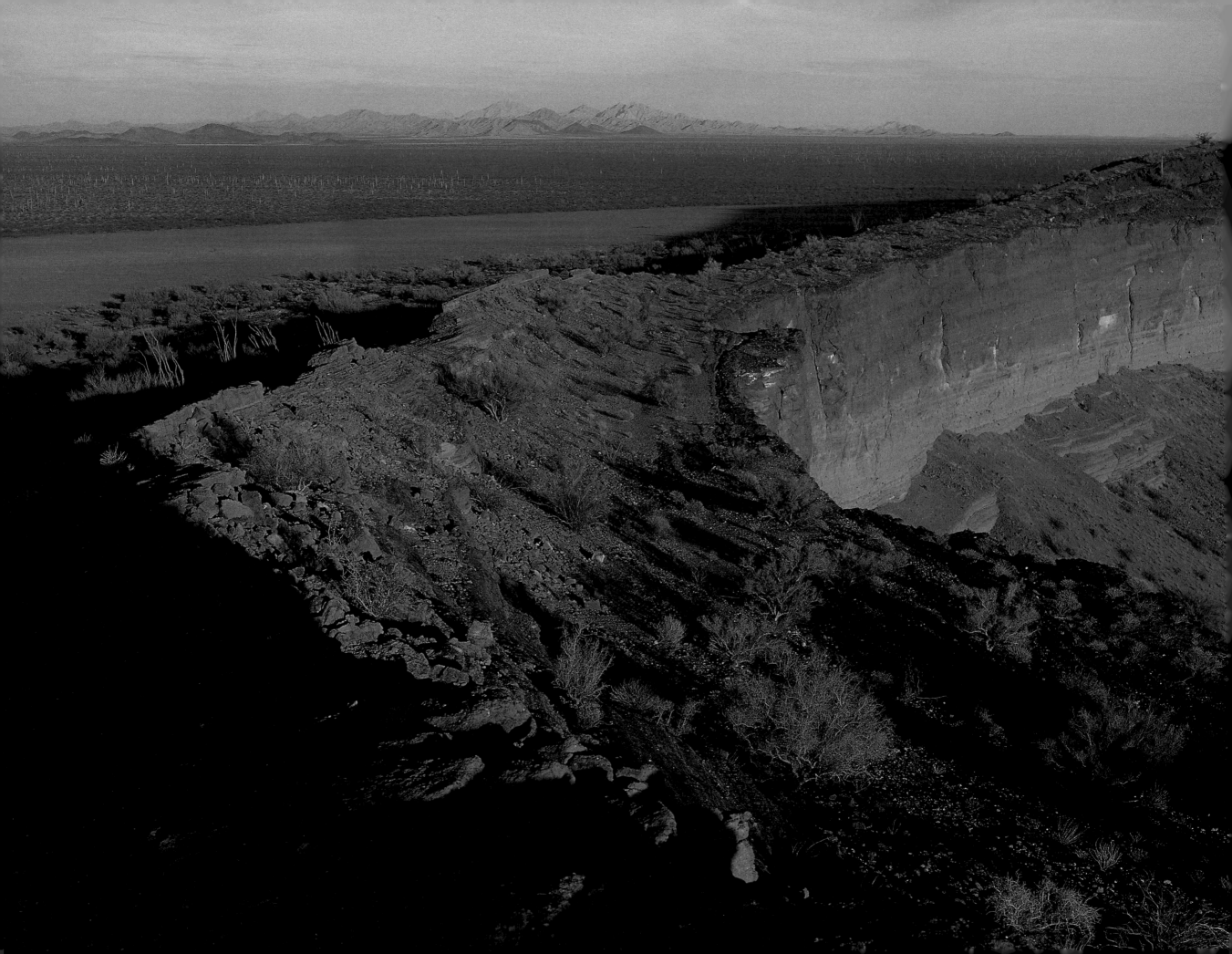

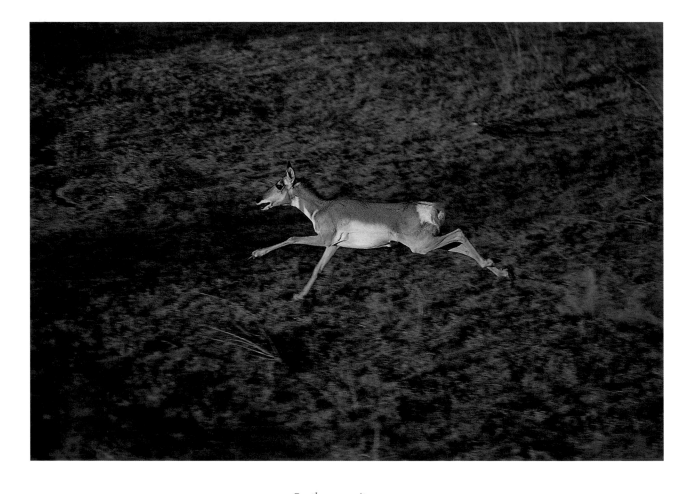

On the opposite page,
silent volcanoes, petrified rivers, witnesses of a past world distinguished by huge eruptions,
and of landscapes that were "frozen" in time, where today, only the wind dares to leave its imprint.

Above, due to poaching and a fragmentation of its habitat, the Sonoran pronghorn, a subspecies,
has come to be seriously threatened. Thanks to the Cabeza Prieta Wildlife Refuge in Arizona
and the El Pinacate and Gran Desierto de Altar Biosphere Reserve,
this agile mammal finds a placid retreat that can ensure its survival.

*The majestic saguaros exemplify the Sonoran Desert; seeing their silhouettes
on the horizon reminds us of sentinels which sometimes house old nests
they have inherited from generation to generation.*

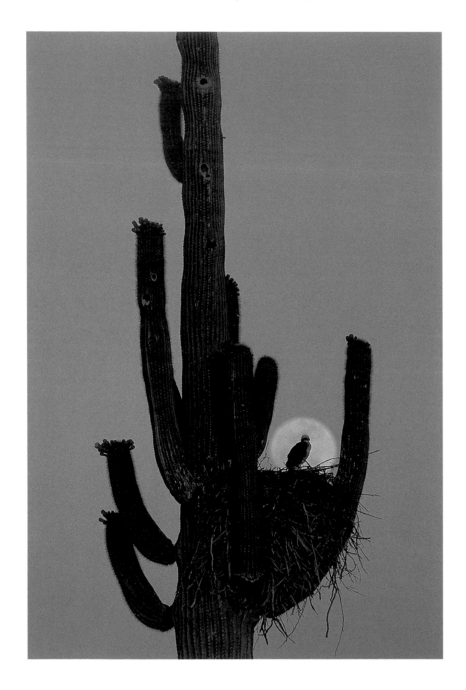

*On the opposite page,
at the dawn of a new millennium, the idea of preserving large expanses
of natural ecosystems is more urgent than ever.
The great region of the Sonoran Desert and Gulf of California
and its protected natural areas have become the world's largest binational
biological reserve, an example for all humankind.*

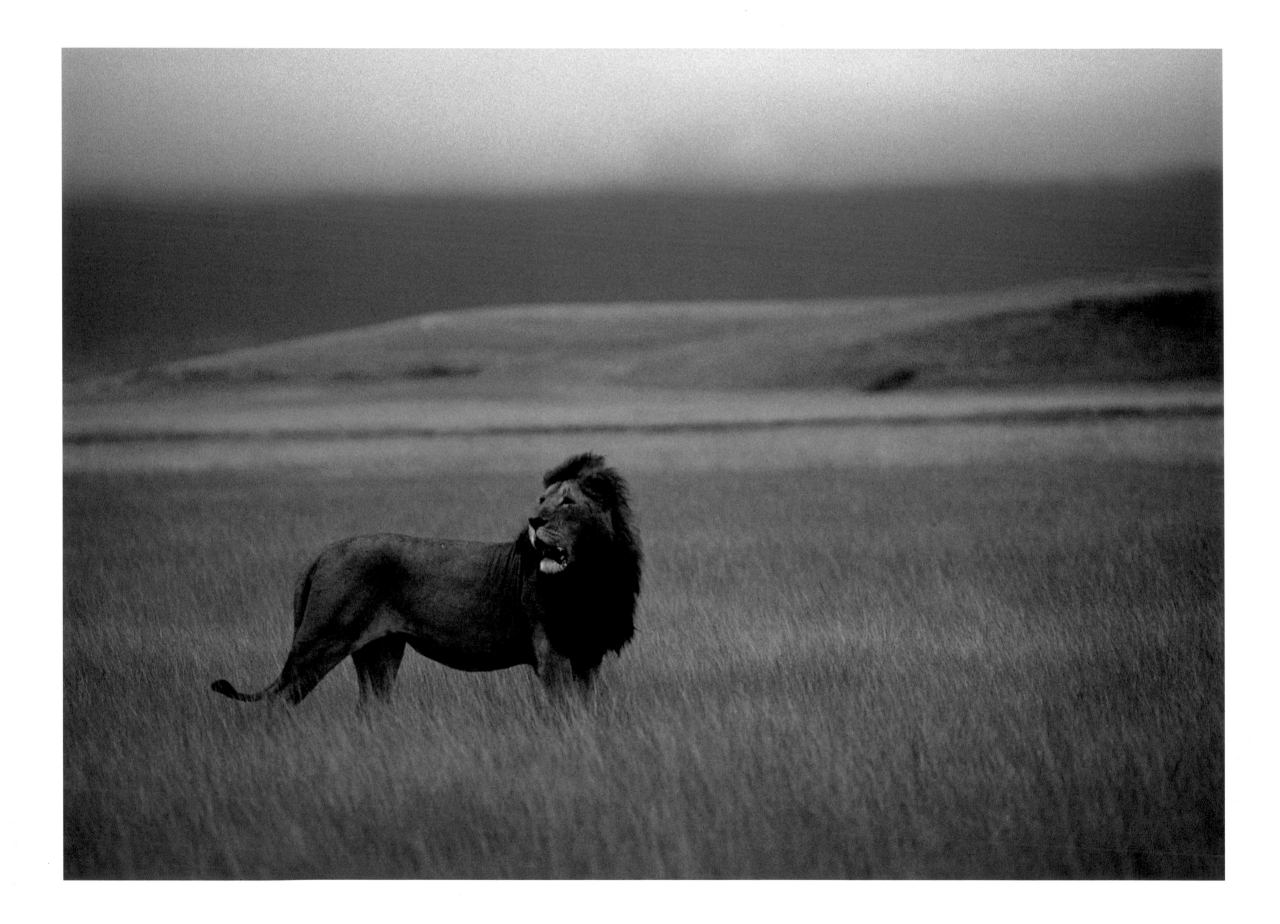

OKITE *IN THE SERENGETI*
Serengeti/Masai Mara/Ngorongoro Region
Photographer: MITSUAKI IWAGO/Minden Pictures

There are not many places in the world where you can see so many animals.
In one frame of film, I have taken photographs of five different species.

MITSUAKI IWAGO

Across the golden sea of grass, a sweet and heavy smell of moist African earth rides the afternoon wind. The airborne pungency carries a potent message: rain is coming. The vast arid plain has waited long to drink its fill.

Lounging lazily as if in repose on the crazy-quilt, deeply cracked geometry of a dry lake bed, a pride of panting lions reflects the shimmering drowsiness of the immense landscape. They, too, are waiting. Perhaps they sense, or remember, that everything is about to change.

Far to the north, in wooded, rolling hills, instincts forged from beyond the reckoning of time *whisper*. The great herds of wildebeest and other herbivores stir and begin to move with a mindless determination that is remarkable to behold. As it has always been, the predators —big cats, pack hunters, and scavengers— will be near, waiting to pick off the young, weak, slow, and unfortunate.

Like a metronome, rain and the wet season it heralds set the tempo for one of the great symphonies of nature. In the tropical savanna that is the Serengeti-Masai Mara ecosystem of lower eastern Africa, reality and metaphor merge in a continually turning wheel of herbivore migration that follows the equatorial rain belt and its abundant bounty: edible grasses and the leaves of the acacia tree.

Every year, two million wildebeests, zebras, gazelles, and giraffes pour from the northern hills of Serengeti National Park in Tanzania, Africa, where they have spent the dry summer and fall, in a counterclockwise migration curving east, then south. Once they arrive upon the great Serengeti Plain, they cover the land like a cloud of huge locusts and graze the winter away.

When spring and early summer return the dry season, the animals move again, tracking the bottom half of the circle west through the boundless, now-golden grass, their daily existence threatened as ever by predators who, in turn, depend on them for survival.

Serengeti National Park, founded in northern Tanzania in 1929 by its former British rulers as a game reserve, is a 14 763-km^2 area that hosts the world's largest mammal migration. The park continues on into northern neighbor Kenya, where it is known as the Masai Mara National Reserve. Both are part of the larger Serengeti-Masai Mara, one of the last large, intact ecosystems on Earth. Its unfenced borders are broadly defined by the migratory ranging of the mule-faced, horse-bodied wildebeest antelope, which numbers more than one million.

The greater Serengeti ecosystem embraces several game reserves and controlled areas including, in the southern part, Ngorongoro Conservation Area. Marked by a huge volcanic caldera, Ngorongoro is a distinct 259-km^2 ecosystem. Here the terrain makes a striking visual counterpoint to the flat Serengeti, wielding a palette of active volcanoes, mountains, forests, lake dunes, rolling plains, archaeological sites, and the famous Ngorongoro Crater and Olduvai Gorge, site of landmark archaeological discoveries into the origins of early hominid species.

Behold the Serengeti, Masai for "endless plain."

INTO THE GREAT WIDE OPEN
Thou shalt go forth and save the world! (Yes, but do not burn yourself out.)

EDWARD ABBEY

You know you've gone native when a horde of black flies descending to cover your lunch brings a smile to your face. Mitsuaki Iwago, a Japanese wildlife pho-

On the opposite page,
this was taken in Ngorongoro.
The black mane is characteristic
of this lion. But the length
of the mane does not correspond
to its age. The territory of a male lion
can cover several prides.

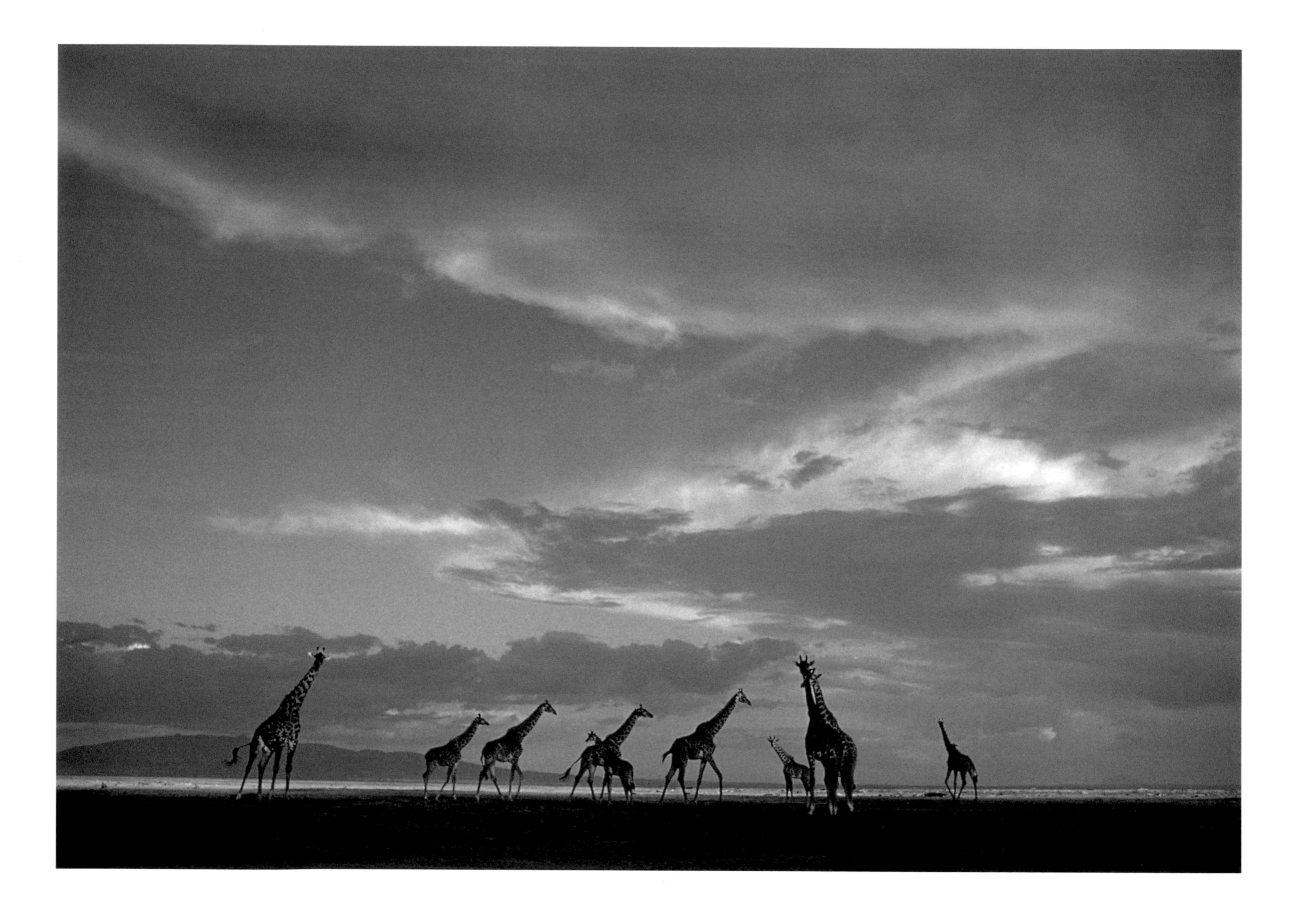

tographer celebrated for his magnificent fieldwork and the many books, published photos, video programs, and articles he has produced over more than two decades, had just such an epiphany while living in the short grass of the Serengeti Plain.

In the 1970s and into the early 1980s, Mitsuaki traveled all over the globe in pursuit of the world's wild animals. But assignment-driven nature photography is a demanding taskmaster. "I felt I had reached a limit to how well I could understand the animals' lives when working in such a hurried, detached manner. I finally asked myself if I could truly capture the essence of nature and animals without living among them. The answer was no, I could not."

In characteristically direct fashion, he rounded up his wife and four-year-old daughter and migrated for an extended stay in a small, rented house in Seronera, a little Masai village right in the middle of Serengeti National Park. The Masai are a tall, handsome, seminomadic tribe living throughout the region.

"I chose the park because I had visited it many times before and was deeply intrigued by it." The Serengeti was familiar to him as possibly the finest area in the world for its selection and number of large animals. "We went to live there for one and a half years. Even that didn't seem long enough: I thought five to ten years might be necessary."

Conditions were austere, compared to his city life in Japan. In the little village, there was no electricity or gas. Water was pumped from a spring more than 80 km away, through old, decrepit pipes that failed frequently. "It was," says Mitsuaki with understated equanimity, "often difficult to wash or find drinking water."

Most of the other amenities of civilization were also missing. His wife dutifully scrubbed clothes on a washboard she had brought from Tokyo. There was a constant shortfall of meat and vegetables, books, newspapers, and music. "She played her Mozart tapes. The sound of the violin, she thought, suited the plain. Although I am a fan of rock music, I had to agree."

HEART OF THE WILD
Let us live most happily, possessing nothing; let us feed on joy, like the radiant gods.
GAUTAMA BUDDHA

The Serengeti-Masai Mara ecosystem lies within a larger ecological zone called the savanna, known for huge expanses of grass with only occasional trees interrupting the view to the infinite horizon. Savanna comes from the sixteenth-century Spanish word *zavanna*, or treeless plain.

The ecoterm savanna has evolved to include light woodland regions as also found in northern Australia and in open South American grasslands (known locally as *campo cerrado* or *llanos*), when enough rain falls to stave off a true desert climate, but not enough to support a rainforest. Sandwiched within this limited range, herbivore grazing and natural cycles of fire maintain a delicate ecological balance.

Africa from its center south is mostly savanna, which is typically warm and has one or two distinct periods of rain that dramatically transform arid conditions into herbivore paradise. And everywhere, everywhere is the grass, which can grow to 1.5 m in height, a perfect tawny camouflage for like-colored predators such as that mighty hunter, the African lion.

ON THE NATURAL ORDER OF LIFE
Parks are not islands; the ecosystem does not stop at the park boundary.
Use of the parks must always be tempered by the need to protect.
PARKS CANADA

Several months into what would seem to most Westerners to be a trial by ordeal, Mitsuaki and his family began to revel in a heightened state of awareness wrapped within a relaxed sense of belonging. He poetically describes the feeling as "the dirt from civilization, slowly washing off. We began to feel ... refreshed."

"It was not exactly intimacy, but I felt something like friendship for the animals I photographed. We found we were hoping cubs of cheetah and lion families we knew would grow up safely."

The wheel of the Serengeti was beginning to turn within Mitsuaki Iwago. In his daily wanderings through the savanna, he felt a growing awareness of what he describes now as a natural order that directs the actions of all living things. One particular time, the feeling was especially strong. "I was sitting in the grass, watching a nearby pride of resting lions. Off in the distance, a herd of zebras peacefully grazed. Birds chirped in the trees, insects buzzed, the winds blew. Everything was in harmony."

Then, he felt everything shift. "I saw no change in the animals' positions. No unusual sounds either. But suddenly the air was charged with excitement. I knew something was going to happen."

On some silent cue, the lions suddenly stirred, *even as* the zebras became more agitated *even as* birds in the trees suddenly took flight *even as* Mitsuaki Iwago picked up his camera, looking, looking.

Then, the lions moved into a stalking crouch toward the zebras, disappearing in the grass. The hunt was on.

"It was if everything there, lion and zebra, the sky, the grass, and me, all were actors in the same play. Everything worked as if planned. But I can not say how."

Mitsuaki's premonitory sensitivity was, he believes, tapping into what he simply describes as *okite* (OH-kee-tay), Japanese for "natural order."

Privy to such mysteries, a mere cloud of flies covering lunch became an easily deciphered, and welcome, sign. Mitsuaki knew when ungulates go on their seasonal big treks, their manure hosts massive increases in insect numbers. "The flies told me the animals were returning to the plain."

Or maybe it was *Okite*.

On the opposite page, near the sunset, giraffes were looking for a sleeping place. When you see them from a car, you would not think they are so tall. But once you stand on the earth and see, you will realize just how tall they really are.

REVIVAL OF THE FITTEST

Up the road, in his shack, the old man was sleeping again.
He was still sleeping on his face and the boy was sitting by him watching him.
The old man was dreaming about the lions.
ERNEST HEMINGWAY, *The Old Man and the Sea* (1952)

For endless generations, the Serengeti plains and the huge savanna ecological zone of which they are a part have been a ferocious evolutionary proving ground. Of all the animals that have sparked human imagination, the big cats epitomize for us those characteristics we most admire in our own, more abstract rites of passage: blazing speed, stealth, cunning, massive strength, and decisive savagery.

Sad and ironic, then, that the big cats have been falling prey to so insidious an enemy as an invisible germ. Unlike H.G. Wells' Martian invaders, invincible against the most formidable weapons of humankind in his science-fiction book *War of the Worlds*, the mighty lions of the Serengeti are showing extreme vulnerability to the microbe that causes canine distemper.

Lions have died in epidemic proportions in recent years from distemper and rabies, caught from domestic dogs in Masai villages on the western edge of the park. Deadly to the big cats in particular, distemper kills at least half of all lions infected. More than 1 000 died in a three-year stretch in the early 1990s from distemper alone —a third of the entire lion population of the Serengeti.

They are not the only victims. Once-numerous wild dog packs have been ravaged, along with silver-backed jackals and bat-eared foxes. Stricken animals can suffer for weeks and even months before they die or are killed by healthy predators.

Meanwhile, the fleet cheetah, fastest land animal on Earth, can not outrun recent and severe threats to its survival. Threatened with extinction by the last Ice Age 10 000 years ago, cheetahs were forced to reproduce with siblings and offspring. The resultant genetic pool became so drastically degraded (cheetahs now share 99% of the same genes) that a disease threatening one cheetah could wipe out all of them in one stroke.

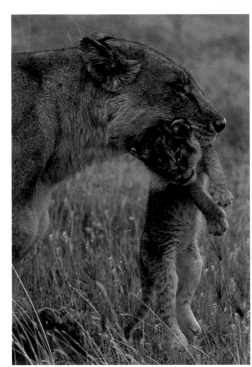

Until a lion cub is one month old, its mother often moves them around for security.

Caught in an "extinction vortex," their numbers are declining worldwide in the face of superior predators amidst overcrowded conditions in steadily shrinking game preserves. To survive, cheetahs focus their efforts on farmland where, like the American wolf, they are being hunted mercilessly by humans seeking to protect their livestock.

In the last decade, 7 000 cheetahs were killed by farmers and fur traders. In India, the species was declared extinct in 1952. Its surviving counterparts around the world may soon follow. The African lion faces the same threats as the cheetah, in addition to disease.

Against the kaleidoscope backdrop of pressures brought about by the ever-

encroaching tide of humanity, concerned and caring people mobilize, driven by that greatest of all human traits: compassion. Organizations like the World Society for the Protection of Animals (through its Project Lion program) have mobilized to stop distemper, which is passed from dogs to wide-ranging hyenas and jackals and thus to lions, in its tracks.

The Cheetah Conservation Fund and Defenders of Wildlife, to name just two, are organizations dedicated to implementing strategies for cheetah conservation in its natural habitat, by working closely with countries that have wild populations, and fostering captive-breeding programs. In these and similar efforts, humans can take some small measure of pride and consolation.

COURAGE AND RESPECT IN THE SERENGETI
Computers are more scary to me than wildlife.
MITSUAKI IWAGO

Once, while observing a pride of lions dozing on a hot afternoon near a kopje, the granite promontories that dot the Serengeti, Mitsuaki suddenly felt a hot, moist, raspy sensation on his arm, which was resting on the windowsill of his car door.

Startled, he turned to find a full-grown adult lioness dreamingly licking his arm. She had casually walked up from his rear without making a sound. It is hard to imagine not jumping out of your skin from such an encounter. But Mitsuaki remained calm.

"I think most photographers do not focus on the dangers of being around wild animals. If they did, they could not take photographs. People see our work and imagine what dangerous things we do. But I think if we felt the danger, then we would stand out to wildlife. I feel there is an 'air' between each of us. We can change the air. That's my personal feeling."

"The first thing I do when I see wildlife is to say, 'I am not a dangerous person, I am a friend.' Sometimes I talk to them, especially elephants."

"Once, a big bull male was running toward my car. I stopped the engine and said to him, 'Okay, you are great, you are big, I am weak.' It was up to him to squash or not to squash me. He calmed down. Turned around. Left. Sometimes I feel the elephant can understand what I am saying."

When a male elephant charged his assistant near a water hole, Mitsuaki grew angry. The male had knocked the person to the ground. "I ran towards the elephant and yelled 'Go away!' He went away."

Talk about flowing into the natural order of life!

WATER IS THE ENGINE

The rain in the Serengeti savanna falls twice a year, from March through May and November through December. But it is not predictable. Sometimes the life-giving moisture is delayed. Sometimes it does not come at all. And sometimes there is fire, which limits the growth of trees and shrubbery.

When the rains *do* come, they come with a vengeance: large, isolated drops first, then a downpour that transforms the plains into a sea of muddy streams and flash floods powerful enough to wash away a car. An hour later, the sky magically clears to blue. In just a few days, the formerly desiccated ground erupts as if in botanical and biological joy. Green buds sprout everywhere, presaging the plenitude of grass that will sustain the large populations of migratory animals that will soon arrive.

Energy cycles quickly through the savanna ecosystem, which grows nearly 2.75 kg of plant matter for every square meter of soil each year —half that of a rainforest, yet with only 10 percent of the total biomass. That's what you call efficiency, resulting in a botanical richness sufficient to host a broad family of insects, mammals, and birds.

The Serengeti, in particular, has gained an international reputation for its array of more than 20 species of large mammals, which reads like a Who's-Who of animal heavyweights: pick a spot anywhere and you're likely to see zebras rubbing their heads against rocks for relief from the incessant swarms of insects; sprawling herds of wildebeest, 10 000 strong; elephants dusting themselves with dirt and sand —the pachyderm version of insect repellent; giraffes wrapping their long, gray tongues around the tender, green buds only they can reach, high in the cloud-like branches of the thorny acacia trees; hippopotami, the great "river horses," lumbering out of bodies of water in the cooler evenings to graze; buffalo, generally staying close to shade and water to control body heat.

Like the musk-oxen of Ellesmere Island, the Serengeti's massive buffaloes form a defensive ring, with calves and cows in the center, when confronted by lions. Nature loves an effective solution, even as it devises ingenious natural ways to breach its own designs and up the ante of simple survival.

Another similarity of the savanna to Ellesmere lies in its expansive, open landscape. Because prey cannot easily hide from predators, speed is often the final arbiter of success or failure on both sides of the hunting equation. No surprise that Africa hosts many of the world's fastest land animals, such as the cheetah and its small antelope prey; the mottled mud-brown and dirty-yellow packs of wild dogs; leopards, the cats of night who drag their kill high up onto tree branches to escape scavengers; hyenas, hunter-scavengers in a constant, bitter war with their chief competitors, the lions.

Many more species make the Serengeti an ever-more-fascinating destination for ecotourists. Baboons, hyraxes (a small, furry little creature that looks like a rabbit but is genetically closer to the elephant!), hartebeests, topi, Thomson's gazelles, klipspringers and other ungulates, pink clouds of flamingo flocks (a favorite meal of lions and hyenas), colorful bee-eaters and other birds such as the pelican, and that antic clown of the plain, the mongoose, all thrive in the savanna ecosystem.

NOTES FROM THE FIELD: DOING "GOOD"
Birds, it would seem, are so intent on being birds that they have no time to speculate on their not being birds.
WILLIAM A. RUSSELL

In his book *Serengeti: Natural Order on the African Plain*, Mitsuaki praises the work of Dr. Bernhard Brzimek, a German zoologist whose exhaustive years of research led to an expanded boundary for the conservation area now known as the Serengeti/Masai Mara ecosystem.

"But creating artificial boundaries brings problems," says Mitsuaki. "More people come, with major impact on the animals." He cites significant increases in poaching in the last fifty years. "More than 200 000 wildebeests are killed every year by poachers. Originally, Africans hunted their own meat but took very few wildebeests. Poaching for profit causes the big numbers."

As elsewhere in the world, rhino and elephant poaching for tusks and horns has increased. With the rise in the numbers of domestic cattle around the park came the danger of rinderpest.

Still, Mitsuaki considers the Serengeti to be a well-run park. "But future conservation is a most difficult question. I feel people are too often not thinking about wildlife and its needs, but about their needs. Conservation for the people, not for nature. People act as if, in doing 'good' things, animals will be satisfied with the environment that is created, but that is not always true. People so often do dumb things. The answer is simple: just observe. Observation is so important. You can not get all the answers from a computer."

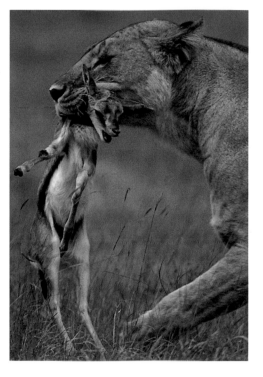

RINDERPEST AND THE VANISHING TREES
Beware the vision of the zealous man obsessed with saving the world: in his clumsy fingers, it may unravel instead.
CLINTON REDFIELD

In a textbook example of how observation can foster conservation solutions of the greatest benefit to an entire ecosystem, ecologist A.R.E. Sinclair published a contradictory evaluation of why the acacia and bush forests of Serengeti National Park were disappearing. The popular notion at the time was that increasing numbers of elephants were killing the trees.

Sinclair's long-term monitoring of the park's ecosystem led him to a more complex conclusion. Since people had always burned the grasses to enhance the growth of new pasture, their absence after a mass starvation in the 1890s gave the forests a new foothold. When human populations rebounded decades later —but rinderpest-ravaged wildebeests did not—, the grasses grew taller. Humans once again burned the plains.

In the 1960s, a wetter climate brought more grasses, thus more, hotter fires —which killed new tree seedlings. Since acacia trees only live 60 to 70 years, fire

The prey was primarily for the cubs.
While the cubs were devouring the
Thomson's gazelle, the lioness was
groaning at a low pitch.
It was as if she were enduring
her own starvation.
Twenty minutes later, there remained
only the head and legs.
She finally stood up and began
to eat the leftovers.

and old age took their toll of the elders, with no new saplings to replace them. By the 1980s, Sinclair's studies clearly established the true culprit: people and their fires, not the elephant, were responsible.

When the wildebeest herds recovered their traditional population numbers, near one million, thanks to a successful rinderpest control program, the grass was again kept short by grazing. In turn, humans set fewer fires. Add to that decreased numbers of tree-damaging elephants and buffalo through poaching, and you have the ingredients for the return of the acacia to the Serengeti.

NOTES FROM THE FIELD: INTO THE FUTURE
It is not enough just to fight for the world.
It is even more important to enjoy it while you can!
EDWARD ABBEY

"Always I am thinking, 'What do we have to do about the natural world?,'" says Mitsuaki. "Maybe no one has the answer. All I can personally do is observe what is happening in front of my eyes. Right now, people are saying, 'Help nature, help wildlife.' Maybe nature will say, 'No, we don't need conservation, just go away.'"

"It is already too late, maybe. People who live in the Northern Hemisphere travel to the Southern Hemisphere. That is wrong. It changes things. The best thing would be to have nobody visit at all."

He adds with a chuckle, "Not even photographers. Native peoples never needed to cut down the trees for wood; we taught them how. They didn't need fire, they didn't need bread. Why should they when they never had before? We give them bread, blankets, we call this 'African aid,' we call it 'helping them.' Which is not helping, it is destroying them."

"I think we can not stop the way we are going, but maybe we can slow down everything. We can learn so much from the animals. But we have to think like they do, not like we do. The first thing we have to realize is, animals are different. They are not 'clever' like us. People think the elephant is clever because it has a big brain. I think, 'Nonsense.'"

"I would not say we can go back, because we have already changed so much of the world. But we have to slow down. Or, as history shows us, nature will react. We are also born by nature, so nature I think will take care of the problem. And we are the problem."

THE MUSIC OF THE WHEEL
I don't know much about history. I just love this tree.
His Holiness the Dalai Lama of Tibet

The rains have stopped for the season. Fires set by the park rangers the night before have gone out as the daily winds died down. The rising sun, etched by the silhouettes of gnarled acacia branches, becomes a huge, fertilized yolk through the orange smoke-filtered sky. Life renews in the Serengeti.

Tens of thousands of wildebeests restlessly move, raising walls of white dust across the plains. The rains are over, the dry season rules again. When the land is parched, and the sun so hot even the lions sleep, tomorrow becomes very much like yesterday: an endless ordeal of dwindling forage and blood battle. Time to leave.

The life tempo of the Serengeti grasslands is a tango: quick-quick-slow, quick-quick-slow. Each animal plays its part in *okite*, the natural order that joins the climax of the hunt to the peaceful glide across the plains, when plant- and flesh-eaters have had their fill and can rest.

The animals gather, answering the music. They will go north, as they have always done.

On the opposite page,
a higher place is preferable to find a prey. Nevertheless, a cheetah is not good at climbing a tree. This is because
a cheetah's claws do not withdraw into its paw. It is more like a dog than like a cat.

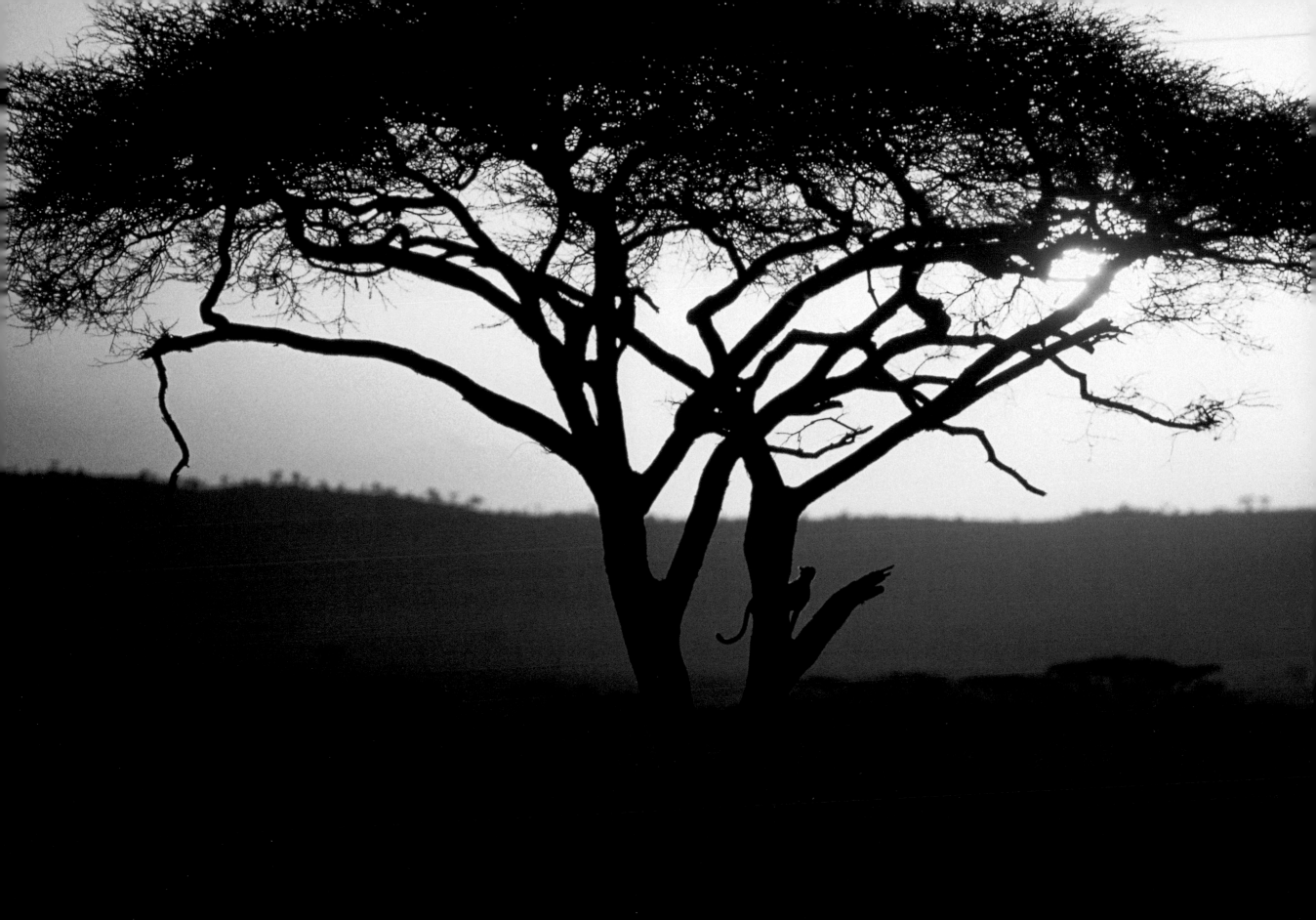

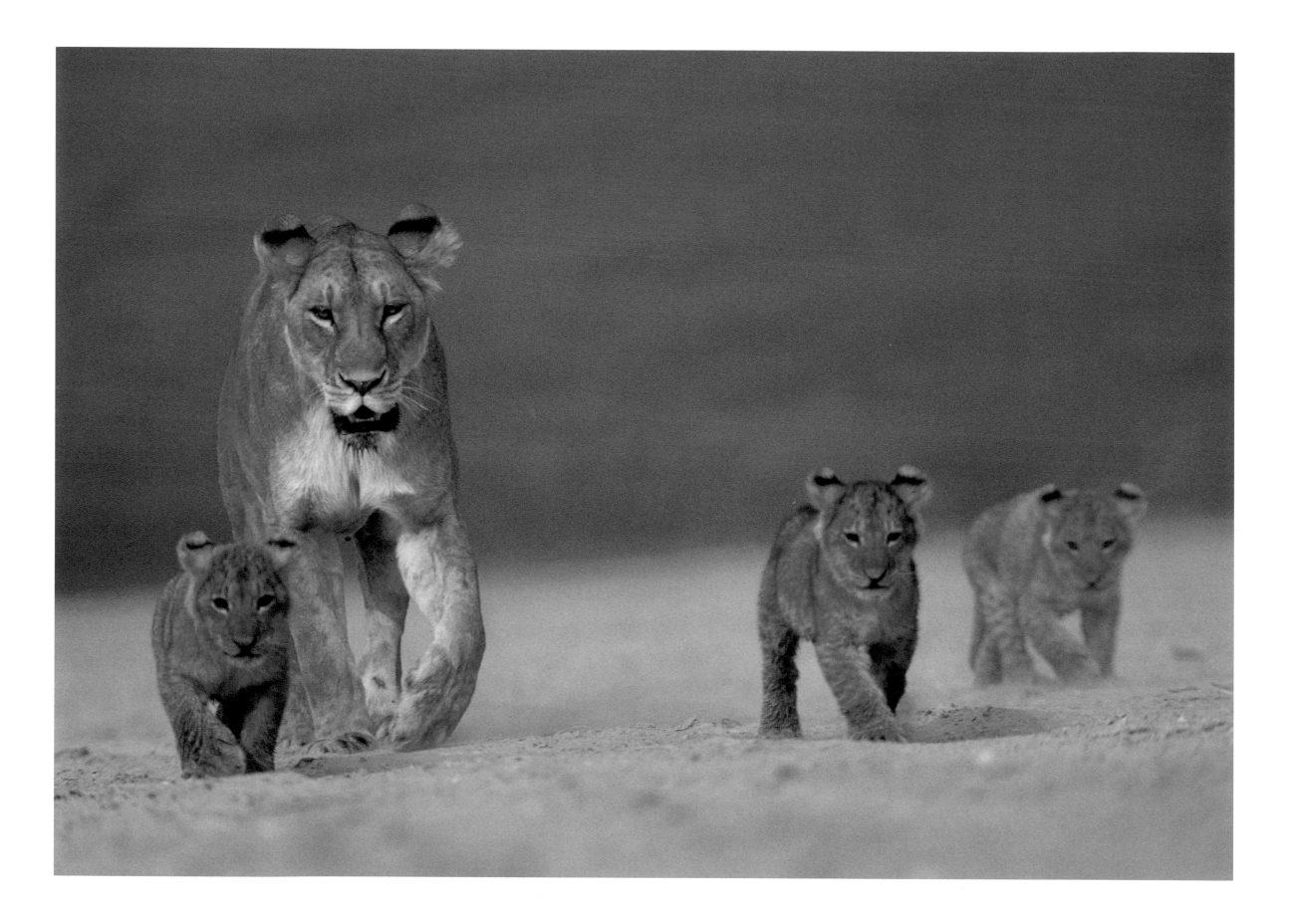

On the opposite page,
these three cubs were maybe the first offspring for this 3-year-old lioness.
The lioness always had to look for prey to feed the cubs.
She sometimes had to go long distances to do so.

Below, a young cub nuzzles against his sleeping mother.

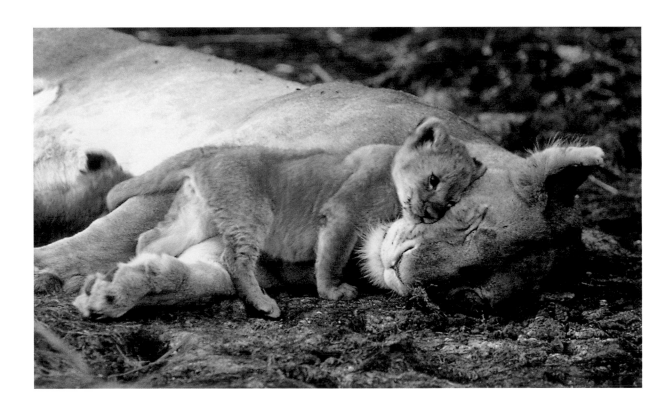

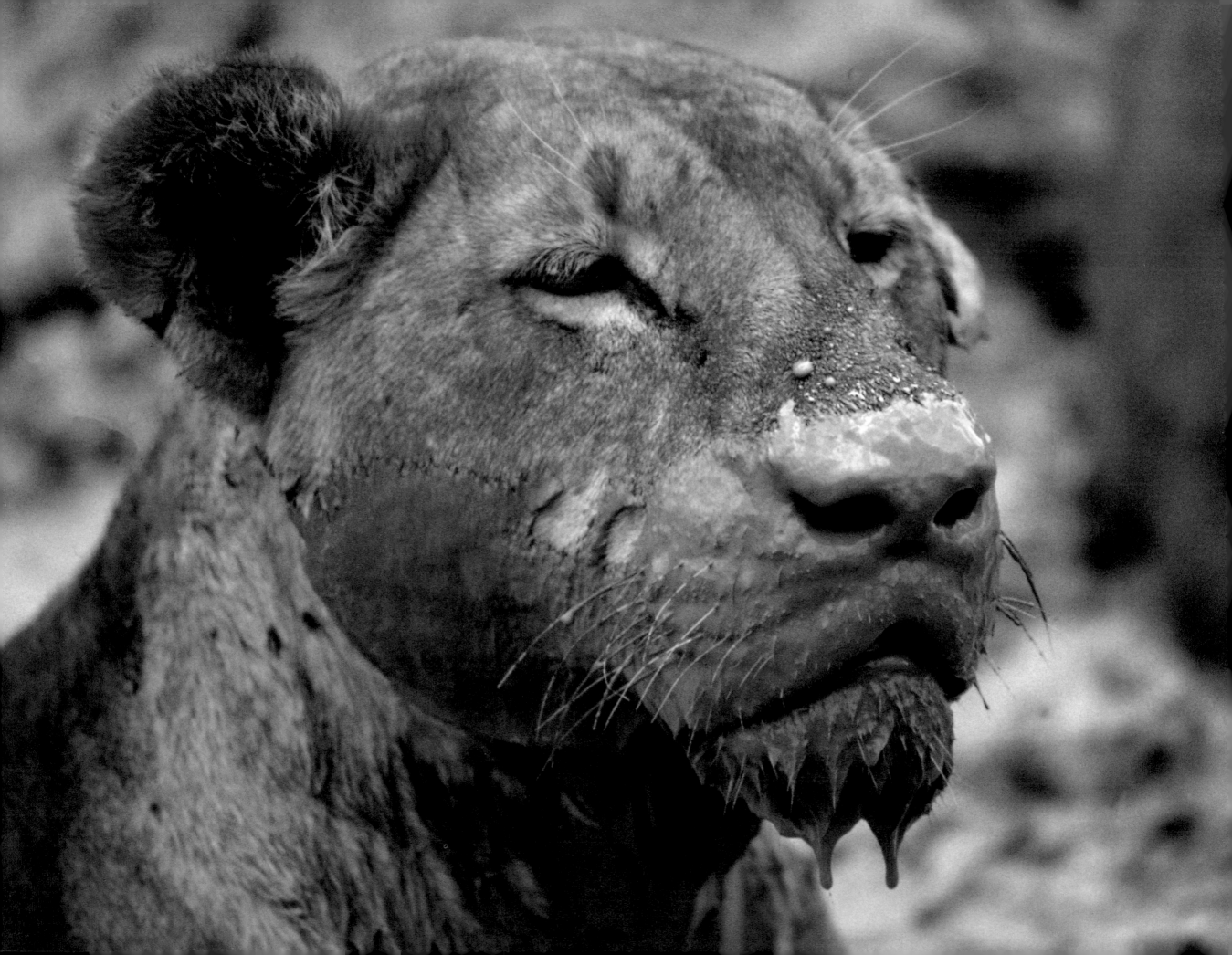

On the opposite page,
lioness with muddy face. A mud bath provides a cooling respite from the African heat.

Below, although the lion looks like it is deep in sleep, it isn't.

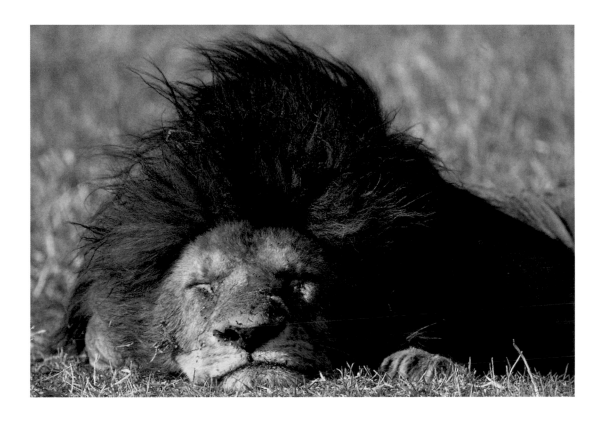

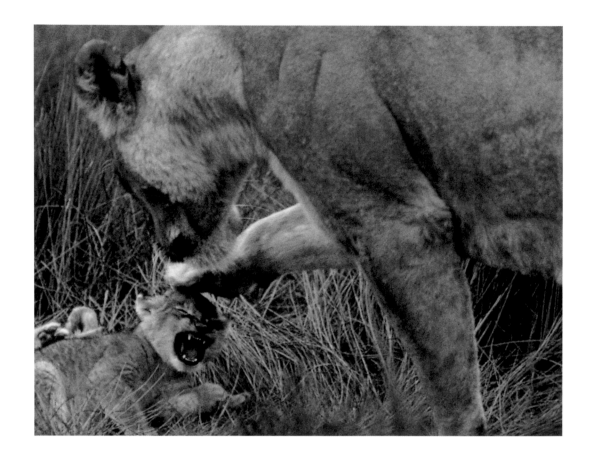

Lion cubs are very impatient. They stay in the same place for only a few seconds.

On the opposite page,
lions in a pride share their prey.

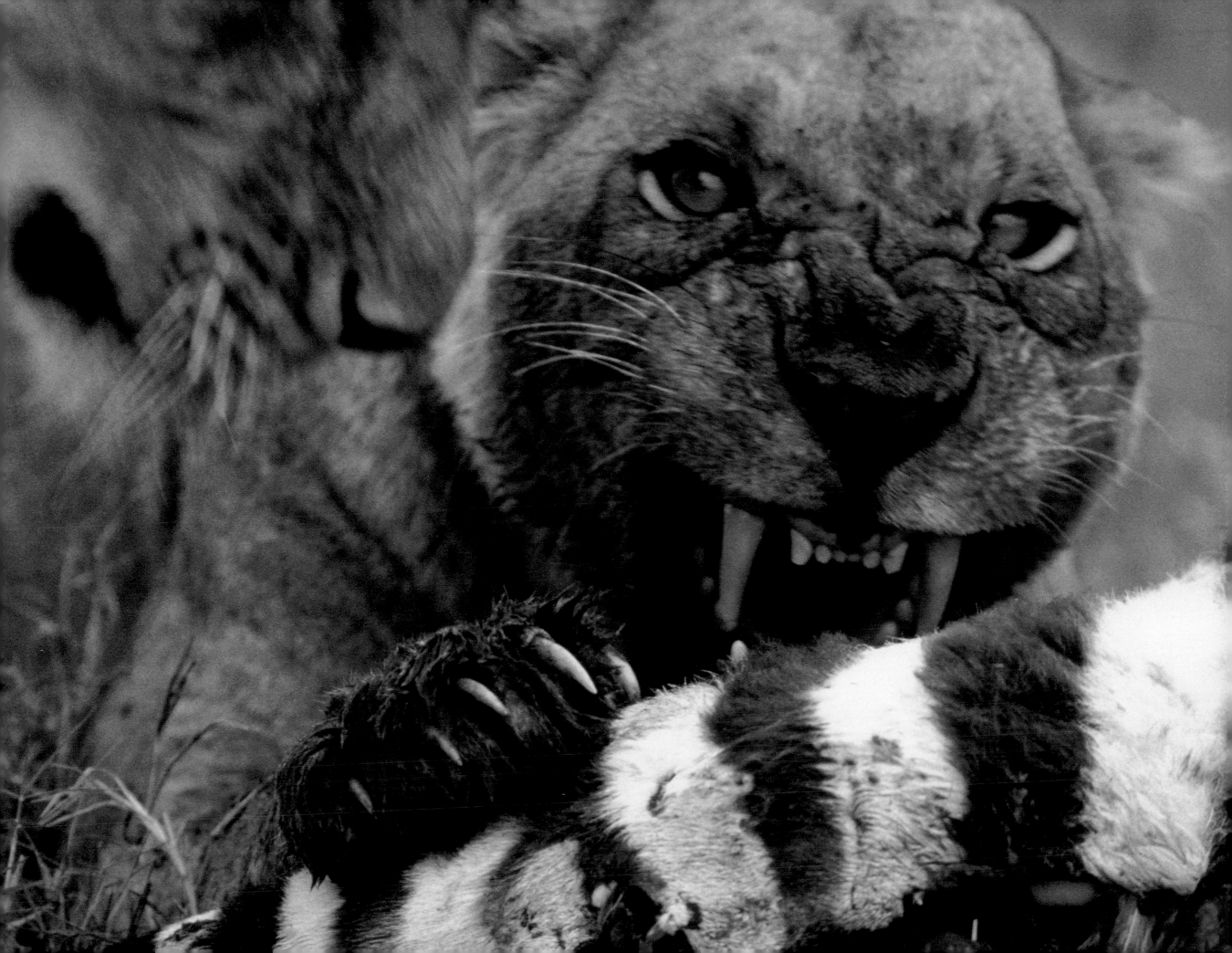

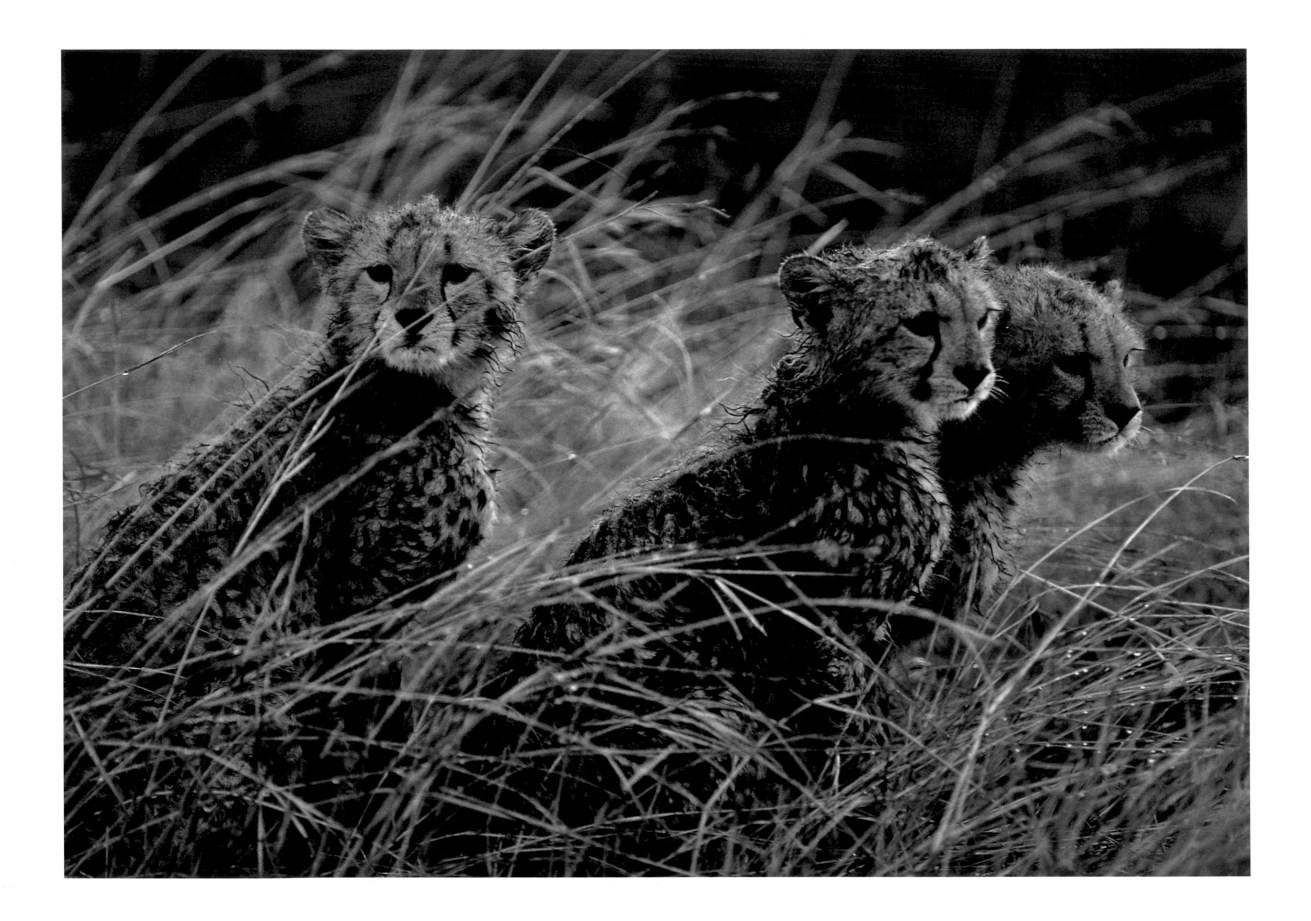

On the opposite page,
Mitsuaki had photographed the three cheetahs for about a year.
During this period, the cheetahs and Mitsuaki had gotten to know each
other. They even identified Mitsuaki's car by the sound of its engine.
Thus Mitsuaki got to be on very good terms with them.
But this has the danger of making him see nature with a human's *passion,*
not nature by itself independently of any human ways of thinking.

On the right, this lioness is called Floppy Ear for the shape of her ear.
Mitsuaki had shot her for 8 years intermittently. At the time of this image,
she had 3 babies.

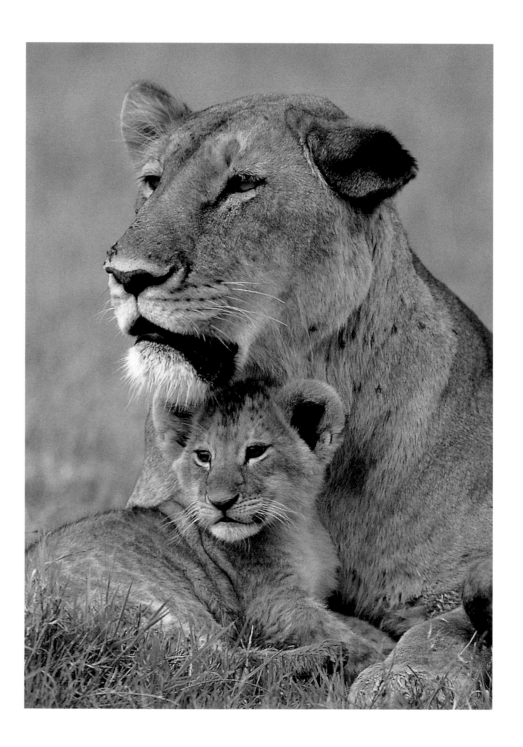

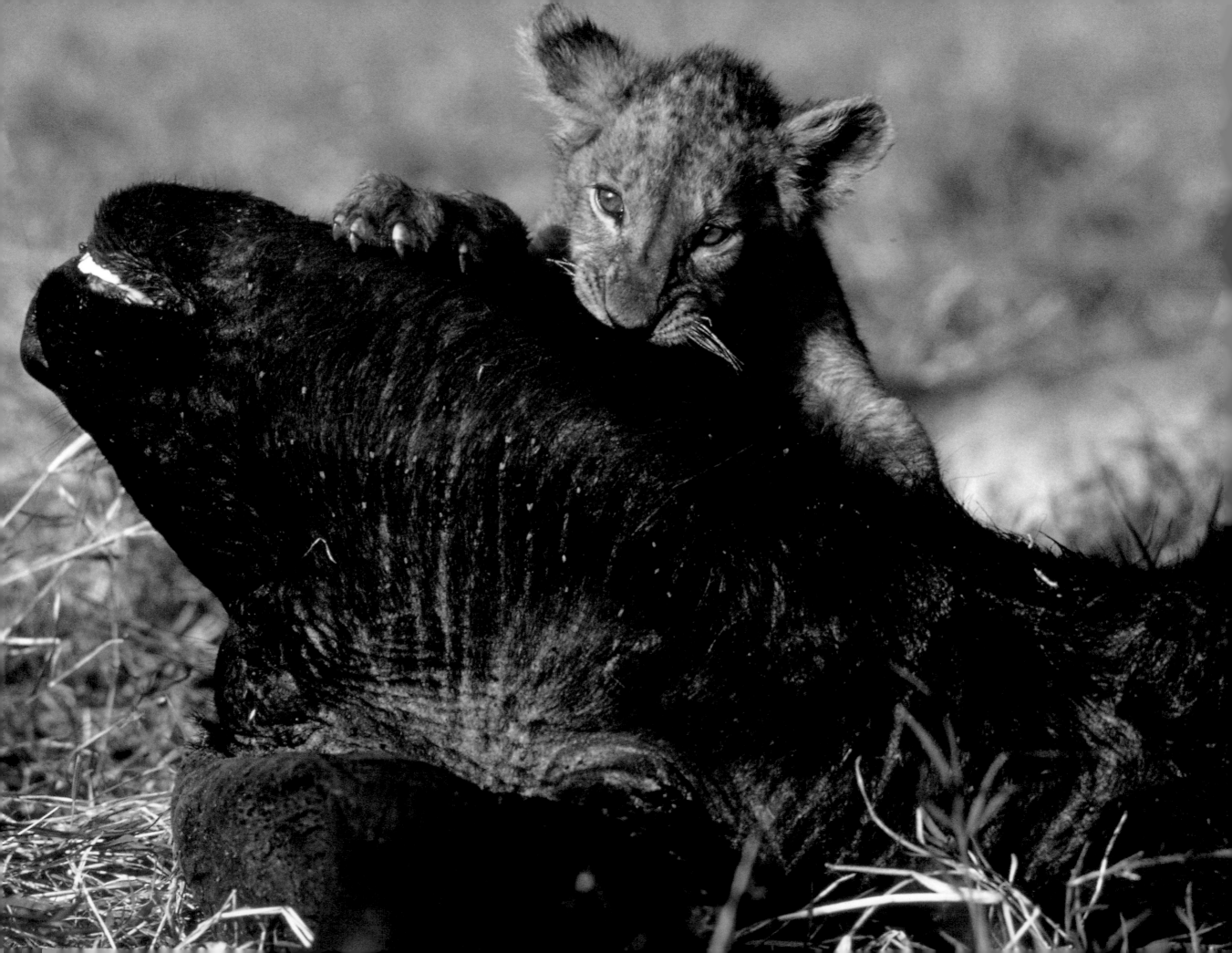

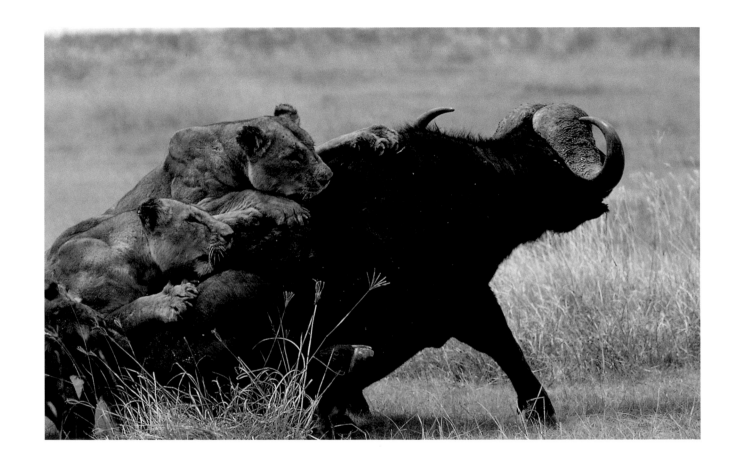

On the opposite page,
very young lion cub sinks its tiny teeth into Cape buffalo, killed by the older females of its pride.

Above, cooperation in hunting and domestic activities is the keystone of pride life.
Typically, the lionesses conduct virtually 90% of the hunts.
Together, three lionesses from the same pride bring down a Cape buffalo.

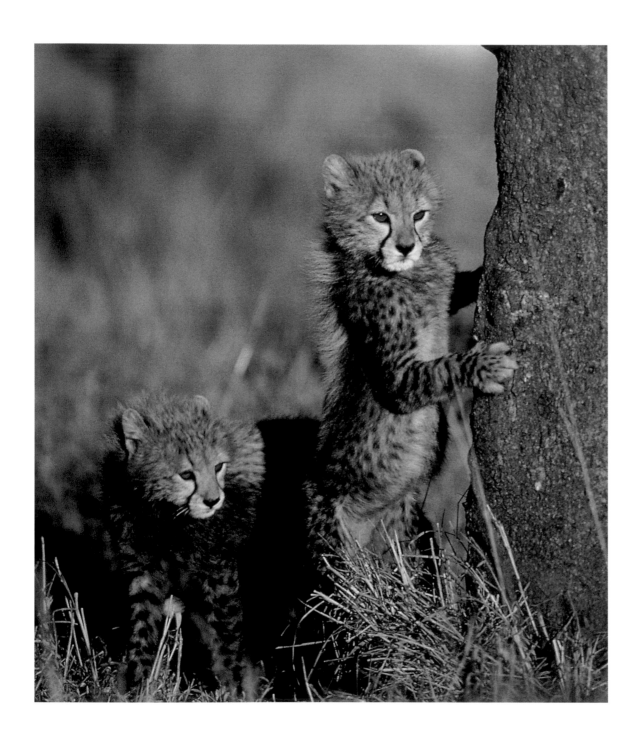

Every day the always curious cheetah cubs
learn something new which is going to be very useful
for their adult life.

On the opposite page,
rock hyraxes and young rest watchfully on a rock
during the warm hours.

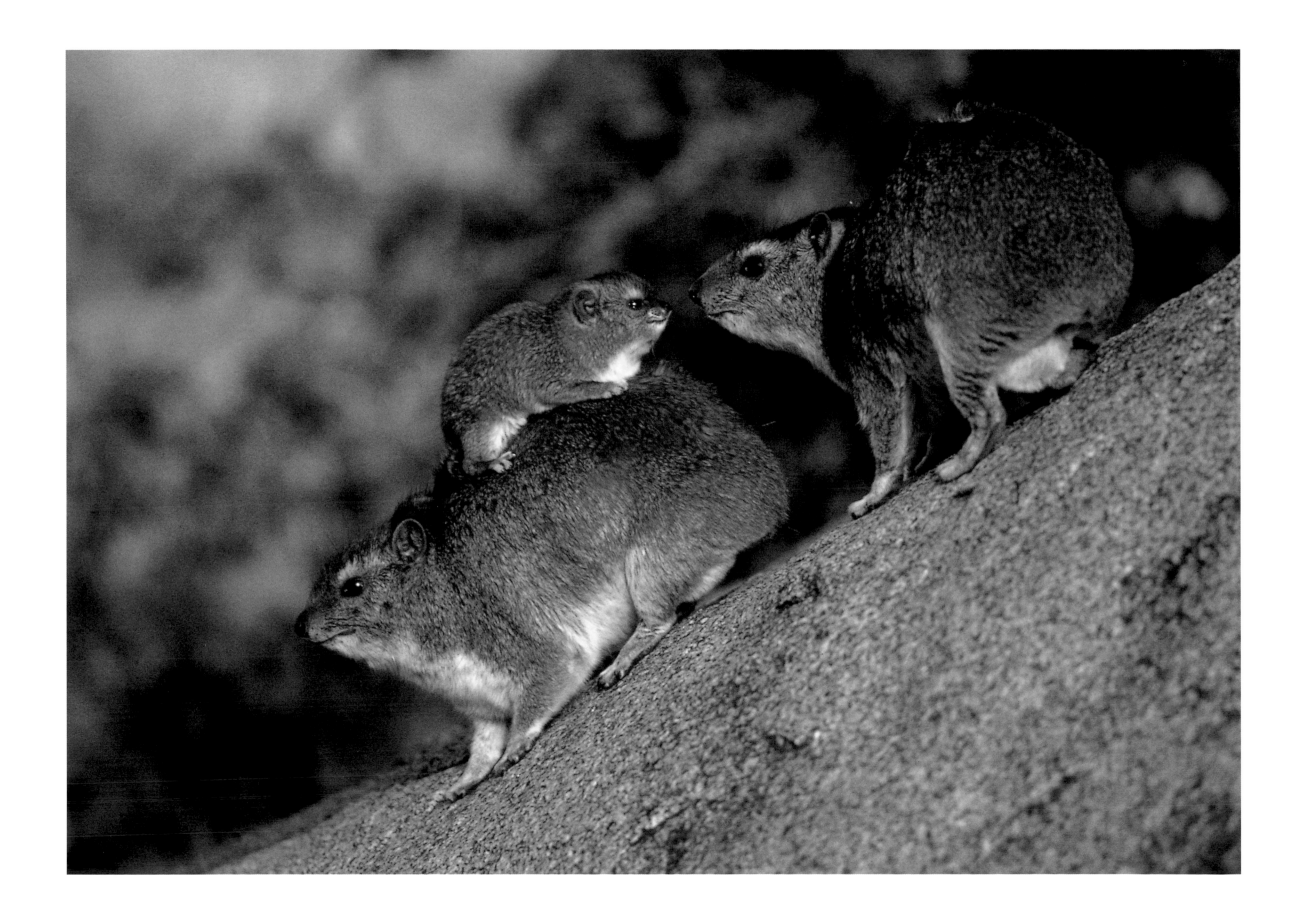

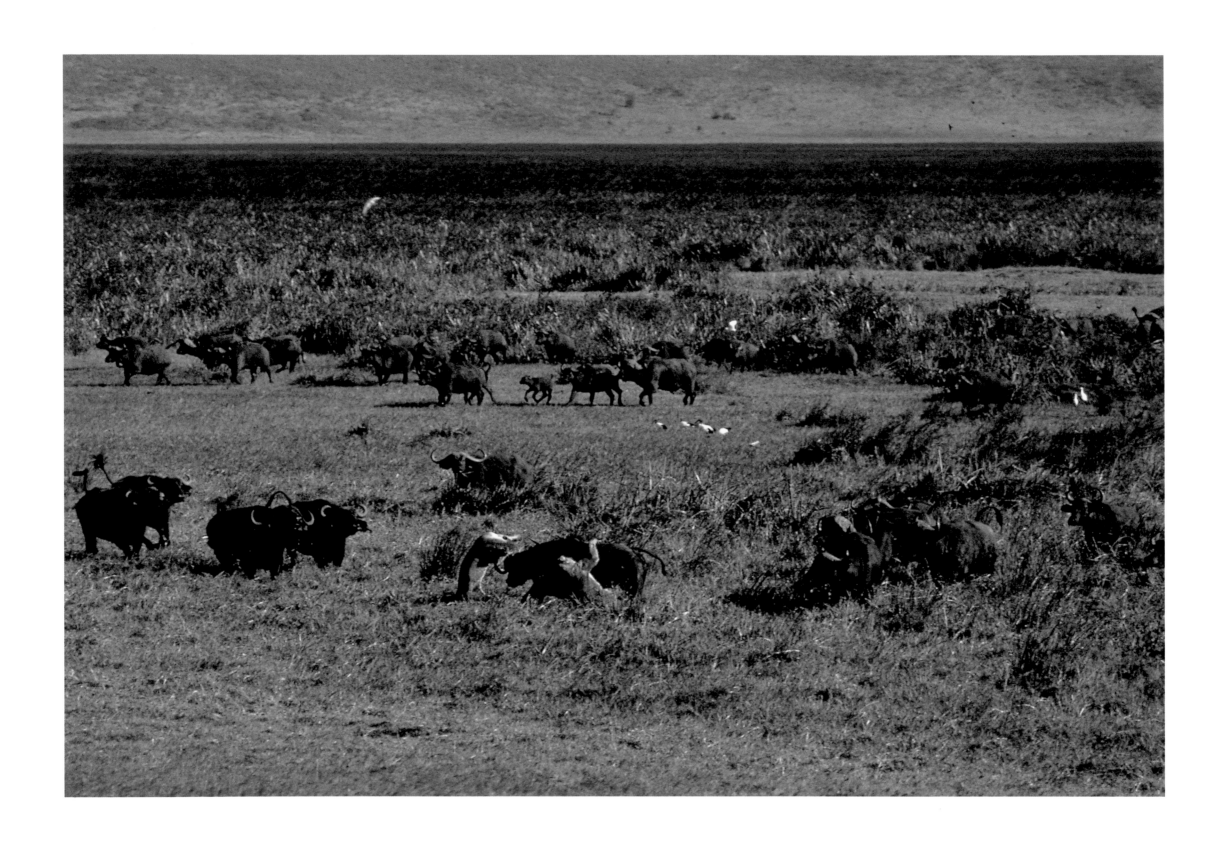

Two lionesses working together to bring down a powerful Cape buffalo.

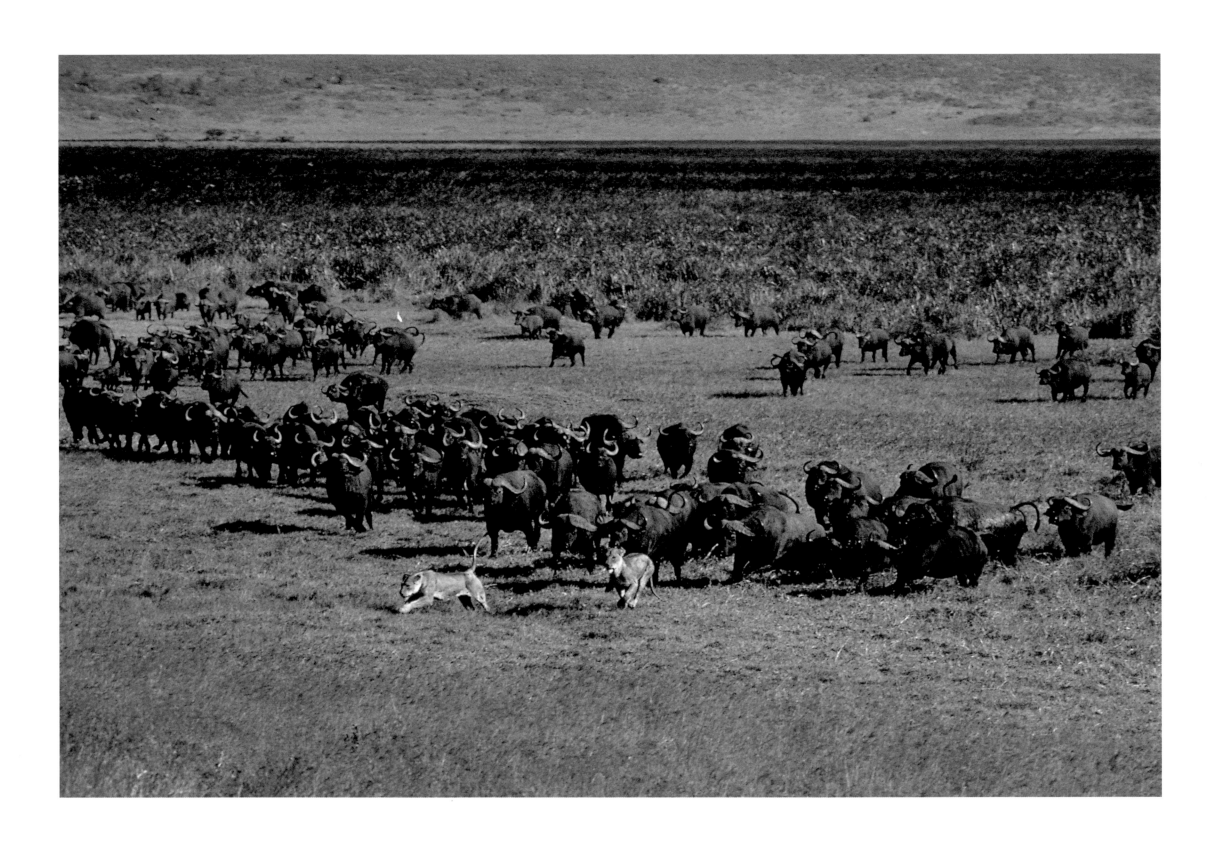

In the end, this hunt failed and the lionesses had to retreat from the advancing buffalo herd.
It chases away the defeated lionesses.

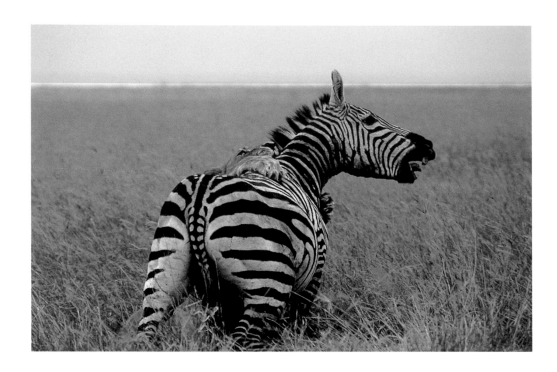

The lioness hid in the grass and attacked. But it was a dangerous business.
It could have been that the attacked zebra
counterattacked and kicked the lioness.

On the opposite page,
the lions had failed in hunting and were sleeping on the grass.
Two hyenas walked by there. One of them was caught.
Although the lions killed the hyena, it was not for eating. When the attacked
hyena was about to die, it put in its mouth the bowels coming out from its belly.
Mitsuaki did not know why the hyena did that. It might be because of terror
or fear or fright. Or the smell of the blood might urge the hyena to do so.
In either case, Mitsuaki was astonished by the sight.

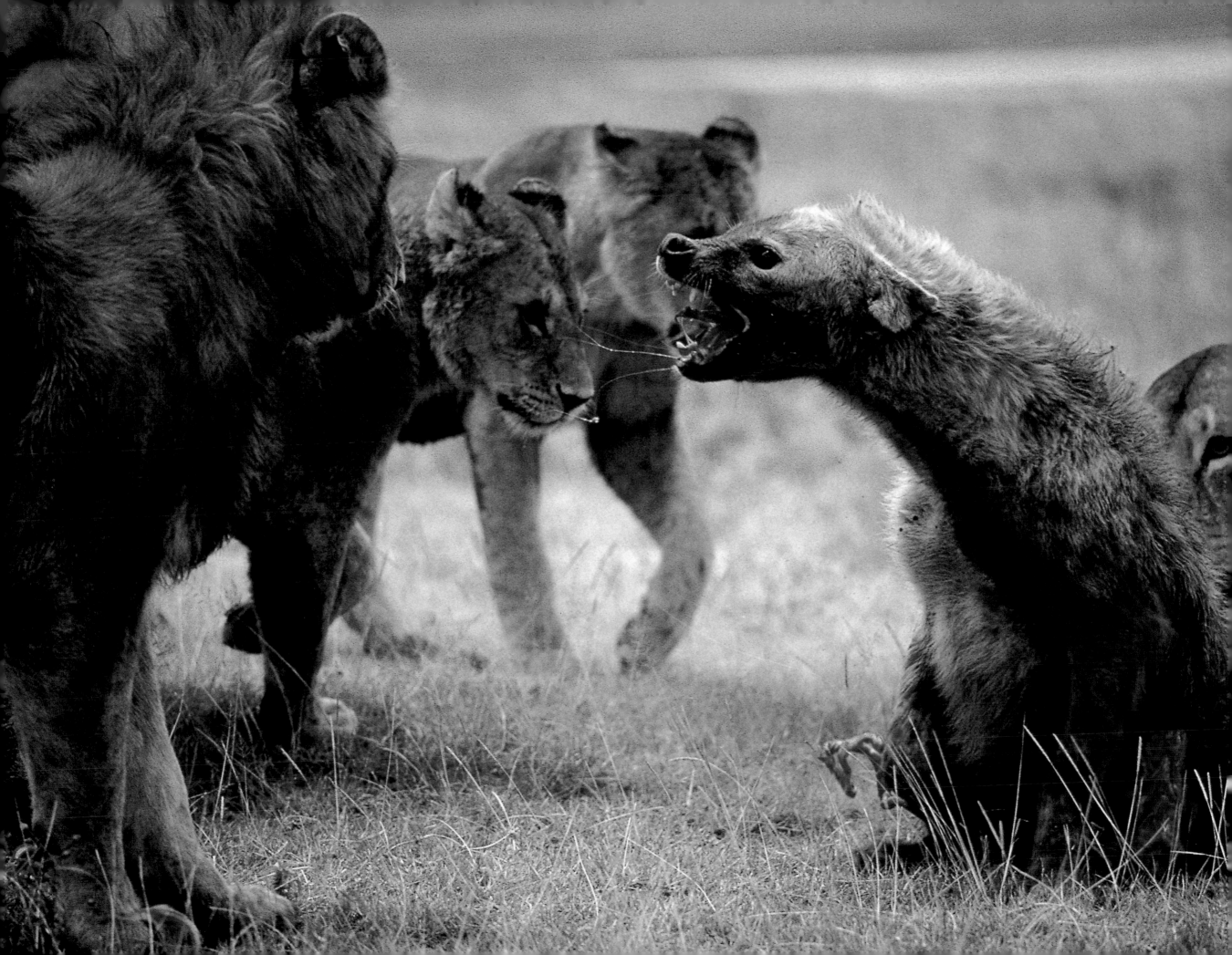

The birthing lair
is in a well-hidden, safe location.

On the opposite page,
an elephant walks peacefully
on the Serengeti as a storm approaches.

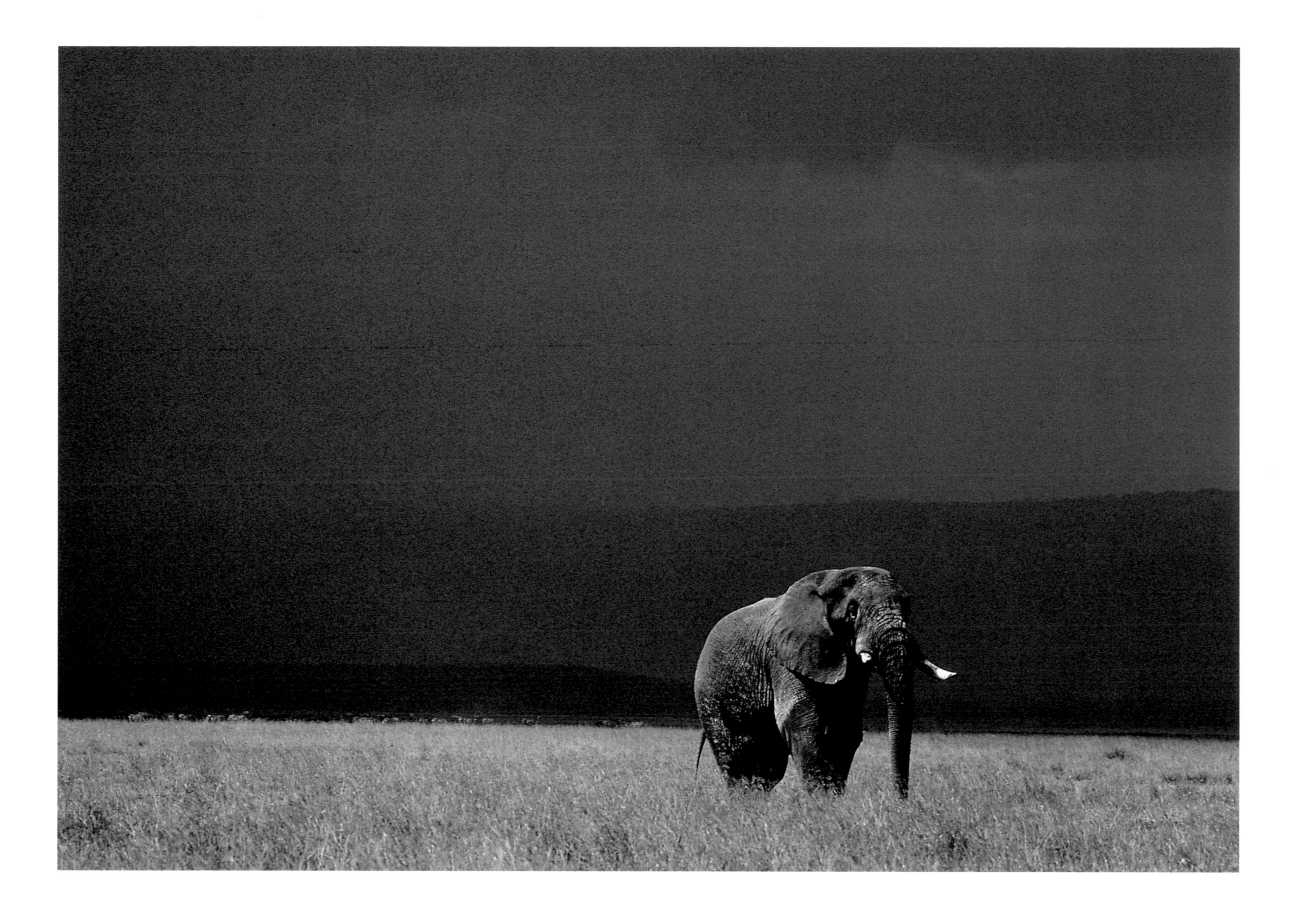

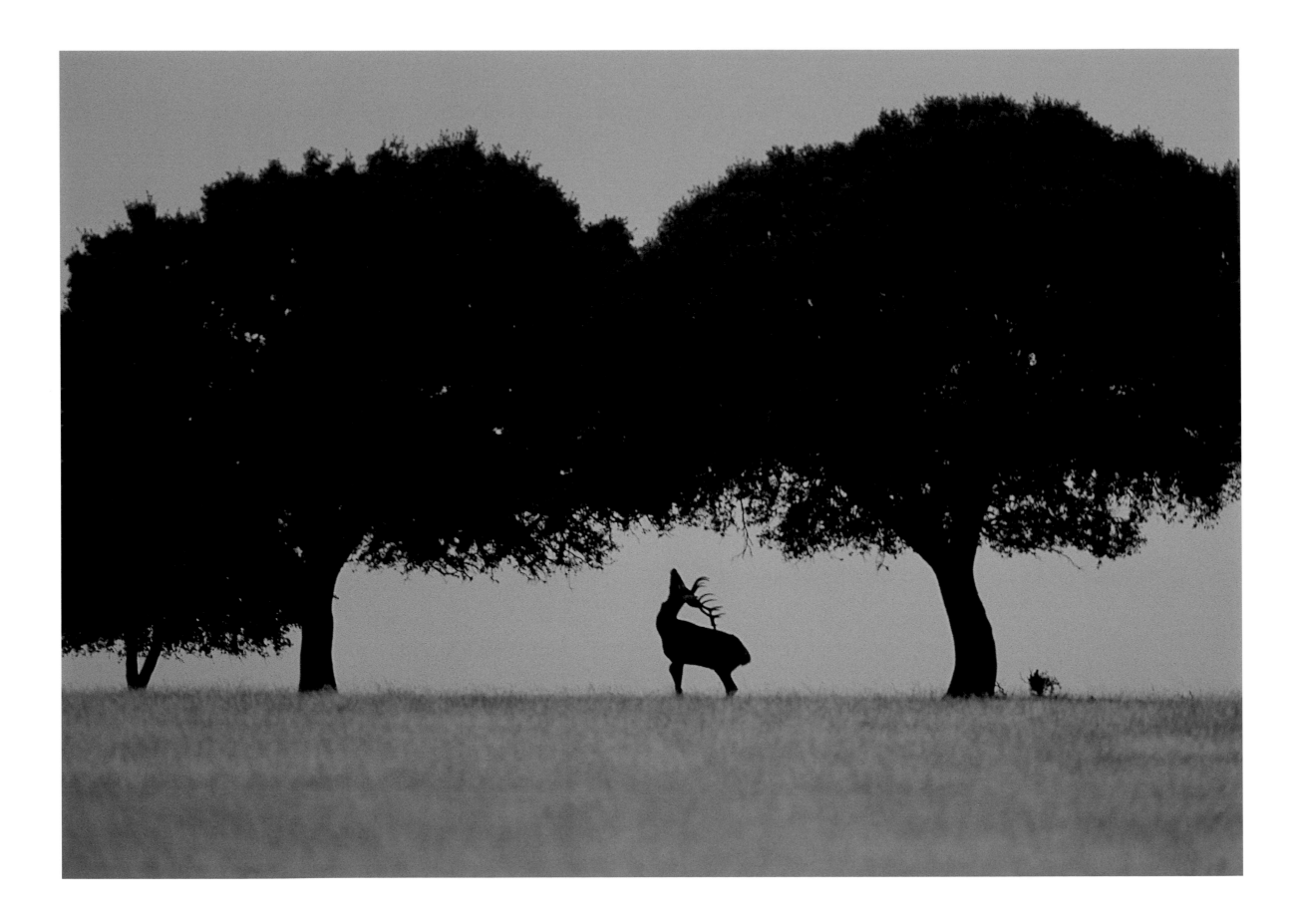

THE THOUSAND-YEAR PLAINS
Cabañeros
Photographer: FRANCISCO MÁRQUEZ

Sing away sorrow, cast away care.

MIGUEL DE CERVANTES

The eye follows with the lightness of a lover's heart the lines of full green oaks dotting the golden plain. Morning light floods the sky with warmth. Sighs come easy when you stand on this broad, flat land framed by occasional croplands in low foothills that run gradually up to the venerable mountains. In the temperate heat of summer days, you would be forgiven for thinking you were in Africa, so wide and open is the vista.

But there are no lions here. No big cats or giraffes, zebras or wildebeests. In fact, humans and nature have lived more or less harmoniously in this place for almost as long as European civilization.

The local villagers call these pastoral expanses *la raña*, an ironic but perhaps deliberate choice of words. Without the tilde over the letter *n, raña* means "frog" in Spanish. And since this charismatic lowland meadow frequently floods during the torrential rains of winter, bestowing life on a bumper crop of various species of frogs and other amphibians, the reference seems altogether fitting.

The *rañas* become in spring a rich sea of grasses that offer abundant food for its broad varieties of wildlife. In the Mediterranean montane forests of the surrounding Paleozoic mountain ranges that form the northern and western two thirds of this protected area, a wondrous array of birds and mammals find a home.

Its name is Cabañeros National Park. Curving like a smile across the southern reaches of the Montes de Toledo mountainous woodland forest of central Spain, a sense of peace, order, and harmony permeates the 41 000-ha park, almost as if its lands had been personally manicured by God.

In fact, it has been the hand of humans that has largely managed and protected the simple natural beauty of Cabañeros for almost 1 000 years. Although

not declared a national park until 1995, these peaceful lands inform the higher instincts and deeds of human beings. Throughout even the despoiling march of European civilization across the Earth, with its spread of urbanization, global empires, 200 years of Industrial Age and devastating world wars, Cabañeros has remained an island of protection, a living embodiment of our willingness to coexist with nature.

Today, Cabañeros National Park provides a rich habitat for its native species and a carefully managed rural environment that requires entry permits and guided tours to some of the more sensitive areas, which explains why the park, although increasingly well-known throughout Europe, receives just 55 000 visitors annually.

By design, Cabañeros embraces the largest Mediterranean shrub and woodland ecosystems remaining in Europe. As such, it has been included as a vital component of the World Wildlife Fund's Global 200 ecoregion that rings the entire Mediterranean Sea and includes almost all of the Iberian Peninsula.

Cabañeros National Park lies between the northwestern quadrant of Ciudad Real province and the southwestern quadrant of Toledo province, nestled between the Bullaque and Estena rivers to the east and west. It includes the Macizo del Chorito, Sierra de Miraflores and Macizo de Rocigalgo mountain ranges, and the Llanada de Alcoba plain —the *raña*.

The terrain reaches from the hotter climes at 620-m elevation to the chilly, eroded Paleozoic mountains and diverse woodlands of several summits, of which the 1 448-m Pico Rocigalgo is the highest. Viewing the area from space, you would quickly see the park and its surrounding area separated into two distinct terrains: the mostly mountainous country to the west and north; and the smaller flat, open lands to the south and east.

On the opposite page, the diet of the red deer is based mainly on the leaves of trees and bushes, and in some cases puts considerable pressure upon the growth of the park's oaks, arbutus trees, and laburnums. In autumn and winter, red deer like to eat the acorns of oaks and gall oaks, lifting themselves up on their hind legs to reach the branches most laden with these nuts.

Cabañeros is situated in the Guadiana River Basin; water is abundant from the rivers that flank its eastern and western boundaries. Because of poor drainage, the rivers turn the *raña* into a floodplain. In the mountainous west, the Estena River has cut deeply through ancient quartzite, carving deep gorges such as the Boquerón del Estena, one of the most remarkable water-carved areas in the Montes de Toledo region.

The seasons are distinct in Cabañeros' typically Mediterranean climate. A noticeable drought is sandwiched between spring and autumn rains. Average annual temperatures swing between 6°C and 44°C, with extremes of –10°C in winter and 50°C in summer. January and February are the rainiest months, more typical of the northern Iberian Peninsula than of Mediterranean ecosystems.

NIGHT GAMES
A dog does not always bark at the front gate.
Spanish proverb

Ah, those vultures. Francisco Márquez's patience is wearing a bit thin, not that he didn't expect it to be just this way. He has spent many hours already in his canvas and aluminum hide, waiting for the buzzards to make life a little easier for him. After all, it has been several days now. He has slept and eaten inside the tiny blind, rather than risk spooking the wary scavengers.

Still, he expects his subjects will eventually give him a good "photo opportunity." The vultures almost always require such diligence: at best, they are a wary and unpredictable photographic subject.

The rest of nature could be a bit more cooperative, too. Last night Francisco set out carrion as bait to attract the birds for dawn photography. Sometime after dark, he heard a snorting disturbance very close to his hide, anchored in the branches of a large oak tree. "The wild boars were eating the bait that was destined for the vultures! I was up half the night, constantly forced to leave the blind and drive them away."

Not that remaining inside the hide was giving him much comfort. A strong summer storm shook the tent all night, frequently threatening his equipment with rainwater and robbing him of the few chances for a nap between episodes of chasing off the nocturnal meat pirates.

When day finally brought its light, Francisco's troubles were far from done. "Over and over, the vultures would drop down close to the meat, but they would refuse to eat it. It seemed at times rather hopeless."

Countless other days in Cabañeros have been rewarding to the native of the nearby city of Toledo. He has enjoyed many wondrous moments here, when the Earth seemed to hold its breath as herds of red deer grazed on the *dehesa* wooded meadowlands, punctuated by the resonant bugling of male stags. Black storks, Spanish imperial eagles, otters, beautiful pink peony blossoms, and deep, river-

carved mountain gorges have graciously opened their beauty to his lenses. "I have had so many very good moments photographing in the park. But those vultures! You never know whether they will tolerate your presence. Sometimes they just go away, although you never know why."

Such are the time-honored triumphs and tribulations of all nature photographers.

THE PROTECTED LANDS
Inhabitants of Toledo were forbidden "either to cut or fell trees … or hollow them out to make hives, or prune them, or uproot them. Offenders will be fined 600 maravedis per tree and 50 maravedis per branch." (Law of the Council of Toledo)
JULIO MUÑOZ JIMÉNEZ, *Cabañeros: un bosque mediterráneo* (1977)

Europe is where the Industrial Age began. By the nineteenth century, most land was privately held; vast dense forest lands and the Atlantic grasslands were largely gone or, like most of the ecosystems on the continent, heavily modified by the millenniums-long presence of humans.

Today, Europe continues to grow, if not horizontally, at least vertically. Everywhere you go on the continent, from storybook castles and small rural villages to the crush of major cities, tall, skinny construction cranes rise, making the most of the limited ground space.

Yet the conservation movement that began with Yellowstone and flourished worldwide in the twentieth century has left its mark on Europe as well. New woodlands are being reseeded. Animals are being reintroduced into restored ecosystems. Burgeoning national park and biosphere reserve systems are to be found in 33 European countries.

The first nation on the continent to follow the U.S. concept of wilderness protection was Sweden, with its 1909 creation of nine national parks. Spain established its own national park system at the end of the Great War in 1918, after so much of the European landscape had been blasted and trenched into a death maze. Yet modern-day conservationists have nothing on the people of Spain, who have long practiced sustainable communion with the land.

The Iberian Peninsula hosts a wonderfully varied terrain of ecosystems that runs from high, rugged alpine zones to island ecosystems and balmy Mediterranean shores. Spain, in fact, has more wild and beautiful places than any other country in Europe. Spaniards and their colonial emigrants have for centuries felt an abiding kinship with the land. And by affording Cabañeros protected status, Spain continues its efforts to reserve ecosystems that reflect its diverse natural heritage.

Spain's environmental movement today thus favors public education over land preservation. Still, more than 1 500 km^2 of the country has been set aside in an enlightened system of twelve national parks plus hundreds of hunting and natural reserves and other protected areas.

On the opposite page, in early March, white storks begin to reproduce in Cabañeros by laying their eggs. The eggs will be hatched in late April, when the adults have to search constantly for food for their chicks. Nests are often built in cork oaks, gall oaks, and oaks located on the raña or large central plain, and offer one of this park's most authentic images.

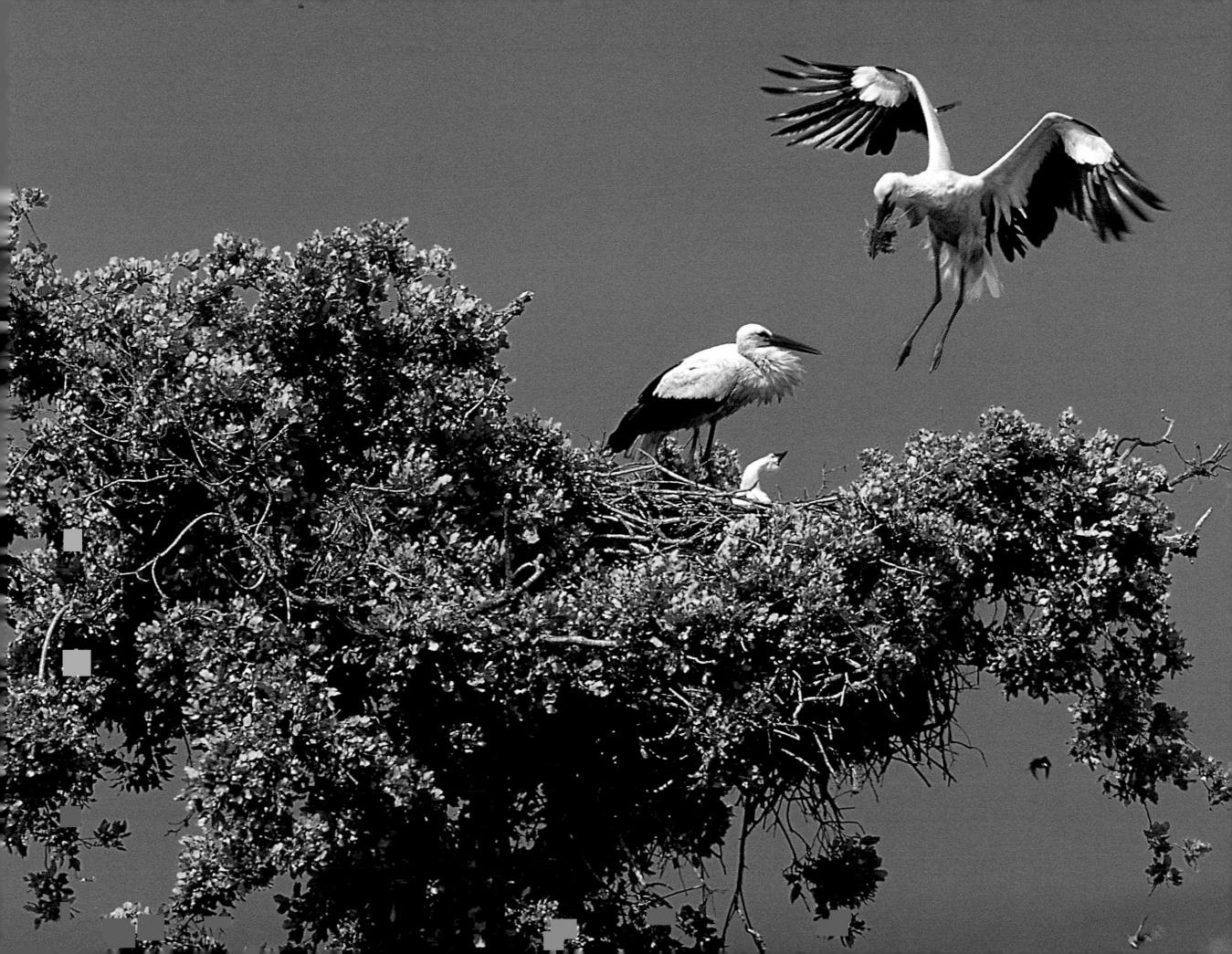

Like a *plein-air* pastoral oil painting, Cabañeros also serves as a perfect illustration of a rural environment that has long featured private- and publicly-held lands. Spanish country people have for centuries been encouraged and even mandated by law to live out their lives within an ethos of harmonic interdependence with the natural world. Sustainable development of natural resources has thus been a core practice of Spanish life for centuries.

HEART'S HOMELAND
To cherish what remains of the Earth and to foster its renewal
is our only legitimate hope of survival.
WENDELL BERRY, poet

If the occasional wildlife subject requires extra patience and dedication, as Francisco's black vulture episode illustrates, this photographer can think of no better environment in which to practice his creative devotions. "I have roamed the Mediterranean forests since I was a boy; it is an environment that is very close to my heart."

Although he was raised just 130 km from the lands that became Cabañeros, Francisco had never heard of the region until he grew older. Nearer his boyhood home, similar woodlands revealed their secrets of animal and plant life to him, and he was seduced forever after.

"I have traveled all over Spain and to many other places outside my country. I have been fortunate to photograph many spectacular landscapes and animals. But I always come back to the Mediterranean forests of my birth. That is where I feel most at home."

Spending time in blinds is therefore no new experience for Francisco, who specializes in photographing the entire story of nature reserves: their natural histories, biota, and environmental threats to their well-being.

"I have spent many hours hidden, watching wild animals. You enter the hide at night, and remain all day or several days, if necessary, locked up inside a square meter of space. You have a long time to think, especially when for long hours nothing in front of you happens."

An avid amateur shooter since 1980, he turned pro in 1987 and never looked back. His work has graced some hundred books, he has created four of his own, and more than 100 international magazines regularly carry his photography, which has won numerous awards.

Through it all has flowed a deep desire to make "personal photographic works" that allow him to share his creative vision of the natural world. "When you begin in professional photography, your major preoccupation is to become well-known. Once you know you can make a living in the market, then it's time to let your creativity run, rather than just spend your life making documentary images."

In the winter, this small, fierce kestrel, which comes from northern Europe, takes advantage of foggy days, or especially rainy ones to fly over the raña of the park hunting for small birds feeding on the ground, such as meadow pitpits, bramblings, and crested larks.

Picasso couldn't have said it better.

In Cabañeros National Park, Francisco Márquez finds the perfect fields for his dreams: a bountiful and historical natural environment and a park director predisposed to restricting public access to sensitive zones, while encouraging photographers and documentary filmmakers to extol the park's wealth of natural treasures.

ALL GOD'S CREATURES
Each country has three forms of wealth: material, cultural, and biological.
The first two we understand because they form the substance of our daily life.
The essence of the problem ... is that we take biological wealth much less seriously.
This is an error that we will be more and more sorry for as time goes by.
EDWARD O. WILSON

Cabañeros has its share of problems with the conservation of its ecology and wildlife. Once the bear and the wolf roamed all these lands. Now they are gone. Introduced plant species have eradicated the food sources of many native animals.

The plight of the Iberian lynx echoes the recurring story of the dark side of humans' relationship with the natural world. Studies show that the population of the feline predator has been reduced by half in just the last ten years. The litany of pressures against the lynx are sadly familiar: loss of habitat, reduction by loss of forage of its principal prey species —the rabbit—, and most distressing of all, trapping for its attractive coat.

Ways in which government and Cabañeros National Park officials and conservationist groups are working to save the lynx include increasing the population of rabbits, which will also benefit the threatened Iberian imperial eagle, and starting up captive-breeding programs to restore their numbers, which may be as low as 600 worldwide.

People are striving to make sure the lynx may return, to join the other landscapes, habitats, and animals that make Cabañeros such a treat for visitors. Famed already as a haven for its Mediterranean montane woodlands, the park is gaining increasing recognition thanks to its wildlife. Sightings of magnificently-antlered red deer stags are common. With a little luck visitors will also spy Francisco's pesky thieves, the wild boars, along with members of the black and griffon vulture species and the elusive imperial eagle.

Visitors are advised to bring binoculars or even telescopes, especially for the birds. There are 198 species of birds in Cabañeros. Three percent face extinction, including not only the black vulture that gives Francisco Márquez his share of creative headaches, but also the imperial eagle and steppe birds like the great bustard and the little bustard.

The black vulture is mounting a comeback. There are about 120 reproductive couples nesting in the forests. Current studies suggest another 24 percent of the park's birds are threatened elsewhere throughout Spain.

In the riparian environments of the several rivers that flow down from the mountains and through the *rañas*, ash forests include growths of king fern, yew, birch, and holly. They shelter the robin and chiffchaff, along with red deer, badgers, and the rare wild polecat, just some of the 276 vertebrate species to be seen in the park. Goshawks and sparrow hawks also thrive in the bountiful ecosystems of the rivers. Otters, too, are found in the river environments of Cabañeros, along with salamanders, common frogs and toads, and even water snakes.

Down in the *raña*, bee-eaters and hoopoes add their songs to oaks and ashes. When the great plain is green and carries large areas of standing water, cranes, lapwings, and golden plovers make abundant use of the proliferation of food; in a few months' time, the heat will turn the plain into a dry savanna.

White storks perched atop the inviting spread of the *raña's* oak trees are an iconic sight in the southernmost part of the park, where they forage for the plentiful grasshoppers. Strawberry trees, guelder roses, myrtles, and other evergreen, bright-leafed plants typical of moist tropical climes bring joy and color to the *rañas*.

GUARDING THE FUTURE
I decided to take up photography for a number of reasons. I loved nature, and I was not attracted to a conventional way of life that offered me only a routine, and little stimulating work.
FRANCISCO MÁRQUEZ

"The first thing you notice about Cabañeros is the silence, the sensation of peace," says Francisco. "It is a great contrast to the cities where we live, with their floods of cars and noise. And then, the eyes arc in for a feast, especially in spring, when the Mediterranean forest wears its best colors. The peonies, lavenders, rockroses, and others bloom, but only if it has rained enough."

In summer, the forest reverts to its characteristic olive drab coloration, providing a fitting backdrop for the *rañas*, which take center stage as their grasslands turn dry and golden.

Francisco not only loves Cabañeros as a sublime and beautiful example of an intact Mediterranean forest, but because it provides a nourishing and safe habitat for animals that have become rare or gone extinct in similar climatic zones that have lost their trees.

The two distinct areas of the park —the craggy, wooded sierra and the lower *raña*— have their respective sets of flora and fauna: The rare Iberian imperial eagle, black vulture, and the particularly endangered Iberian lynx can be found in the foothills and mountains, along with a great number of plants like the oak, gall oak, Turkey oak, and cork oak. "That makes it a very special place to me," says Francisco. He is proud that his native country values and conserves a great many near-virgin natural spaces like Cabañeros, and ensures they are properly managed and protected.

"This park is an oasis of life but also of tradition, a tradition of natural conservation that lives in the history of the towns that still surround Cabañeros. Spanish people believe in nature, working with the land while protecting it for themselves and future generations."

For example, locals still harvest the regenerative bark of the cork oak, as they have done for centuries. Once the spongy bark is stripped off, it grows back better than before —talk about a renewable resource!

And yet, Cabañeros might never have become a national park at all, were it not for the tenacity of intellectuals, ecologists, journalists, and private citizens from around the country who opposed the utilization of this land by the Spanish Army as a shooting range.

A CRY FOR THE LAND
Man masters nature not by force, but by understanding.
JACOB BRONOWSKI

The flat pasturelands of Cabañeros, isolated and virtually unpopulated, sitting conveniently, from a strategic point of view, right in the middle of the nation, offered an ideal open territory for military maneuvers. Or so proposed the Spanish Ministry of Defense, and then the government in 1982, when it called for a 16 000-ha area to be set aside as an aircraft bombing and shooting range.

But this was the 1980s, and this was Spain. Conservationist groups locally and around the world howled in protest, staging demonstrations and bringing public attention to the area. The government eventually abandoned its proposal in favor of turning Cabañeros into a protected natural park and finally, with an increase in area, a national park in 1995.

Cabañeros today owes much of its still-representative Mediterranean ecology and beauty to centuries of forward-looking civic leadership. The lands of the Montes de Toledo have changed hands many times throughout history. The Romans, Visigoths, and Moors are only the most illustrious of many tidal influences on the rich Iberian culture and its dominions. But the story of the preservation of Cabañeros and its greater surroundings perhaps really begins with King Ferdinand III, who in effect turned ownership of the land over to the people of the town of Toledo near the end of the thirteenth century.

Over the next 500 years, a strict policy of preservation that would compare favorably with the tenets of modern conservationism explains how the diversity and vitality of the ecosystem survived largely intact into modern times. A key factor was the official opposition by the ruling Council of Toledo to new farm settlements in selected large tracts throughout the region. The Council entreated the city people who worked the lands that would one day become Cabañeros to neither "destroy nor lay waste" the woodland vegetation

The European wildcat is another of the carnivorous mammals found in Cabañeros which, just like the lynx, depends on rabbits for its survival. Nowadays, its principal threat consists of hybridization with domestic cats, which could lead to the disappearance of the original form of this cat in its pure state. This is a widespread problem in all of Europe, and has yet to be sufficiently studied.

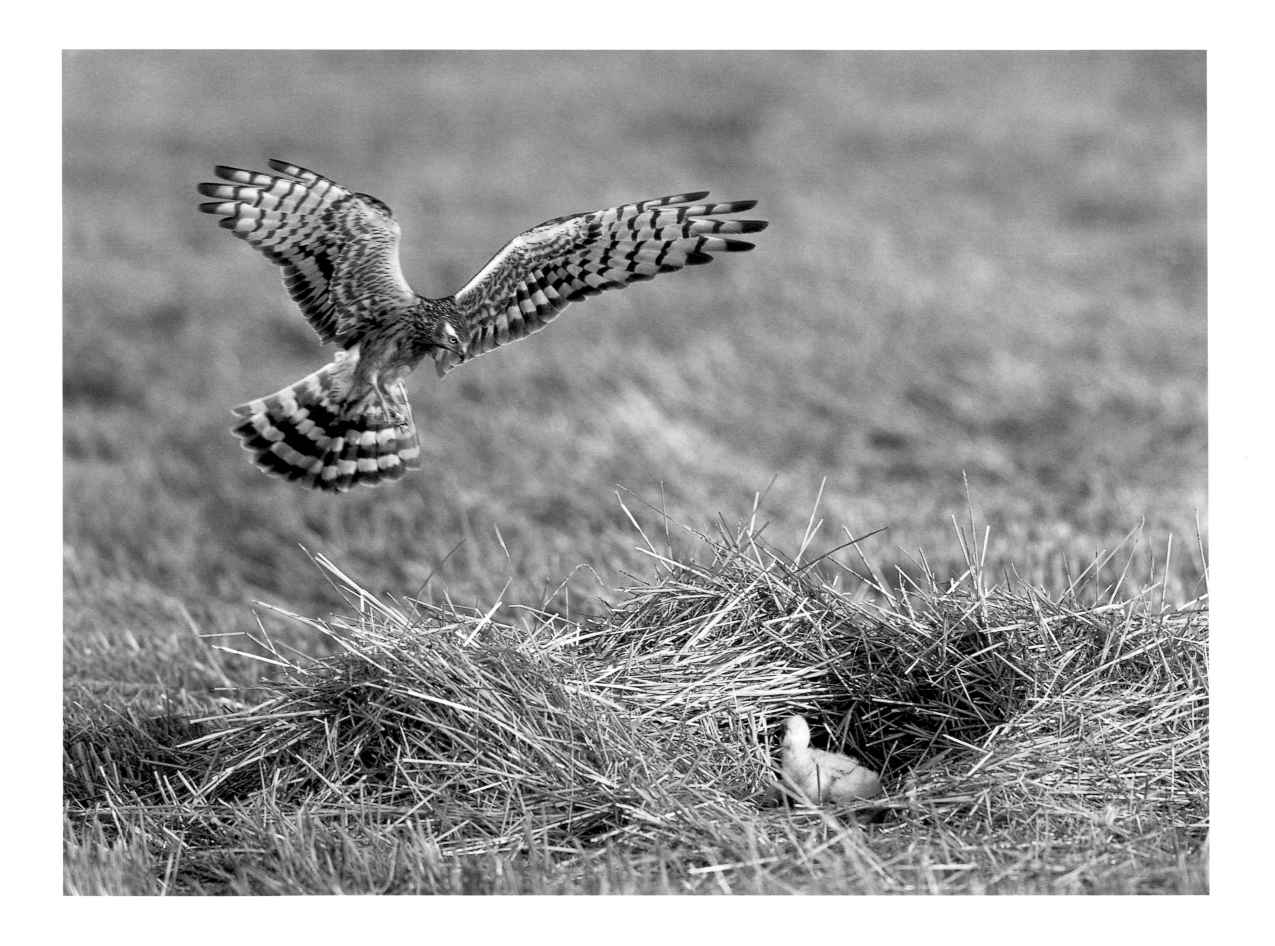

nor adversely impact the "conservation of the game commonly found there."

In these protected areas, Toledoans were also permitted logging only for their own needs, and could gather kindling and burn charcoal, again strictly for private use. Small domestic livestock herds, cork harvesting, and beekeeping were allowed. Uprooting of undergrowth for crop cultivation was forbidden. Only small parcels could be set aside for the sowing of wheat.

Cabañeros today includes lands that show the tradition of olden days. Since the *rañas* near villages were most suitable for cultivation, they were plowed, while vegetation in more remote *rañas* and the mountains remained largely untouched. Much of even the cultivated land was rocky anyway, and with the fog and freezing temperatures prevalent during the colder seasons, farming and the attendant growth of human populations were at best limited in potential.

THE NEXT THOUSAND YEARS
A generation which ignores history has no past and no future.
ROBERT A. HEINLEIN, *Stranger in a Strange Land* (1961)

"The park restricts access to its most sensitive interior areas," says Francisco. "This is one way the park system controls overcrowding, although there is pressure all the time to increase access and add activities; Cabañeros has become very well-known throughout Spain. But the management makes sure the land and its animals are protected."

Increasing the rabbit population to provide more food for the endangered arboreal species, creating new breeding grounds, and improving reasonable public access to the park are priorities for the future.

"We need to continue to sensitize the public to the need to conserve nature. Photography is so perfect a medium for catching the attention of the people. It raises sensitivity for the plight of threatened animals, plants, and landscapes in the world, generates concern in their hearts, and moves them to demand changes."

When Francisco was a boy, he was very fond of birds. On weekends, he would go with friends into the fields just to catch fleeting glimpses of them. "When I was 17, I began to photograph them with a camera my parents gave me. That simple gift changed my life."

Like so many nature photographers, his love of animals first led him to consider the idea of pursuing a career in biology. "But when I was about to enter the university, I decided instead to embark upon the adventure of photography. It was a risky idea: in Spain, there were not many opportunities at the time to make a living with a camera in nature," he says with a laugh.

"Fortunately, this adventure came out well. I can't conceive of my life without photography and the freedom to plan my life as I want."

Beneath the broad umbrella canopies of the oaks, summer shade brings a sense of safety, like a mother. The rocky mountain walls low in the distance invite imagination worthy of Don Quixote; ideas come on the wings of dry, warm breezes. Life feels good. The future seems bright and worthy of our best efforts. We wish to stay, just a little while; to sip wine, break bread, and sing the praises of this beautiful world that we love so much.

Such is the legacy and the promise of protected lands.

On the opposite page,
Montague's harrier is a bird of prey that has evolved to a point that it flies like no other.
It spends half of the day flying over the open spaces it inhabits, drifting in the wind like a kite. In Cabañeros,
one can find the nesting variety of this bird, which builds its nest where grain is cultivated.

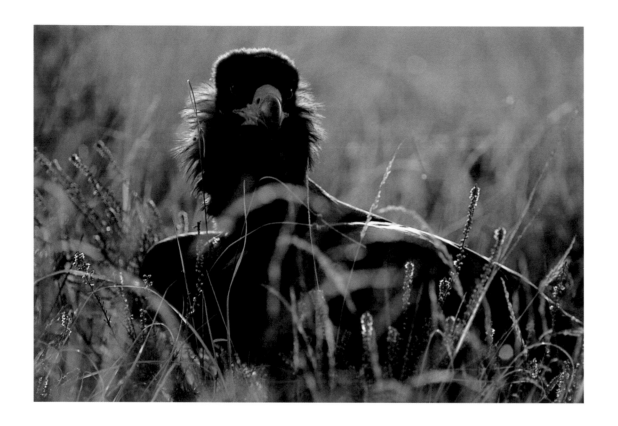

The black vulture, commonly known in the region of Montes de Toledo
as an abanto, *is one of the leading flagship species of Cabañeros,*
the site of its second most important breeding colony in the world. Easy to spot anywhere
in the park, this bird is most conspicuous in the autumn and winter, during its mating season.
Moreover, it is one of the most aggressive vulture species. On different occasions,
it has exhibited a distinct form of cleptoparasitism towards other species,
which has been observed and described.

On the opposite page,
for years, Spanish conservationists and scientists demanded a national park comprised
of Mediterranean woodlands, the most genuine ecosystem on the Iberian Peninsula,
which was still not represented in the Spanish network of parks.
Finally, in November 1995, the Congress of Deputies approved a law
which gave Cabañeros national park status, as had been requested for so long,
after many vicissitudes and resolute pressure on the part of society, which saved
this incomparable natural area from becoming a military shooting range.

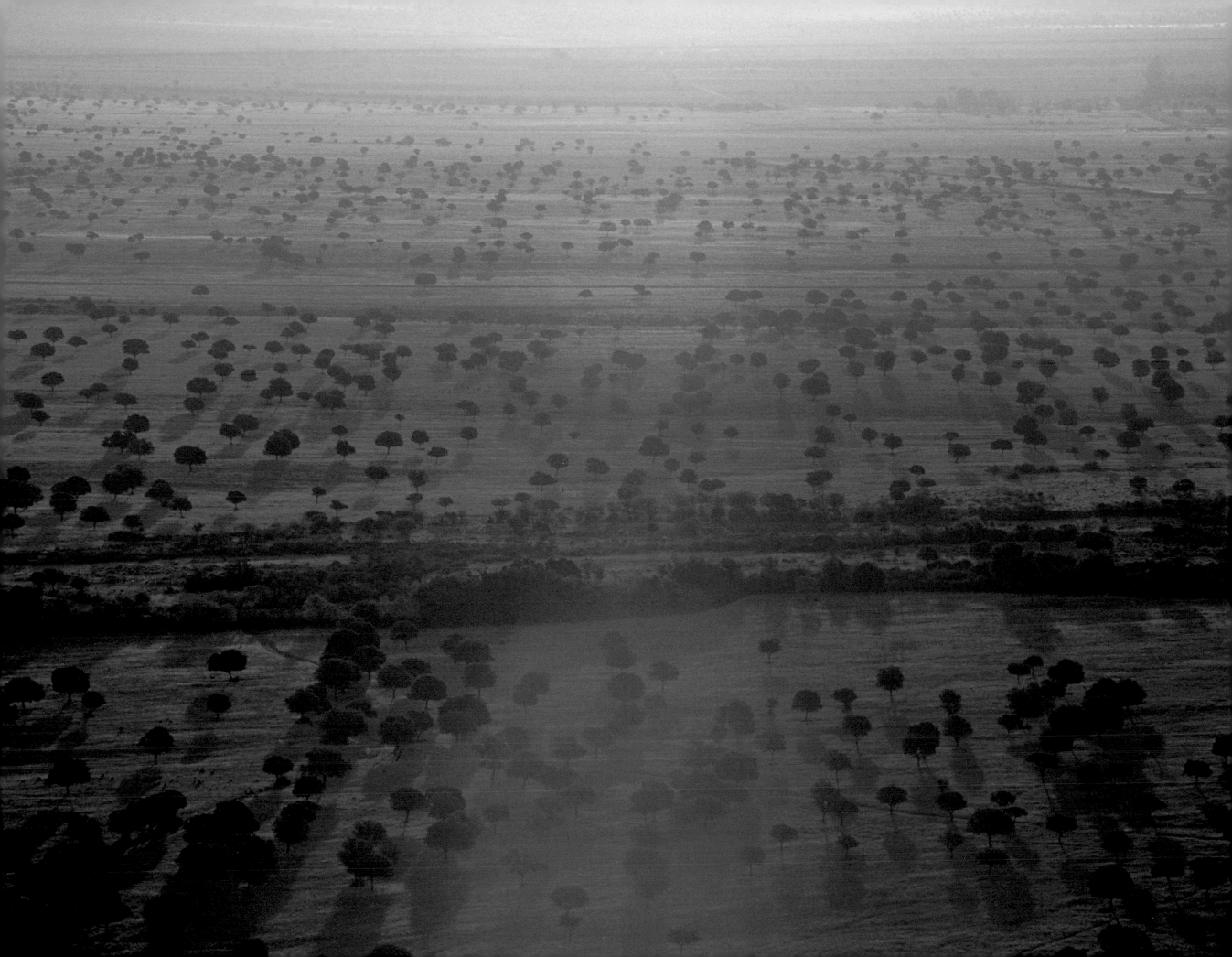

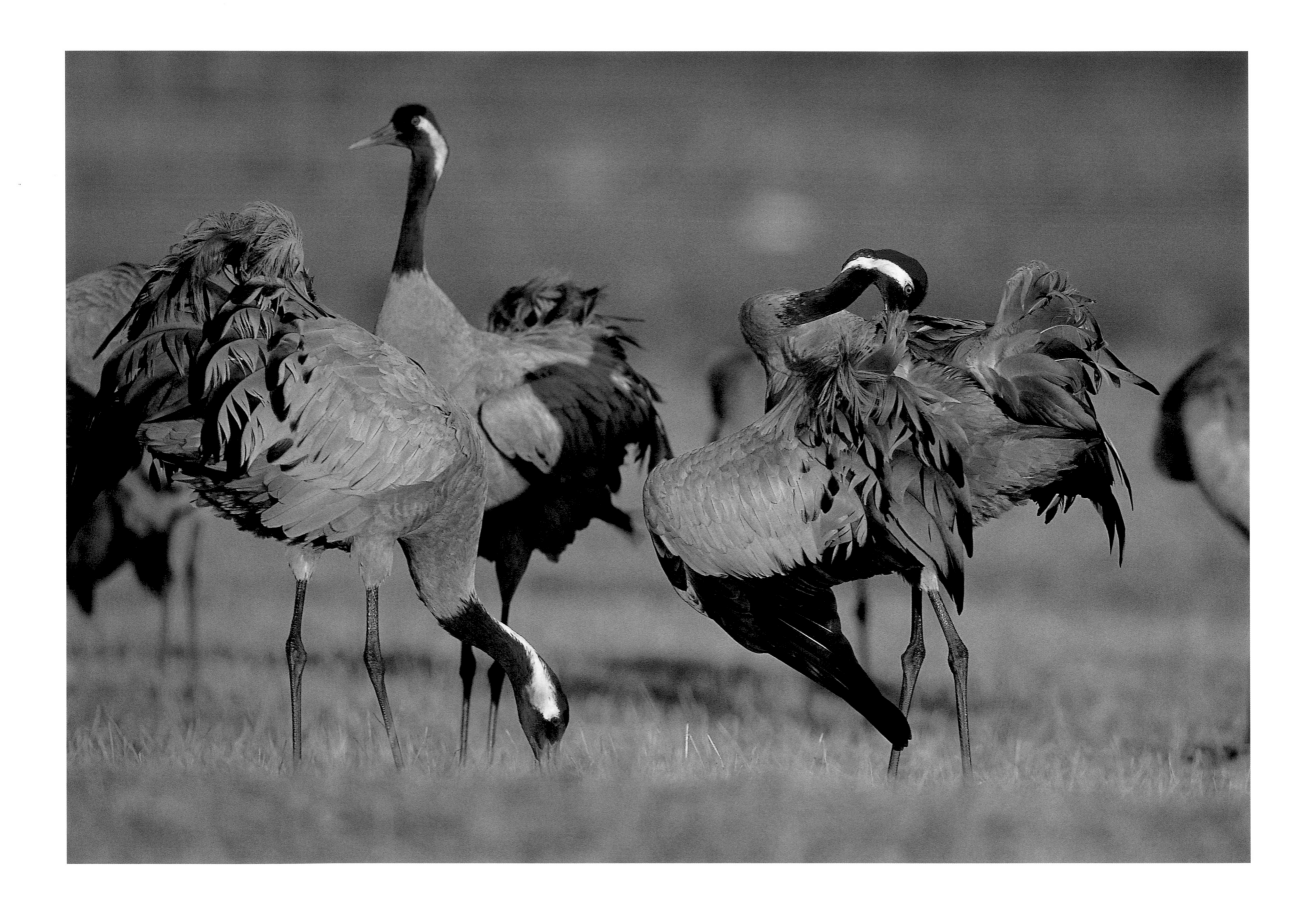

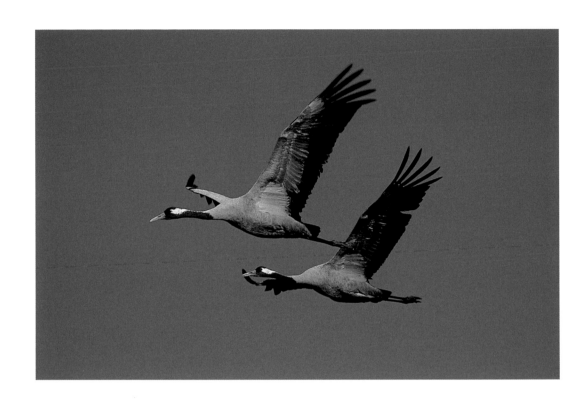

On the opposite page,
Cabañeros is a stopping and eating place for approximately 300 Eurasian cranes
from northern Europe which come to Spain to winter. It is easy to spot them in grain fields
located in mixed pasture lands with oaks and gall oaks.

Above, Eurasian cranes fly across the skies of Cabañeros twice a year:
in late October, when they arrive, and in early March, when they leave.
A small wintering population settled in the park as of 1990.

On pp. 200-201,
a storm is threatening, and rain is always welcome in these rugged, fragrant hills.

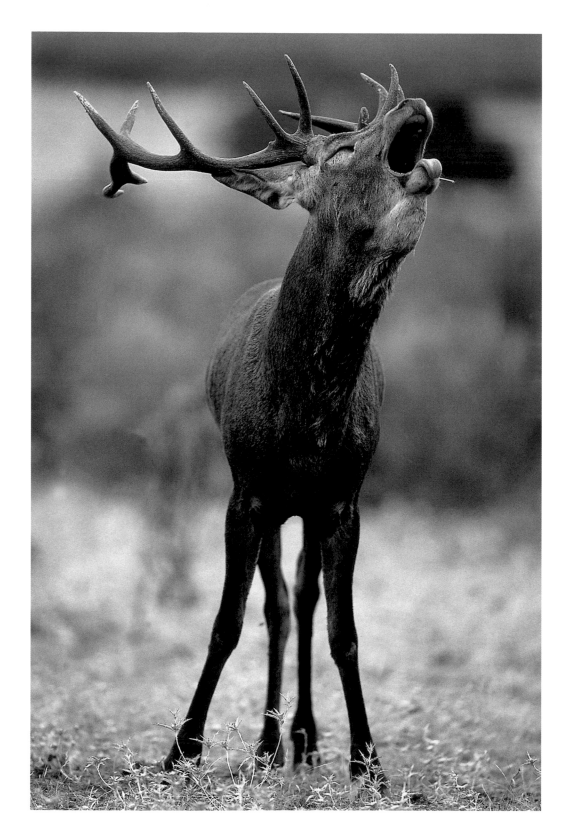

In early September, red deer fill the sierra with the thundering sounds
of their bugling during the rut. This bugling is a type of signal-response
behavior of the males to maintain a prolonged state of excitement,
and also one of the most unforgettable displays offered by Cabañeros.

On the opposite page,
after eating the remains of a dead animal in the field,
a griffon vulture opens its wings to tidy its feathers and take a sun-bath.

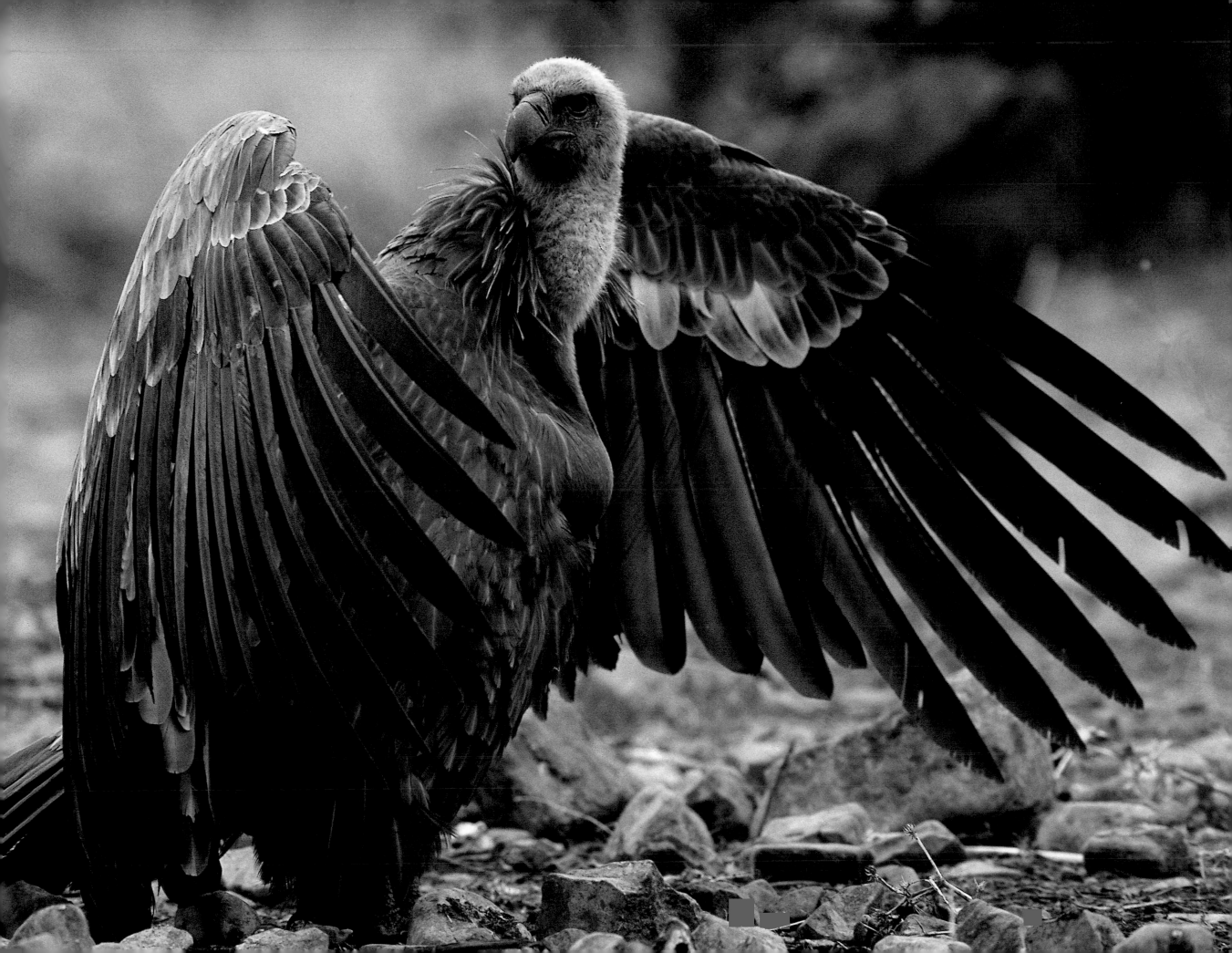

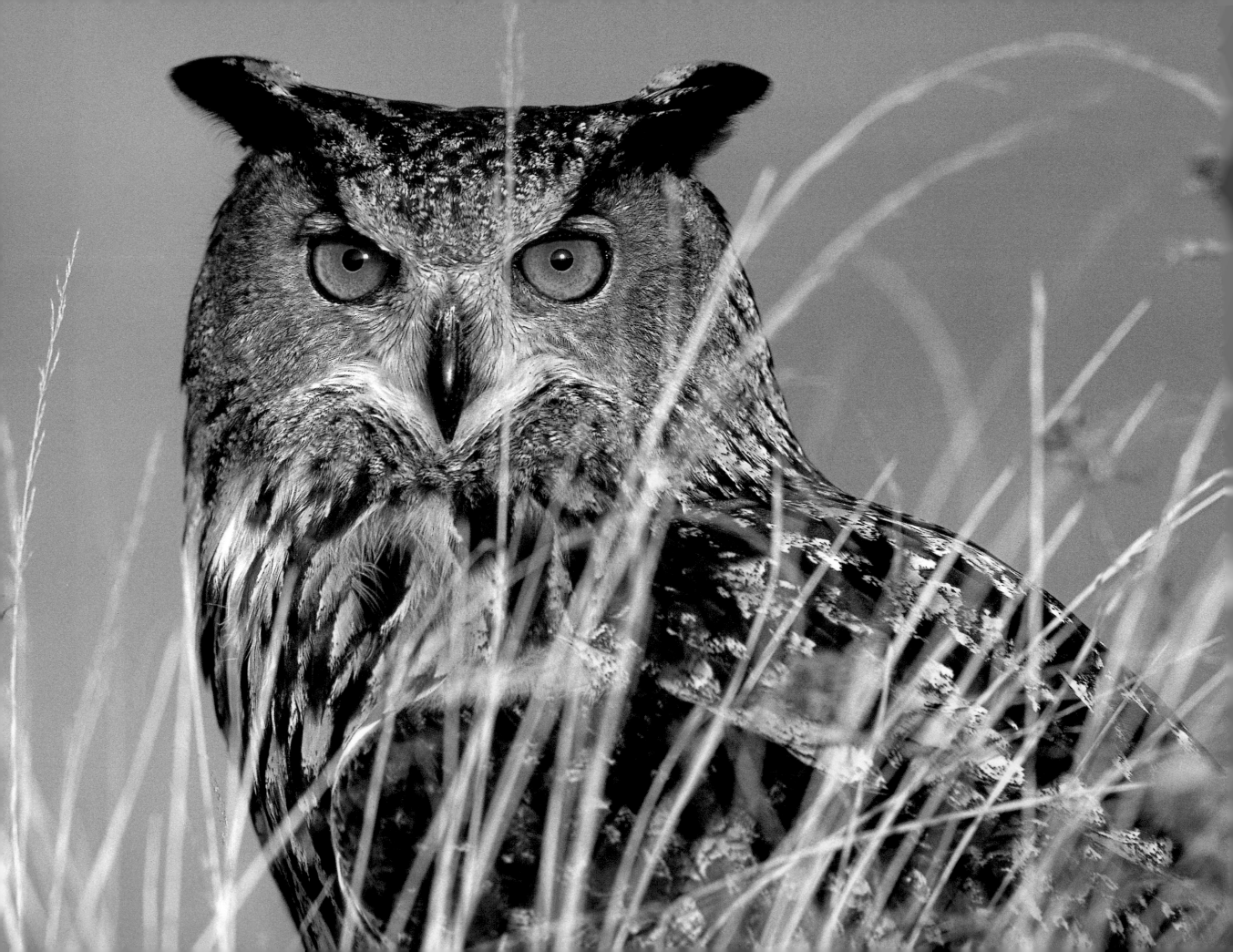

On the opposite page,
the largest of Spanish nocturnal birds of prey, the eagle owl is another
of the inhabitants of the crags of Cabañeros, as well as a consummate predator of
mammals. It isn't easy to see them, due to their extraordinarily mimetic plumage,
but their characteristic hoot can be heard from November to January,
during their mating season.

Below, the Iberian lynx still roams about the sierras of Cabañeros,
but its numbers are very small. It is believed that here, it does not reproduce
due to the scarcity of rabbits, its main prey. The situation of this species
is alarming throughout the Iberian Peninsula, and it is seriously threatened
with extinction in as little as 20 years if its plight is not remedied.
It is the most threatened feline in the world.

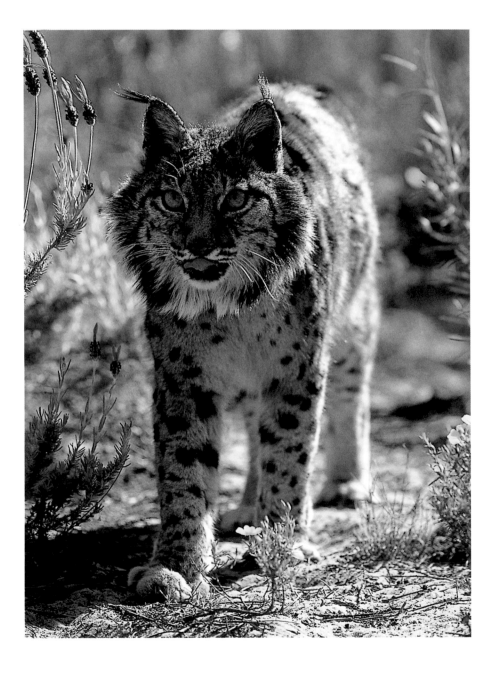

The Iberian imperial eagle is one of Earth's large birds of prey that is most threatened.
In Cabañeros there are two adult breeding pairs and some 6-7 young birds during the winter.
Its low density in the park can be explained by the scarcity of its main prey, rabbits, and competition
with other species such as the golden eagle and other predators.
That makes it necessary for this eagle to have vast feeding grounds of over 8 000 ha.

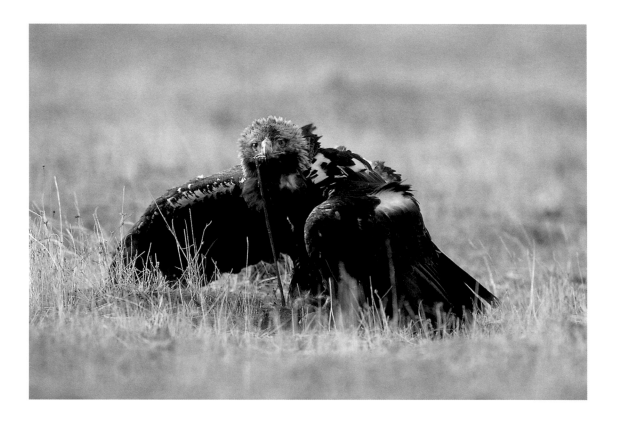

On the opposite page,
in the late afternoon, a common fox hurries to sink its teeth into a dead female red deer. It is the first
animal to arrive, before the crows, eagles, and vultures which will devour the carcass at daybreak.

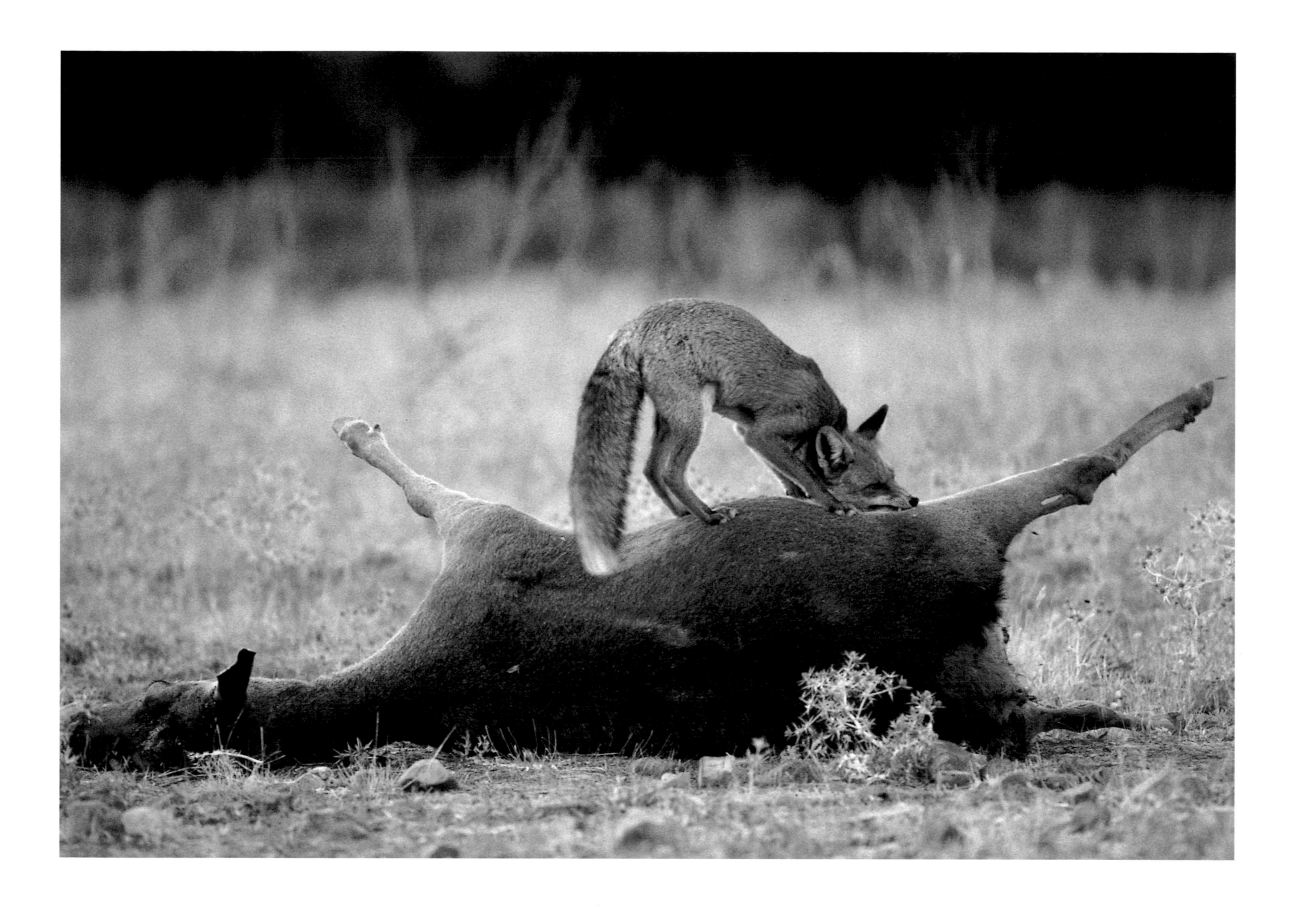

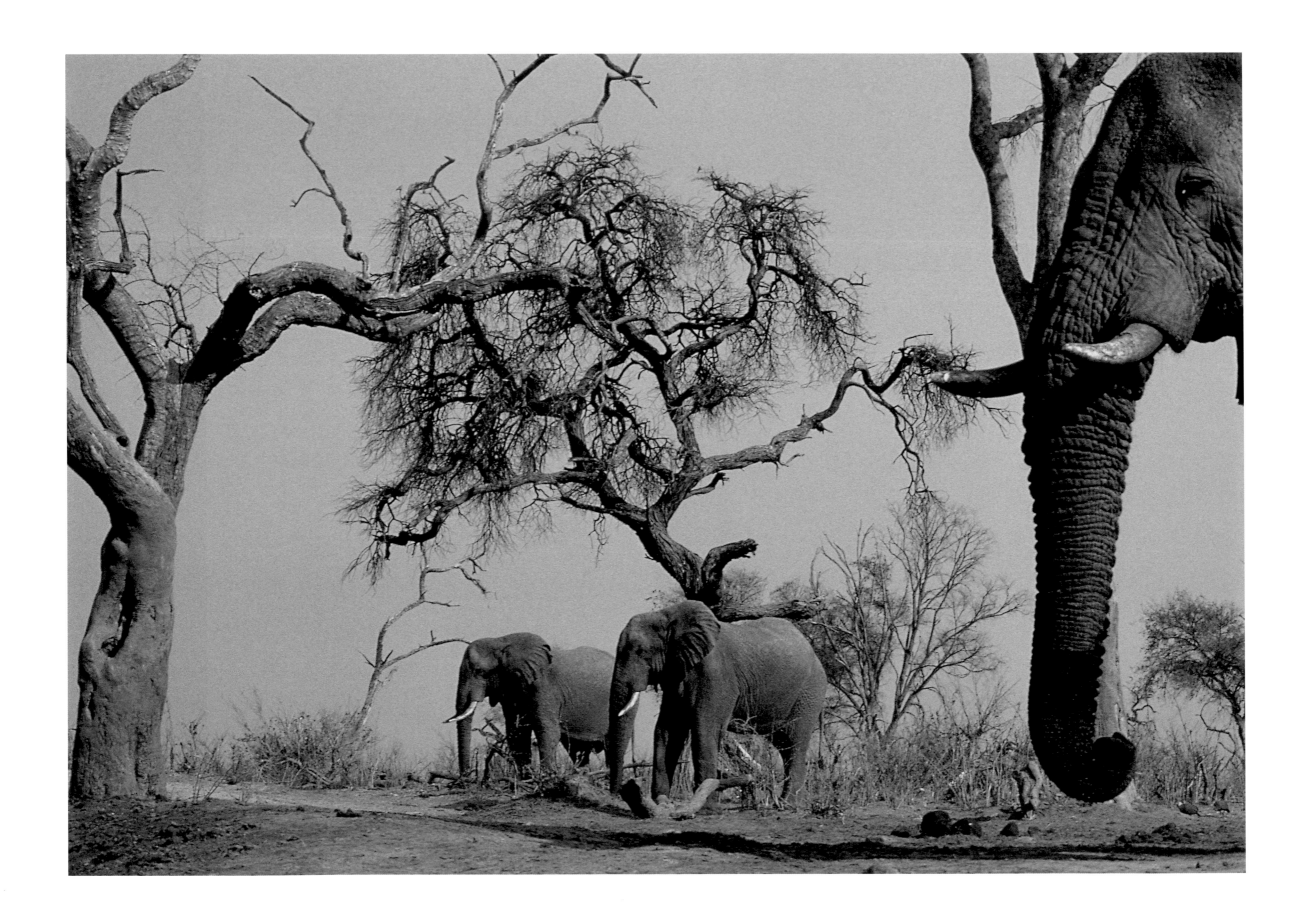

THE LAZARUS LAND
Chohe/Kalahari/Okavango Delta Region
Photographer: FRANS LANTING

Wilderness preserved is the hallmark of civilization.
KEVIN A. PEER

Listen: Can you hear it? Is that a drum echoing deep in the distance?

A blistering, arid stillness lies like a flame upon the land. The clean desert air of the plateau has been dry for months; the animals are both listless and irritable. They know it is coming, but when? When will their Eden renew?

Again, the deep rumble. Perhaps it is the Earth, grumbling. No: it is lightning from the line of thunderstorms boiling into the sky beyond the far, flat horizon.

The panting lioness lifts her head to sniff at the air. The elephant throws another spray of dirt on its back to ward off the insects, then stops.

The water is coming. They can feel it.

Even the humans who live nearby sense the change. Flowers are beginning to bloom, though the earth is still cracked and dry. "Suicide Month," as the locals call this time of growing tension, is nearly over. The water is coming.

Nearly a kilometer from the elephant's swampy refuge during the dry season, completely entombed within the cracked, dried mud of a dead pond, a bullfrog lies in estival dormancy. When the flood comes, it will struggle free of its life-preserving membrane to return to a nurturing world: the waters of the floodplain. Perhaps it will be eaten by one of many birds that will come here, where none are to be found now in this oppressive, heat-blasted wasteland. If the frog survives, it will return to its dried-mud sarcophagus, to rise like Lazarus during the following year.

But now the world that holds it fast is still a relentless desert. The frog must wait its miracle of rebirth, like all the animals, for just a little while longer.

This is the Okavango Delta, a vast alluvial plain that, every fall, restores the miracle of life to Africa's southeastern desert and savanna scrublands. Starved for water several months of the year, the entire plant and animal biosphere slips inex-orably toward the ragged edge of severe deprivation. Great migrating herds of zebra, elephant, buffalo, and wildebeest go far afield in search of life-giving water.

Many mammals, fish, and birds retreat to the swampy core of the delta to wait out the dry season, altering their survival patterns until the arrival of the next flood they have evolved to expect. Lions, elephants, deer, fish, reptiles, and birds share what water they can find while playing out the daily dramas that ensue from their contact. And when the flood comes, all life rejoices. Even the lions find the inclination to engage in a little play. With the water comes a carpet of green to spread quickly onto the vast Kalahari Desert, more than doubling the size of the verdant biorealm that will soon welcome the hordes of returning animals. Life, like a wheel, turned by water.

STRANGER THAN FICTION
In nature's infinite book of secrecy /
A little I can read.
WILLIAM SHAKESPEARE

"In my mind, the Okavango Delta is a world-class wonder," says Lanting, remembering the excitement of his discovery and subsequent three photographic odysseys to the southern African paradise.

"Imagine if I said, 'There is a river that starts somewhere in a mountain range and flows hundreds of kilometers into the middle of a dry desert. It transforms this desert into an immense, bountiful oasis that attracts thousands of animals.' You would think I was telling a fairy tale or describing a movie script!"

"There is something really unique there that is born out of a geologic anomaly. Fault lines made Okavango the way it is. Normally, fault lines are not that noticeable in the landscape. But because Northern Botswana is so totally flat, even minor faults become boundaries of significance, because there are very few features there that break the horizon."

He tallies the rocky formations of the Tsodilo Hills, famous for their ancient

On the opposite page, Frans Lanting thought this photo in the dry, parched landscape captured a listlessness "that I sense in animals at the end of the dry season." The torpor seems pervasive among all species, but is especially evident in elephants, which he finds "so expressive." Note the dry, stripped vegetation everywhere, telling signs of prodigious pachyderm appetites.

rock art. Like Australia's Uluru and Kakadu sites, these isolated chunks of rock that rise from the endless expanse of the Kalahari are a treasure-house of cultural significance. Tsodilo has been inhabited by ancestors of the San people for perhaps 35 000 years and displays more than 3 500 rock paintings.

The animal, human, and geomorphic designs painted in ochres and whites clearly depict zebras, rhinos, humans, and even whales; this speaks of travels and contact with other cultures far from this desert.

"Botswana is flat as a pancake, by and large scrubland. A different ecology than people generally equate with Africa, like the golden plains of the Serengeti. The dominant vegetation type throughout southern Africa is miombo woodlands." Miombo is a deciduous tree that thrives in a lengthy dry season and drops its leaves for most of the year.

"Now picture you're driving through this harsh Kalahari Desert sand and scrubland, and suddenly, you're at the edge of a swamp! Now you see dense clumps of papyrus and other reeds, fish jumping out of the water, and birds everywhere. It's miraculous. It's a place where lions swim and giraffes wade through water; quite unparalleled anywhere else in the world."

In his photographic career, Frans has endured every privation from freezing Arctic cold to malaria to long periods of isolation from human company. And because he immerses himself for weeks and often months into every nuance of the ecosystems he visits, he remembers vividly the feeling of the Okavango.

"The end of the dry season is a dramatic demarcation. The desert is parched. It's winter and because you're on a plateau, you need a down jacket. It's freezing in the morning, you can see the breath come out of your mouth. Some mornings you even need gloves. The air is super dry and super clean; it hasn't rained in months."

"And then you look down to where you're standing on dry desert sand, and you see the waters of the delta trickle in around your feet. The water has finally made it down from Angola and has begun to fill out the edges of the delta. Things turn green overnight. Herds appear out of the bushland. It's magic."

ANATOMY OF A MIRACLE
We never know the wealth of water 'til the well is dry.
English proverb

Imagine two fault lines, roughly parallel and 160 km apart. Next, visualize the plain between them as a gigantic elevator floor. Watch as an earthquake along the fault lines drops the "floor" a few meters. Now bring in a seasonal supply of floodwater and its silt cargo, courtesy of the River Okavango. Kick back for a million or so years and watch the Okavango Delta form.

The river is the pulsing lifeline of this largest inland freshwater delta in the world. Fed by mountain runoff from seasonal rains 960 km north in the African nation of Angola, the Okavango meanders from those headwaters ever southeast, until it spills over the edge of the Gomare Fault in Botswana. That long break in the flat plain splays the river out into a broad alluvial fan of channels and smaller, shallower waterways.

More than 9.9 billion cubic meters of river water carry nearly two million tons of sand and silt during a typical flood season. Over the millennia, the delta has become a lavish paradise of botanical life that grows to an 28 490-km^2 floodplain in some years, swelling the dry-season, perennial swamp that takes up just over 10 360 km^2 while carrying welcome water onto the utterly parched lands beyond.

More than 97% of all the delta floodwaters, as well as the moisture from a second season of local rainfall evaporate, transpire through the leaves of vegetation, or sink into the earth. The remainder runs up against the Thamalakane and Kunyere Faults, which act like a 240-km natural dam, diverting the water into the Boteti River. From there it continues its journey south and east, toward the vast Makgadikgadi Pan that was once a mighty lake and is now a flat, dry salt bed that only irregularly receives the gift of measurable standing water.

And now you know why Botswanans call the Okavango "the river which never finds the sea."

LOW-ANGLE GUTS AND GLORY
There are places and moments in which one is so completely alone that one sees the world entire.
JULES RENARD

The big bull tusker is getting uppity again. He's swaying back and forth on his front legs and spitting water with his trunk in Frans Lanting's general direction. The intent is clear: he's sending Frans a "pick another spot!" message.

For Frans, the trick is knowing when to move ... and when to stand his ground —or water. This big tusker has displayed before without forcing the issue to dangerous levels. And besides, this is where Frans thinks he may get the shot he's been thinking about and working towards. Right down here, kneeling to shoot at toenail level with the huge pachyderms crowding the edge of the pond, he senses everything is about to come together.

Frans is famous for taking his photography to a higher level, which he describes as telling stories. That and his meticulous execution of his art and craft are what have made him perhaps the most celebrated nature photographer in the world today. Frans doesn't just take pretty pictures of the natural world. He gets the dirt of a place under his fingernails, its smells into his pores. He's as likely to crawl on his belly like a reptile to cozy up to a dangerous caiman as to spend weeks acclimating a nesting albatross to his beneficent presence.

As always, he's looking for ways to tell that story, ever a variation on a theme: Life is complex, fragile, beautiful, and always changing; animals need us to protect, not destroy, their world; it is the photographer's mission to give a face to a place and its characters —so we will care enough to take steps to protect and preserve them.

On the opposite page, a group of zebras enjoys a peaceful moment on the Savute plains, where they typically gather in great numbers during the rainy season. A looming thunderstorm promises more water.

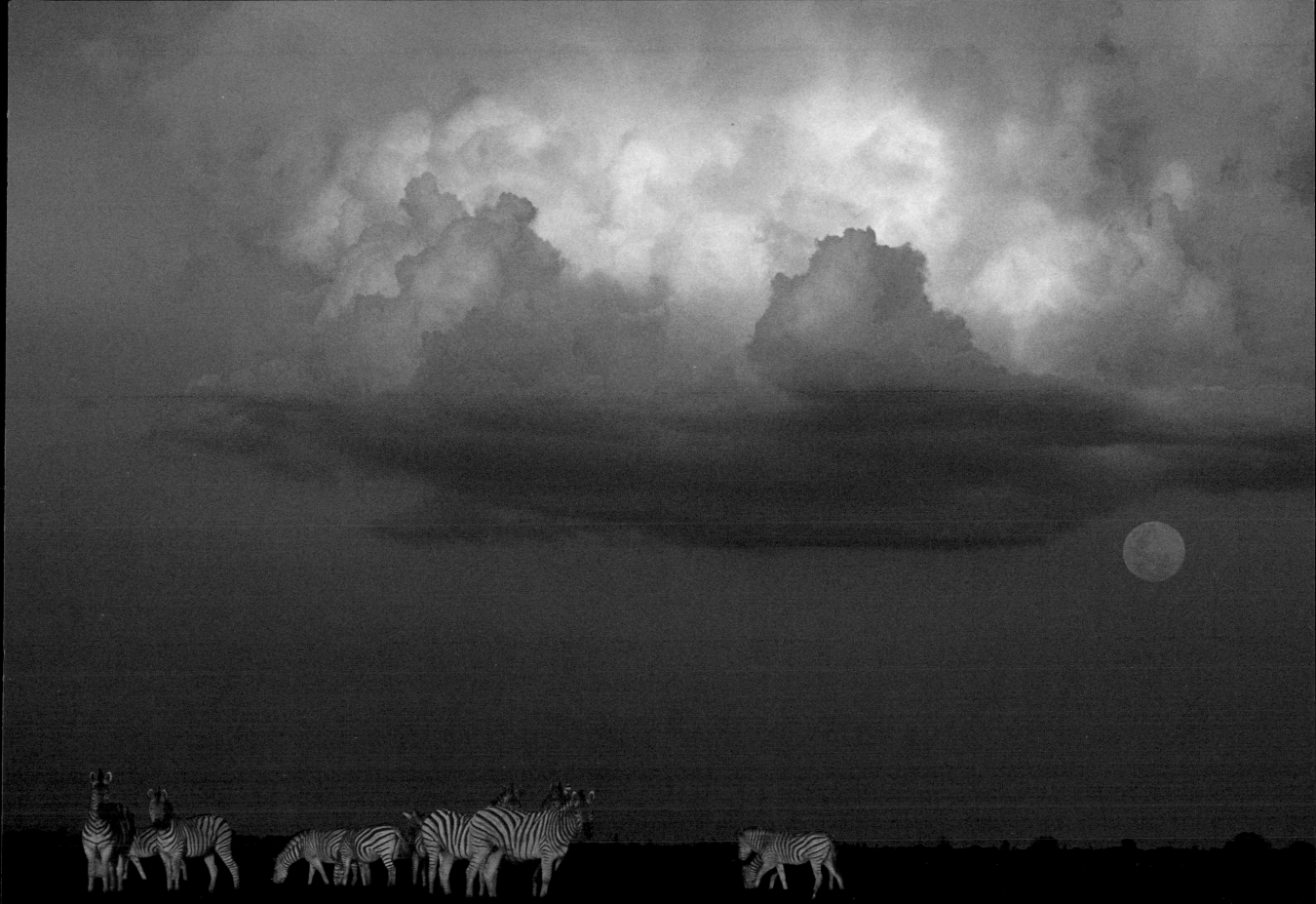

He has been crawling through bogs and hanging from trees long enough to know the natural world is shrinking, animals are disappearing, the seas are warming, the Edens are vanishing —all because civilized humans have sought to abandon any sense of connection with their animal origins. In helping people see the beauties and threatening tragedies of our remaining paradises, sometimes right under our noses, Frans carries forward a lifelong advocacy for all life that began in his childhood.

Now, as he crouches down in the shallow water just a few meters offshore from the crushing potential of the elephant's massive, tree-like gray legs, Frans searches for that composition which will illustrate this particular chapter of the larger story: in the ever-changing dry/wet world of the Okavango, thirst is the common language. By framing just the elephant's legs in such a way as to include a distant impala drinking from an adjacent bank, as if in the midst of a gray forest, Frans at last has the image he had conceptualized.

He works the scene for some time. When the bull elephant again demonstrates his irritation, Frans slinks off in a pose of subservience, averting a charge and perhaps real danger. Flocks of birds descend to drink. A small herd of zebras wades into the water, eyeing all the while four lionesses a few meters across the pond who have also come to slake their thirst and beat the heat.

Through it all Frans roams, just another animal with an appetite that may be more abstract than physiological, but is nonetheless vital to his existence and well-being.

MIRACLE OF THE WATERS
Nature often holds up a mirror so we can see more clearly the ongoing processes of growth, renewal, and transformation in our lives.
MARY ANN BRUSSAT

The floodwater that comes to restore the parched Kalahari Desert tableland covering most of Botswana is the seminal event for this entire region. It arrives at the peak of stupefying autumn temperatures in March and April, six months after it left the Angolan highlands. It takes another four months or so for the waters to make it all the way to the bottom of the delta.

Transforming the desert in such a dramatic fashion provides, in effect, a giant wateringhole for hundreds of species of large and small animals, many of which would otherwise never be found in a desert like the Kalahari. Fish, shorebirds, crocodiles, hippopotamuses, and swamp antelopes feed on the vegetation that explodes from the land that was so barren just days earlier. The world's largest protected elephant population and the second largest herd of migratory zebras share the wealth that water brings.

The Okavango Delta's geology is by nature unstable: faults adjust to tectonic pressures by shifting. Watercourses fill up with sand and debris over time; huge islands, mat systems of papyrus and termite mounds, divert the flow.

Change is the one constant of a landscape drama written in sand a million years ago.

Although almost all the flood remains on the delta through evaporation and transpiration, enough water flows onward to remove the dissolved salts, which allows the delta to remain a freshwater system. If it did not have so many outlets over its broad expanse, the delta would have evolved into a single saline pan like the neighboring Makgadikgadi to the southeast.

In the delta's perennial swamps, two plants predominate: the Phoenix palm and the papyrus, a reedy giant sedge used by the Egyptians millennia ago to make paper. Papyrus grows in large floating beds over water that can run as deep as 4 meters.

You need look no further than the aquatic life of the delta to appreciate the full range of its biological profusion. More than 35 million fish of nearly 80 species provide a rich diet for a host of predators. A common sight in the Okavango swamp is an anhinga or snakebird sporting, then downing whole, the bream it has just snatched from the water with its long, pointy beak. Bream are the most numerous fish of the ecosystem, thanks largely to the crocodiles which prey heavily on the bream's main predator, the tiger fish.

Life in the Okavango is one endless round of cooperative evolution. Hippos, which along with crocodiles are the largest permanent swamp dwellers, fulfill an engineering role by dredging water channels through the reeds and fertilizing vegetation with their considerable quantities of waste matter. In nightly rambles through their watery world in search of exposed forage, they bulldoze a network of trails for the sitatunga and other antelope species which cross the swamps during the day.

By thrashing around in the reeds and papyrus islands, hippos also make it easier for crocodiles to build nests for their young. Crocs are carnivores, first of fish, then as they mature, of mammals. But the "river horse" is strictly vegetarian, so there is little conflict between them.

The swamps are ringed by forest belts of tall miombo trees that provide shade for large animals and nesting opportunities for many of the more than 400 bird species so far recorded in the delta. Beyond the forests, drier, Serengeti-like savanna parklands are host for the highest concentrations of predator and prey animals.

Wandering prides of lions in congress with cheetahs, leopards, the endangered wild dog, and their hated rival the hyena, do what they have always done: keep the balance of life by preying on the nearest of the ungulates and other animals.

In the forests and savanna grasslands of the delta and beyond, elephants and giraffes mix with antelope, buffalo, sable, roan, impala, and the great migrator, the wildebeest. And so the Okavango clockwork has run for a million years, until the encroachments of civilized humans and their domestic animals.

THE NATIONAL WEALTH

The national park idea represents a far-reaching cultural achievement,
for here we raise our thoughts above the average, and enter a sphere in which
the intangible values of the human heart and spirit take precedence.
ADOLPH MURIE, naturalist

Okavango has its share of the complex problems that face all primeval ecosystems: an expanding human population; wildlife predation on domestic animals; political pressures in neighboring countries to divert the life-giving water of the delta for human use; realigning extensive fences designed to protect domestic herds from diseases that block wildebeest migrations, resulting in the needless death of thousands of animals; wildfires set to improve grazing lands that scorch large areas of the delta every year.

Like many African nations, Botswana has its hands full surviving the turbulent economic changes of a developing third-world continent. Nonetheless, the landlocked nation that is only slightly larger than France is making a concerted effort to preserve its natural heritage, especially now that it enjoys the boom in sustainable income that comes with tourism and high-paying big game hunting, a boom in no small part brought about by Frans Lanting's photography of the region.

Botswana has set aside no less than 17% of its total lands in a system of national parks and wildlife, forest, and game reserves —an impressive commitment by any standard.

The Moremi Game Reserve in the eastern part of the perennial delta enjoys a characteristically wide range of habitats from riparian woodland, reed beds, and permanent swamp to forests and dry savanna woodland. It has been set up to provide water activities such as fishing, game viewing, and photography tours.

Some 50 km from Moremi is the Mababe Depression, the heart of Chobe National Park and the adjacent Chobe Forest Reserve. Chobe is a living example of the complexity of ecosystems —and humans' challenges in trying to protect them. In partnership with neighboring countries such as Zimbabwe and South Africa, Botswana has successfully implemented a program of protecting the elephant population from ivory poachers. Along the Chobe River, tens of thousands of elephants now gather seasonally. But they are tearing up the riparian forest like rampaging army tanks at war. Yet because it is protected, the Botswanan elephant herd is increasing at an alarming rate of nearly 3 000 elephants per year.

Nxai Pan and Makgadikgadi Pan National Parks to the east and southeast of the delta were once lakes. Now they are either flat, salty expanses that only occasionally receive moisture or broad expanses of short, nutritious grasses —which makes them excellent game reserves and wildlife viewing areas. Beautiful islands of Acacia trees help by bestowing welcome shade for animals and tourists alike.

"Going to Africa to cover a complete ecosystem as diverse as the Okavango Delta," says Frans, "was for me a dream come true. I wanted to translate that opportunity to show how the animals are all tied together in this fantastic ecosystem that pulses with the seasons and the varying amounts of water that arrive each year in the delta."

It took him awhile to get the "lay of the land." Much of the region was roadless and difficult to traverse then, even with flat-bottomed boats and *mokoro* canoes to help on the water.

"I immersed myself into the complete ecosystem. It was a fantastic way to live. You live with the animals and by the end of the year you feel you are as much a part of that world as they are."

"Most people who haven't been fortunate to spend as much time as I have in Africa don't know how rare these places have become, how precious they are. Modern-day Africa is crisscrossed by roads and settlements. That's what makes Okavango so unique —it has survived virtually intact into the present day."

WETLANDS AS BIO-SCULPTOR

On the day of the first heavy rain ... I watched gazelle on the dawn horizon,
jumping high against a rising sun, and though many might say it can't be so,
I couldn't help but imagine this was joy.
FRANS LANTING, *Okavango: Africa's Last Eden* (1993)

Like all ecosystems, Okavango's wetlands play a major role in the particular configurations animals evolve to help them cope with survival. The African fish eagle and the Pel's fishing owl, which hunts only at night, have specific adaptations to help them hang on to their aquatic catches.

On the underside of the fish eagle's long-taloned toes, sharp spines, like thorns on a rose bush, allow the superb hunter to firmly grip the slippery bream and other fish prey. The fishing owl has similar, sharp-edged spiny scales on the bottom of its feet.

Also unique is the owl's silent-flight plumage —fish don't hear the sounds of a swooping owl above their water domain.

Birds are most abundant in the fringe areas around the swamp, where the water is not so deep and they are in less danger from crocodiles. To make the most of their watery world, avian species have developed specific tools for harvesting aquatic food sources. The African spoonbill has a long bill that is flattened at the end, perfect for sifting for food. Pelicans have their famous pouches for storing multiple catches.

Land animals of Okavango had to evolve to escape predators on ground that is often wet or muddy. By developing elongated hooves to go with their bounding gait, red lechwe can actually run faster through shallow water than they can on land, giving them a distinct edge over predators like the lion that fare much better on hard, dry surfaces.

The sitatunga antelope has an adaptation that is similar to the lechwe's: widely-splayed hooves that help it distribute its weight on the mushy surface in the Okavango swamps. Several bird species take their cue from the land

animals with elegantly wide, elongated toes that provide the same benefit.

Animals are not the only brilliant adaptations of nature to a dry/wet ecosystem. Water lilies flourish in the shallow-water habitats of lagoons and open waterways. Their stalks spiral up to the surface, flowers blossom, then a few days later the stalks pull them back under water to ripen and release their seeds to the current.

Baobab trees squat their improbable shapes upon the land, demonstrating their versatility in hydration —they can absorb and hold water like a sponge for years. And one baobab tree that was painted by an artist more than 135 years ago has *shrunk* in diameter by 1.5 m in the intervening years.

In nature, life survives —any way it can.

WATER TO WATER, DUST TO DUST
By the end of the dry season, the land is etched with animal trails
leading to the last sources of water All that remains are deep hoofprints
in soft clay and tracks leading out.
FRANS LANTING, *Okavango: Africa's Last Eden* (1993)

Listen: Can you hear it? Is that a drum beating? Or the loud rumbling of the elephant's stomach as it searches for food and water?

The lakes have turned to mudholes, the mudholes to caked earth. The frog is tucked away in its baked clay bed. Immense flocks of flamingos walk the salt flats, their watery world of last week now merely a dry salt pan —a sudden theater for the forced death march toward water that will claim thousands of them.

The green vegetation withers into brown memory, the catfish pack swarms up the thickening muddy waterways toward the delta's core swamp, driving its fish prey before it to sustain the long journey.

The desert is returning. The land echoes with emptiness as the animals leave by ones and twos and multitudes.

Back in the swamps, along the riverine forests, in the dry-season places where they wander to the whims of Earth's pulse, a new generation of fish and fowl and reptiles and land mammals will soon be born. They will learn in their timeless way to know when the water will come again. They will learn where to go to find it.

Life the water wheel, turning.

On the opposite page,
the end of the rainy season is foretold upon the savanna land of Okavango as a herd of tsessebes
makes its way through golden grasses.

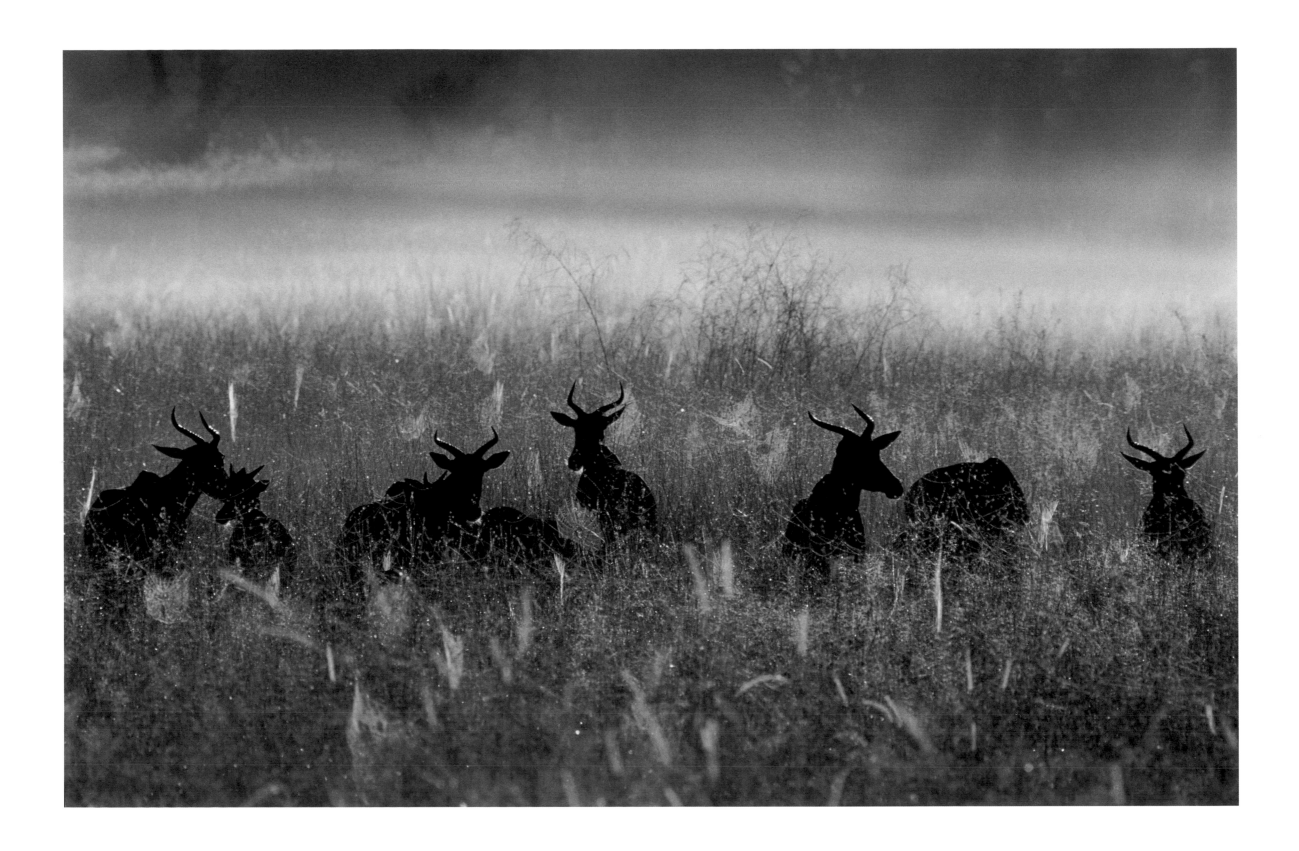

After spending many months in estivation beneath the hard clay
of a parched delta pan, this resilient bullfrog has emerged from its life-preserving
moist membrane to enjoy the pan's transformation into a seasonal pond.

On the opposite page,
like a refugee from a masquerade ball, a colorful yellow-billed stork carries nest materials
to its construction site in the delta. The practice coincides with subsidence of the flood,
signaling greater availability of prey to feed to hatchlings.

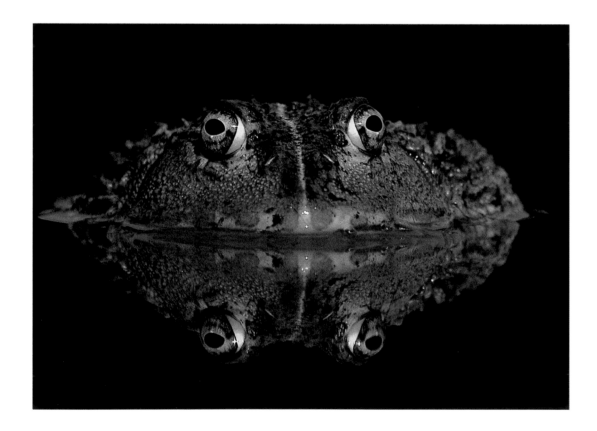

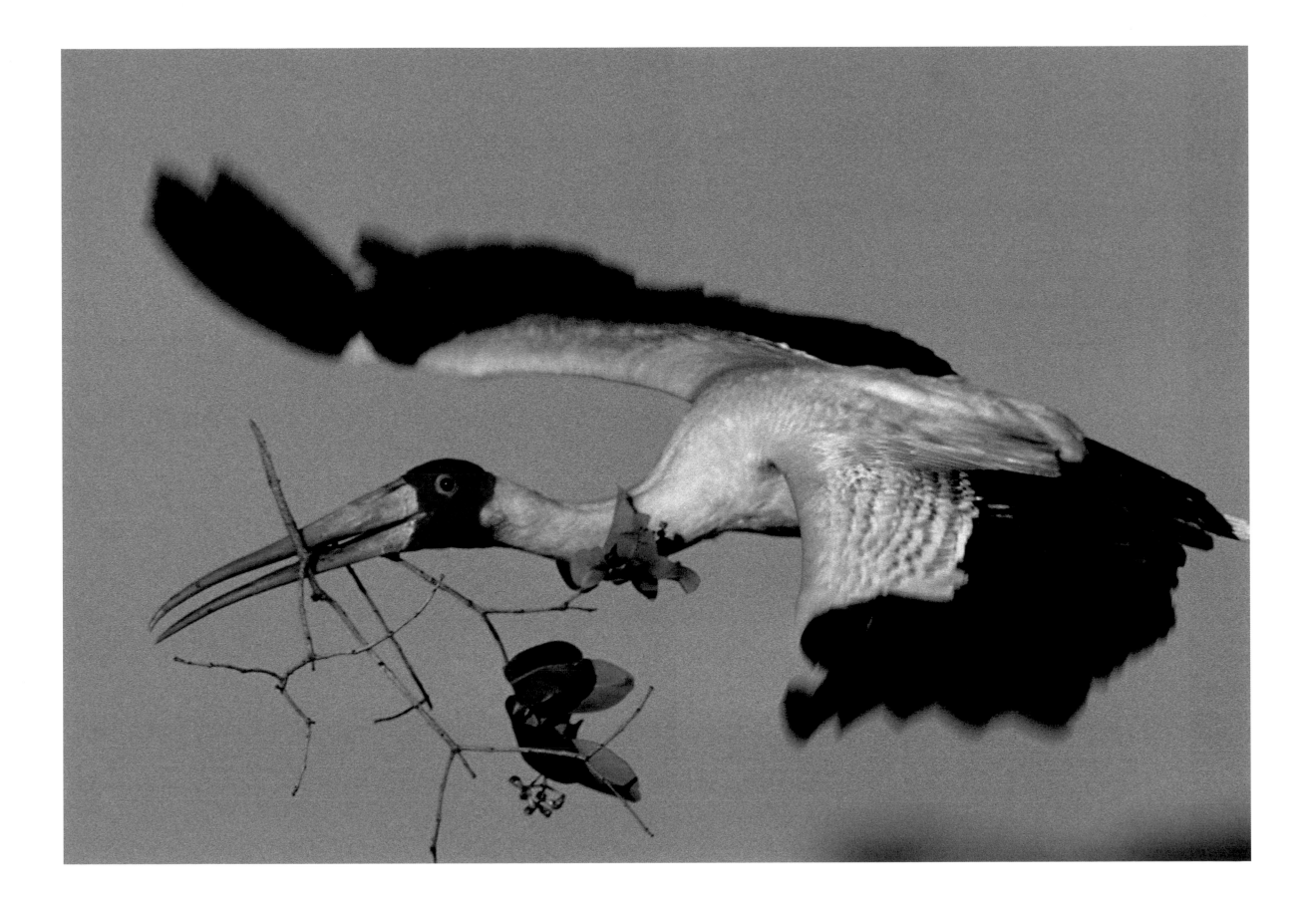

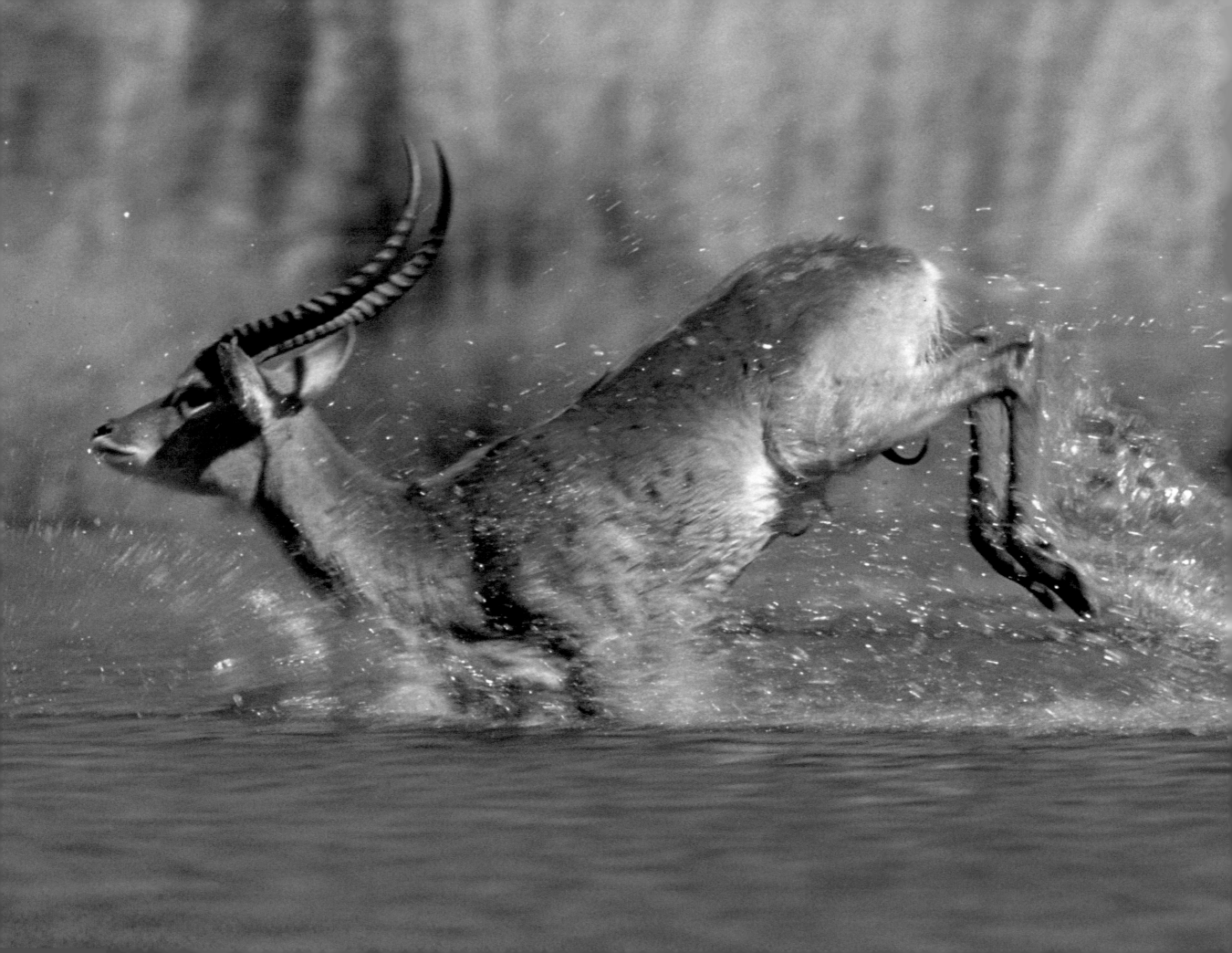

On the opposite page,
a race across shallow sheets of water demonstrates the adaptation of antelopes to water.
Characteristic of many delta animals, red lechwes like to keep their feet wet and are often found
in flooded grasslands. When spooked, they seek deeper water for safety, rather than land.

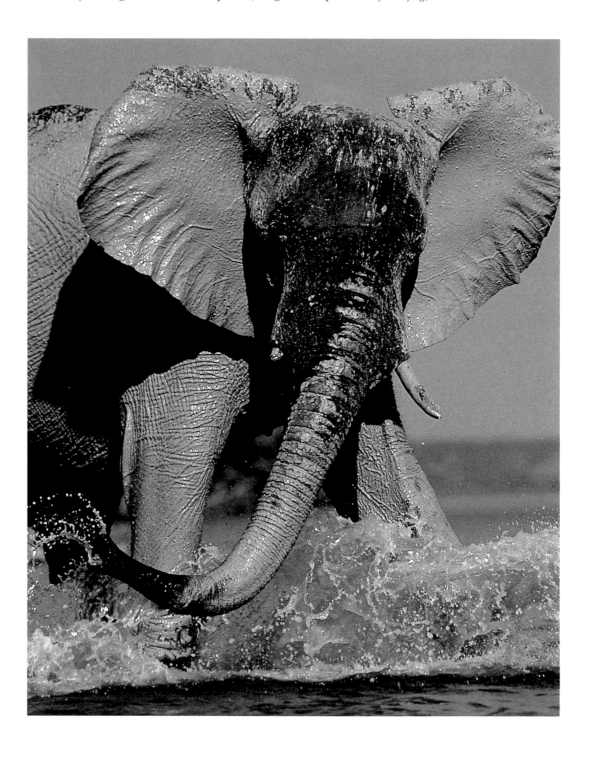

Above, an African elephant gallops up a spray to deliver a threatening message
to Frans, of the "Hey, I'm the big guy here, not you" variety. The warning came after Frans
stepped out of his vehicle, but the encounter "wasn't that serious."

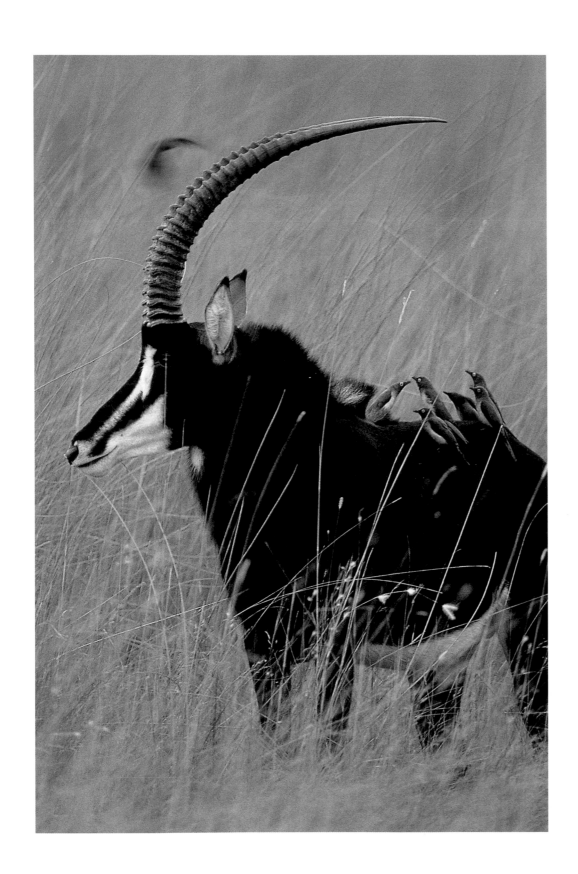

Oxpeckers harvest ticks from the back of a horse-sized sable antelope.
This animal is typical of rare southern African ungulates that never
congregate in huge numbers. Such behavior is more typically found in
woodland areas than in the savanna ecosystem this one inhabits.

On the opposite page,
an African wild dog cools off in a seasonal pond in the Kalahari.
In a few weeks' time, the dry season will return this place to a desert.

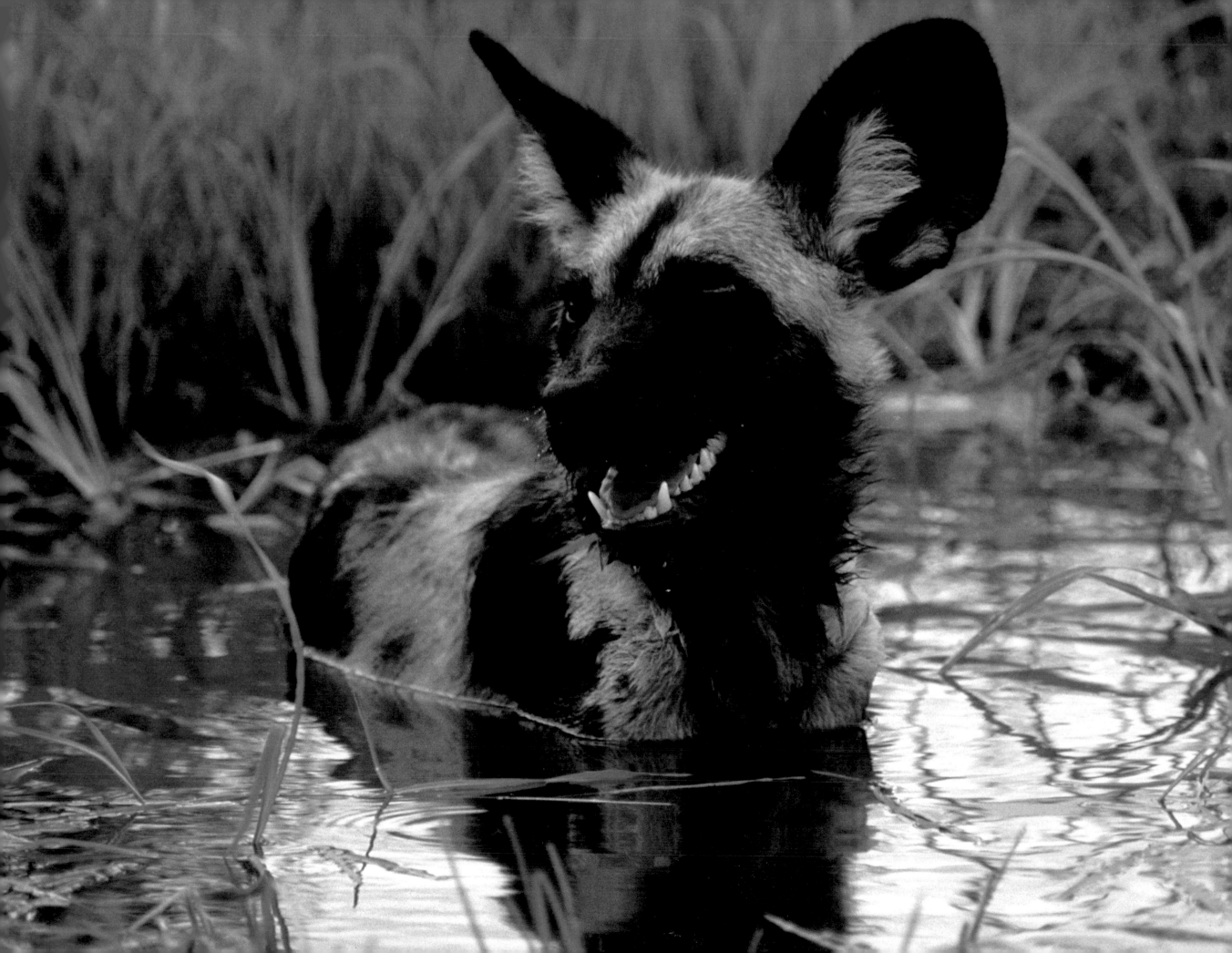

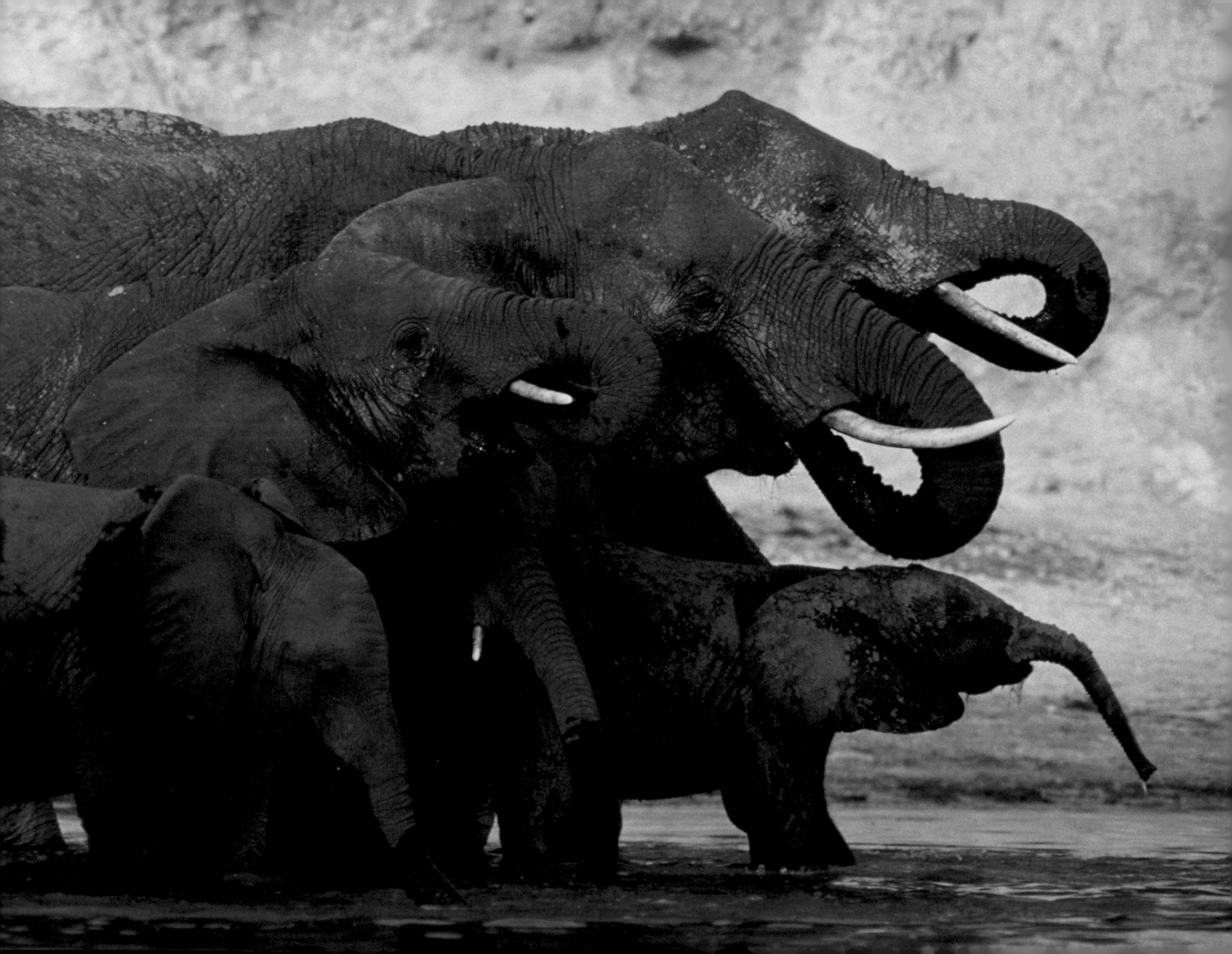

On the opposite page,
a herd of elephants enjoys liquid refreshment at the edge
of the Chobe River. When they can find it,
elephants suck up to 110 liters a day through their trunks.

Above, Frans spent two days in a blind to capture
this "hard-won picture" of the anhinga, or African darter,
at the triumphant moment of its successful hunt.
Also called the "snakebird," the darter
is a wonder of reptilian grace beneath the water.

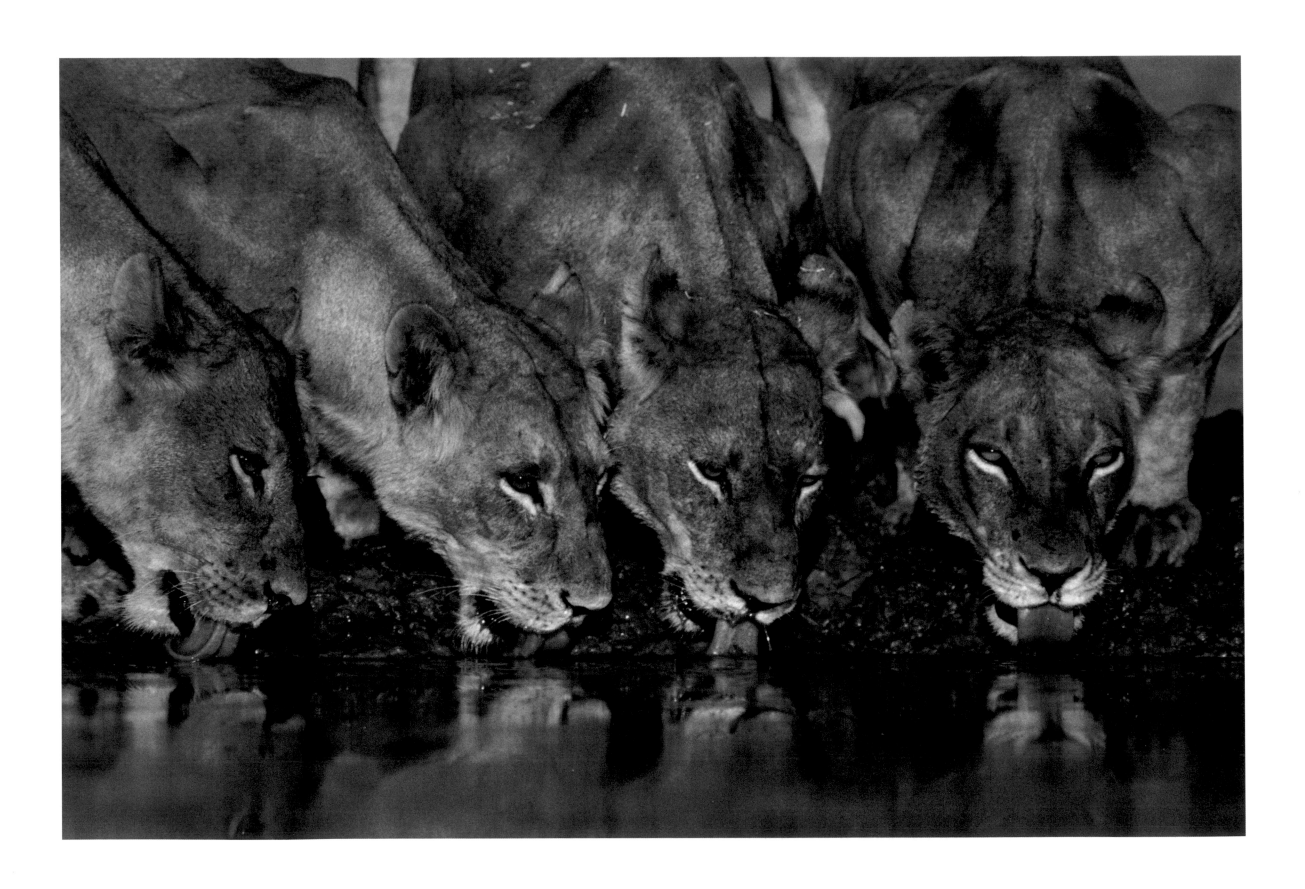

On the opposite page,
these lionesses were so near that I could hear their quick breaths
as they lapped up the water. They ranged a territory
that included a water hole in Savute.

On the right, Kalahari lions stand out for their magnificent manes
shot through with black. Their great value as trophy animals
has led to decimation of their numbers at the hands of Great White Hunters
since the nineteenth century.

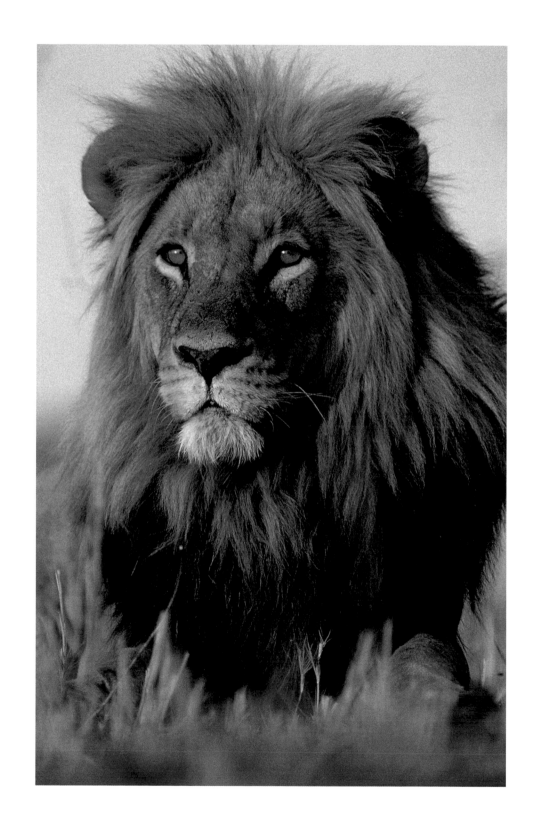

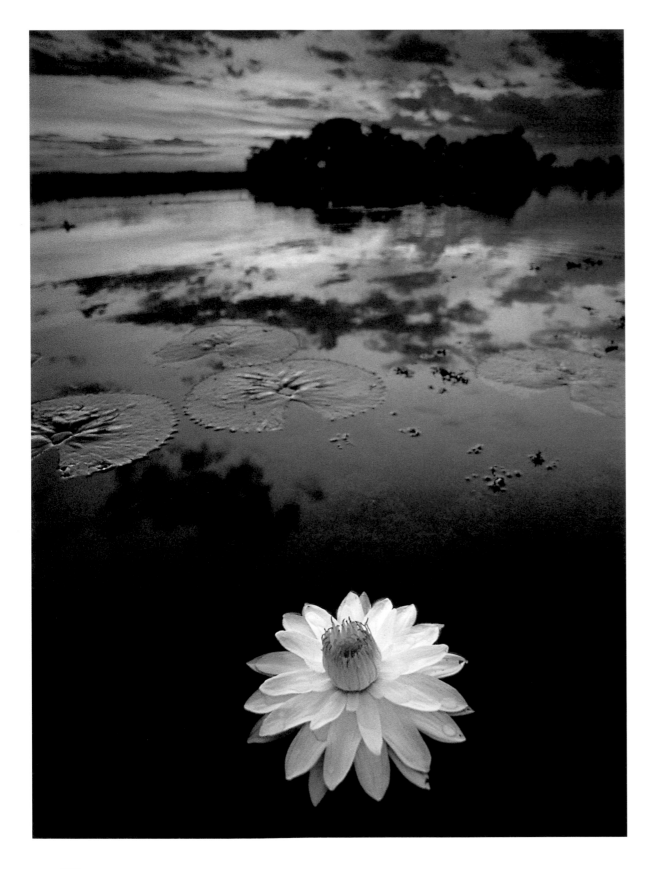

On an Okavango Delta lagoon, evening begins with a day-blooming
lily closing, as the petals of night lilies
nearby are just beginning to open.

On the opposite page,
nature's sublime artistry reveals itself in the jacana,
a water bird with big spidery feet for walking on water-lily pads.
A profusion of water-bird species are on display throughout the rainy
season here in the heart of the Okavango Delta.

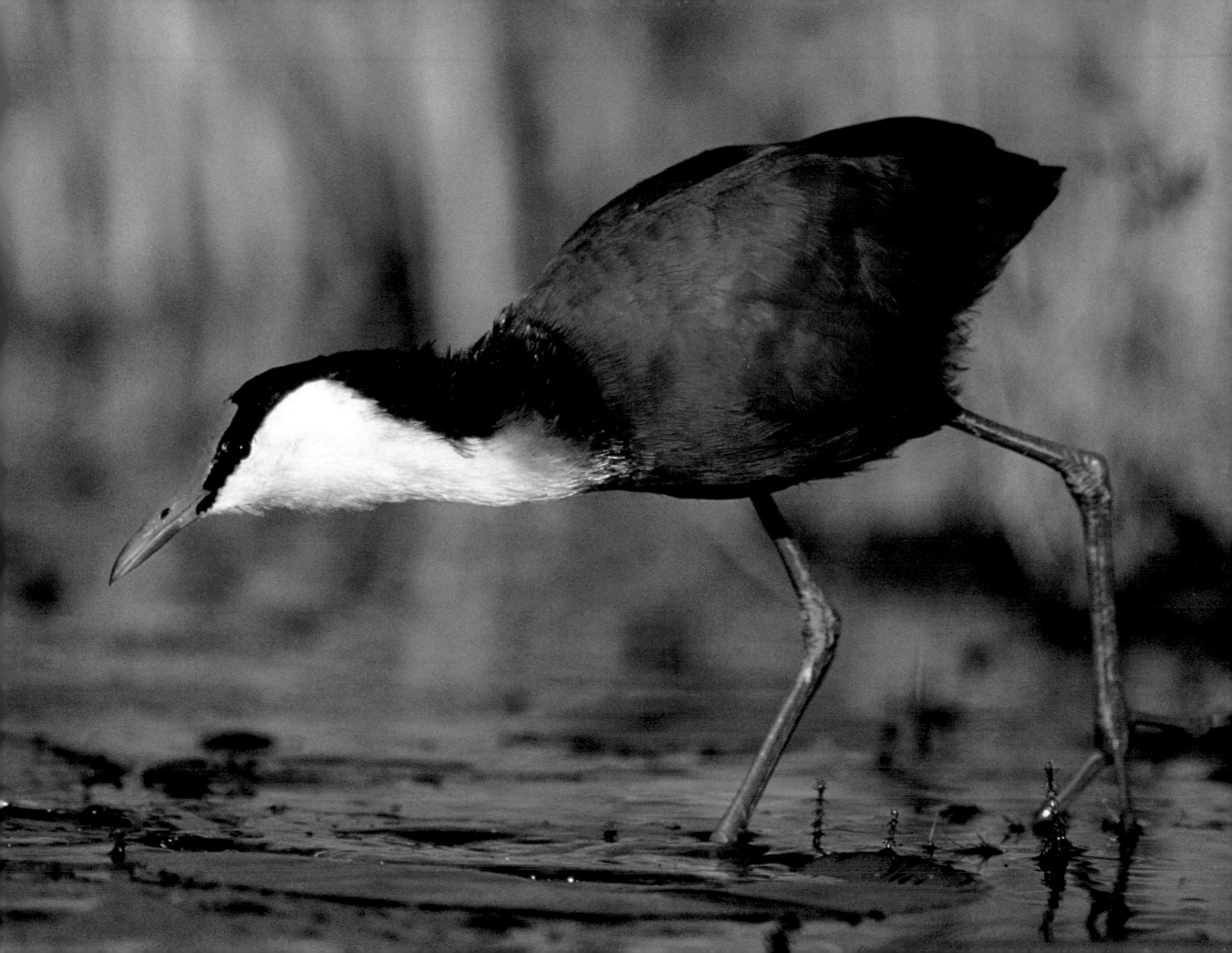

As dusk darkens in Botswana, two lionesses awaken.
The tension in this eye-level encounter is evidenced by the twitching tail and the taut bellies.

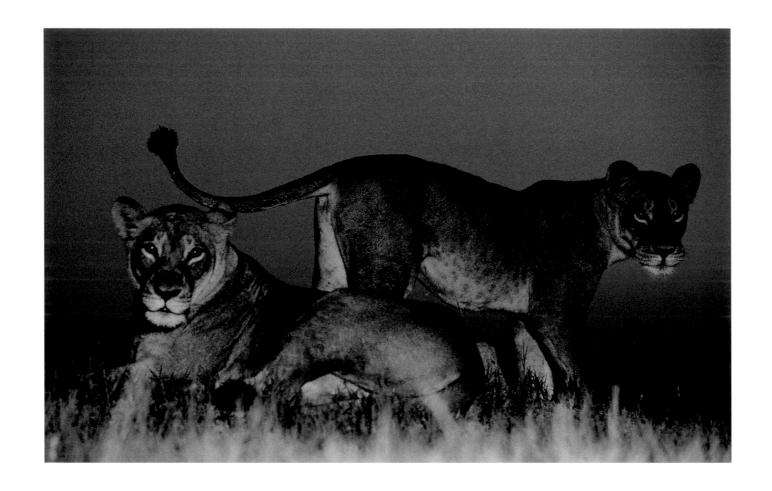

On the opposite page,
in the last light of day, a flock of ibises wings past a perch at the edge of a nesting colony in the middle of the Okavango Delta.

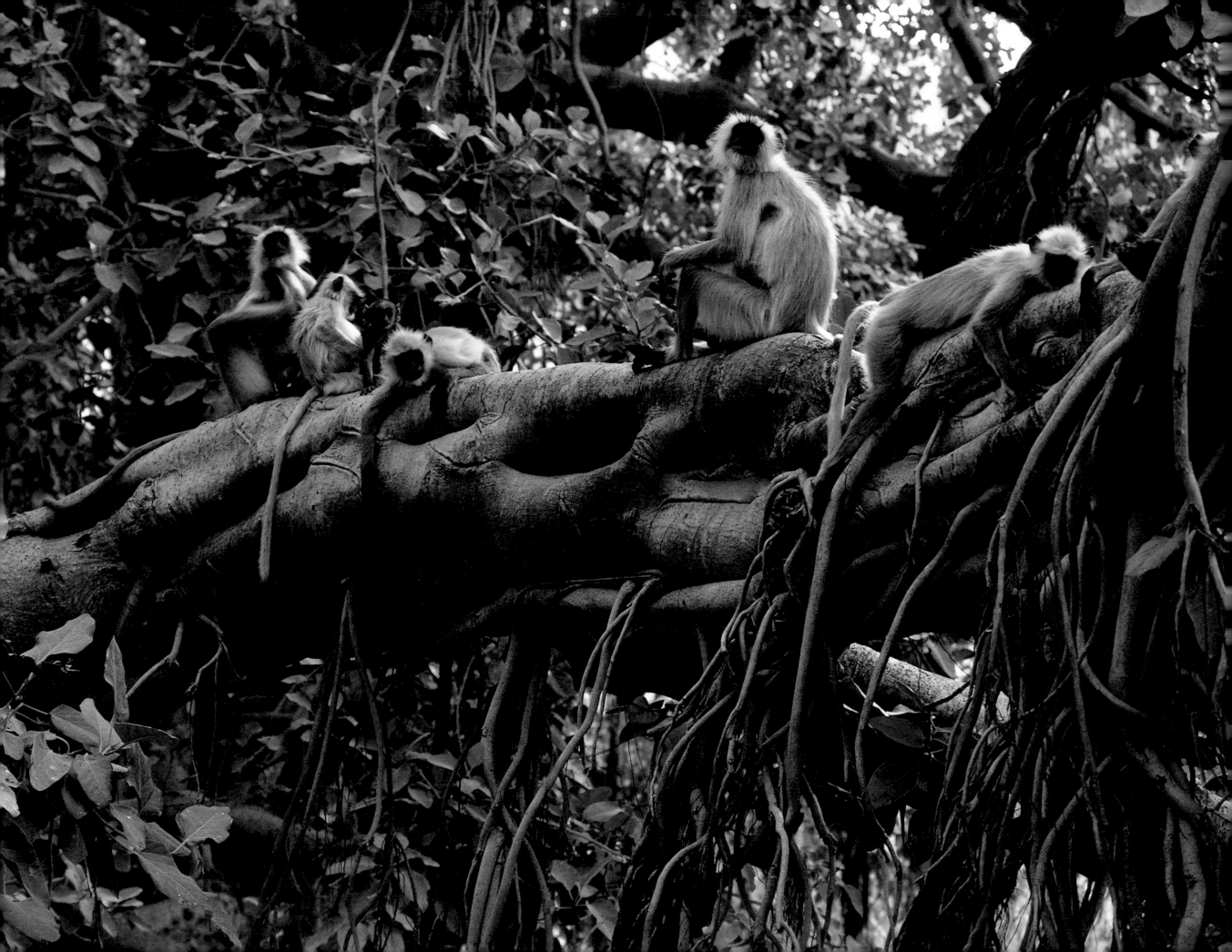

THE LONG NIGHT OF THE TIGER
Ranthumbhore
Photographer: GÜNTER ZIESLER

Beauty is truth, truth beauty —that is all Ye know on Earth, and all Ye need to know.

Traditional saying

Her name is like the sigh of a lover: Ran...tham...bhore.

For centuries, exalted over all others, she courted the noble maharajahs of her ancient land, then beguiled the lords and ladies, dukes and princes of the British conquerors. Today, the visionaries are her masters, although beauty can have no true master.

But if pride in ownership is a form of affection, then the once-lofty maharajahs of Jaipur did indeed love their private hunting reserve, named Ranthambhore after the exotic, hundred-meter high domed fortress built here in the tenth century. Hunting of the area's plentiful game was allowed for only six weeks a year, with stringent protection afforded the native beasts the rest of the time. Ultimately, according to Valmik Thapar, dedicated anthropologist, naturalist, documentary filmmaker and outspoken champion of the park, this early paternalism is what probably saved the area from being overrun by people and its pristine magnificence completely destroyed.

"The dry, deciduous forests," Thapar writes in his book *Tiger: Portrait of a Predator*, "engulfed me: low rolling hills, open grasslands, steep cliffs, and the crumbling ruins of an historic past dotted around, all merged in perfect harmony, a harmony that held me spellbound."

Ranthambhore National Park, just 192 km below the capital city of New Delhi in the northern center of the subcontinent of India, is an oasis of pastoral calm set square within the turbulent gut of the nation's ever-expanding population. It is a wonderland rich in biota: more than 450 plant, 272 bird, 22 mammal, three reptile and numerous insect species thrive here. The typically warm and dry climate is punctuated July through August by monsoonal rains. Through winter and into spring, the surrounding ecosystem is cool and hospitable.

Most notable among the many birds are the purple heron, painted stork, crested serpent eagle, golden oriole, and grey heron. The indigenous reptiles are the Indian monitor lizard, soft-shelled turtle, and Indian marsh crocodile. The sloth bear, spotted deer, langur monkey, sambar deer, jackal, wild boar and, most famous of all, the regal tiger, roam the forests and grasslands.

Ranthambhore has been praised worldwide as one of the finest natural areas in existence. Its smallish size, just 392 km², does not suffer from lack of botanical diversity. Once it was part of India's massive, dense jungle expanses. Now it is a rocky, rolling terrain with a preponderance of dhok and ancient banyan forests, woven into emerald unity by the spreading roots of the peepal trees. Massive rock formations and large wild grass savannas breathe visual respite into the luxuriant landscape. Generous groves of mango trees and thick growth belts of jamun benefit from the relatively cool temperatures and abundant waters of perennial lakes and streams.

To the indigenous people living near the park and the park's rangers, Ranthambhore is by turns either a fortress standing firm against possible salvation or a symbol of hope for a compassionate humanity trying to ensure a natural future for the park. Can such polar opposite views both be valid? As in all the many theaters of environmental controversy around the world, a person's viewpoint is forged by the ground on which he or she stands.

If your stand is on the outside, shoulder to shoulder with an Indian peasant who lives along the park's borders, you look into its forbidden realms with hunger and deep frustration. How like a cruel mirage, a teasing phantasm of bounty and salvation, Ranthambhore must at times seem to be. Within its profuse territory lie uncut timber, a source of income; plentiful forage for livestock; firewood for cooking and warmth. All represent improved sustenance or even relief from a lifelong condition of unrelenting poverty.

To the committed conservationist roaming footworn paths through its green, rolling sea of forests and amber savanna grasses, Ranthambhore is a

On the opposite page, a group of common langurs quite often comes to this banyan tree to spend in the shade of its mighty crown the hottest hours of the day. This banyan tree is said to be the second largest banyan fig tree in India.

refuge, an oasis of preservation, a living, breathing model of how human compassion for wildlife can be effectively put into action. They believe that maintaining this island of care against short-sighted harvesting and ultimate resource destruction is a noble calling.

Atop their long list of priorities sits the protection of its most famous —and most threatened— inhabitant against the human forces of organized depredation. For to speak of Ranthambhore is to speak of the tiger, whose tales of woe, triumph, and ongoing ordeal occupy the heart of the place. For as the tiger goes, so goes Ranthambhore, so in fact goes the very reason for conservation: to hand down, intact, the wild places to our children's children's children.

A WALK IN THE FOREST

If wildlife is to survive, man and nature must find a harmonious balance.
VALMIK THAPAR, *Tigers: The Secret Life*

There are still holy men in Ranthambhore," says globe-hopping wildlife photographer Günter Ziesler, telling one of his favorite stories of the park. "An old hermit with a white beard who lives near a small river was out walking one morning with a young man, perhaps his disciple."

Günter was also roaming with his Indian colleagues, looking for tigers to photograph. They drove their jeep to a spot overlooking a road. There they saw a male tiger lie down in the brush just 10 m from the same road along which the holy man and his acolyte were approaching.

"We knew this tiger. He likes to stay close to a road and watch people passing by. He even looked in our direction, perhaps he saw us. We didn't know if he would stay there the whole day. After a while, here come the two walkers. They see me and another photographer, Fateh Singh. They know immediately that if Fateh Singh was near a road, then a tiger must also be very close."

He chuckles. "The holy man doesn't care; he knows tigers are not dangerous and, for a religious Indian, there is no greater luck anyway than to be eaten by a tiger." But the young man has a decidedly different attitude. Günter and Singh watch mirthfully as the pair move toward the tiger's position.

"The old man just walks along nonchalantly. But the young man! His eyes go left, go right, back and forth, big and wide. He knows that tiger is close, but he can not see him. We had a very good laugh."

In India, tigers kill and devour humans where they have acquired, over generations, a taste for this vulnerable prey. Such calamities are almost unheard of, though, in Ranthambhore. Tigers have in fact been observed within striking distance of large groups of humans as well as isolated individuals, yet generally seem content to just watch from the cover of foliage or forest. It is one of the remaining mysteries of the big orange cats that makes them so fascinating.

The safe passage of the hermit and the anxious boy exemplifies Günter's awareness of the special, somewhat idyllic relationship between tiger and human in Ranthambhore. In his visits to the park he has encountered and photographed the resident population of big cats in all phases of their daily activity. Each time, he has come away with new appreciation for their ongoing attitude of laissez-faire with their human coinhabitants.

Driving home the point, he recounts another incident in which a disturbed young man, "not right in the head," went to Ranthambhore with the intention of being eaten by a tiger and thus putting an end to his miseries. Alerted by a concerned friend, local police went into the park to find him —before the tigers did. After a long, anxious night, they discovered the man, completely unharmed. Backtracking his meandering path of the night before, they were astonished to see his footprints intermingled with those of large paw marks. The big cats had been walking close behind him, tracking him for much of the night, but had never once posed a threat.

"If you want to be eaten," says Günter, "go someplace else."

TO BREATHE UPON A DYING EMBER

When a man wants to murder a tiger, it's called sport; when the tiger wants to murder him, it's called ferocity.
GEORGE BERNARD SHAW

The mythic embodiment of speed and savage power that William Blake immortalized in verse is today barely a spark.

Just two centuries ago, eight tiger subspecies roamed the vast reaches of Asia from the equatorial islands of Java and Bali all the way up to Siberia. Some even hunted the red deer of eastern Europe. Estimates of their numbers in those times exceed 40 000. Today, there is a disturbingly small fraction of that population still in existence, of which the majority live in the 440 sanctuaries and 23 tiger reserves established by the Government of India as part of Project Tiger, a concerted effort to stave off its imminent extinction and codify the time-honored reverence of Indians for all life.

During the imperial rule of the British, their sometimes fanatical appetite for sport hunting infected many of the less spiritually-inclined Indian noblemen such as the Maharajah of Surguja (who single-handedly slew more than 1 100 tigers). Unfortunately, the result was an acceleration of the demise of the tiger throughout India.

Today, poaching and the recent pressures of ever-expanding human settlements perpetuate the threat to tigers and other animals such as elephants and rhinos. The numbers are alarming: although the subcontinent harbors 60% of the world's tigers, there may be as pitifully few as 1 200 or as many as 3 750, depending on whose census you go by. At less than 10% of the world population of a century ago, neither figure is cause for celebration.

Like a bombed-out city, the tiger is mostly a ruin of memories, a pile of dusty trophy rugs and heads mounted on the aging walls of country manors. In

the 200-odd years of mindless slaughter, five tiger species have gone extinct. This splendid predator, instantly recognized from antiquity by its splendid caramel-orange coat with the shadowlike black stripe camouflaging, has been hated and loved, relentlessly, almost to death.

In recent decades, as human pressure against its habitat increased, the tiger went into accelerated decline. With the proliferation of firearms that were delivered into the hands of the masses after World War II, conservationists realized that action was needed. Project Tiger, the Indian government's rescue effort, established nine reserves in 1973. There are now 23, of which Ranthambhore National Park is one of the most successful.

As a jewel in Project Tiger's program, the park continues to weather problems and controversy. Increasing world awareness of its uniqueness has brought ever-growing numbers of ecotourists and photographers to its few roads and trails. On their heels came a new generation of organized, wily poachers. Not surprisingly, by 1990 visitors began to complain of drastically reduced tiger sightings. Authorities soon discovered poachers had reduced the park's tiger population to perhaps as low as 12!

Yet tigers have survived for millennia because of their adaptability. Take away their habitat and they will adjust to a different one. Deplete their prey and they will switch to other, more plentiful animals. They have been observed thriving on a diet ranging from the bisonlike gaur, which weighs more than 900 kg, to the 45-kg chital deer. The tiger may yet go into the dark night, but it will not go for lack of resourcefulness.

IN THE FORESTS OF THE NIGHT
I think losing the tiger would be a tremendous loss for humanity because it is not just a beautiful animal that arouses our emotions and gives us pleasure, but … is also a symbol of a conservation effort to save all forms of life. If we can not save the tiger, which so many people admire, what can we save for the future?
GEORGE SCHALLER, Director for Science, New York Zoological Society

"For us, Ranthambhore was very special, mostly because of the tiger," Günter remembers of his several trips to the park in the 1980s. "The tiger is different from lions and other animals. You get to know them: their characters and personalities stand out. That's a very special thing, unusual for a wildlife photographer to find. Add to that the unique cultural ambience of the maharajah's crumbling ruins and you have quite a magical place."

A friend from Kenya had told him about the park and its unusually benevolent tiger population. Although he had to be escorted, as do all visitors to the park, in a park jeep, he fell into ideal company: Valmik Thapar, a driving force in the preservation of the tiger and founder of the Ranthambhore Foundation, and Fateh Singh, like Günter a photographer with a passionate interest in wildlife —but especially the big striped cats.

"I immediately felt that here was the best place in the world for photographing tigers, because the animals were so calm and even sometimes almost friendly."

Once there were many villages in the area that is now encompassed by the park. The Indian government relocated them, and not very diplomatically either. Resentments still run deep for those who moved, but received little or no appreciation or reward.

"Even when the people lived in the park, tigers rarely killed them. Elsewhere in India, along some of the coastal regions, the cats have become man-eaters. They will even go for people in boats on the water. But never in Ranthambhore."

Günter does not go so far as to claim tigers are benevolent animals that pose no threat. "Sometimes we would come within a few meters of one. Perhaps it was eating its prey, or protecting its cubs. It would come out of the brush or forest and charge us. Sometimes it would snarl or roar and chase the jeep. But never once were we attacked." Which made it a breeze to work with his camera and tripod braced on the back seat of the open jeep, instead of photographing through a window.

One of Valmik Thapar's favorite tigers, a huge male known as Genghis who was featured in his books, was "absolutely the greatest. He was the tiger we loved the most," remembers Günter. "Very strange, often aggressive. We saw him and a female the most times. He would charge rather than allow people to come close, unlike other males who didn't care about the jeep. He could get crazy! Genghis was not so handsome. But he was a very clever hunter."

Günter was able to photograph the big cat hunting sambar deer, using a dramatically unique and highly successful tactic.

"During the dry season of February through March, there is less food for the deer, so they go into the lake to feed on water lilies." Genghis, wily old cat that he showed himself to be, established his hunting territory along the edges of Ranthambhore's Padam Talab, Raj Bagh Talab, and Milak Talab lakes.

Since tigers prefer to hunt at night, the sambar wisely ate its aquatic forage only by day. Genghis would creep ever closer to wait in hiding until several deer were out in the water eating. Then he would spring from cover and dash back and forth along the banks, spooking the deer's flight until one would venture into deeper water, where it could not use its superior speed and agility to escape. Then the big male cat would streak straight for the deer and as Günter describes it, "take his speed" right into the water to make the kill with the throat bite common to large feline hunters.

"It was amazing to see. Genghis knew to wait for them to get in the right place. When the water levels dropped later in the dry season, he showed his flexibility by moving his prime hunting ground to another, deeper lake, as if he figured out his odds were lower for success." As it was, Genghis had an unusually high ratio of one kill for every five attempts.

But the next year, the big cat disappeared. "No one knows what happened

to him. Another male, more calm and friendly, less unpredictable, took over his territory. The female that had been with Genghis taught the new male the lake hunting technique and he became successful at it, too."

Whether Genghis was killed by poachers or succumbed to natural causes was never determined.

MANY FACES TO SEE, MANY MOUTHS TO FEED
I lived among laws which were absolute ... but which
it was not possible for me to keep.
GEORGE ORWELL, *A Collection of Essays* (1954)

Ranthambhore shines as an example of good tiger reserve management thanks to its resurgent population of perhaps 36 tigers, up from the 12 when Günter Ziesler knew them in the 1980s. But Eden-like oases create desire in the heart of the surrounding, ever-growing populations.

Endemic to the question of conserving parks, wildlife reserves, and wilderness around the world has been the problem of how to deal with human populations denied the fruits of protected areas. An Indian man and wife with hungry children, no matter how much they may revere life, can not be asked to go quietly when told they must not graze their goats or cut down trees to sell, just because such actions might endanger a few tigers who will probably die out anyway. At least the children will now be safer.

Domestic grasslands outside the park have largely been denuded by livestock, but thrive within. Not to be denied, villagers sneak thousands of cattle into park territory, leading to bitter clashes between Ranthambhore's armed staff and their angry fellow countrymen who understandably choose their own survival over that of the tigers.

Fateh Singh Rathore, former director of the park, unhappy that conservation success seemed to come only at the great expense of the Indian peasant, established the Ranthambhore Foundation in 1987. His stated purpose was to maintain diligent protection for all of Ranthambhore's wildlife and its beautiful landscapes while also improving the lives of its human neighbors.

Mobile health care clinics that include family planning education, rehabilitation of cattle grazing areas, and development of high milk-yielding buffalo, which do well as stall-fed stock and thus can eventually replace grass-chewing cows, are just some of the programs the foundation is implementing. Looking to the need for reframing entrenched viewpoints, village children are taken on field trips into the park and taught the concepts behind and importance of preserving valuable ecosystems.

One of Rathore's long-range goals is to transform the prevalent resentment against the stereotypical image of elitist, tiger-loving do-gooders into an understanding that people may care about nature, but they care about their fellow humans, too.

On the opposite page,
after a long and unsuccessful
hunting night, the tigress Noon takes
a rest in the coolness of the winter
morning at Lake Rajbagh.
As soon as the sun rises,
she gets up to look for a cool shady
place, where she will stay
for the rest of the day

Still, the inherent corruption of the human animal, ever willing to throw all moral caution aside in pursuit of wealth, finds fertile ground in the bountiful resources of Ranthambhore. The trees within its remaining forests might as well have price tags nailed to their trunks. Estimates place their harvested value at 5 trillion rupees, or 138 billion U.S. dollars. Sweeten the pot with the estimated U.S.$ 6 billion in ever-escalating poaching, not just of tigers but of rhinos, leopards, bears, and elephants, and it becomes alarmingly clear just how big an uphill battle efforts like the Ranthambhore Foundation face.

"Project Tiger" is in disarray, though millions of dollars in foreign aid continue to flow into many programs. The Indian government isn't exactly helping matters. While patting itself on the back for its landmark conservationist ethos, it simultaneously perpetuates the killing of tigers by failing to enforce anti-poaching measures throughout the country. Not a single tiger poacher was prosecuted in a two-year period in the 1990s. Meanwhile, estimates of tiger populations in the many protected areas throughout the nation are generally suspected of being inflated to stave off controversy.

A STEP AT A TIME
... there is nothing wrong with the world. What's wrong is our way of looking at it.
HENRY MILLER, *A Devil In Paradise* (1956)

For Günter Ziesler, the plight of poor Indians from Ranthambhore's peripheral towns and villages was nothing less than a shock. "As far as we had contact with Indians, we liked them very much. We visited many towns and each was different. But everywhere, the people were very kindly and open; very different from areas in Africa or South America."

"It is a very old culture. Even though they are poor, such a life is natural to them. At a Sunday market in Peru, high in the Andes, you feel you don't belong to the people or the place. You are always an outsider. Not in India."

He reflects on the comfort and lifestyle his nature photography affords him, relative to the poor Indian farmer. He wonders about the effect his work has had and may continue to have on sounding the message that protecting wildlife is an important and worthy cause for a civilized person to take up.

"Everybody wants to believe they're not just earning money but doing something to help the world be a better place. Certainly I hope for this, too. But I'm very realistic. You need stories about wildlife and films to show people and yes, that will help a little bit; if people see something and learn to like it, this is an important first step to taking an interest in helping to conserve it, to keep it going."

"I believe most people would be very sad if the tiger would vanish from the Earth. I hope, as all people hope, that my pictures can help make a difference."

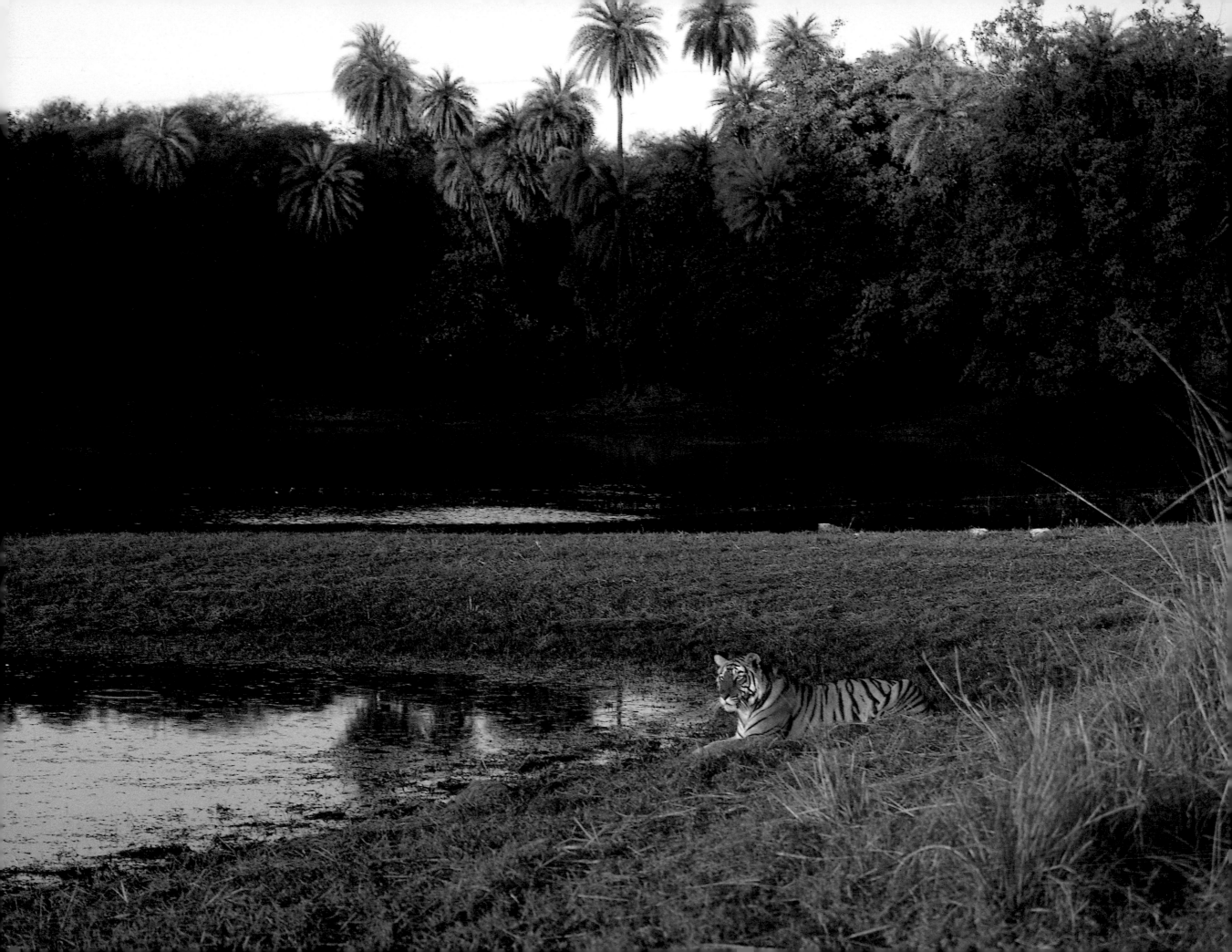

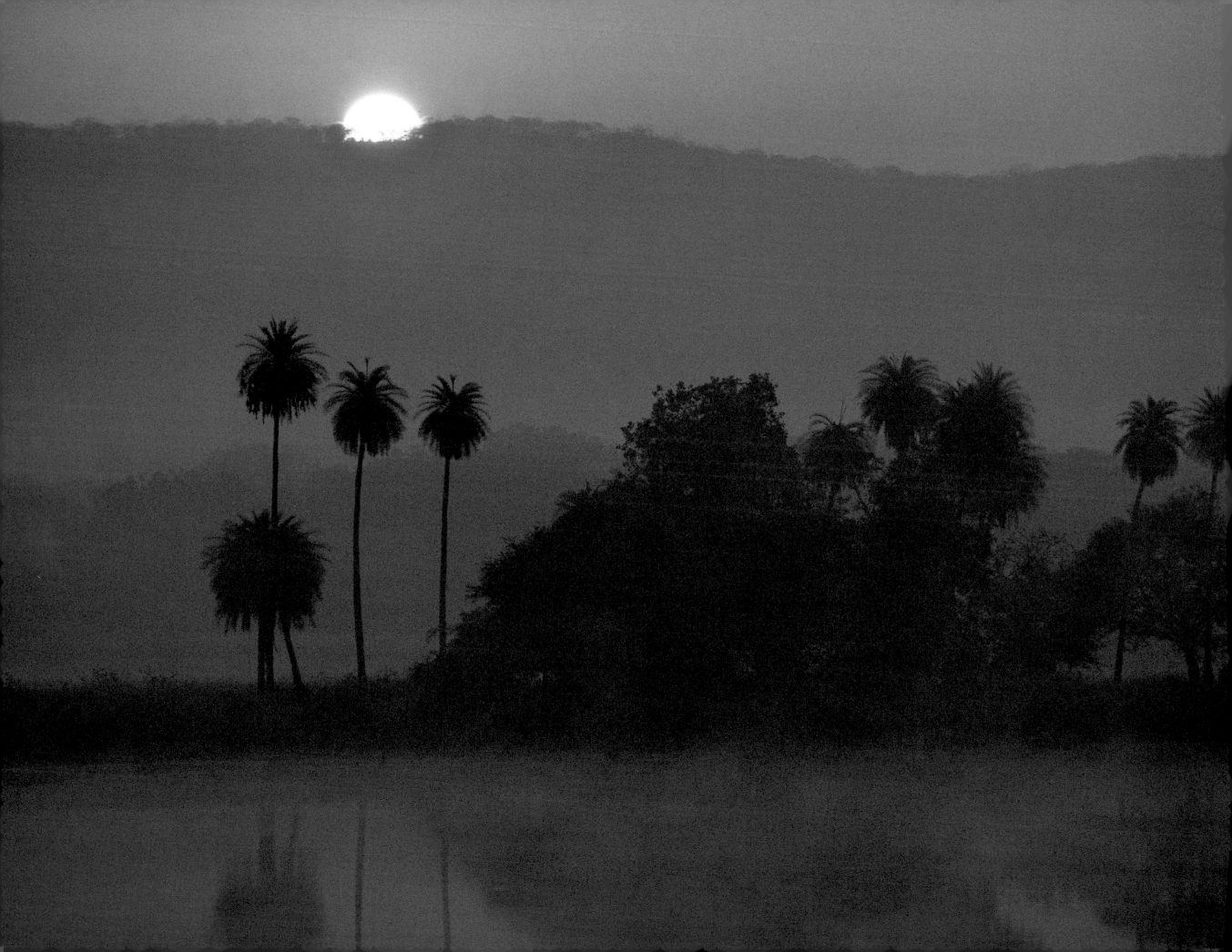

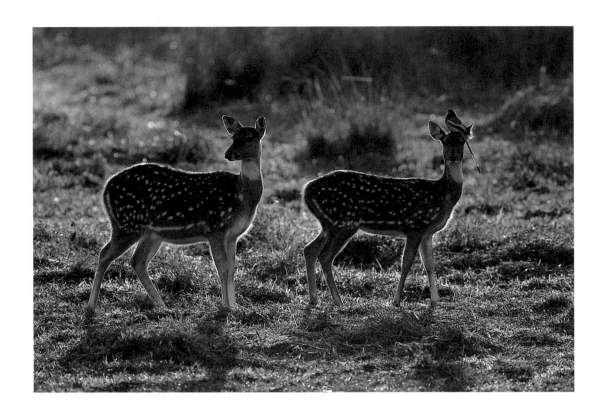

On the opposite page,
sunrise at Rajbagh Lake on a cold misty winter morning.
On some days, it becomes cold enough in the early morning
to build up hoarfrost on the grass around the lakes.

Above, like cattle egrets, this Indian magpie follows a group
of female spotted deer to pick up insects. Sometimes it will sit
on the back or head of an animal for a better view.

A spotted owlet looks out from
the hollow of a tree where it has its nest.

On the opposite page,
a sloth bear climbs a little tree to feed on its berries.
Sloth bears eat everything from grass and fruit
to small mammals and even carcasses.

On pp. 240-241,
in the dry winter season, sambar deer
often enter the lakes in Ranthambhore to feed on
the submerged water plants.

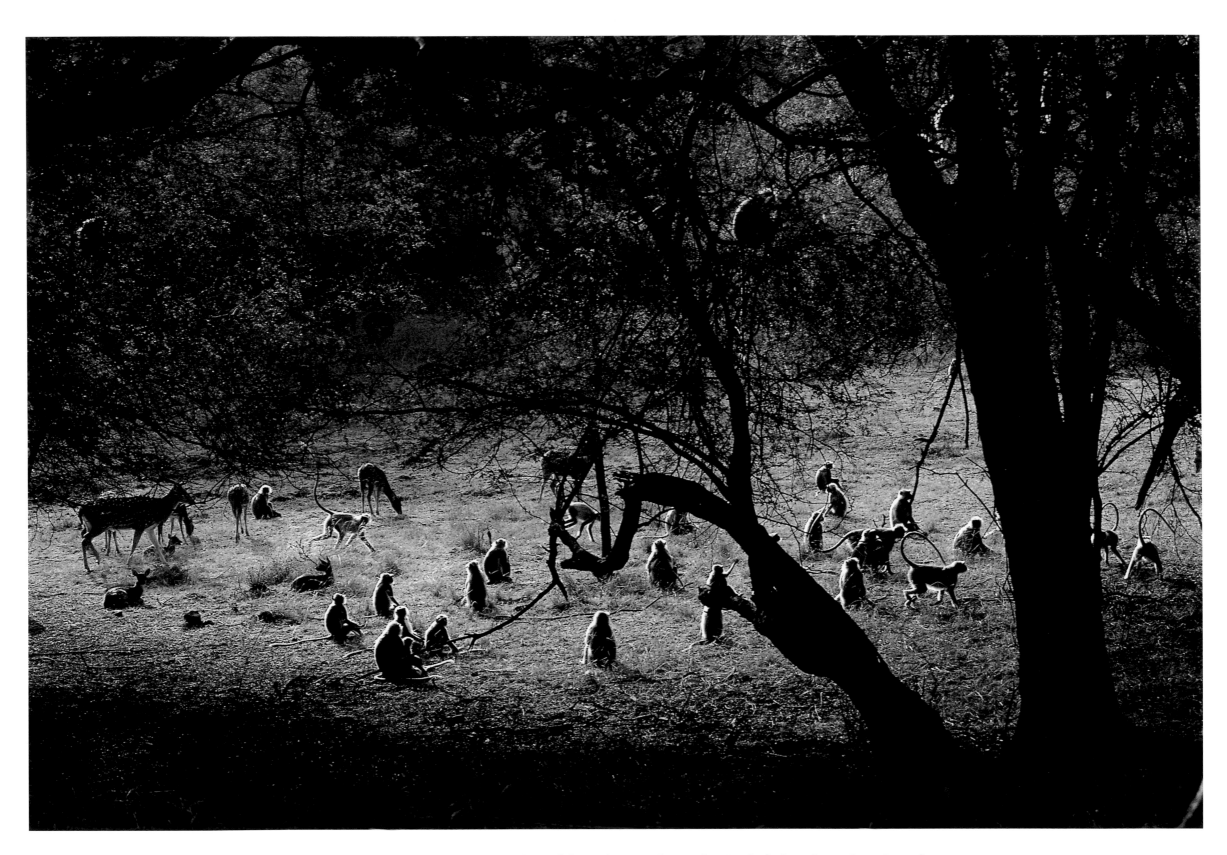

*In Ranthambhore, there are often groups of spotted deer and common langurs foraging for food together. Both species profit
from this community: the monkeys have sharper eyes and spot a stalking predator more easily, and the deer have a better sense of smell.*

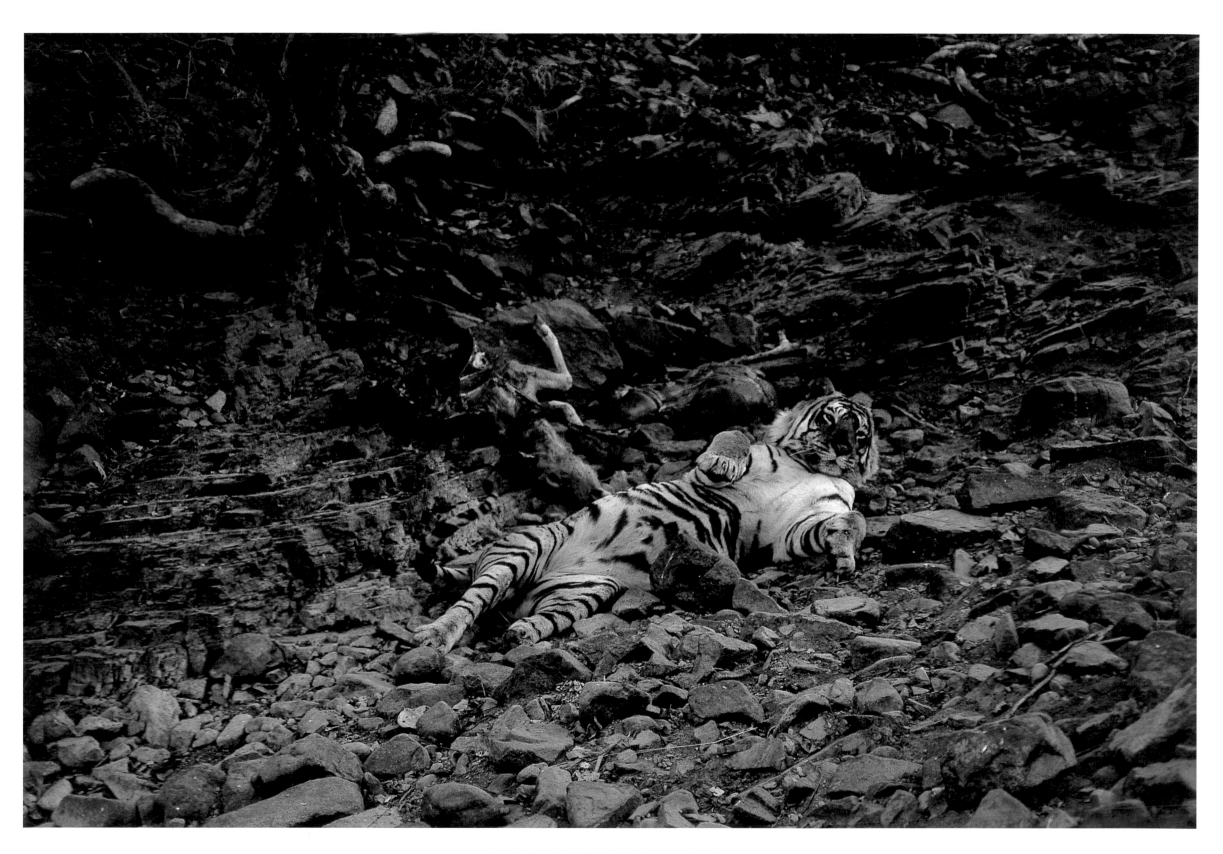

A male tiger has killed and eaten a sambar deer.
Now he rests beside his prey to keep scavengers like magpies and crows off the carcass.

The nilgai antelope is the biggest of the three antelope species in India.
The male is dark grey, whereas the female is brown and much smaller.

On the opposite page,
in late winter and spring, the peacock is on magnificent display.

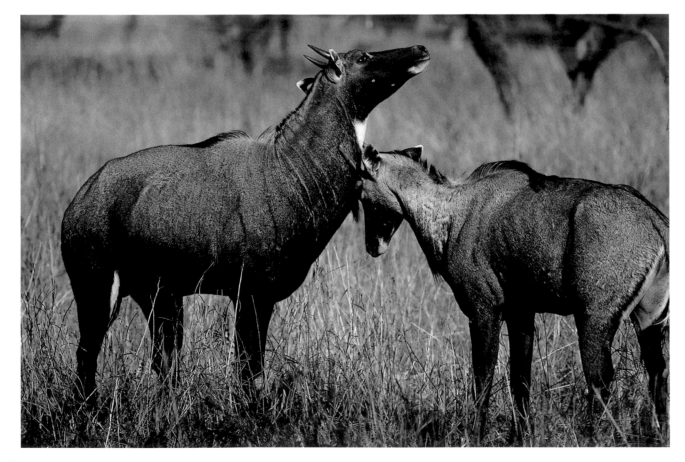

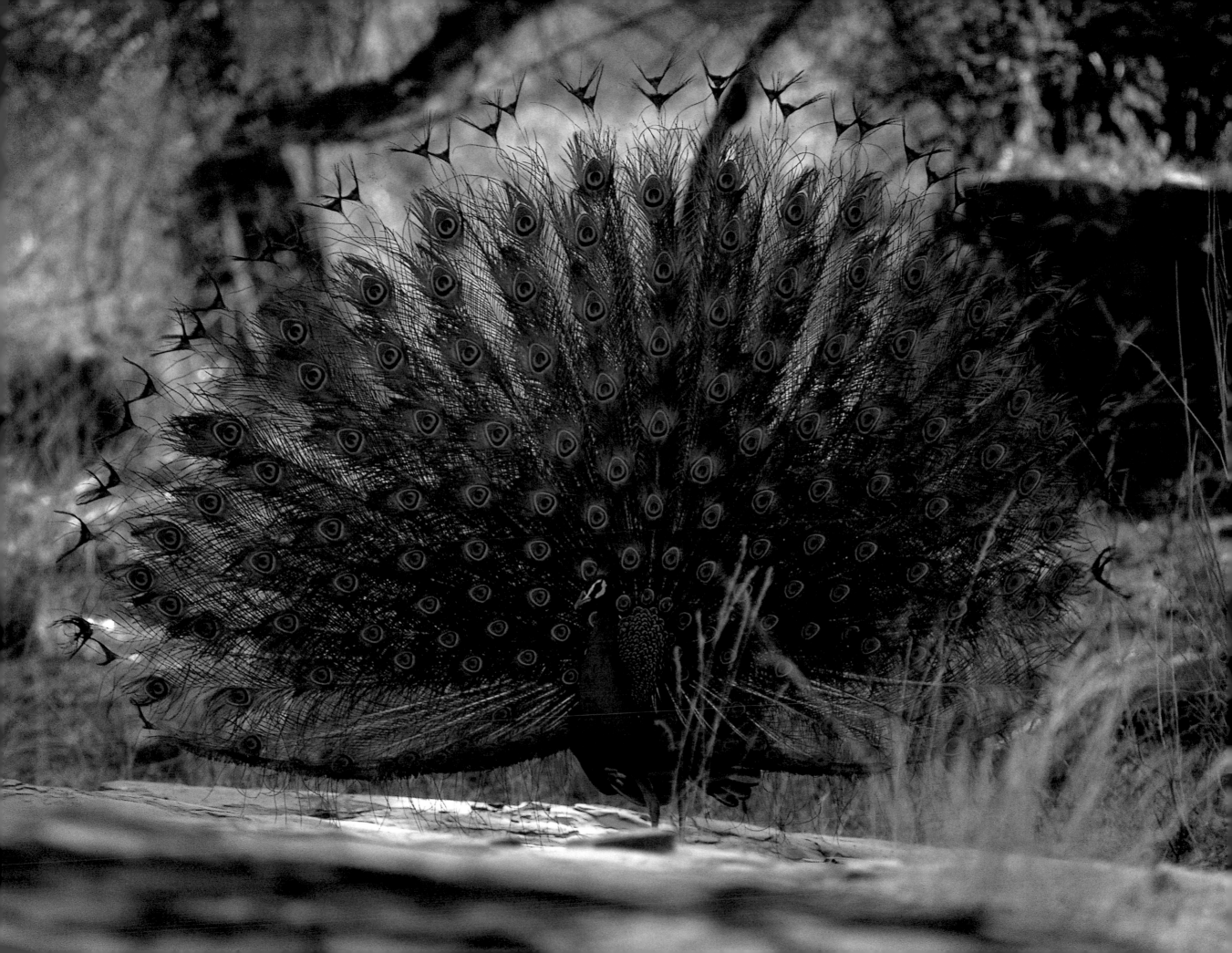

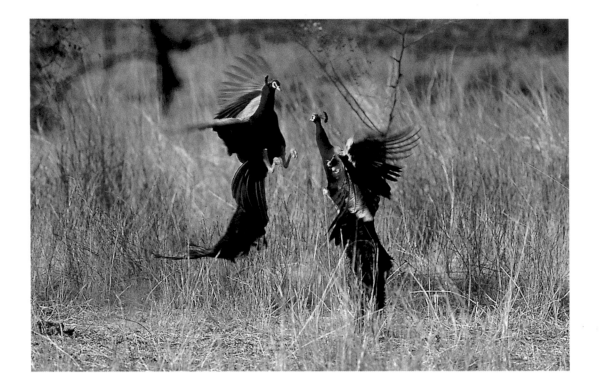

In spring, peacocks get very aggressive
and heavy fighting takes place sometimes.

On the opposite page,
the tigress Laxmi has killed a sambar deer.
This large prey will feed her for a couple of days
—if no male walks by and chases
her away to take over.

On pp. 248-249,
after stalking through the high grass
very carefully, tigress Noon managed to come very close
to a female sambar. But then the deer smelled her
and the huntress lost this last chance
for an attack. The next second the deer
ran away at full speed.

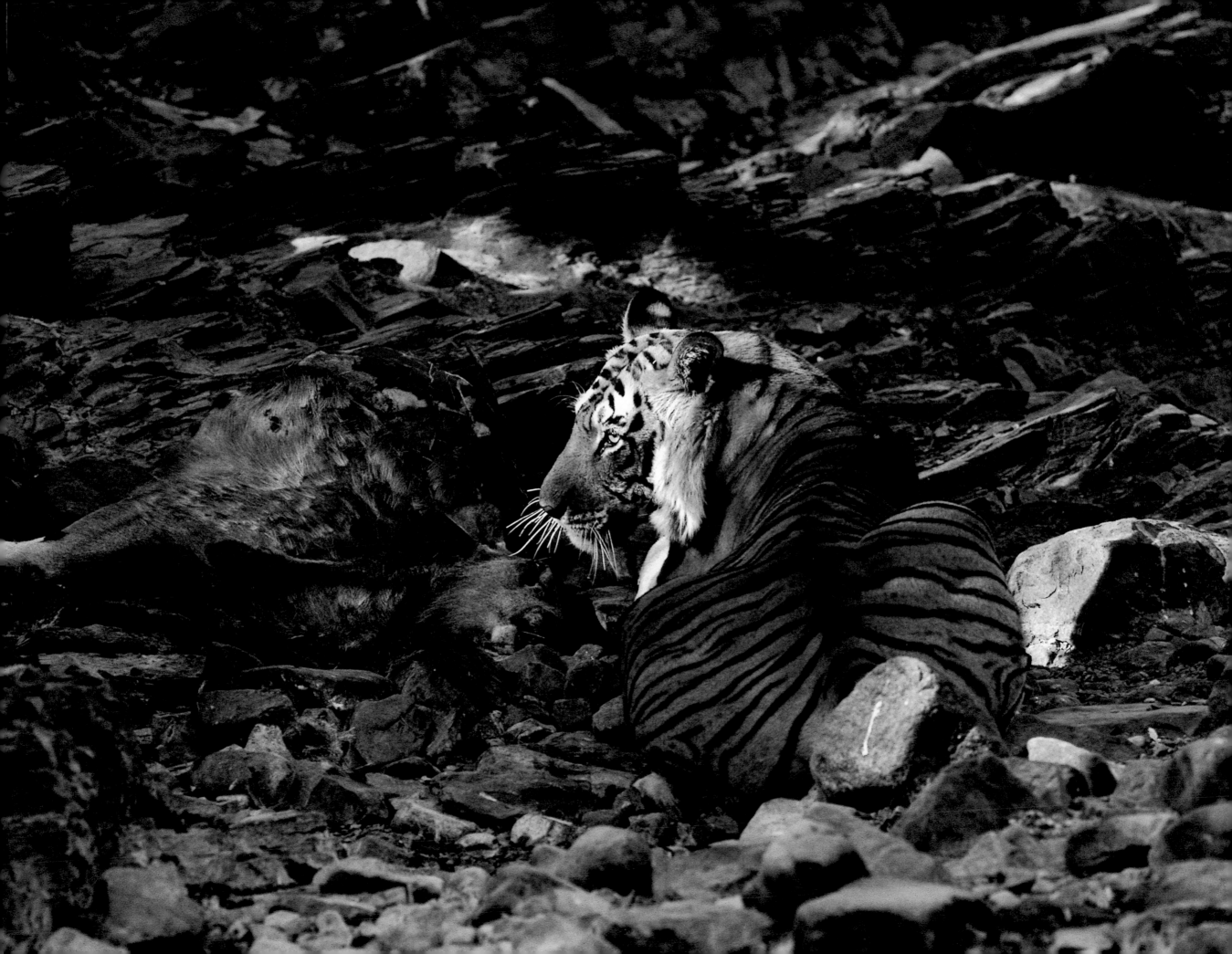

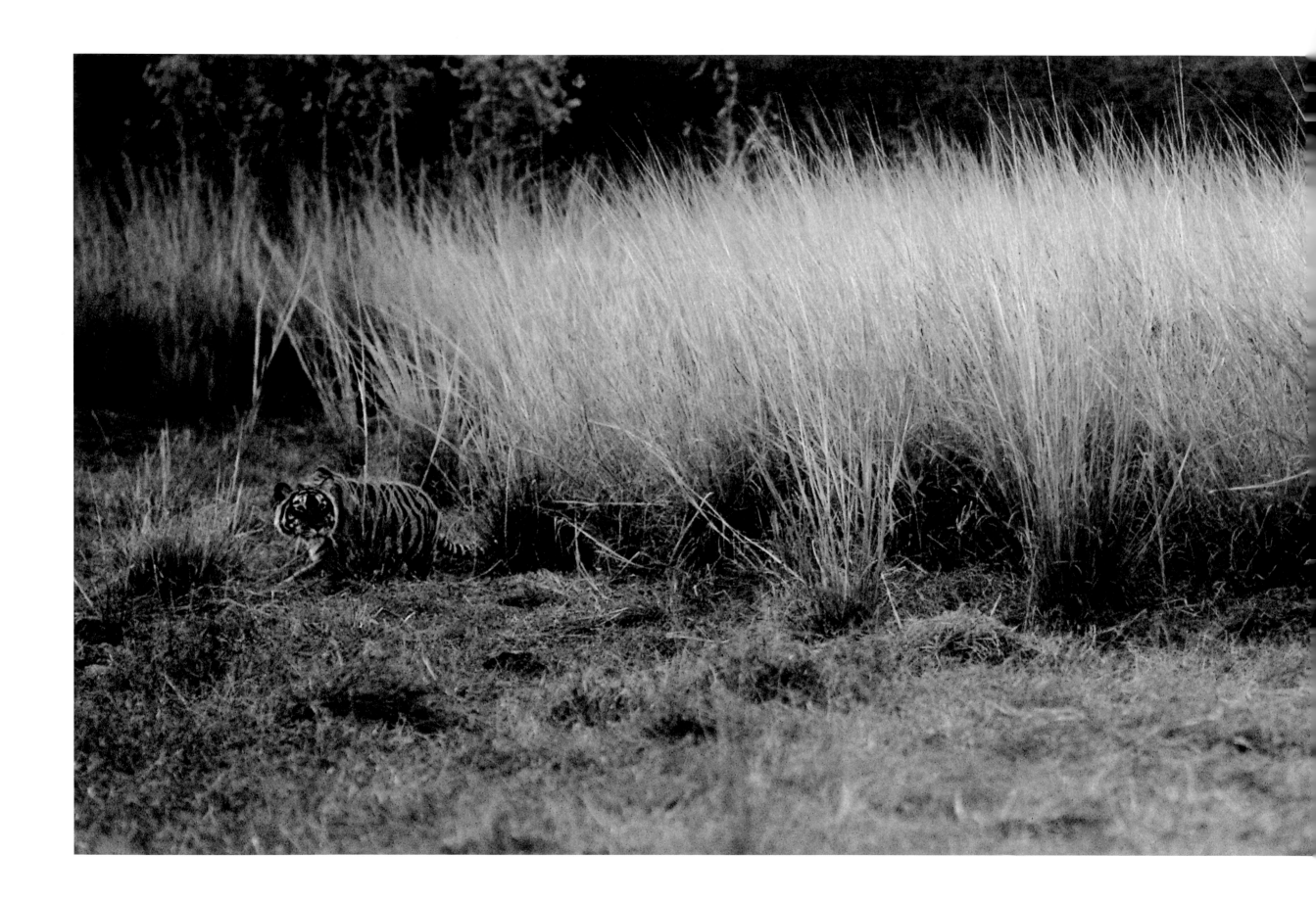

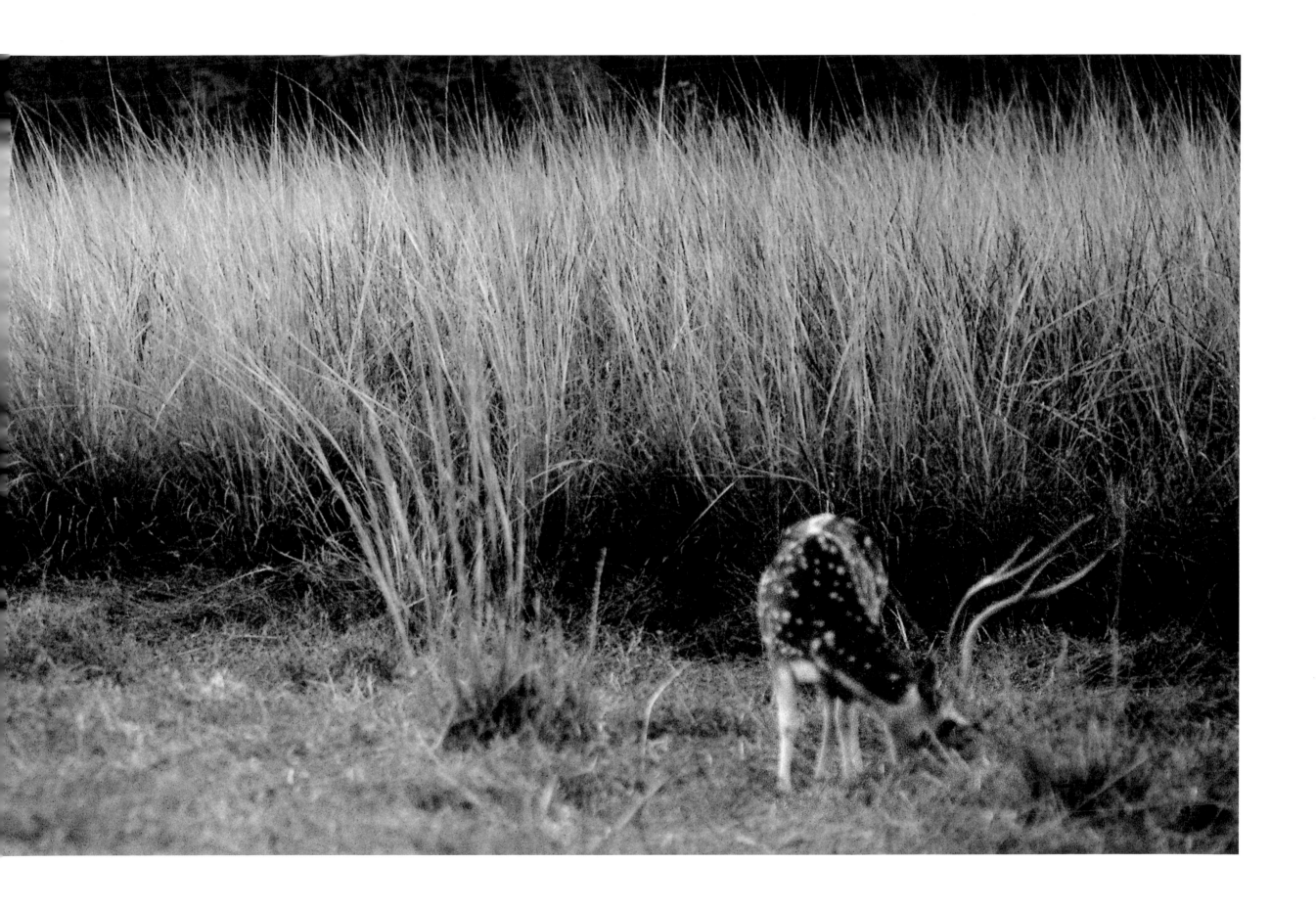

Greylag geese, which live and breed in Siberia, regularly migrate
to India to spend the Siberian winter at this little lake in Ranthambhore.

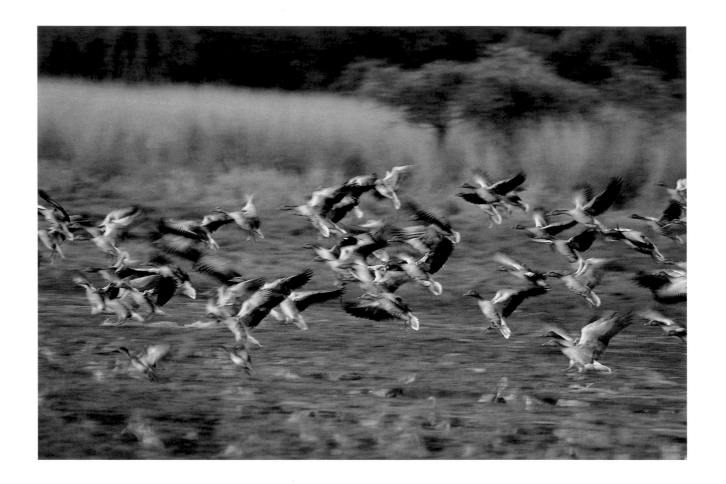

On the opposite page,
tiger Genghis was the first known tiger at Ranthambhore to develop a technique
to hunt the sambar deer while they stay in a lake to feed on the submerged water plants.
Most of the time he was successful, especially if he had chosen a small calf.
As the sambar would only enter a lake in the daytime, Genghis was also forced
to hunt in full light, even around midday.

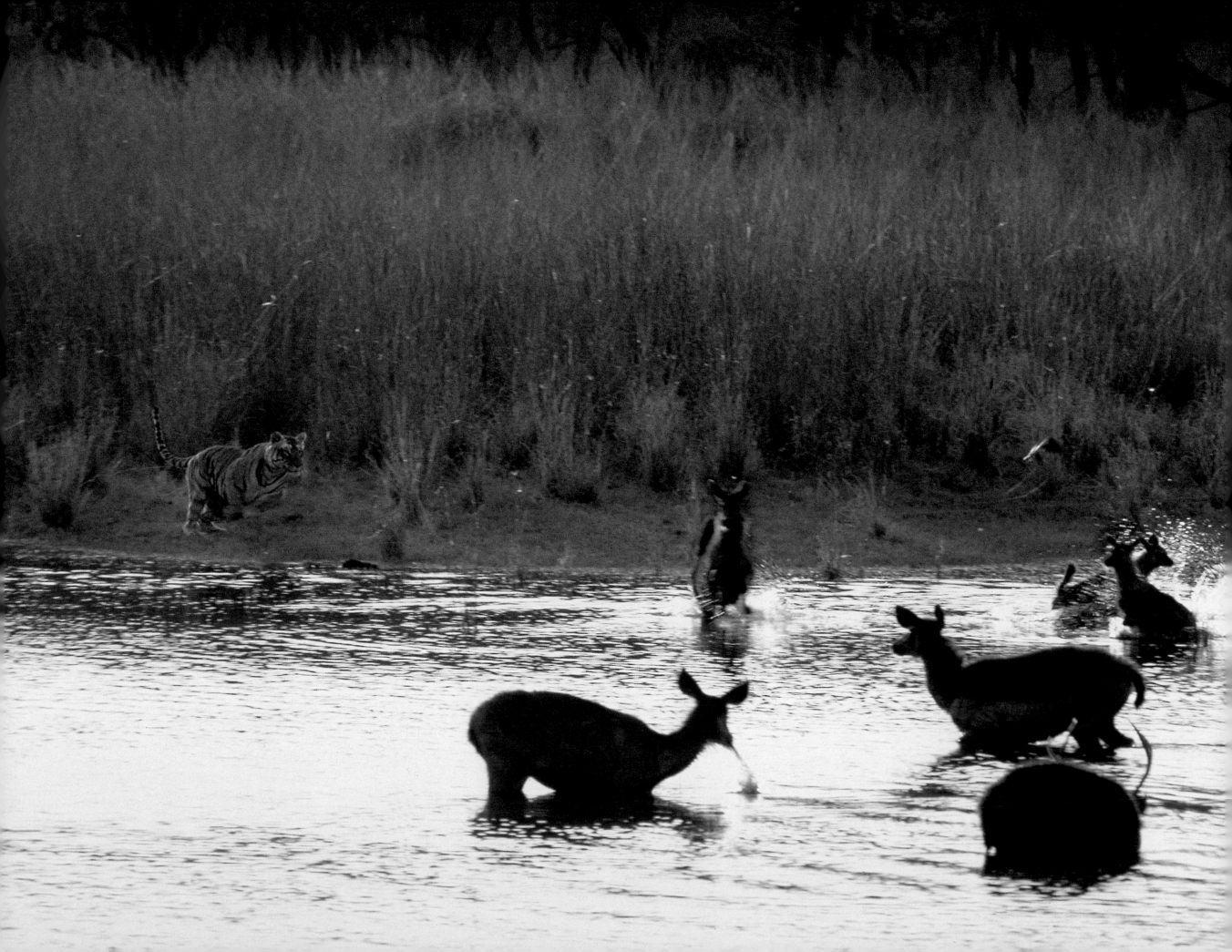

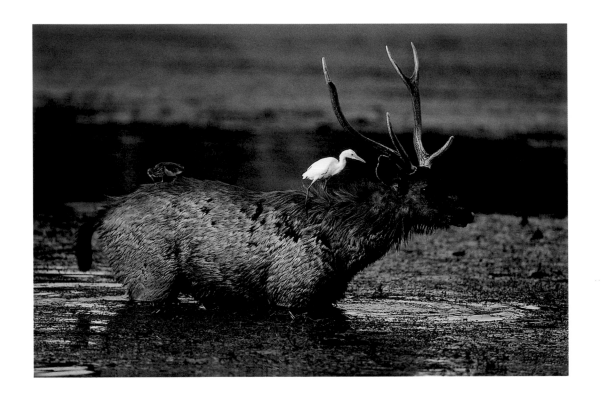

Sambar deer feeding in the lakes are often accompanied
by several egrets who go for the frogs being disturbed by the deer.
It is not uncommon to see them sitting on the back
or even the head of the deer.

On the opposite page,
perfectly camouflaged behind the high grass at the shore of a lake,
tigress Noon is watching some spotted deer.

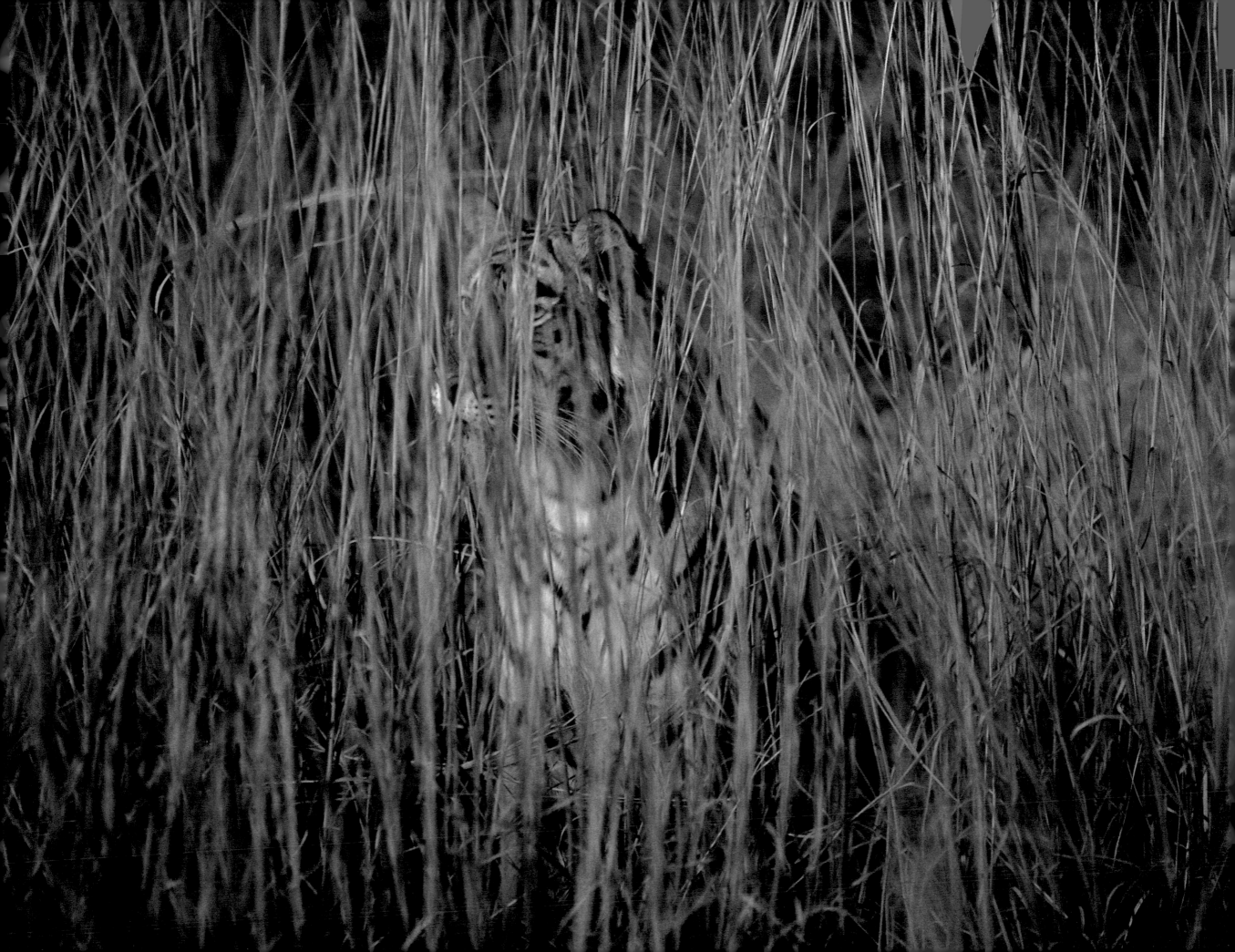

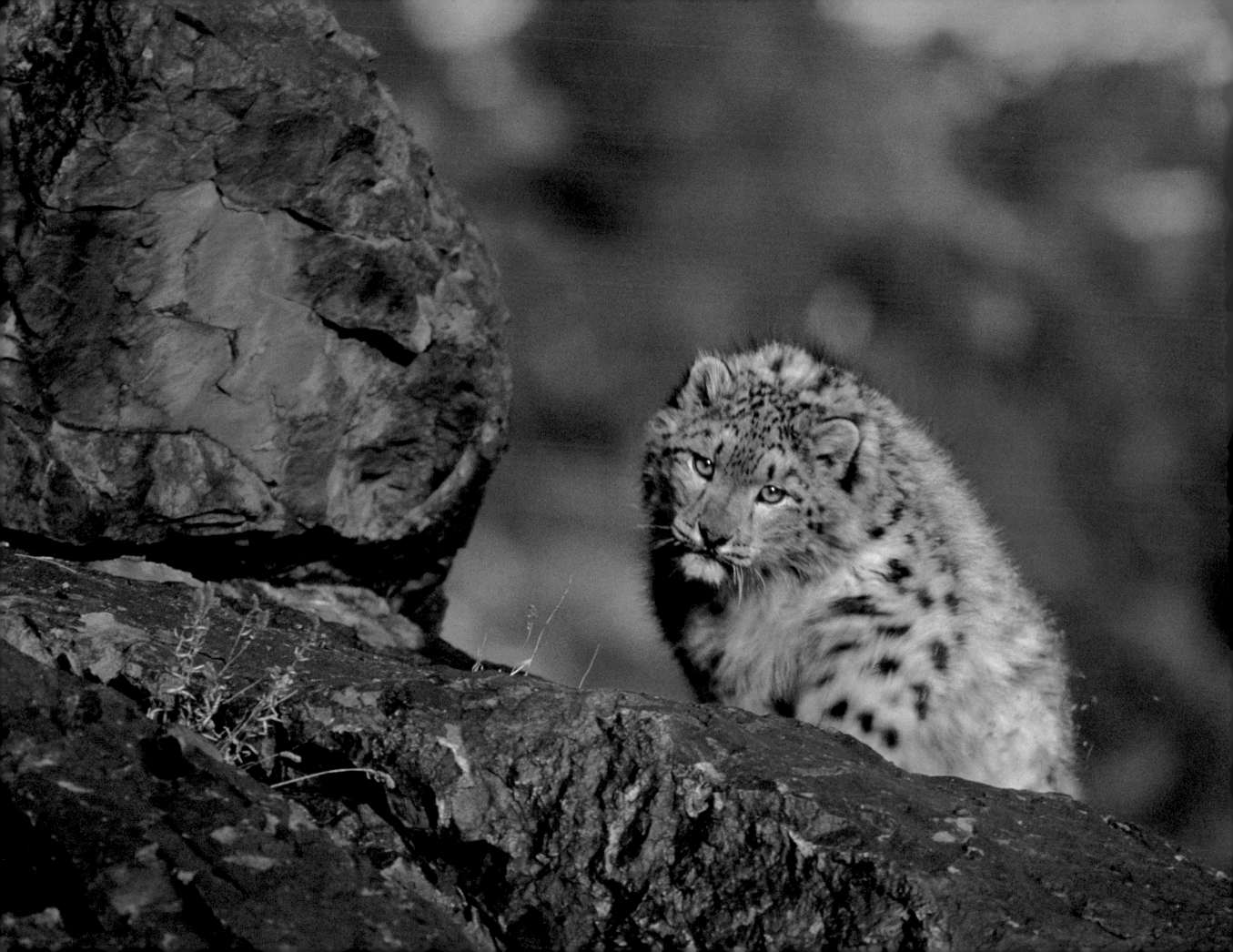

HOME OF THE MOUNTAIN GHOST
Trans-Altai/Gobi Region
Photographer: FRITZ PÖLKING

Mongolians prohibited hunting during the birthing and weaning period of hare, elk, roe deer, gazelle and other animals by law. Therefore there are plenty of animals and wonderful opportunity for the increase of animals. Violators are strongly punished.
MARCO POLO, 1274 journals

Like a mote in the eye-shaped nation of Mongolia, the mountains known as the Altai rise like snow-dusted daggers in the southwestern part of the country. An impressive range of almost 4.5 million hectares, it is the highest of three major chains in this hard-riding horse land of "Chinggis Khaan" —the great Mongol leader Genghis Khan.

Every schoolchild learns of the young warrior king who united the region's warring clans in the late twelfth century. Fewer remember that when his fearsome army of 200 000 horsemen was finished with its rides of conquest, Chinggis Khaan and his descendants forged the largest empire the world has yet known.

Mongolia may be most famous for its Gobi semidesert and the plains from which the marauding hordes rode to subjugate most of Asia, but geographically it is significant as the meeting of two major landforms: the dry, frozen mountains that dominate the north and west, and the high, arid basin which meets the Gobi plateau of steppes and semiarid desert expanses to reach into the south and southeast.

The peaks of the Altai range form part of a massive mountain arc that begins in China and runs all the way to the Himalayas, then back up to Mongolia. It has been characterized as "the dead heart of Asia," in that many ethnic groups live a harsh life of either nomadic wanderings or subsistence farming there. The backbone and wealth of their existence is the domestic livestock: the yaks, horses, goats, and camels so vital to their survival.

Though the country's herders have grazed their livestock across these lands for centuries, relatively undisturbed natural areas remain, with wild plants and animals that grow increasingly rare throughout the rest of Asia.

The former land of the Mongol hordes is at the crossroads of social and economic change, and therein lies the tale. Rising human population and tourism have increased the threat to wild places. The government has responded by expanding its system of national parks and nature reserves, enacting a series of environmental laws, and initiating biodiversity conservation programs, many in association with international organizations.

But the capital, Ulaanbaatar, is nearly three hours even by airplane from the Trans-Altai Gobi Protected Area. There are no rangers, no visitor centers, none of the infrastructure you would expect in a protected area. To the people who live in this alpine desert of little snow, it is in effect a dotted line on a map, and little more.

And that is bad news indeed for the bane of their existence, the elegantly beautiful, severely endangered snow leopard.

SHADOW TRACKS
Some people think that wildlife photography is a hobby, a pastime. In reality it is exactly the opposite, a sort of purpose in life.
FRITZ PÖLKING

He knows one must be near as he climbs down from his horse to check the fresh tracks in the snow. Yes, very near now: the wide, padded pugmark of the snow leopard is unmistakable. And there were the rumors that flew around the stove in the *ger* tent last night, that have been heard from dwelling to isolated dwelling among these precipitous Trans-Altai crags and pinnacles.

The people talked of the foal —horses are very valuable property, almost like family to these struggling, hard-working people— that was killed by the mysterious big cat over in nearby Djunga Gobi. They whispered to each other of the snow leopard mother that had come down into a valley two nights in a row with

On the opposite page, this snow leopard is coming over the mountain ridge and moving towards the camera. This nature photographer does not seem to interest it.

her three cubs, both times killing yaks that belonged to local herdsmen.

And he heard how all five of the beautiful smoky-white, spotted predators were found dead soon afterward, killed for their transgressions against the livestock so vital to the survival of the people.

"Around this time of the year," remembers Fritz, a 40-year veteran of nature photography, "it is difficult for a leopard mother to capture enough food for herself and three large young. Tame domestic animals are such tempting prey."

Now, looking at the pugmarks in the thin crust of snow, he shakes his head; five of nature's rarest big cats, killed in a relatively small area of 50 km², in just one month. Fritz can't help but wonder how many snow leopards will die over the next year. The same pressures he knows threaten many species around the world —dwindling natural prey and increasing human population— are evident even here, so high above the arid plains, so far from the nearest paved road and the rush of civilization.

A story in the *Ulaanbaatar News* reported that, in a one-year period, 200 snow leopard furs were confiscated at the local airport. Police believe that figure represents the tip of the iceberg, a mere five percent of all illegal smuggling. At such a horrific attrition rate, the estimated 4 000 to 7 000 animals remaining worldwide would seem to have an extremely precarious future. As indeed they do.

The family Fritz lived with in the Altai had about 100 sheep, 100 goats, 20 to 30 head of cattle and yaks, 5 camels, and 20 horses. In the last year they had given birth to seven young. None of them survived. Two died from cold or disease, but five were killed by wolves and leopards.

"This was nothing less than a tragedy for the family," says Fritz, "to lose the animal harvest of an entire year." He reflects on the impact to their well-being. "It is rather easy in Europe and America to demand the strict protection of all snow leopards; it doesn't require any personal sacrifice."

He cites a personal experience from his native Germany. "When the Free State of Bavaria intended to slightly enlarge a 25-year-old national park by adding wooded areas already owned by the State, a surprising storm of indignation and protests broke out among the local population." The measure was defeated. The reason? "The 'natives' would have to stay on signposted trails rather than walk wherever they felt like!"

He laments the irony in such self-interest. "Sure, Mongolians should accept without complaint the destruction of their entire year's harvest ... but please, don't ask us to stay on paths!"

HOWL OF THE YETI
As yet we still know practically nothing about the life of this cat.
GEORGE SCHALLER

Darla Hillard and biologist Rod Jackson spent four years radio tracking and studying five snow leopards in the high, sheer rock slopes of Langu Gorge in western Nepal's Kanjiroba Himal region of the Himalayas. It took another four years to write a book from their experiences: *Vanishing Tracks: Four Years among the Snow Leopards of Nepal* (1989, Arbor House/William Morrow, N.Y.). Their devotion to the task endured through daunting weather cycles including the worst Himalayan winter in recorded history, mud-slewing monsoons, and a location that was a two-week trek from the nearest airport —or doctor.

But the wealth of data that took two years to collate and interpret led to important insights into one of nature's most elusive creatures. As suspected, the feline loners have traits common with their biological cousins, the common leopard and the tiger: they move each day, usually at dawn or dusk; high, steep, well-defined topography such as cliffs, huge boulders or sharp ridges are favored perches for scouting potential game below (as occurs in the case of the cheetah, lion, panther, and leopard); and kills of large prey such as the bharal sheeplike goat come every 10 to 15 days.

During the mating season, the eerie yowling cries of snow leopards echo through the rocky terrain, prompting Rod Jackson to wonder if this is the sound visiting mountaineers and local Sherpa alike claim is the cry of the Yeti, or abominable snowman.

When larger game are scarce due to lack of winter forage, pheasants and even diminutive pikas and marmots become part of the snow leopard diet.

Although solitary by choice, the big cats range in territories that overlap with others of their kind. And several leopards often share general "centers of activity." Yet these elegant creatures apparently signal each other of their proximity with their scenting and droppings in locations that remain unchanged for generations. By alerting others to their presence, dangerous fights are avoided ... but mating opportunities increase.

At least fifty breeding pairs are required to sustain genetic variability in the population on a long-term basis. Protected parks in mountain areas are generally quite small, which increases the chance of inbreeding. Jackson suggests that transient protected zones between parks and animal sanctuaries might help ensure the healthy diversification of the species.

But first, people have to know they are inside a national park.

HIDE IN PLAIN SIGHT
The key to the mystery of a great artist is that for reasons unknown, he will give away his energies and his life just to make sure that one note follows another ... and leaves us with the feeling that something is right in the world.
LEONARD BERNSTEIN

Only one other person has ever made decent photographs of a snow leopard: naturalist George Schaller, whose near-heroic exploits in the 1970s to find the cat were chronicled by Peter Matthiessen in his riveting celebration of the bond between man and nature, the book *The Snow Leopard*.

Fritz is after "bigger game," photographically speaking. Oh, he has seen the many cute and cuddly closeup images taken of snow leopards in game preserves and zoos —but only Schaller's show them in action in their native habitat. For Fritz and most other wildlife photographers, that is the defining difference between a great photograph and a pedestrian one. In his career, he has published images in books and magazines all over the world, as well as written his own guide to successful nature photography. And he does not speak the language of "captive animal photography."

"Should game farm pictures be taken seriously? The question is: what are they good for? Do they move our emotions? Is there something that speaks out to us when we look at these perfect, doll-like cliches? I don't think so. The eyes and the heart do not overflow; only boredom gets the upper hand."

Yet recent surveys by Schaller suggest there are perhaps 1 000 snow leopards ranging over more than 90 000 km² of steep, mostly inaccessible terrain. Even if the animal weren't a master of evasive tactics, this lack of density alone would skew Fritz's odds heavily against ever even seeing one.

And then, riding along a high, steep mountain looking for tracks, he strikes the naturalist's equivalent of a diamond mine: the site of several snow leopard kills.

The dead animals — a female ibex, horse foal, and two yak calves— are in various stages of consumption. Three of the four kills are domestic animals. That's not good news for some local family. But at least the search for tracks is over: they're everywhere! One set indicates the last feeding visit was just a day earlier.

"At last, I seemed to be in a good area to see this mysterious cat." But the brutal challenge of –30°C temperatures keeps Fritz from remaining overly optimistic. How long can he endure the cold?

He rides on, looking, always looking. Then, beneath a wonderful evening sun, he glances up from his search for tracks and markings —right into the faces of two snow leopards not 30 meters away!

"One was about to disappear over a low, rocky ridge. The other one lay down in front of it and simply observed us."

Fritz grabs his camera. The two cats are fairly young, about two years, and identical in size: that means they must be siblings. He snaps off a couple of shots as one of them quickly slinks out of sight. But the other remains, watching him.

The dark, tigerlike facial markings on its soft, white fur seem to express indignation, challenge ... and perhaps a hint of curiosity.

"After some time this one, too, sneaked away around the rocky slope, following the other one. I moved very slowly on foot to get around the rock and climb down the 30 or 40 meters to where the two should be."

A couple of minutes of careful scrambling over the sheer rockfall rewards him with an extraordinary sight: the first snow leopard is hiding in a cave.

Perhaps it is the pair's den. Only its fluffy tail, as thick as a man's forearm, is visible in the shadows.

But the second cat ... the second cat is hunched down on all fours nearby —looking right at him! Its expression seems part trepidation, part challenge, as if to say, "And what manner of creature might this be, to intrude upon my domain?"

"Mostly, it seemed unconcerned with my close presence. After a couple of minutes of hovering close to its brother (or sister, I could not tell), it climbed a bit higher onto a ledge and disappeared."

But a short while later the beautiful cat returns —to move with deliberation directly toward Fritz and his camera. It stops at the edge of the deep crevice that separates the two, then looks across the 10 meters of space. Perhaps it is this 200-meter-deep gap, Fritz considers, that explains the animal's lack of fear. No matter: he triggers the shutter over and over, excited by this behavior that he has seen before —but a long way from here.

"In Africa, one leopard will stay in hiding while the other strolls around quite lightheartedly. This is typical leopard behavior."

Fritz's amazing run of good fortune lasts another half hour. Then the snow leopard gets languidly to its feet and disappears into a maze of rocks. The first cat stays hidden in the cave. But now, darkness is falling. High in the cold Altai is no place to be at night. He must break off the encounter.

Still, as he returns to his horse and makes his way toward the encampment, he is flushed with joy. It has been a life moment, to be forever cherished.

LIFE IN HIGH PLACES
Everybody needs beauty as well as bread, places to play in and pray in, where nature may heal and give strength to body and soul alike.
JOHN MUIR

The snow leopard is not alone in its skillful adaptation to mountain extremes. Argali or mountain sheep, ibex, ermine, stone marten, and mountain hare all manage to survive in the vaulting stony halls of the Altai. Altai snow cocks, rock ptarmigans, white ptarmigans, Pallas' reed buntings, Brandt's rosy finches, and Eurasian dotterels wing through the thin air of Altai's upper reaches.

The red-billed chough, the only bird ever known to soar the windy ridge lift above Mt. Everest, is found here, too.

In the lower altitudes of the Altai, vegetation finally gets its chance to thrive. Ground birches, mountain pines, willows, kobresias, sedges, alpine meadows, and mountain saxifrages add the colors of growing things so lacking at higher elevations.

No cat on Earth lives as high as the snow leopard, although it will readily follow prey down to as low as 1 800 meters. The highest reaches of the Altai are mostly bare gray and brown rock, perfect for the beautiful gray-white, mottled

On pp. 258-259, because of the dry climate, there is only a little snow in the Altai Mountain Range, even in the depths of winter and severe cold.

scheme of the snow leopard's coat. Its camouflage makes it almost invisible from just meters away.

But that same pelt was prized in ancient times for shamanist practices. Humans have always had a sacred regard for the big, furtive white cat. At the beginning of a Mongolian *tsam*, a snow leopard pelt was placed in the middle of a courtyard, around which ritual dances were performed.

In the recurring confrontation between humans and creatures of the wild, though, sacredness gives way to matters of survival, and the big cats are the big losers. Polls of Mongolians show a staggering bias against snow leopards: almost 90 percent think the animal should be allowed to go extinct.

The potential bounty from poaching doesn't help. In an increasingly market-efficient world, the bones and fur of one snow leopard can bring more than 60 times a herder's yearly income.

The challenge, as always, is to educate the locals to the long view —without asking them to sacrifice their own welfare.

TO LIVE FREE

You need knowledge, you need to learn, you need to speak up for the environment. Stand up and shout on behalf of the planet and people will listen.
GEORGE SCHALLER

If we really want to protect them," says Fritz Pölking, "we must compensate the people living there for the loss of their animals. It is a simple proposition: Animals killed by snow leopards are recognized by the killing bite in the neck or throat and by the fact that the snow leopard devours its prey in a distinctive fashion. If Western nature-protection organizations and governments really want to protect and preserve this beautiful cat, then they must find sufficient funds. All other declarations of intent are nothing but printed paper."

Creative solutions are being put into action. Donations to snow-leopard recovery groups from around the world help fund programs that provide money and children's clothing, food and flour to local people in exchange for a new attitude of protective husbandry that will allow ungulate populations, and thus snow leopard numbers, to both rise.

The International Snow Leopard Trust believes the smoke-colored cats provide a barometer of a healthy mountain environment. The more forage, the fatter and healthier ungulate species can become, the more milk and meat they provide for the people, and the smaller the percentage of them that is lost to leopards.

For Fritz Pölking, whatever works is worth pursuing. "For we in the West are the only ones who really want to protect it."

There are between 300 and 500 snow leopards in zoos, game farms, and similar facilities around the world. "About 230 specimens are kept in 50 American zoos in the U.S. and Canada. Zoologists believe this number will help them save 90% of the genetic purity of the species over the next 200 years."

"Then —perhaps— we will have evolved to a point where the leopard can again safely survive in the wild."

*On the opposite page,
the Bactrian camels live their whole life in the open.
The Mongolians only use them to travel from winter to summer places and vice versa.*

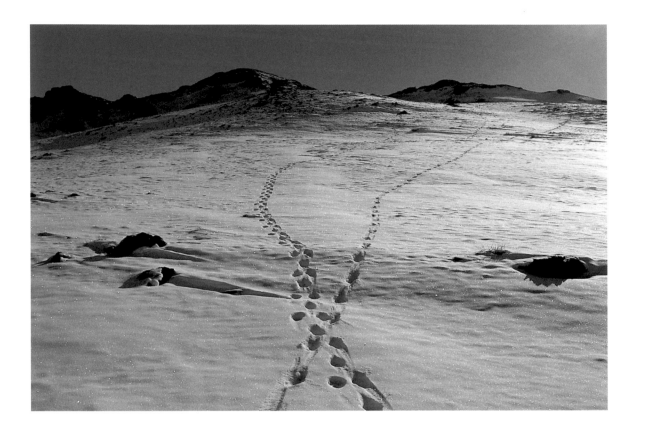

A rare document: three tracks
of snow leopards are crossing each other. Two of the animals are moving uphill
and one track of a specimen is coming down.

On the opposite page,
low snow and mountains not very much up and down, more like waves,
are typical of Mongolian mountains, where the snow leopard lives.

On pp. 264-265,
while one of these snow leopards only shows the white tip of its tail in the shadow
of the edge of the rock, the other one stays on its resting place, keeping an eye
on this nature photographer.

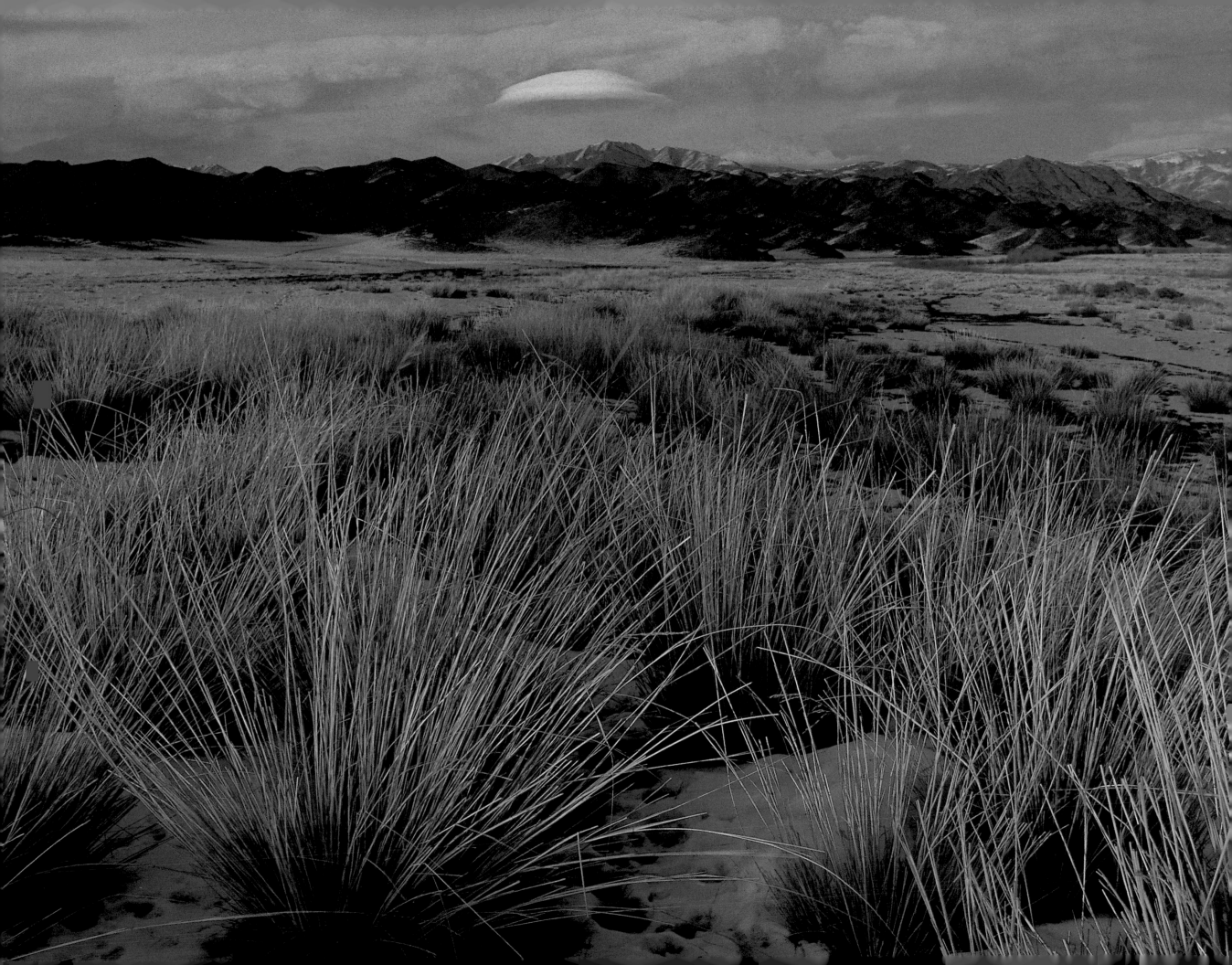

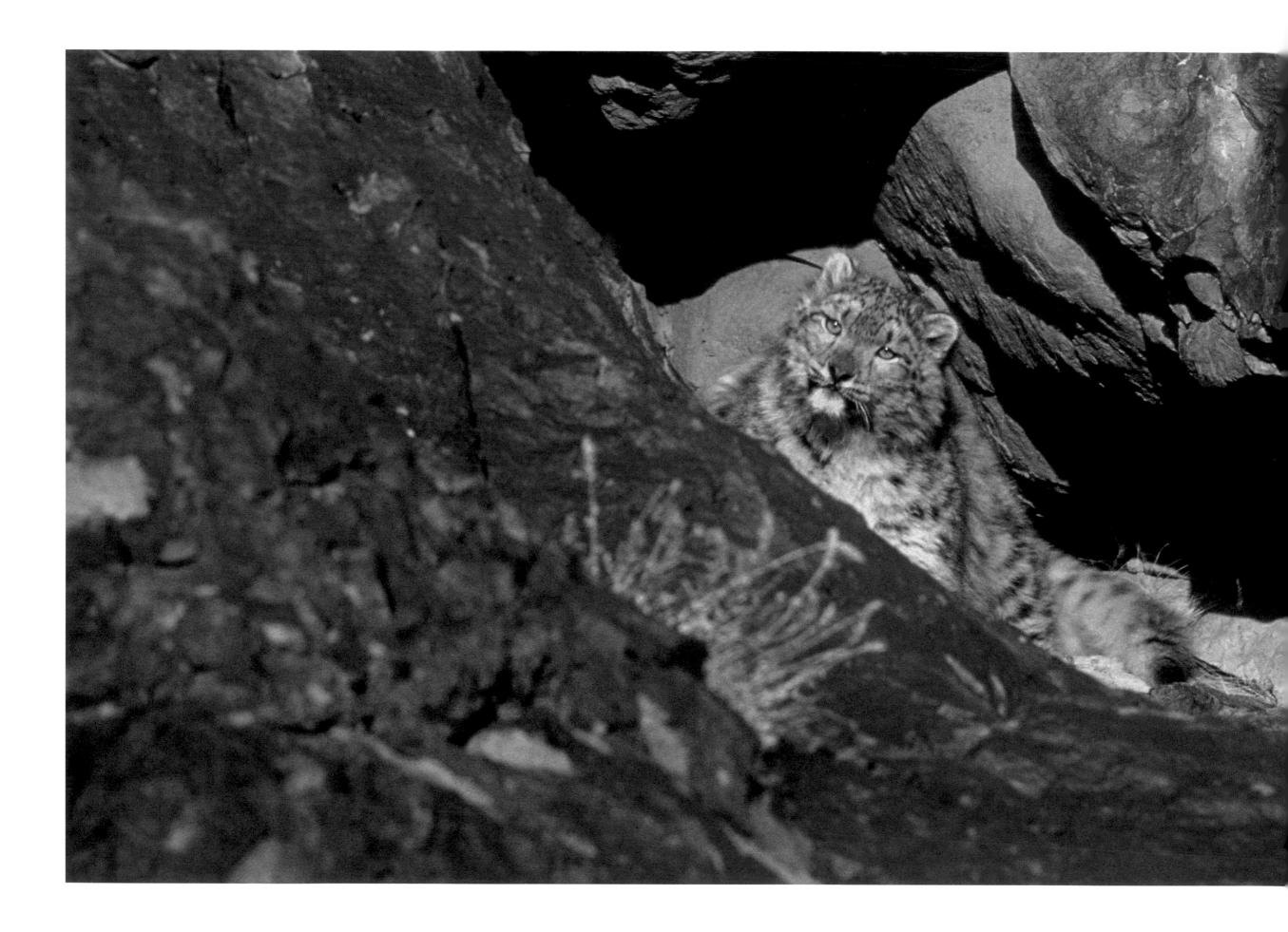

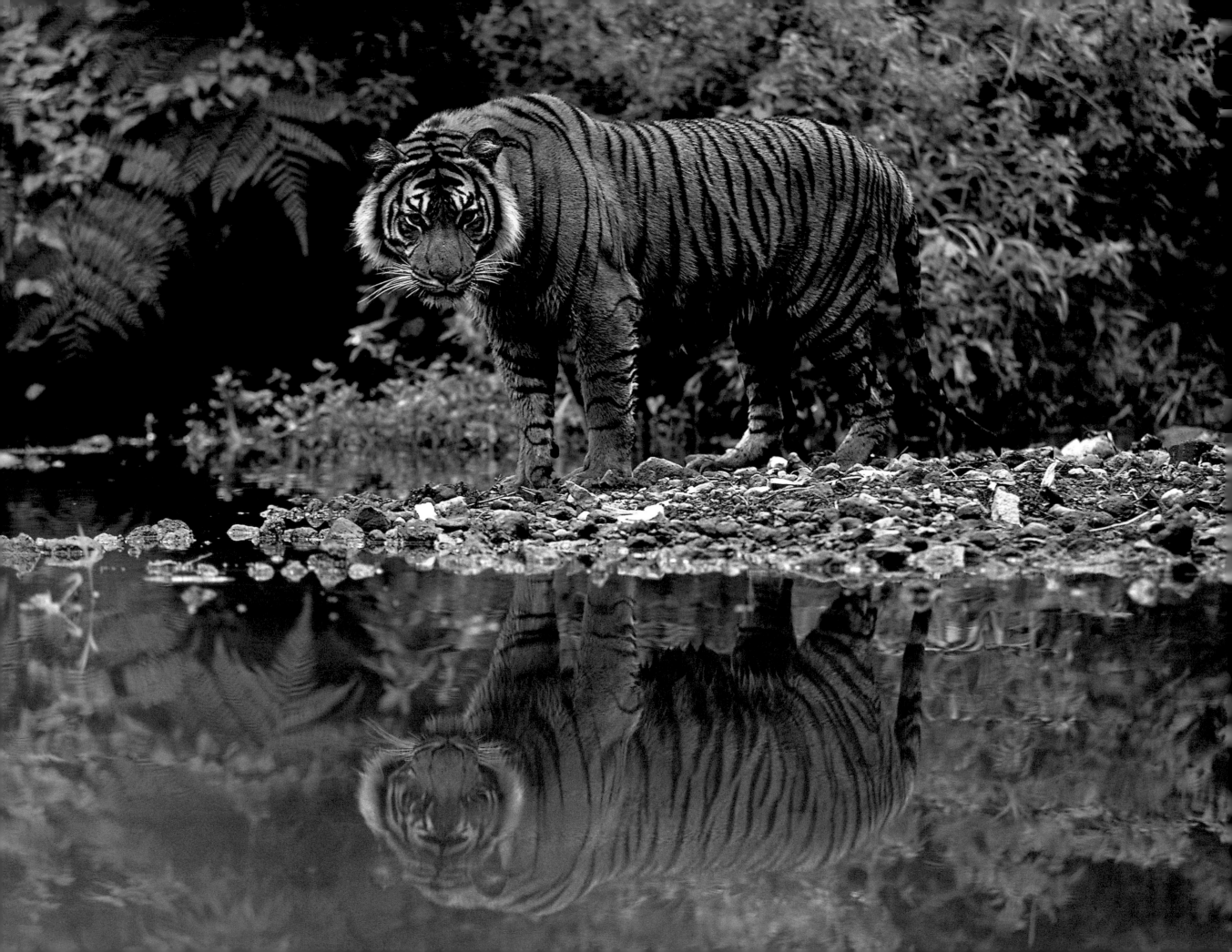

PARADISE AT THE CROSSROADS
Gunung Leuser, Sumatra
Photographer: ALAIN COMPOST

THE PERSON OF THE FOREST
He was sounding the deeps of his nature, and of the parts of his nature that were deeper than he, going back into the womb of Time.
JACK LONDON, *The Call of the Wild* (1903)

She swings through the high dipterocarp canopy of her rainforest home effortlessly, her large, elongated palms grasping the branches with the confidence of years and the instincts of eons. It is late morning —a few hours since she left her makeshift nest far behind to leisurely soar through the galaxy of leaves. The air is warm, moist, luxuriously buoyant. It is a good day.

A familiar fragrance wafts up from a fruit tree below. Food. She has eaten from this particular tree for nearly 30 years. Like a stone she plummets toward the bountiful, appetizing fruit, avoiding a fatal fall to the ground 40 m below by catching this limb here, that trunk-wrapping liana vine there.

Landing on a thick cluster of vines adorned with an extravagantly vibrant spray of orchids, she deftly picks a large Neesia fruit, then, glancing around her immediate environment, finds what she's looking for: a long, slender branch. She breaks off a long section, strips the leaves from the twig, then, holding the fruit so its sharp, irritating hairs won't hurt her, uses the twig to scoop out the precious, juicy meat that the tool has rendered vulnerable to her appetite.

Far off, she hears a deep, hooting kind of bellow. She raises her head, sniffing the humid air. It is a male, calling out his territory. And she recognizes the nuances of tone and pitch —it is the voice of her son, who left her care several years ago.

Because she and her kind are solitary by nature —the largest enduring social unit is a mother and her offspring—, she will move off in another direction rather than seek the company of her son. But first she will climb higher into the canopy for a long midday nap.

BETWEEN TWO OCEANS, BETWEEN TWO WORLDS
… a wide extent of unbroken and equally lofty virgin forest is necessary to the comfortable existence of [orangutans]. Such forests form their open country, where they can roam in every direction with as much facility as the Indian on the prairie, or the Arab on the desert; passing from treetop to treetop without ever being obliged to descend upon the earth.
ALFRED RUSSEL WALLACE, *The Malay Archipelago* (1869)

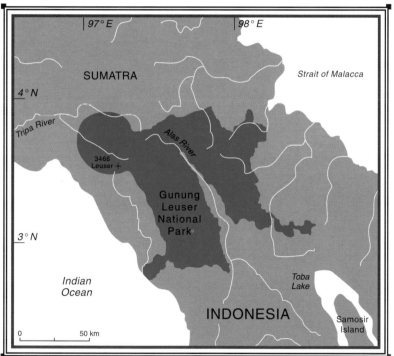

She is an orang-utan, or simply orangutan, from the Malay for "person of the forest" (*orang*: person, *hutan*: forest). An intelligent great ape, she is a tool user, a skill our lofty ignorance once led us to believe was the sole province of the human being.

She lives within the montane forests of the mountain spine that runs down 1 790-km-long, lens-shaped Sumatra, one of the main islands of the vast archipelago known as Indonesia. Luckily for her, her range falls within one of the largest protected areas in the country: the 950 000 ha of Gunung Leuser National Park. The park was established to protect the vast Gunung Leuser rainforest ecosystem, and harbors a major percentage of the rich profusion of animal and plant species that all of Sumatra and Indonesia are famous for.

Indonesia is a spray of more than 13 500 lush green island clouds sailing across the emerald waters that link the Indian and Pacific Oceans. Only 6 000 or so of its islands are inhabited, yet the government struggles to support and unify a burgeoning and diverse human population —at 211 million (300 million by 2 050), the fourth largest country in the world. Indonesia's peoples represent more than 300 ethnicities and speak more than 250 languages. Jakarta, on the island of Java, is its capital city, vital international business center, and one of the most crowded places on Earth.

On a world map, you find Indonesia sprawling across the equator, filling the ocean void between Southeast Asia and Australia. There are five main

On the opposite page, it is around rivers or lakes that tigers are most often seen during the early morning hours or at dusk. They can swim and don't like the open sunlight. I remember one day, I was intrigued by alarm calls of a group of macaques on the tree above. As I slowly opened the rear window of the hide, I spotted the tiger, just a few meters from me. I could feel that he was aware of my presence but he didn't show any sign of worry or hostility. I believe that he had been around the hide more than twice and had somehow accepted my presence.

islands: Java, Kalimantan (the major part of Borneo, which it shares with Malaysia), Sulawesi, Sumatra, and Irian Jaya, the western half of New Guinea, along with 30 smaller archipelagos.

The world's most populous Muslim nation, it has for centuries drawn both wanted and unwelcome attention from world powers bent on reaping and plundering its abundant natural resources: oil (a nine-billion barrel reserve), natural gas, timber, and incredibly rich, fertile soil. Today, those natural treasures are being rapidly converted into income by one of the fastest-developing nations on Earth —far too quickly, say many alarmed experts within and outside the country, for its own good.

Indonesia is still mired in recovery from the devastating economic collapse that affected all of Asia in the late 1990s, even as it transitions from decades of strongman autocracy at the hands of President Sukarno, then Suharto, into a tenuously-governed democracy. Meanwhile, its leaders wonder how to keep from squandering the nation's resources all at once, yet still meet the insistent needs and demands of its exploding population to compete with the great economies of the world.

Geographically, the islands spread as wide as the North American continent and make up 1.3% of the land area of Earth. Its extravagantly luxurious climatic zones and rich soils host an incredibly broad range of biodiversity: 10 000 species of trees, 10% of the world's flowering plants, 12% of all mammalian species, 17% of bird, reptile, and amphibian species, and 33% of fish species, including 2 500 types of reef fish alone.

Indonesia is, by any reckoning intuitive or scientific, a natural paradise. It is also a conservationist's nightmare in the making.

The Radjah's Brook bird wing is found in Sumatra and Borneo. This impressive butterfly can reach a wingspan of 17 cm. When they come to damp spots in search of moisture and minerals and in early morning when they dry before takeoff are the only moments when it is possible to admire their exquisite beauty. The rest of the time one can only take a glimpse at this piece of jewelry flying restlessly under the forest canopy.

ALAIN IN WONDERLAND
**I'm the first photographer to completely cover the wildlife of this country.
I feel I have contributed to something.**
ALAIN COMPOST

Sweating in the humidity and early afternoon heat, Alain Compost, born in France but most alive and at home in the wilds of Indonesia's paradisiacal island rainforests, stops to rest on the crest of a ridge in Gunung Leuser National Park. Far below, snaking through the steep-walled valley, the river Alas murmurs its age-old song.

Then, across the gap on an equally high ridge, he hears the unmistakable, deep call of a male orangutan. He smiles in recognition and memory. It was the anticipation of hearing that call that first brought him to this land so many years ago.

"I came from France in 1975 because I wanted to take pictures of orangutans," says Alain by phone from his Bogor home on the island of Java. "In the years since, I have learned to listen and feel Indonesia ... and it is a magical place. In the city, you can lose the sense of time."

"Here in the forest, after a few days, you learn to develop your lost senses. You listen, you smell, you make pictures, you act on instincts that tell you to go here to see an animal, and you go. And ... I can't explain how ... but the animal you were wanting to photograph is often there, as if waiting for you, as if you were sent there to find it."

"After a few weeks or months, it is easy to imagine that people living inside the rainforest all their lifetimes make the most of the potential of the human body."

Since childhood, Alain has been drawn to wildlife. He believes his calling is to serve the cause of global conservation. Indonesia, with its incredible diversity of animal species, is his perfect life match.

Alain photographed his first orangutans within Gunung Leuser National Park at rehabilitation stations where domesticated apes, once sold as infants for the whim of the illegal pet trade, then abandoned when they grew to unmanageable adulthood, were being taught how to live in the wild.

"I started submitting my photos to the publications of the world. Endangered orangutans were a symbol for conservation; they are so close to us biologically. The photos sold well. People sympathized with their situation."

Over time, he broadened his palette to include Indonesia's animal, plant, and landscape subjects. Whereas orangutans at the rehab stations were relatively easy to photograph, the more elusive of endangered species took years of constant research, patience, and lots of time in the field. Known initially for his captivating portraits of the red-haired apes, he became a specialist in photographing the Sumatran rhino.

"But it never ends: there is always something new! That is why I came to Indonesia. It is so rich in islands, climates, habitats, wildlife; there is a lifetime of work to do here!"

His approach to nature photography is simple: give and give generously. He has no major sponsor, and so must use money from his sold images to "shoot more photos. And I offer them for free to the government. In return, they give me official support to get into areas others have difficulty getting permits for."

"Sometimes the photos are not used as I would like, but often they are printed in books for students and researchers, or in guidebooks for national parks. So I feel I am serving the bigger picture first, and money second."

Over the last quarter century, Alain has seen change come to his adopted islands, and to the big conservation picture all over the world. "The wild places are disappearing ... quickly."

FRAGILE ARCHIPELAGO, FRAGILE PARK
Faith is an island in the setting sun.
PAUL SIMON

Indonesia is a country on an ever-accelerating treadmill, a nation whose people seem bent on ravaging its rainforests at a greater pace than even the nations of

Amazonia. More than 10 percent of the world's total tropical moist forest is spread across the islands —and roughly two million hectares are being felled every year. Nearly 85% of all of Southeast Asia's annual deforestation occurs here.

The Gunung Leuser ecosystem and the national park that was created to protect it from decimation is a microcosm of the bountiful ecology —and pressing problems— of greater Indonesia.

Within the park, 12 major rivers flow from the 3 000-m-high Barisan Mountains, to bring domestic and agricultural water to more than two million people. The park covers 830 500 ha, over 9 500 km^2, and most of it is steep, high country. It can be reached by road from the major city of Medan to the north, and lies mostly within the troubled and secession-minded province of Aceh.

Its tremendous array of climatic zones and soil diversity, from coastal swamp to tropical rainforest to alpine steeps, bestows a profligate wealth of biota —thousands of species of flora alone, of which none is more dramatic than the meter-wide spotted red rafflesia flower. More than 40% of the 9 000 plant species of the entire West Indo-Malayan region are found in the Leuser ecosystem alone, a dramatic testament to the biodiversity that makes Gunung Leuser one of the most important national parks in all of Southeast Asia.

The bounteous variety of animal life alone is staggering. Sumatran rhinos and tigers, elephants (which mostly pass through the park from other, unprotected areas), Malayan sun bears, rangkong birds and nine species of hornbills, civets (a foxlike mammal often mislabeled as a feline), sambars, barking deer, lesser and large mouse deer, wild dogs, golden cats, leopard cats, clouded leopards, seven species of primates including orangutans, white-banded gibbons, Thomas' leaf monkeys, and long-tailed macaques, jurong fish, and huge, marvelously camouflaged butterflies are just a few of the hundreds of creatures to be found in Gunung Leuser National Park. By the numbers: more than 385 bird, 125 mammal, and 190 reptile and amphibian species live here.

Yet numbers can tell two tales. Much of the wildlife thrives more easily in the lower elevations, where animals are more accessible to the ravages of poaching, logging, and agricultural clear-cutting. The orangutan and Sumatran rhinoceros, once common throughout Southeast Asia, are now among the most endangered of all wild species.

The last remaining lowland rainforest tracts in all of Sumatra are mostly within Gunung Leuser. But illegal logging, agricultural encroachment, wildlife poaching, and logging road construction continue to pressure all of Indonesia's many parks and preserves. To head off the threat, the private Leuser International Foundation (LIF) represents an innovative, joint operation between the government of Indonesia and the European Economic Union. It brings to bear high-level official support and international funding to the park and an additional one million hectares of surrounding land.

By partnering with the provincial government and local authorities and law enforcement, universities, villages, and park managers, the novel program is a grand experiment that is developing a much-needed infrastructure —sanitation, potable water, schools, roads, health clinics, and more, all constituting the engine of aid—, in exchange for educating the local populace in the vital need to protect the park from piecemeal destruction.

Whereas elsewhere, Indonesia's hardwood forests are being cut down to make way for pasture and large-scale monoculture plantations (rice, coffee, rubber, and palm oil for export), Gunung Leuser hopes to provide an embraceable, alternative model that may yet prevent the pollution of river systems, destructive fishing practices on coastal reefs, and the hasty and wholesale obliteration of entire forests of plants and animals.

Progress is being made: one local project recruited and educated local village fishermen in the wisdom of policing their own section of the river to prevent outside poaching of fish. The once-depleted fish stocks have almost completely recovered in a short period of time. Where there is a larger view and consensus, tides can be turned.

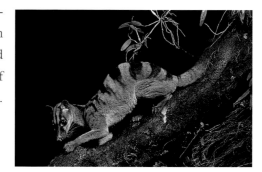

GREEN REALITIES
Humankind can not stand very much reality.
T.S. ELIOT

Alain knows all too well the difficulty of trying to turn determined people away from a course of action they believe is right, no matter how destructive it may prove to be.

"Gunung Leuser is surrounded by the Batak people and the Karo people. In the middle of the reserve is an enclave, the Alas River Valley, full of rice fields and villages. It is one of the main pressure areas against the ecosystem because the forest has been logged and the soil planted all up and down the river."

"The people always try to expand their territory, to get more and more. Conservation is not taught in the schools. These people have lost contact with nature. They have no feeling, they don't care about the tiger, about the orangutan. All that is important is money for living. So the only way to get support is to have international organizations doing things on a local level. Like me; I can provide pictures and stories about wildlife."

The province of Aceh has never welcomed outside influence, whether from the colonial Dutch they fought for 350 years or their current Jakartan leaders. "They want to be a separate state, which makes everything quite difficult for control of the park. Some enforcement people have been kidnapped and never seen again."

Aceh separatists reflect the devoutly Muslim sentiments of 4.5 million people who have more in common with nearby neighbor Malaysia than with Jakarta. Newly-elected Indonesian President Abdurrahman Wahid has proposed a referendum to permit Islamic law in the oil-rich province, although independence remains unnegotiable.

Civets are very adaptable creatures, but some, like the banded civet, prefer undisturbed forest. This is the most secretive civet in Sumatra and very rarely seen. It is by chance that I spotted it one night as it had just emerged from inside the hole of a dead tree. I was not able to photograph it the first time, but managed to find a passage and a location where I could install a hide and set a remote-operated flashlight.

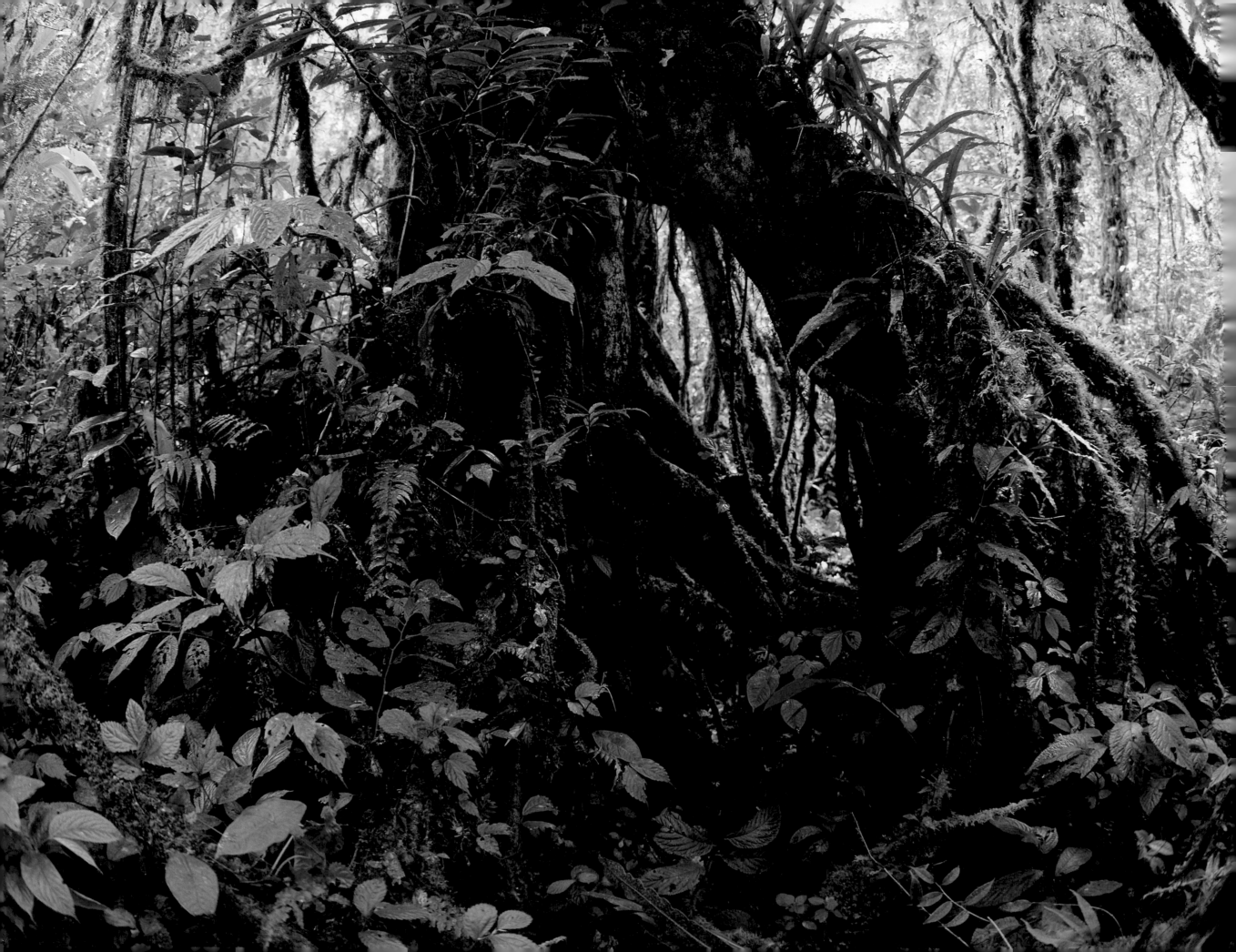

Yet even in the midst of political turmoil, Alain finds Indonesians in general a "very friendly people —as long as they don't get angry! Very nice, very open, and supportive of everything I have done in my years of work here."

"When you live with them for days and weeks, they have so much to teach you about the forest. Yet when you leave, they go out and cut down the forest. Of course it is very important for their income, but they don't realize that they are cutting the last of the trees. In their minds, there will always be forest. It is so difficult to explain to them that what they see at the edge of their villages and towns, that looks endless, is instead nearly all that is left of the forest. When it is gone, it will be gone."

TREES LIKE DYING STARS
The logging companies are wide-ranging and omnivorous … the forest
with the highest incidence of endemic species can also be the forest
with the highest incidence of logging companies.
GAVAN DAWS AND MARTY FUJITA, *Archipelago: The Islands of Indonesia* (1999)

Look at a map of the World Wildlife Fund Global 200 ecoregions, and you will see the Indonesian island of Kalimantan/Borneo, a few score kilometers across the water from Sumatra. Once known simply as Borneo, the island is colored almost entirely green. The green represents the original extent of Borneo's montane forest ecosystem. An inset box on the map shows a representation of the island today: only about one third of that original forest area remains green.

In visceral terms, you find landscapes throughout Indonesia where huge red-brown tracts of former rainforest are newly laid bare to the sky. The rectilinear abominations butt up in stark counterpoint to the lush random aquas and emeralds of the forests at the borders, an indisputably grave depiction of the problems facing natural areas around the planet.

Thus, in 1997, as Gavan Daws and Marty Fujita chronicle in their book *Archipelago: The Islands of Indonesia*, Indonesia was a maelstrom waiting to happen.

Once land is logged, the most expedient way of clearing it for planting is to burn it. Compounded by the drought effects of the El Niño global weather phenomenon, immense areas of ancient, dried-out peat bogs up to 6 m deep caught fire —and kept burning. Peat burns long, hot, and with terrible pollution, even worse than that from forest fires. A smoldering peat bog is virtually impossible to extinguish. As you read these words, some peat fires from 1997 still burn in Indonesia.

The monsoons finally arrived, although later than normal. Yet even the downpour of the heavens wasn't enough to right humans' follies. Many fires continued to burn for more months. When it was over, two million hectares of the country's remaining 100 million were burned to the ground.

Large-scale forest burning had been made illegal in 1994 in Indonesia. Many of the large logging companies and small developers alike continue even today, in defiance of the law.

To the holocaust of flame, add the financial crisis that struck all of Asia, and you have the seeds of popular dissent. The 30-year autocratic reign of President Suharto ended in favor of the elected democratic government led by President Wahid. As all leaders before him, Wahid strives to minister to the diverse needs of Indonesia's many ethnic groups rather than continuing the political quest for a national identity based on sociological and religious unification.

The larger dilemma finds echoes in Gunung Leuser National Park, where blatantly illegal logging by a number of timber companies continues despite official efforts to enforce park borders and protect the ecosystem.

Yet in a landmark decision on May 20, 2000, the Jakarta government, increasingly pressed by world governments and global conservationist organizations for its lax timber policies, has shifted control of forestry concessions from the hundreds of private logging concessions to state-run companies.

Private logging combines will continue to operate the concessions, but now as subcontractors to state timber bureaucracies. Given Indonesia's 140 million ha of remaining forest, of which nearly half is operated by concession holders, the ruling can only be described as a ray of hope.

Sustainable logging movements, though still a modestly supported concept, are gaining ground. And Indonesia works hard to expand its already respectable natural bounty of 20 national parks, 360-plus protected areas, and many marine parks. Its goal is to bring ten percent of the nation's land under the umbrella of protection, nothing less than a noble expression of political intent.

THE WISDOM OF THE FOREST
In the forest you don't need a watch.
You tell time by the sound of different groups of insects during the day.
ALAIN COMPOST

"When I watch animals over a long period of time, when I am among them every day, I begin to feel part of their world. Sometimes I am in a hide, and they behave as if they noticed me, though they don't know I am there. I feel I could go out there and be with them and they wouldn't be bothered by me."

In the middle of the forest, Alain feels his humanity merge into the hypnotic susurrus of sounds and the feeling of life everywhere. A giddy rush of fragrances informs his senses of the proximity of flowers, plants, and vegetation decaying back into the soil. All life is connected to light and the timeless processes of nature.

When he first came to photograph the orangutan at the rehabilitation stations, these were remote places deep within the pristine rainforest of Gunung Leuser. He still remembers how that first hooting call of the orangutan filled him so with excitement.

A quarter century later, he laments that same station that now stands at the edge of the forest, just into the trees adjacent to a large rubber plantation.

On the opposite page,
of all subjects, trees are the most
challenging to photograph because
there is nothing you can really
control about them.
Fortunately, nature has designed
some of them to look just right.
This tree with its complicated aerial
root system is covered by lush
epiphytic growth. Everything
arranged in harmony,
nothing in excess, a piece of art
signed by the finest artist of all.

Tourists come. Local villagers open more and more shops selling T-shirts at the station gates.

Perhaps it will all turn around. Perhaps not. Alain knows he can only do so much, but that will not deter him from his life's mission. He hopes only to inspire others everywhere to do the same. He wants only to live free, to walk beneath the high green canopy, to bring the stories that can still be told of the natural world to Earth's children.

A PLACE OF HER OWN

This week, for the first time, I heard a gold-mining generator just across the river.
Dr. Biruté Galdikas, primatologist

After a satisfying nap, she awakens to the buzzing of insects. She eats another piece of fruit, then surveys her surroundings in the long shadows and diffuse yellow-green light. A few large butterflies flutter nearby. Down below, branches shake furiously: several noisy gibbons taunt a prowling tiger. She throws a derisive hoot in their general direction, scratches her red fur absently, then moves off again through the canopy, branch to vine, vine to perch, and so it goes for the rest of a leisurely afternoon.

Suddenly a new sound echoes through the forest and she jumps with alarm —a startling, rasping kind of growl she knows all too well. A frenzied squawking flight of hornbills adds to her disquiet.

All senses peaked, she listens as the snarling stops. For a moment, quiet, laced with tension. Then a series of loud, sharp voices, like her son's, only different. More threatening. They are the same voices that have come to kill other mothers and steal their children.

And now, a crack and crashing roar of leaves, a shuddering WUMP! she feels through her grasping hands and feet, and she screams and screams in fright and confusion.

Overwhelmed, she turns from the chaos and flees, hand over hand, back into the forest she has known all her life. Eventually the sounds fade in the distance. And still she moves on until, exhausted and hungry, she stops to rest, eat some fruit, and calm herself.

Climbing higher into the canopy, she builds a new nest of leaves and quickly falls asleep, exhausted.

That night, her rest is fitful. She dreams of the little round-eyed babies who suckled at her breasts and kept her constant company for years, until, old and wise enough, like the son she heard today, they left her forever.

She dreams of her own mother, dimly remembered.

When she wakes, she relieves herself over the side of the nest, then sets out on the day's journey, after a stop to share the bounty of the fruit tree.

Perhaps today will be a good day. Perhaps she will never hear the crashing of trees again.

She wants only to live free, to swing high in her green cosmos, and now and then, to greet her grown children.

Prof. Biruté Galdikas, who devoted her all life to orangutans in Borneo, wrote: "I look them in the eyes, and the eyes that look back at mine are exactly the same. It is so easy to relate to them. There is a total absence of malice about them. I think orangutans preserve an innocence we lost when we left the Garden of Eden. Orangutans never left it, never made the break. That's why we perceive the basic goodness in them."

On the opposite page,
this mountainous region is the island's water reservoir, where most of Sumatra's rivers start.
High annual rainfall and an absence of a distinct dry season are typical of heavily-forested regions.
Preserving the forest is the best and cheapest insurance policy against drought and fire.

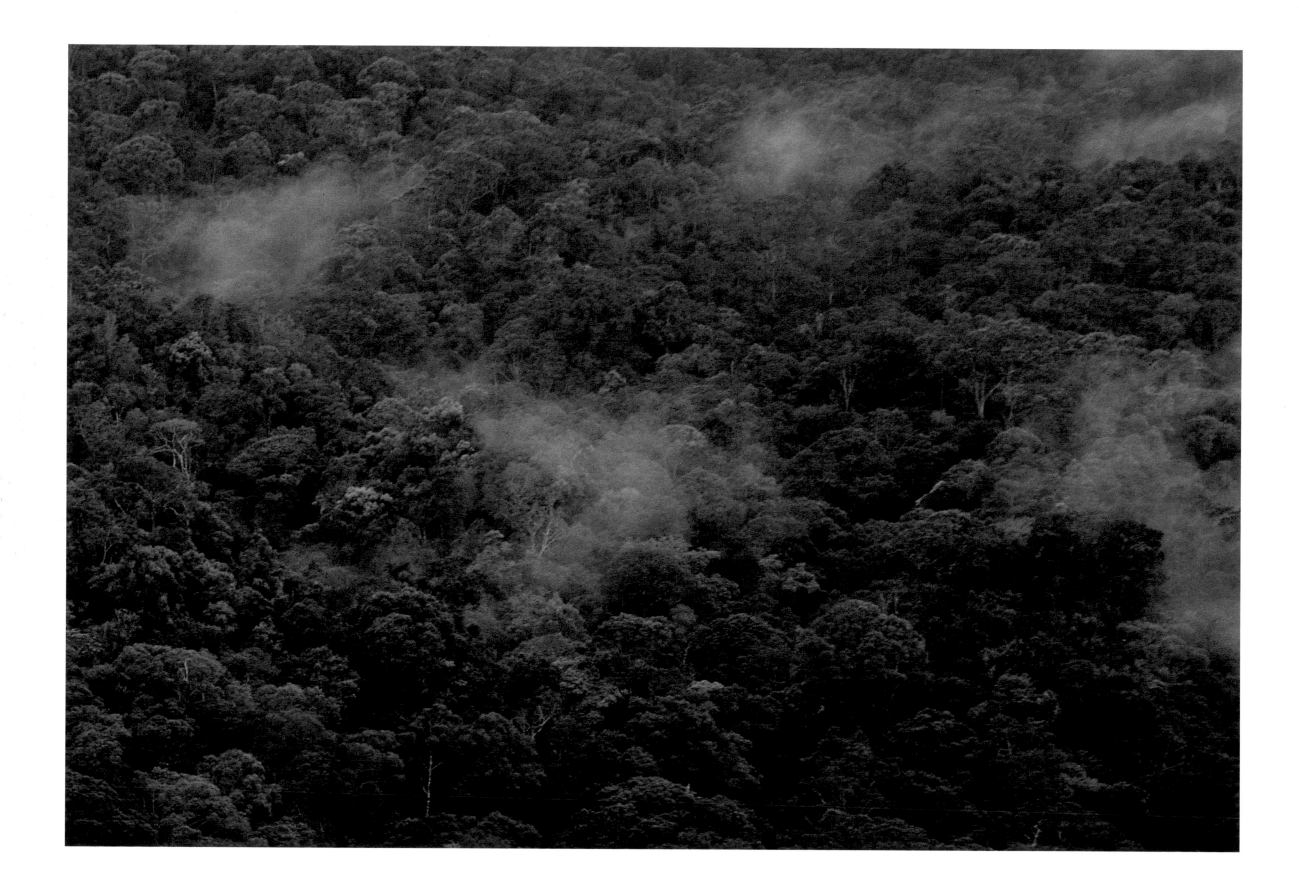

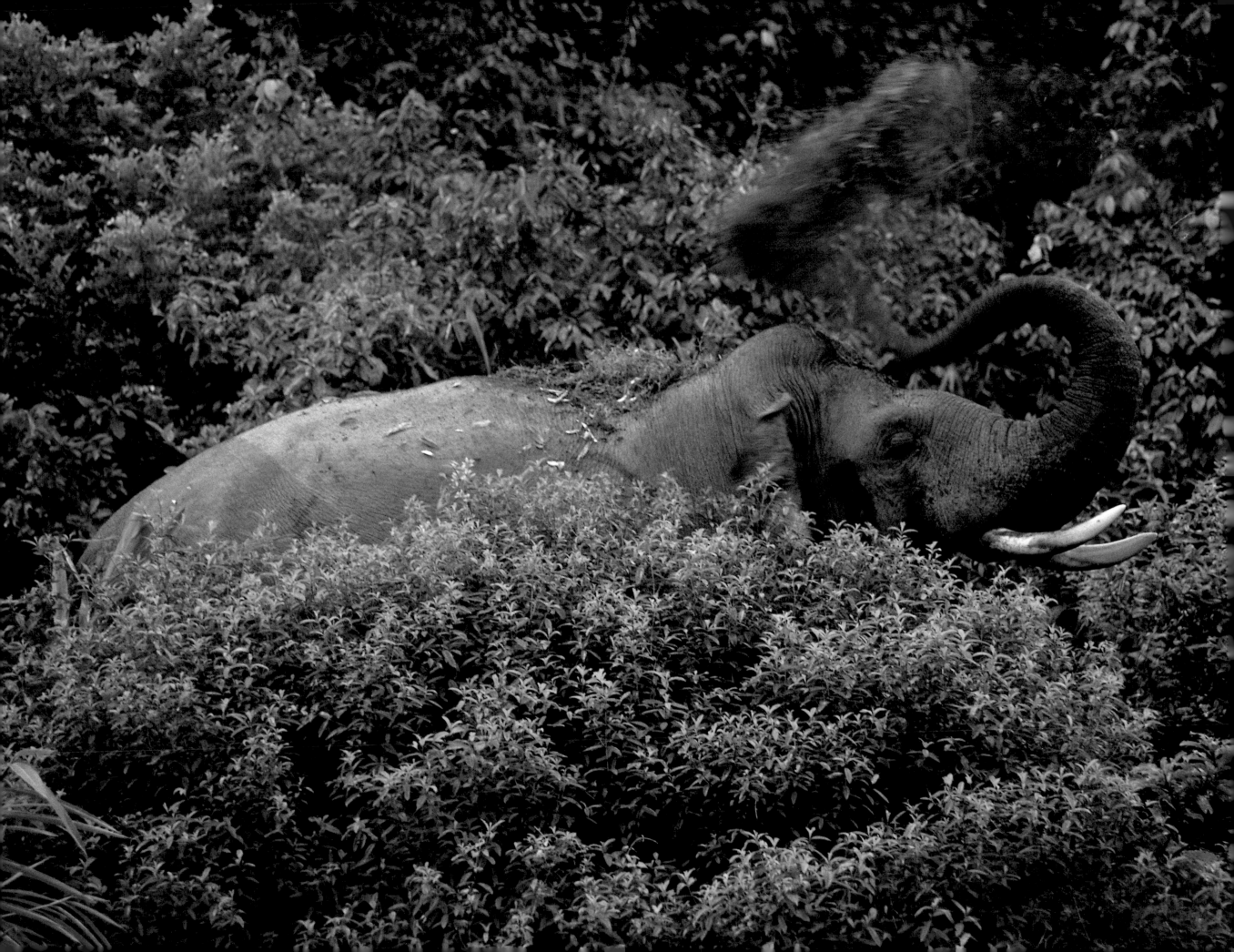

On the opposite page,
Gunung Leuser National Park is one of the last strongholds of the elephants in Sumatra.
Less than 2 500 of them are left on the whole island, with fragmented herds
always threatened by human activities. Elephant herds pay little attention to the boundaries
demarcating national parks and reserves from human habitat. That is why, like for tigers,
reinforced protective measures for the animals staying outside the protected area must be taken.
In developing countries like Indonesia, where farmers are fighting for their own survival,
big-animal conservation is unfortunately not a priority.

On the right, I had never imagined that one day I would have the chance to photograph
a Sumatran rhino in its wild habitat. Although it is the second biggest land mammal
in Indonesia, a rhino in the wild is very rarely seen. It is sad to realize that, if nothing serious
is done urgently, rhinos in Sumatra will soon be gone forever. In a country where the government
is more occupied dealing with political and economic issues, hopes that rhino conservation
will be on the agenda are very slim.

It is hard to describe my emotion when I encountered an orangutan for the first time.
As I was walking up the trail, the sound of a broken branch attracted my attention.
In a tree, at about 15 m, two young orangutans were playing, biting each other
while hanging in the branches, performing their arboreal skill. They stopped as they saw me
and gently looked back with their typical investigative expression.
I had waited for this moment for so long.

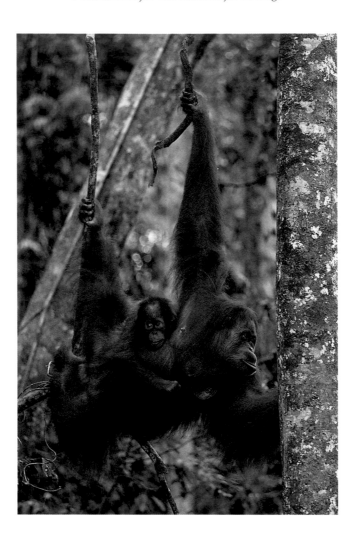

On the opposite page,
the first time I came across tiger tracks, somewhere in the forest along the Bohorok River
(Gunung Leuser National Park), my guide was afraid to pronounce the word harimau,
"tiger" in Malay. The rainforest and the local culture were new to me at the time
and I learned later that for the Malays, it is considered bad luck
to call the tiger by its real name. In the Jambi province,
people use the honorific "datuk" as if to call it "Sir Tiger."

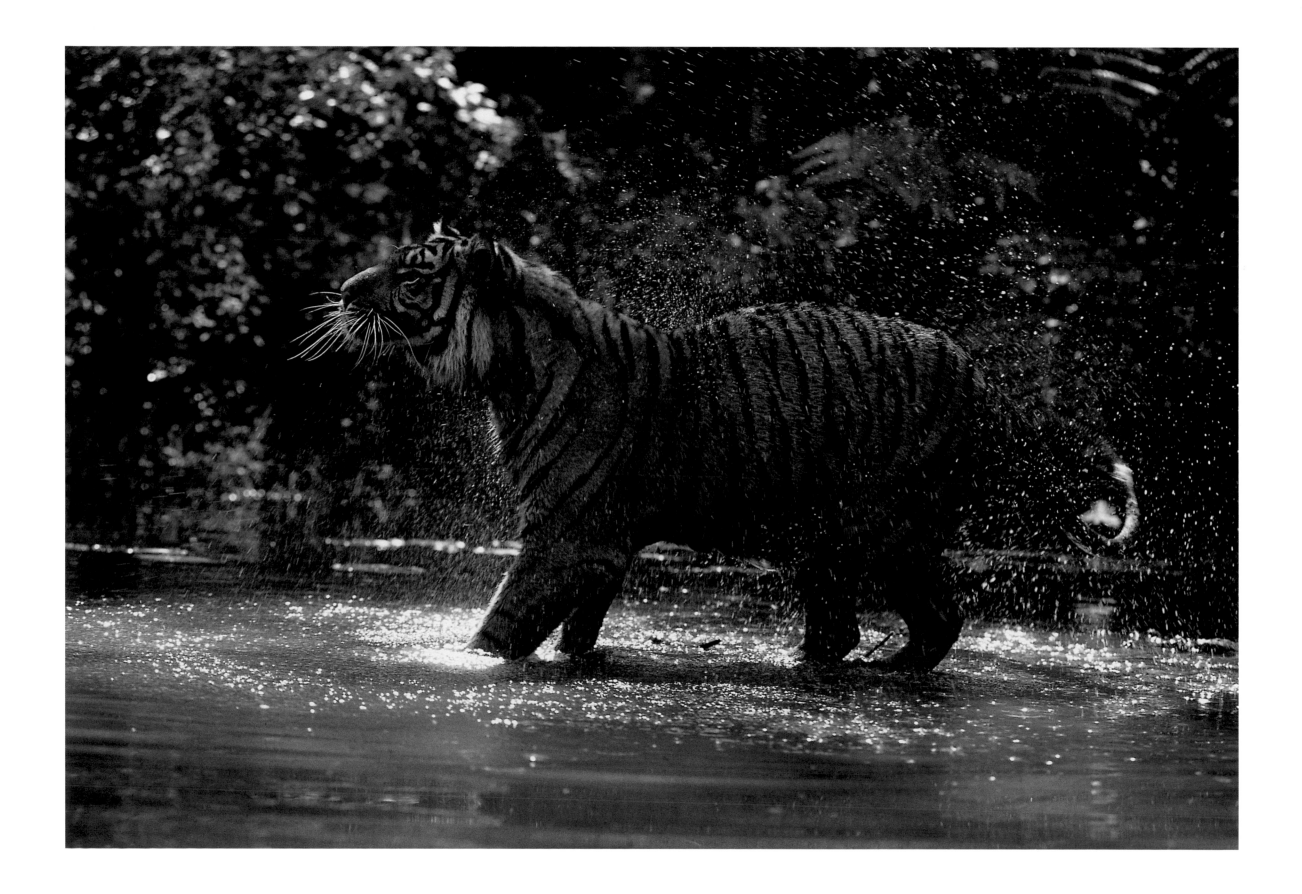

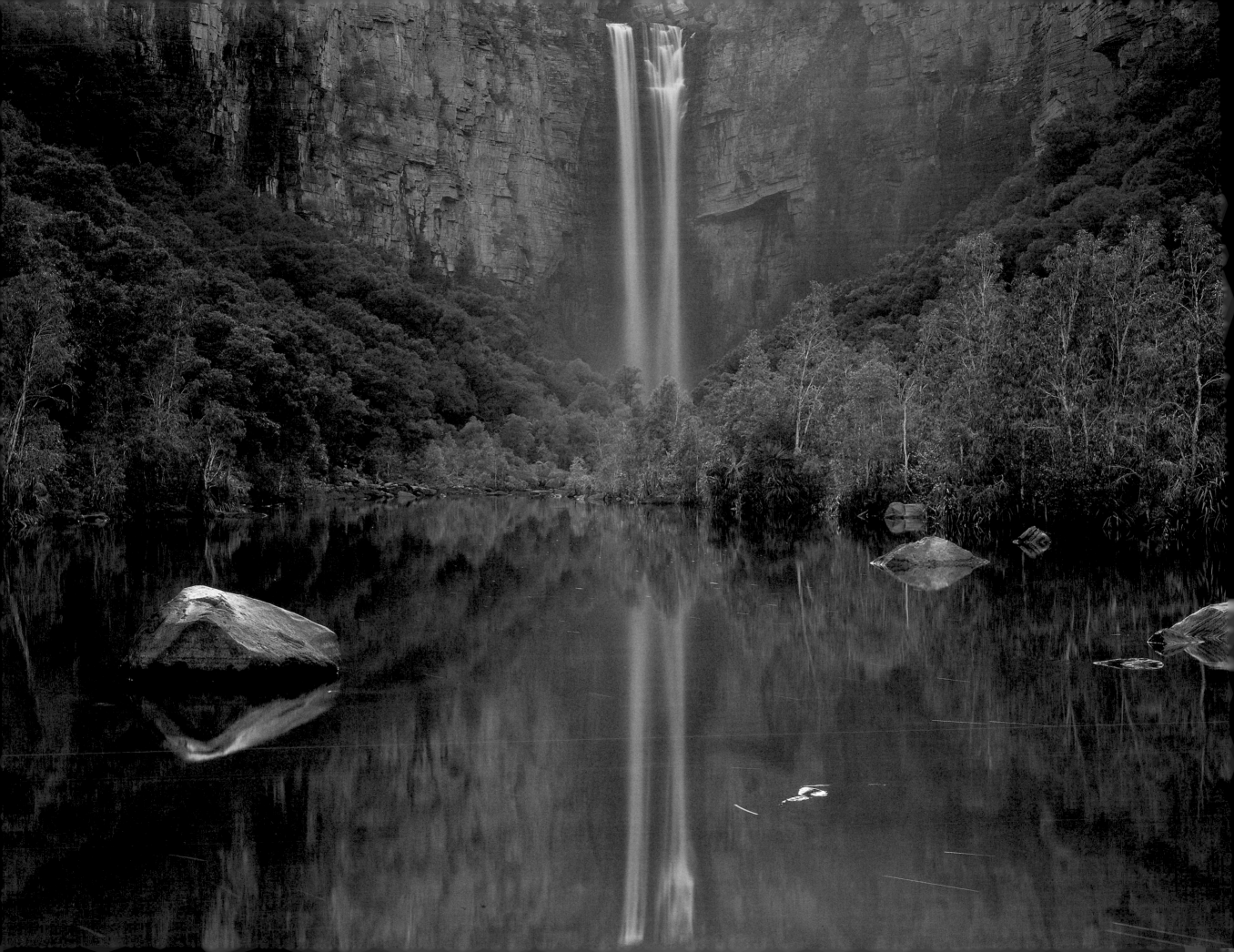

THE SONG OF KAKADU
Kakadu Region
Photographer: JEAN-PAUL FERRERO

All things from my childhood crystallized in Kakadu: the early rock paintings,
the tropics ... and the reptiles.

JEAN-PAUL FERRERO

Erupting with a thunderous flapping of wings from the puzzlework of lush, emerald green islets, an immense flock of black and white waterbirds quickly settles into migratory formation. Coppery golden sunset light reflects from the maze of parceled water, to silhouette the flock into a yin/yang abstraction of light and black shape.

Life and land, sun and water: choral voices in the vibrant song of Kakadu.

Kakadu National Park is a natural paradise of unequalled abundance and diversity. Situated on the coast at the very top of Australia's Northern Territory, the park's nearly 20 000 km² include the western edge of the Aboriginal reserve known as Arnhem Land, a large angular peninsula that juts into the Arafura Sea south of Papua New Guinea.

Arnhem Land's expansive tropical woodlands are dominated by a massive sandstone plateau with a high, sheer western edge called "the Escarpment." Water is the medium of exchange between Arnhem Land and Kakadu: immense, glorious waterfalls channel the prodigious wet-season runoff over the edge of the scarp ramparts and down to the lowlands, to become the driving force behind Kakadu's ecosystems.

Unspoiled until recent times by the pressures of Western civilization, the entire region has for tens of thousands of years been a living model of how humans and animals can live side by side in true, sustainable harmony.

As such, Kakadu is both a new and an old land. It wears the cloak of a completely pristine ecology, with minimal encroachment from modern settlements or roads. Yet it has been shaped for scores of millennia by the fire-wielding hand of its human stewards, the Bininj/Munguy Aboriginal people.

The overall Kakadu biosphere is shaped by two primal forces: fire and water. Monsoonal rains are followed by long drought, called "the dry" by white Australians. Since there is no place on Earth where lightning strikes the ground more often, at the end of the months-long dry period, devastating fires are a frequent natural occurrence.

Mitigating the forces of nature, the Bininj of Kakadu have taken up the task of preventing excessively destructive fires from raging over the land by routinely igniting areas of grasslands before they become overly luxuriant. The local ecology has thus adapted to fire, exactly as America's Yellowstone National Park and other fire-prone regions of the world, by evolving seeds that require searing heat for successful germination.

No visitor need ever complain of boredom in Kakadu. The park is a feast for the senses with its eight distinct habitats: *stone country, rivers and billabongs* (stranded river meanders also called oxbow lakes), *tropical woodlands, floodplains, monsoon forests, paperbark swamps, mangrove forests,* and *coastal shorelines.*

Of these, tropical woodlands make up more than 75 per cent of the region. During the wet season, the floodplain, paperbark swamp, and rivers and billabong ecosystems all merge into one large drowned wetland.

Kakadu lies within what is generally described as a savanna, but one of its outstanding qualities is the variety of discrete ecosystems within a general ecology of savanna woodlands, coastal wetlands, monsoon forests, and expansive floodplains. The park has another distinction unique among parks: the entire catchment of the South Alligator River lies wholly within its borders.

On the opposite page,
Jim Jim Falls: to most people
this is the image of Kakadu —abrupt
rock face and water. This picture
was taken with exceptional
permission to land a helicopter
a few years ago. We camped for two
nights as the weather
did not allow photography.

The South Alligator is named for its most famous inhabitants, chief among them the gigantic saltwater crocodile, which can grow between 5 and 7 m long and weigh more than 450 kilograms. At the end of the long dry, "salties" have run out of water habitat and must travel overland in the cool of night, using their uncanny sense of direction to regain open water. Sometimes they are caught and killed by fires. More often, they reach the safety of the restorative rivers and live to hunt again.

AFTER 'WHILE, CROCODILE
Only when you have crossed the river can you say the crocodile
has a lump on his snout.
Ashanti proverb

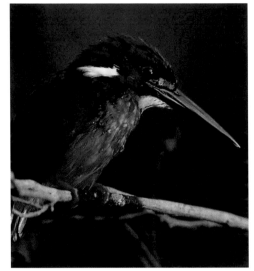

Of commonly seen kingfisher species, only one has a true fishing habit. The azure kingfisher is restricted to forests bordering streams and inlets, and does all of its hunting over water —perching within a meter of the surface.

Jean-Paul Ferrero knows he's in a bit of a jam. Directly blocking his path, a huge saltie floats motionless as a log. Only its cold, protruding, reptilian eyes move —and they've just locked onto the photographer and his small boat.

"He was a big one," Jean-Paul remembers, his animated energy charging the tale. "Maybe 4.8 meters, maybe five meters long: I wasn't about to measure him!"

Jean-Paul had been taking pictures along the banks and was just wrapping up the session when the newcomer and another, smaller croc had a territorial encounter in the middle of the river.

"The river was no more than 20 meters across at this place, not much room for me to get by. The two crocodiles started to swim around each other, getting ready to fight as adults often do. But the smaller one left, leaving this big saltie in my path. Instead of returning to the bank he had been lying on a few minutes ago, he stayed in the middle. I could see he was slightly upset. I got scared —there was no way I was going to cross his path!"

Normally, Jean-Paul would simply wait out the croc, knowing it would eventually lose interest and return to the bank, or swim off. But night was falling fast.

"I think, 'Okay, he's not going to assume I'm another crocodile, he'll be nice and let me pass.' So I move slowly —and he starts coming right toward me!" Not keen on a close encounter of the toothy kind, Jean-Paul backs off. Fifteen minutes later, the croc hasn't relinquished the right of way —and the surrounding gloom is deepening.

"This is the first time I am a bit unsettled by a crocodile," the energetic Frenchman admits. "Still, I have to get past him —one way or another." Finally, unable to retreat and unwilling to remain past nightfall, he gradually adds power to his small outboard motor. The boat eases towards the croc, closer, closer —no reaction yet, that's good— then, just a few meters from the hoary reptile, Jean-Paul gives it the gas and races by as quickly as he can.

Fortunately, the big croc has no appetite this evening for boats or human

flesh, or the intrepid photographer might not have survived to tell the story: salties can swim 25 km per hour, and can easily overtake and swamp a small boat.

Jean-Paul Ferrero had been enchanted by wildlife since his early boyhood years in Paris. "I wanted to be a zoologist at one time. I collected insects, lizards, and snakes at home, and loved tropical wetlands and bird life." When he saw a Time-Life book about Australia, his life was changed forever.

"Two things, the reptiles and these strange Stone Age people, the Aborigines, fascinated me. Australia is the most amazing continent in the world for reptiles. There are 140 species of snakes, among the most deadly in the world. This was very attractive to a reptile-loving Parisian kid of 11. Australia was the continent for me!"

He first came to the land down under from his native France in 1973, then visited Kakadu in 1979 —and found the perfect home for his childhood dreams. He returned many times, finally moving permanently to Australia in 1982. In 27 years of nature photography, with published work in major magazines worldwide and many books, Jean-Paul Ferrero has celebrated the wildlife of Australia and helped bring Kakadu National Park to world attention.

GUARDIANS OF THE LAND
There are areas on our land which are sacred …. They are the ancestral creation
being's journeys and resting places which require our protection.
The Mirrar clan of Kakadu

Kakadu has yet another unique quality: an unparalleled trove of Aboriginal rock paintings for which Arnhem Land's *stone country* is famous. Spread liberally throughout the area, these ancient and ongoing records chronicle the intimate custodial relationship of the Bininj to the land and all its creatures. No surprise then that Kakadu is one of only 17, from a total of 469, U.N. World Heritage Areas selected for both natural and cultural values. It shares the distinction with other exotic locales such as Peru's lost city of Machu Picchu, Uluru-Kata Tjuta in Central Australia (Uluru used to be known as Ayers Rock), China's Holy Mountain of Tai Shan and Mt. Athos in Greece. Kakadu is also included within the World Wildlife Fund's Global 200, as part of the Kimberly Rivers and Streams freshwater ecoregion.

Increasing numbers of visitors from around the world come to see Kakadu's resplendent biota: 300 kinds of birds, 50 mammalian species, 75 types of reptiles, 900 plant species, 30 amphibian species, and a quarter of all Australian freshwater fish. And don't forget the innumerable insect species.

Kakadu gets its name from one of three dominant Aboriginal languages spoken here, a fitting designation: According to recent archaeological discoveries, the area may have served as the ancestral home and hunting grounds of the Bininj for as long as 90 000 years!

In the timeworn way of Aboriginal people, humans fulfill a custodial role

in partnership with the land and all life. Their complex social structure forms around this central belief in stewardship, which is faithfully practiced from birth to death. The Bininj have an incredibly sophisticated knowledge of plant and animal species that is even today superior to modern scientific inquiry in both depth and detail.

The beating heart of the Bininj custom is their conviction that humans are the spiritual companions of all living creatures. Equally important is their mystical sensitivity to the cycles of the land. They do not keep track of yearly changes with a fixed calendar but instead use their refined sensitivities, honed over tens of thousands of years, to recognize the comings and goings of six annual seasons (described later) and the bountiful blessings each bestows upon their survival.

In the particular timing of a grasshopper's call or the crawl of caterpillars up a tree trunk, the Bininj know how to read the coming of seasonal cycles. Individual clans use these insights to time their yearly migrations between traditional encampments.

The Bininj harvest plant and animal species for food only at that time of the year when they are at their most thriving and nutritious state. The rest of the time they are left alone. Thus, in such age-old practices as waiting to spear a basslike barramundi at the peak of its yearly cycle when, after gorging on smaller fish and baby crocodiles at the end of the dry season, it might have grown to more than 45 kg, the Bininj employ an efficient form of natural conservation that can serve as an enviable model for all peoples in their efforts to harmonize within ecosystems.

As author Ian Morris postulates in his natural history guide *Kakadu National Park* (Steve Parish Publishing Pty. Ltd.), the ancient Bininj way of minimizing human impact on biota is a likely explanation for how such a broad diversity of species could have survived over tens of thousands of years, even as a large population of humans depended on them for survival from year to year.

THE GREAT GOD WATER
... to lie sometimes on the grass on a summer day listening to the murmur of water ... is hardly a waste of time.
Sir JOHN LUBBOCK

"Kakadu's landscapes change dramatically during the dry season," says Jean-Paul Ferrero. "Bushfires happen naturally or by design. Because of their long association with life there, the Aborigines regularly burn most of the park. They're assisted as part of official policy by park rangers."

The dense, smoke-filled air and look of devastation that falls upon the land during the burning times remains one of the major complaints that rangers hear from tourists. "Of course, the trees are blackened and the landscape is not pretty at that time of year. But the tourists don't understand that the vegetation of Kakadu, the entire look of the land, is like it is today only after 50 000 years or

more of deliberate burning! As soon as the grass dries, it is burnt. And many plants need the fires to regenerate."

After the scorching six-month brutality of the dry season, life renews with the monsoons. The best time for photography comes at the end of the monsoonal season, some time in March. "The end of the wet season brings its miracles. The land transforms from scorched earth and dried leaves to a lush green carpet. Lots of plants flower at that time of year. Lots of wildlife start mating. The more rain, the more insects for birds, so they have a better chance to raise their young. It is a very rich time of the year."

For a photographer, getting around is still a major hassle due to the standing water, bogs, and ubiquitous muddy fields. You're as likely to see a young crocodile swimming along the median line of a submerged asphalt roadway as in a billabong. "Many roads are cut off by the floods, so that even with a boat, it can be hard to find your photographic target."

Once the waters subside, tropical woodland trees flower. "Then you hear the cacophony of lorikeets calling in the morning, and of red-tailed cockatoos when they leave their roosting places to look for food."

"Much of the time I work from the boat. I go out before sunrise, never knowing what I will find. Most of the time it is the same thing; that is the nature of wildlife photography."

EIGHT LANDS FOR KAKADU
Heaven is under our feet as well as over our heads.
HENRY DAVID THOREAU

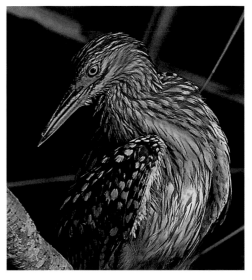

Roaming across the Israel-sized habitats of Kakadu National Park, visitors encounter an amazing cornucopia of plant and animal life.

In the *stone country*, a diversity of plateaus and sandstone ramparts that add impact and scale to the landscape, a profusion of endemic species thrives: the oenpelli rock python, the black wallaroo, the banded fruit dove, and the exotic anbinik tree with its dense closed-canopy forest refuges.

Along the *shoreline* ecosystems, mangrove forests and mud flats provide a home for the endemic flatback turtle. White-bellied sea eagles, Brahminy kites, and ospreys soar the monsoonal winds looking, always looking for sea snakes, crustaceans, and fish. In the *rivers and billabongs*, formed by the Wildman, West, East, and South Alligator river systems, crocodiles, geese, heron, barramundi, dinosaur-like water monitors, and rocket frogs lead the cast of characters.

The predominantly open land of the *tropical woodlands* is dominated by eucalypts, with shrubs and grasses displaying riotous diversity, notable of which are the brilliantly-colored gomphrena and borreria flowers, yamitz (the green katydid), frilled lizards flaring their umbrellas in territorial disputes, woodland monitors, estuarine crocodiles, several varieties of bats, magpie geese, green ants, and big greasy butterflies.

Nankeen night herons forage alone along shallows and shores, fresh or briny, in the early night and before dawn where they hunt for fish, amphibians, and crustaceans, as well as insects, chicks, and eggs stolen from other birds.

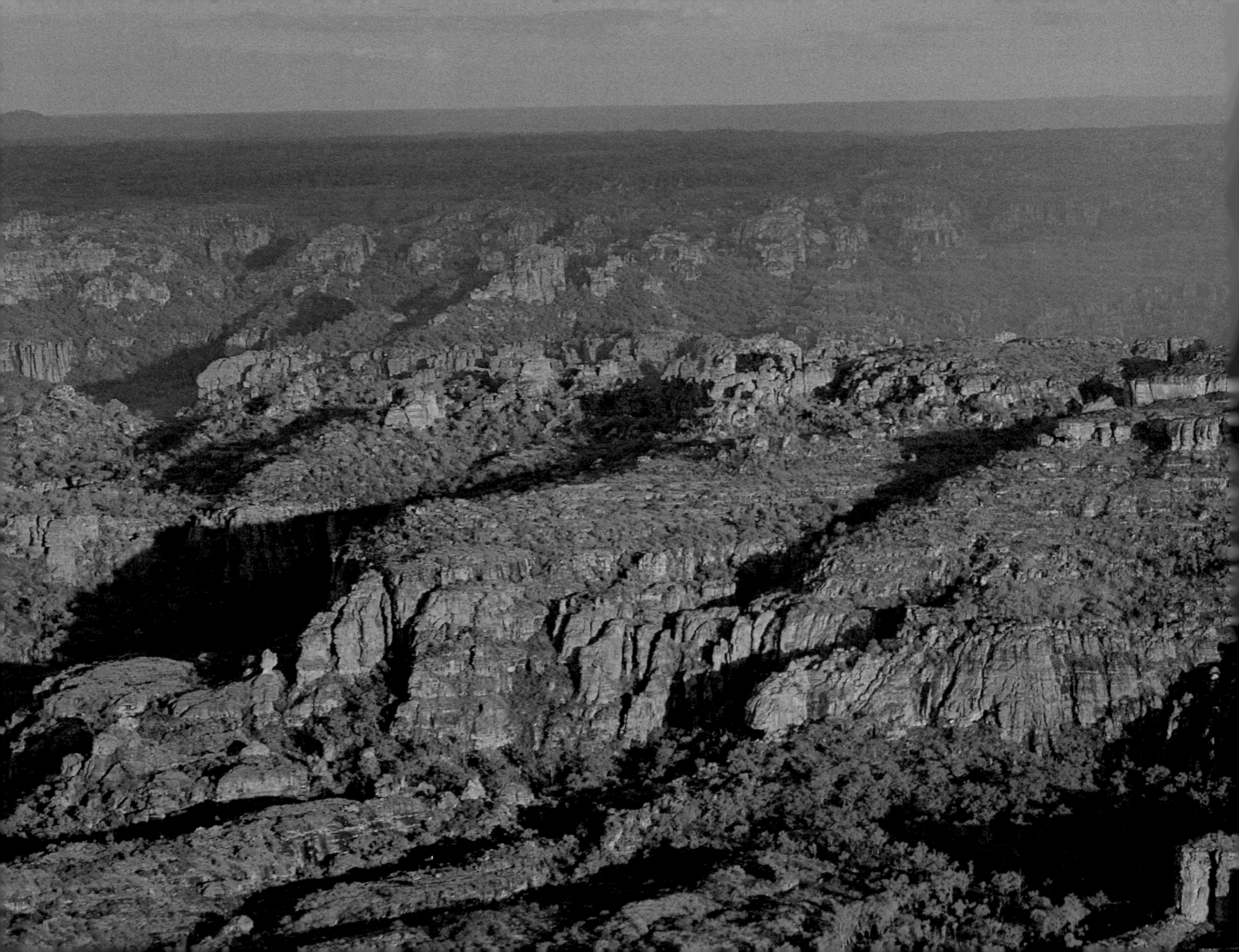

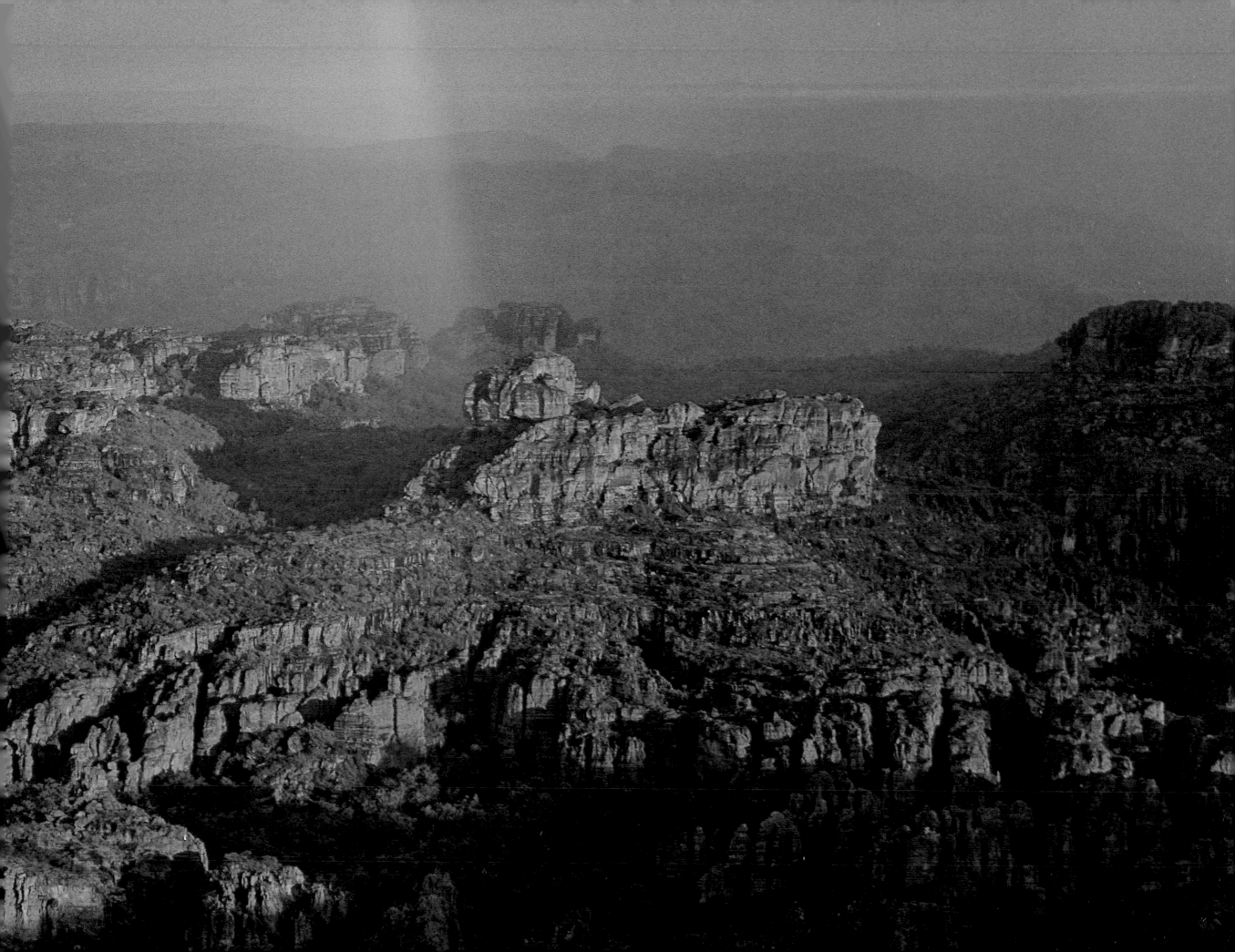

In the *mangrove forests*, more than 30 species of the trees thrive within their own special zones, evolved to special hardiness by the abrupt swings from extreme wet to extreme dry. Mud lobsters, mangrove worms (part of the oyster family and a prized Bininj food source), mangrove monitors, false water rats, and northern brushtail possums live here.

When the rivers overflow their natural levees, the water covers the land to create vast *floodplains* of hundreds of square kilometers, in places up to 6.1 m deep. With the floods come entire ecosystems that disappear again as the waters recede. Black kites, pheasant coucals, white-browed crakes, Australian pratincoles, and other birds face increased competition when the rains stop and the region slowly reverts to a land of drought.

Paperbark swamps are left behind in areas of poor wetland drainage. Giant paperbark stands and forests grow around the abandoned water bodies, which also eventually dry out. Owlish-eyed black and little red flying foxes pollinate the blossoms of paperbark trees. They are a favorite food of the nocturnal rufous owl, which also preys on bandicoots and possums.

IN PARADISE, AS EVERYWHERE
Let me make it plain. We say no to uranium mining now and for the future.
Our right to say no comes from our ancestors, our heritage,
our law and culture, our Native Title.
JACQUI KATONA, Aboriginal speaker for Stop Jabiluka!

Conflicts between new industrial cultures bent upon extracting resources from ecosystems and older indigenous cultures fighting to keep them pristine are nothing new even within the expansive habitats of Kakadu.

Echoing the Galápagos Islands' struggle to remove feral animals, the British-introduced Asian water buffalo that caused so much damage to the ecosystem required a massive eradication program. Commercial net fishing in major rivers has finally been prohibited. Ever-proliferating feral pigs, encroaching alien weeds, and growing numbers of tourists continue to impact the park's ecobalance and challenge Aboriginal and government management programs.

Kakadu's most dramatic confrontation pits the park's Mirrar clan against the Australian government over Jabiluka, a uranium mine set smack dab in the middle of ancestral sacred sites. Jabiluka is only the latest attempt to extract the radioactive ore. The Ranger Uranium Mine, in the heart of the park, has been in full operation for years.

The Mirrar clan of the Bininj continue to challenge the Australian government's mining on its traditional lands. As always, there is no clear path through the turbulent fog of economic, political, moral, and ethical perspectives.

Ranger Mine has been in operation for years, with recurrent claims and counterclaims over its environmental impact on the Kakadu ecosystem. When UNESCO's World Heritage Committee refused to declare Kakadu an endangered area, cries of "foul!" from environmental groups led to blockades of the Jabiluka site.

The Mirrar continue their challenges in court. As of April, 2000, a final decision from the Australian Resources Minister was pending.

The dark specter riding herd on uranium operation is the threat of radioactive waste that can leak contamination into the environment for 300 000 years. The Mirrar, educated in the potential of uranium mining to devastate the land, are understandably determined to keep their homeland off the long list of nuclear resourcing calamities.

Jabiluka is only the most visible front in the mining conflict. Fully three quarters of West Arnhem Land alone is either licensed for mineral exploration or subject to negotiation with the traditional owners.

Although granted power to veto as part of the Aboriginal Land Rights (NT) Act of 1976, the people are subjected to constantly-renewed pressures to grant exploratory licenses. They often find themselves tricked or manipulated into granting permission to explore for minerals through lack of vital geological and environmental impact data and loophole legalese. Using the weapons of legal manipulation instead of the guns of direct force, Western civilization continues to exercise its self-bestowed right to extract resources wherever it finds them.

Aboriginal peoples, conflicted between material betterment resulting from mining payments and maintaining their ancestral values, ride the fence, struggling to make the right choice for their culture while avoiding lasting damage from ill-informed decisions, as they wade through the maddeningly abstract thought processes of the *whitefella* legal machinery.

FOLLOWING BLISS
We shall be known by the tracks we leave behind.
Native American saying

Ferrero's fifty years have been driven purely by his love of wildlife. "I knew I couldn't study rats in a lab for twenty years. I decided I would rather travel the world and study living things. I grabbed a camera and haven't looked back since."

He knows all too well the abiding patience required for success in the field. "I think no one sets out to be a photographer, then becomes a wildlife expert; you're into wildlife first, then you choose photography. Then you become a better technician, you investigate more, and you become a *real* photographer."

One of his recent highlights, and a prime illustration of the ephemeral nature of the Kakadu landscape, came when he was working around the floating nest of a comb-crested jacana. "The nest was floating in the middle of red lotus flowers. I really wanted that picture. The first day I worked the scene, the lotus flower hovered high over the nest. The next day, it was right at the surface of the water. On the third day, the picture was gone: the flower was completely submerged. The water had risen over half a meter in three days!"

In hindsight, the impact of the experience remains. "Special moments always appear when you reflect back on them. The nest within the flowers, the rising water: I could never improve on that photo."

Jean-Paul avoids wearing the mantle of committed conservationist. "I hardly feel the need to justify myself. I don't think, 'I want to save the world for the generations to come.' I do what I do because I love the natural world. To some small extent, not that I was fully aware of it at the time, I've been instrumental in bringing a wider interest to the natural world through my photography. But I didn't set out to do that."

"To me it's just a normal thing to want to protect the environment."

SIX COLORS OF PARADISE
If you respect the land, then you will feel the land. Your experience will be one that you cannot get anywhere else in the world.
Aboriginal traditional owner, from the *Kakadu National Park Visitors Guide*

Over the eight mini-ecosystems of Kakadu falls the heavy, extravagant hand of nature, turning parched earth to floodplain and back again in a linked symphony of six seasonal movements, as described by the Bininj. In one year, Kakadu's ecosystems undergo remarkable changes that run the gamut from parched savanna to massive floodplain.

Gudjewg, the Bininj name for the monsoonal season, begins around December and runs into March. *Banggereng* runs from March to May and is a transitional season between the continual monsoonal rains and the coming six months of the dry season. The Bininj know harvest time is not far away.

May and June are the cool weather months of *Yegge*, with temperate nights and mornings, lower humidity, and primeval valley fogs and mists that lift with the rising sun. *Yegge* time is painted with masses of water lilies and the fragrance of flowers drifting through the paperbark forests.

Wurrgeng marks the beginning of the early dry season and lasts from June to August. It is the primary cool weather season of Kakadu. Clear skies accompany the lower temperatures, but mosquitoes, carriers of deadly and incapacitating diseases, are a major threat to humans.

Things heat up during *Gurrung*, from August to October, when former wetlands lose all their water and transform into cracked, inhospitable grounds. From October to December, *Gunumeleng*, the pre-monsoon season, orchestrates the most dramatic visual changes in sky and landscape. The cloudless dry season gives way to world-class thunderstorm columns that can race west at more than 100 km per hour and wreak havoc on the forests with winds and electrical storms. Fires started by lightning can be devastating if earlier burning has not minimized the potential fuel load. Fires sometimes burn for a week and more across many habitats.

Finally, the monsoons of *Gudjewg* return to begin again the flow of seasons.

Kakadu's cadences shift and mingle, beating out the music of the land. The whump-whump-whump of the shy kangaroo across a soggy meadow extends the distance between itself and a threatening pack of dingoes. The undulating, sensuous sway of the crocodile tail drives its stealthy underwater search for food.

A magnificent sea-eagle snatches a fish from the water. In a bizarre duet, it flies off with its catch, the rhythmic thrust of its wings against the cool air matching in perfect synchrony the side-to-side death flutter of its silvery dinner.

Life ending, life renewing: the song of Kakadu.

On pp. 282-283,
Southerners speak of only two seasons in the Top End, the Wet (October to April) and the Dry (May to September).
Northern Aboriginals recognize many more changes and have named at least six periods for the weather
that can be expected and for the plant and animal responses.

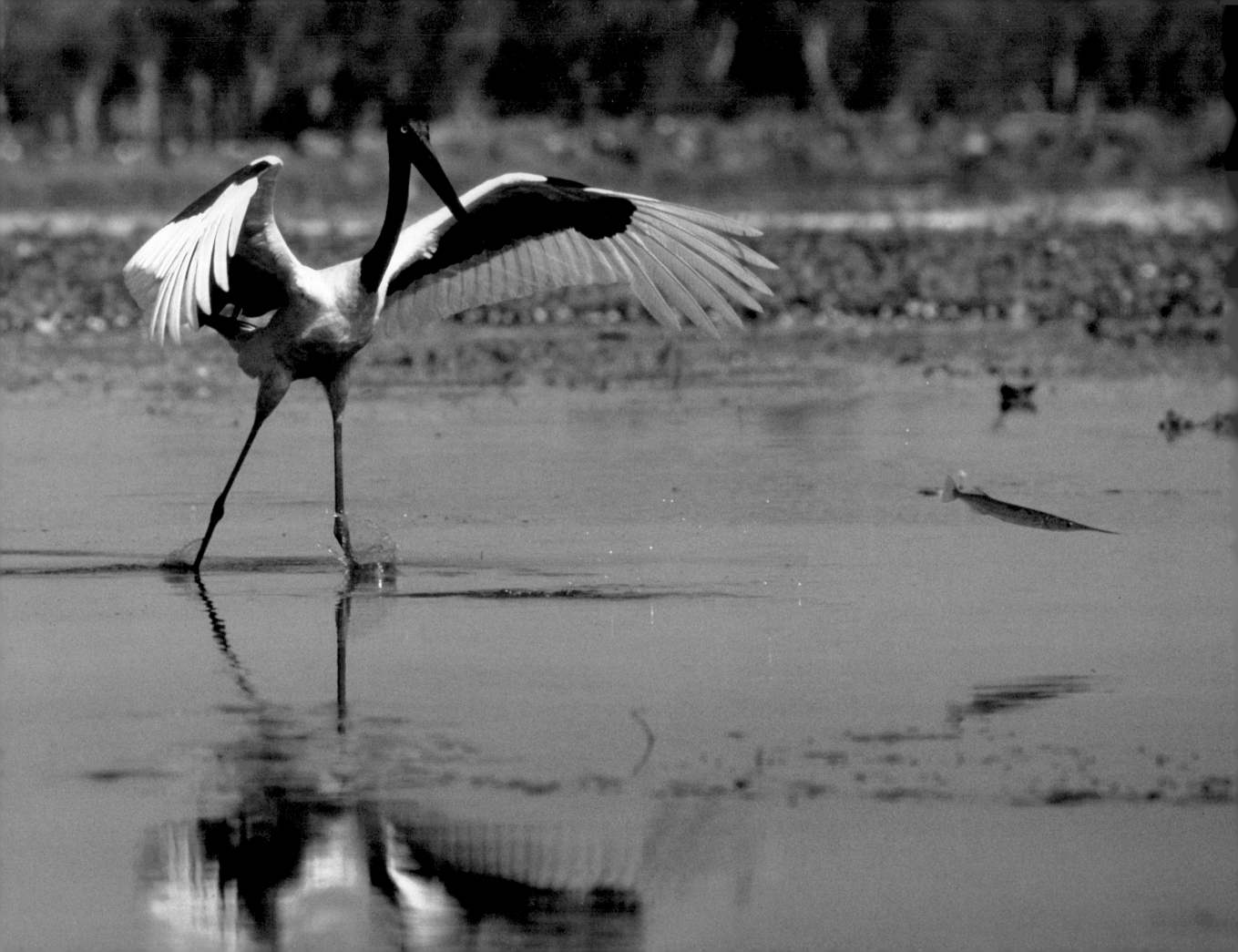

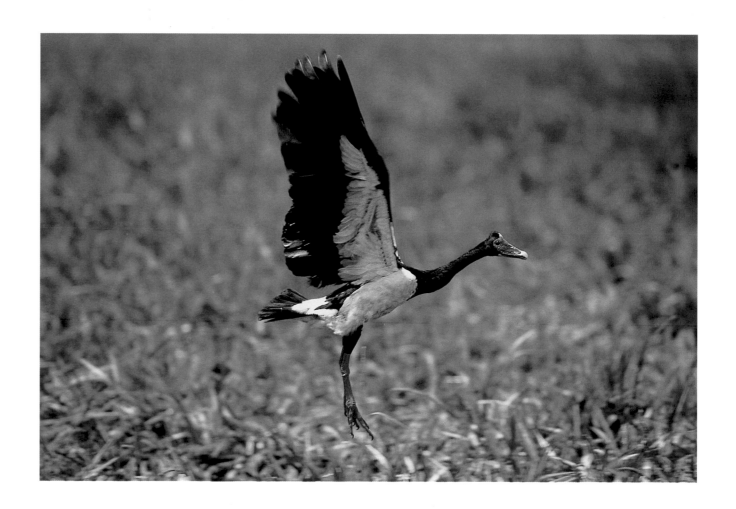

On the opposite page,
black-necked storks start their flight with two or three running jumps, and fly with slow flaps
of their wings alternating with short glides. The birds often soar as high as several hundred meters.

Above, this picture was taken towards the end of the dry season, when large flocks
of magpie geese congregate at the remaining pools of water.
When the rain starts, they will disperse and feed on wild rice
on the flat plains, then nest around April.

On pp. 288-289,
Magela Creek Wetlands, taken at the peak of the wet season, in January, from a helicopter.

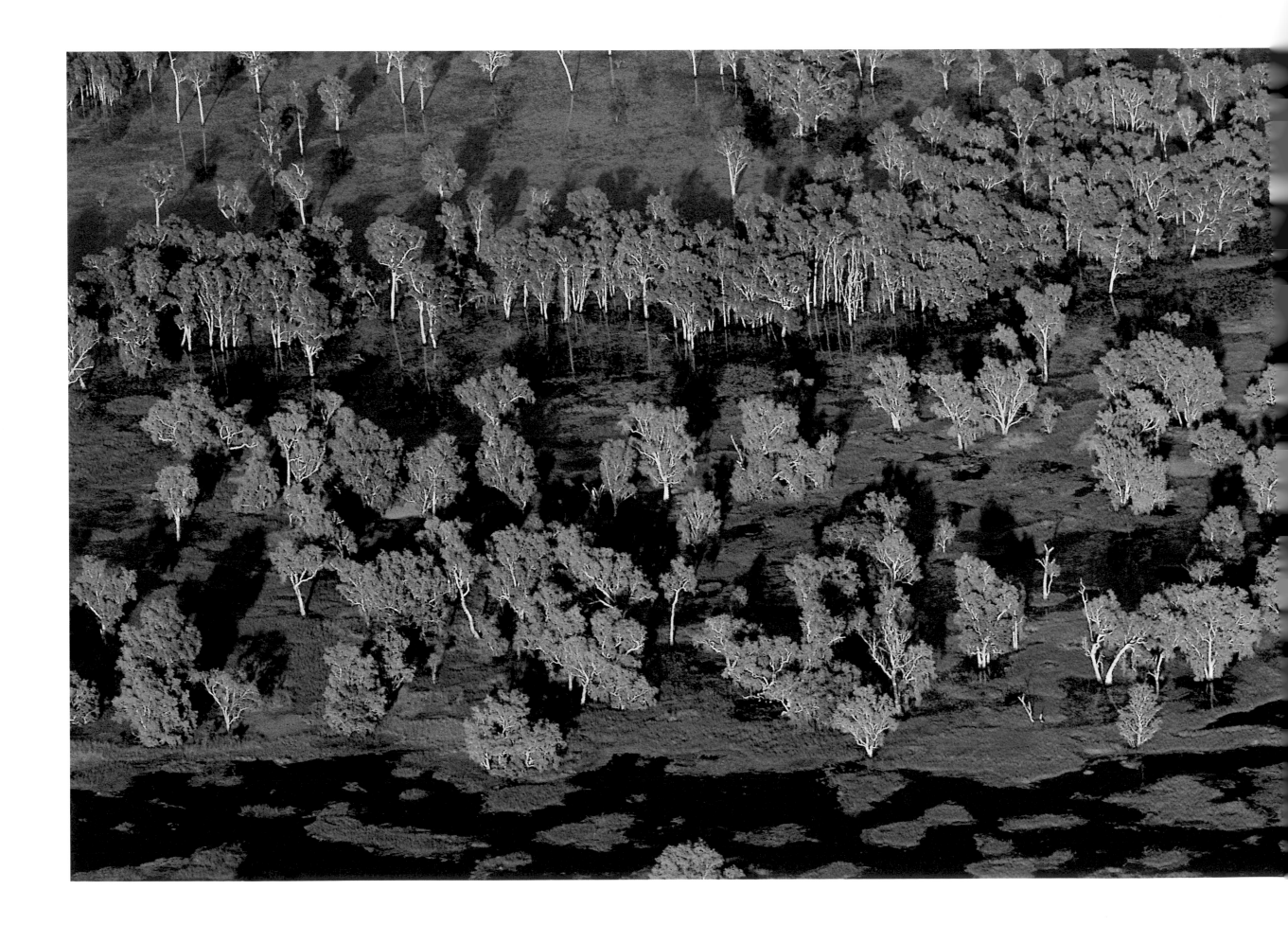

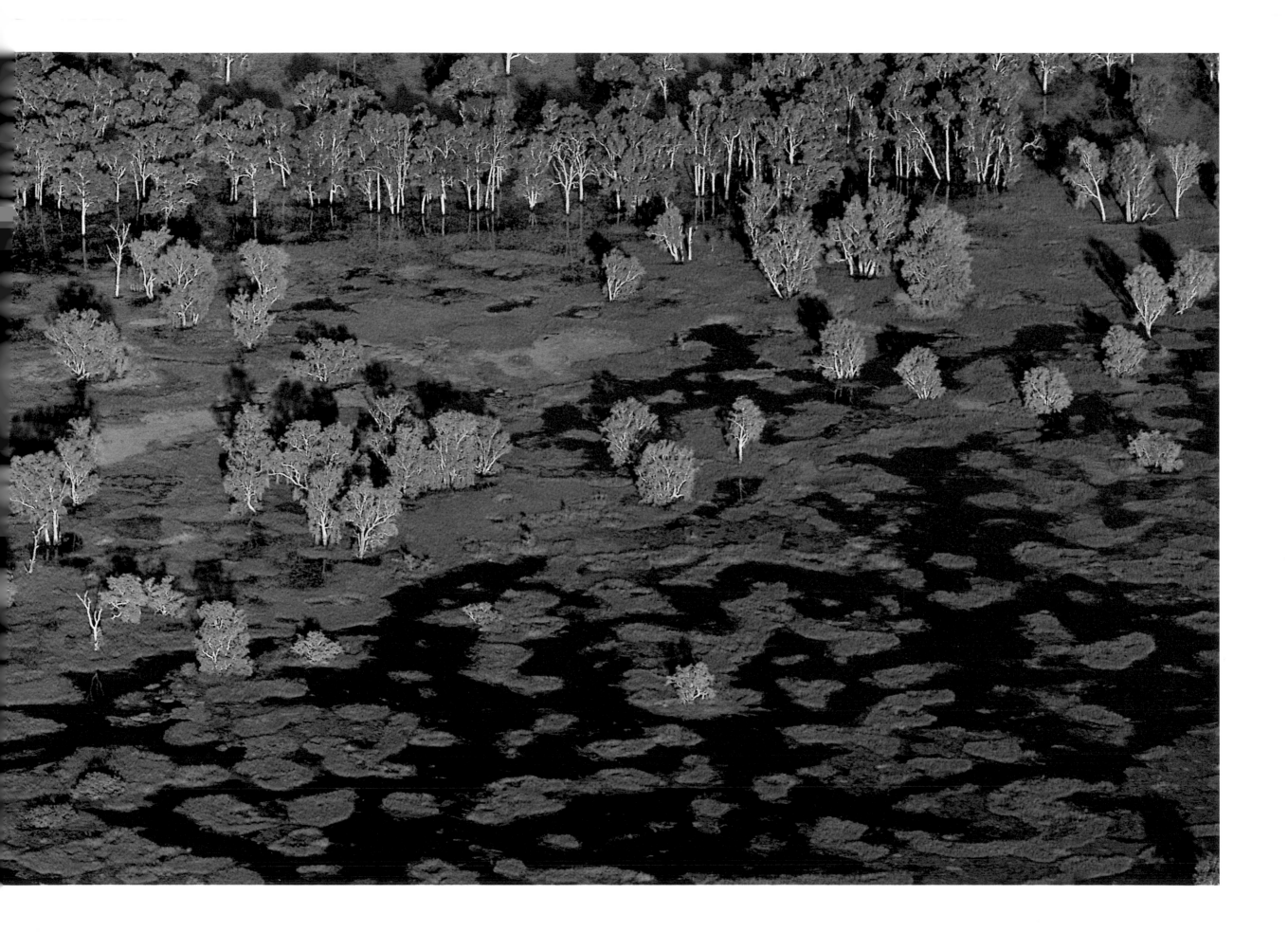

Frilled lizards have three ways to respond to threats:
this one is the most commonly photographed. They also play dead
on the ground, or escape at great speed on their hind legs.
If cornered, they will jump on you and bite.

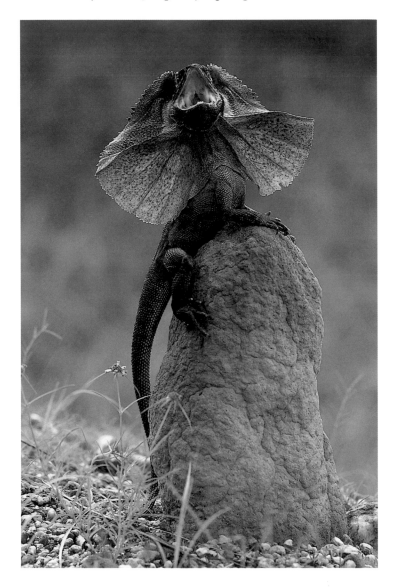

On the opposite page,
barramundi are a significant food source for crocodiles,
although they will take anything including mammals of any size.

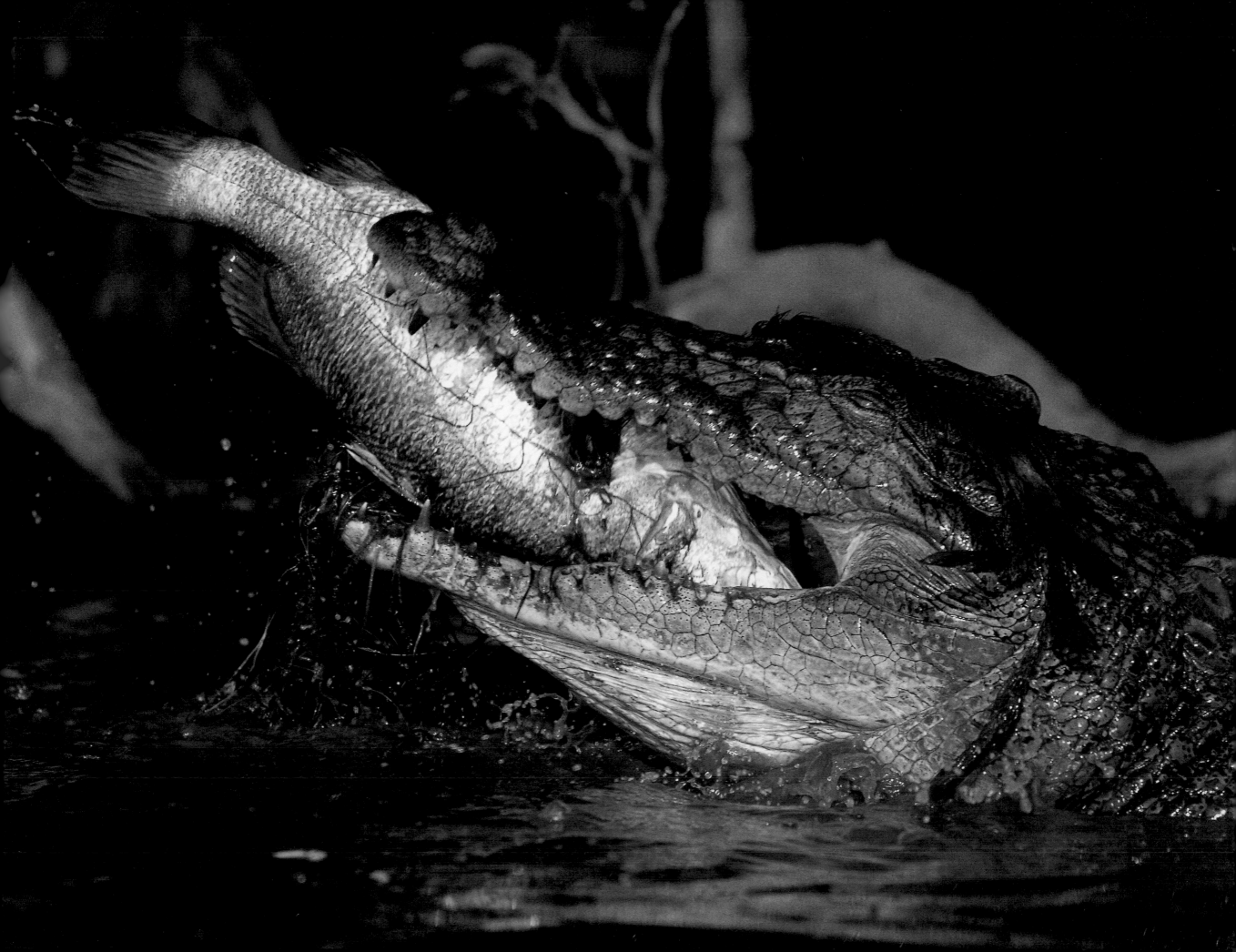

On the opposite page,
the northern dwarf tree frog, one of the smallest of the Australian tree frogs
(about 3 cm long), is one of the very few frogs that can be seen during daylight.

On the right, the red-collared lorikeet is one of the few species
of birds that bring the woodland alive with sound
in the morning and evening while flying in search
of trees in flower. And it is not a pretty sound!

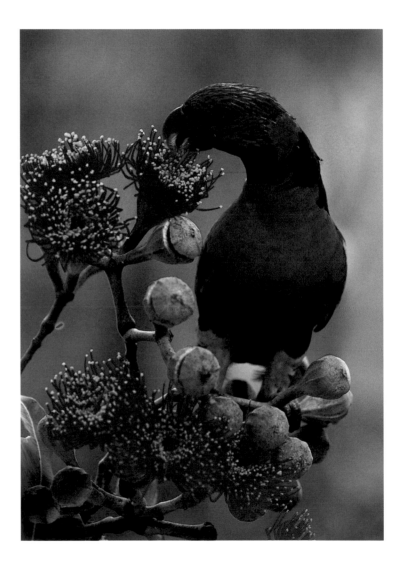

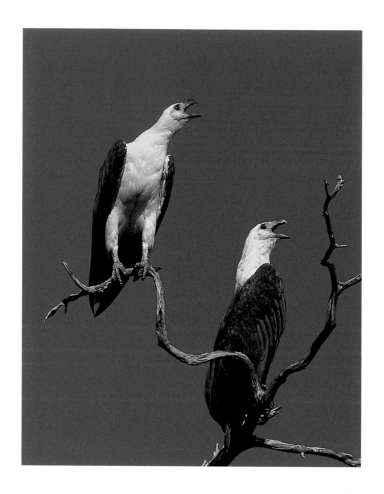

The white-bellied sea eagle is always found in pairs,
even outside the breeding season. They are highly
territorial, so one pair will keep the same site
year after year.

On the opposite page,
during the dry season fires are lit by Aborigines or
by Park rangers, or occur from natural causes.
Kites patrol the fire front to catch prey, such as insects,
small mammals or reptiles, disturbed by the flames.

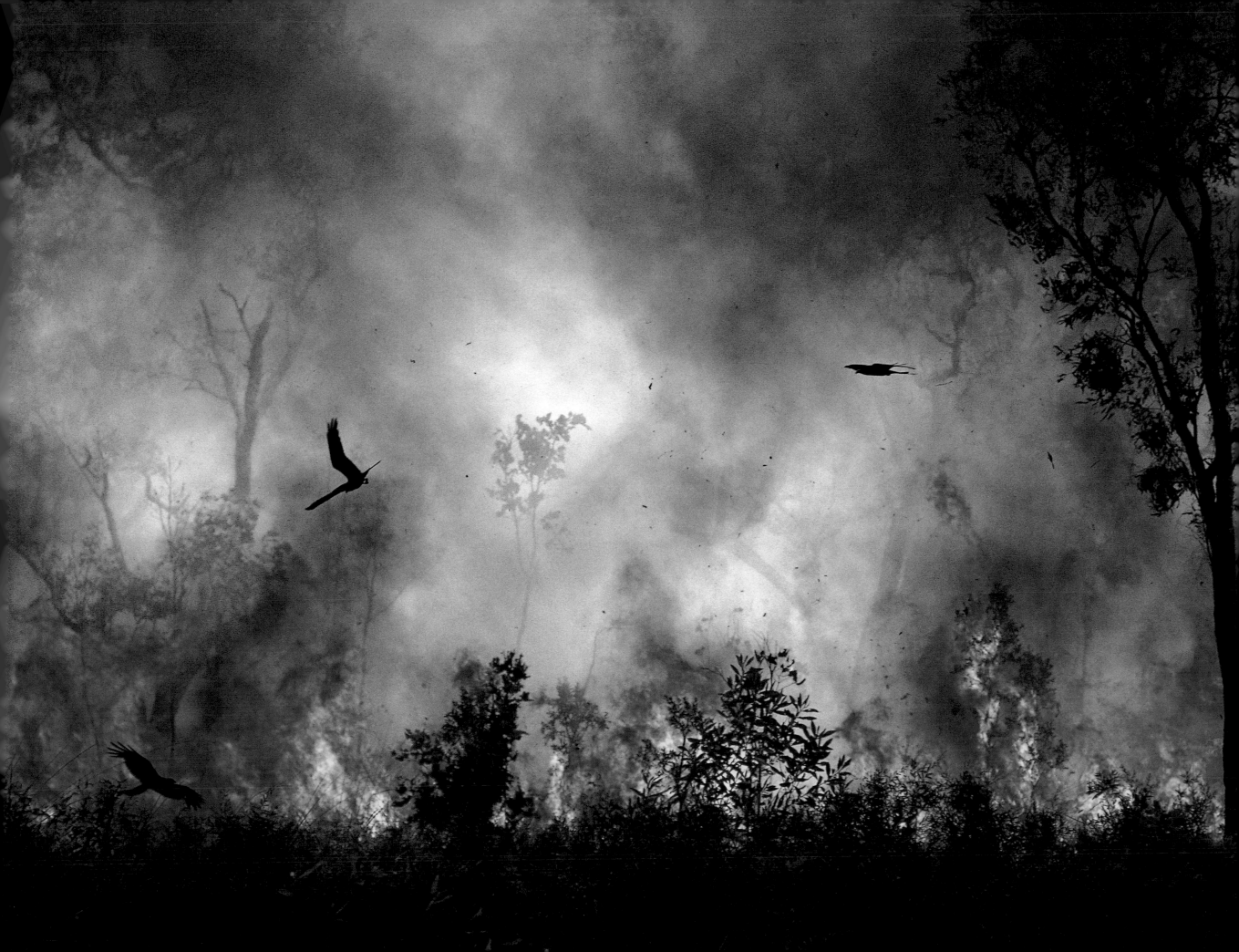

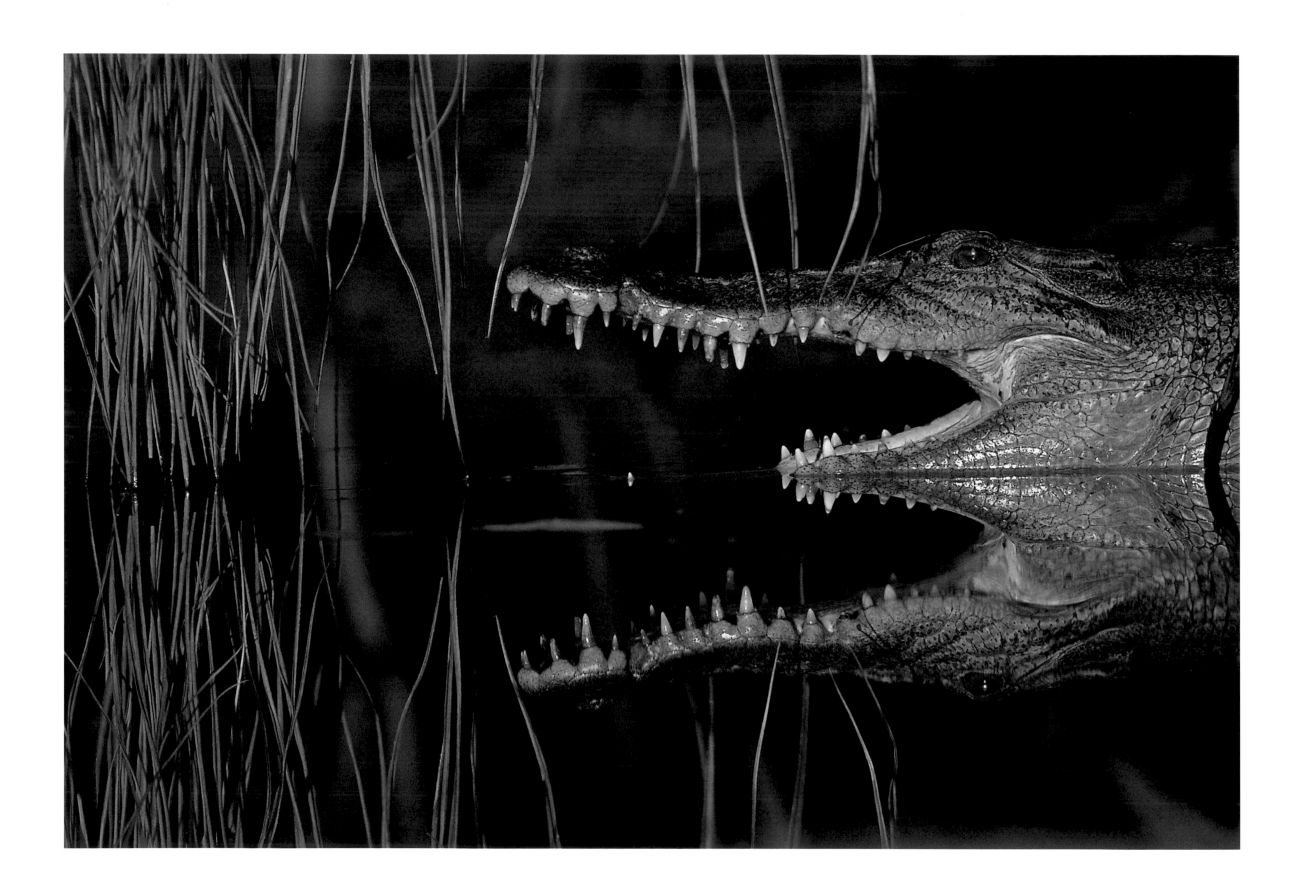

On the opposite page,
on Yellow Water, a part of a billabong on which tours
are conducted, crocodiles are accustomed to seeing boats,
which makes a photographer's life easier.

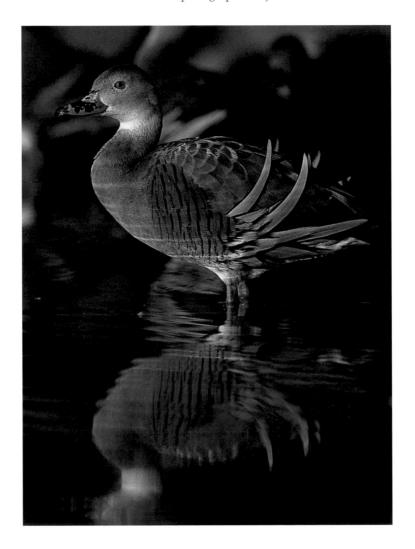

Whistling ducks spend most of their days on the water
and feed at night. They are closely watched
by crocodiles, which will regularly try to grab one.
(I never saw a successful attempt.)

*Comb-crested jacanas are said to nest
all year round. Their nest is merely a little platform of floating vegetation,
designed to rise or fall with changing water levels.*

*On the opposite page,
although intermediate egrets have a worldwide distribution,
their presence is always impressive and welcome.*

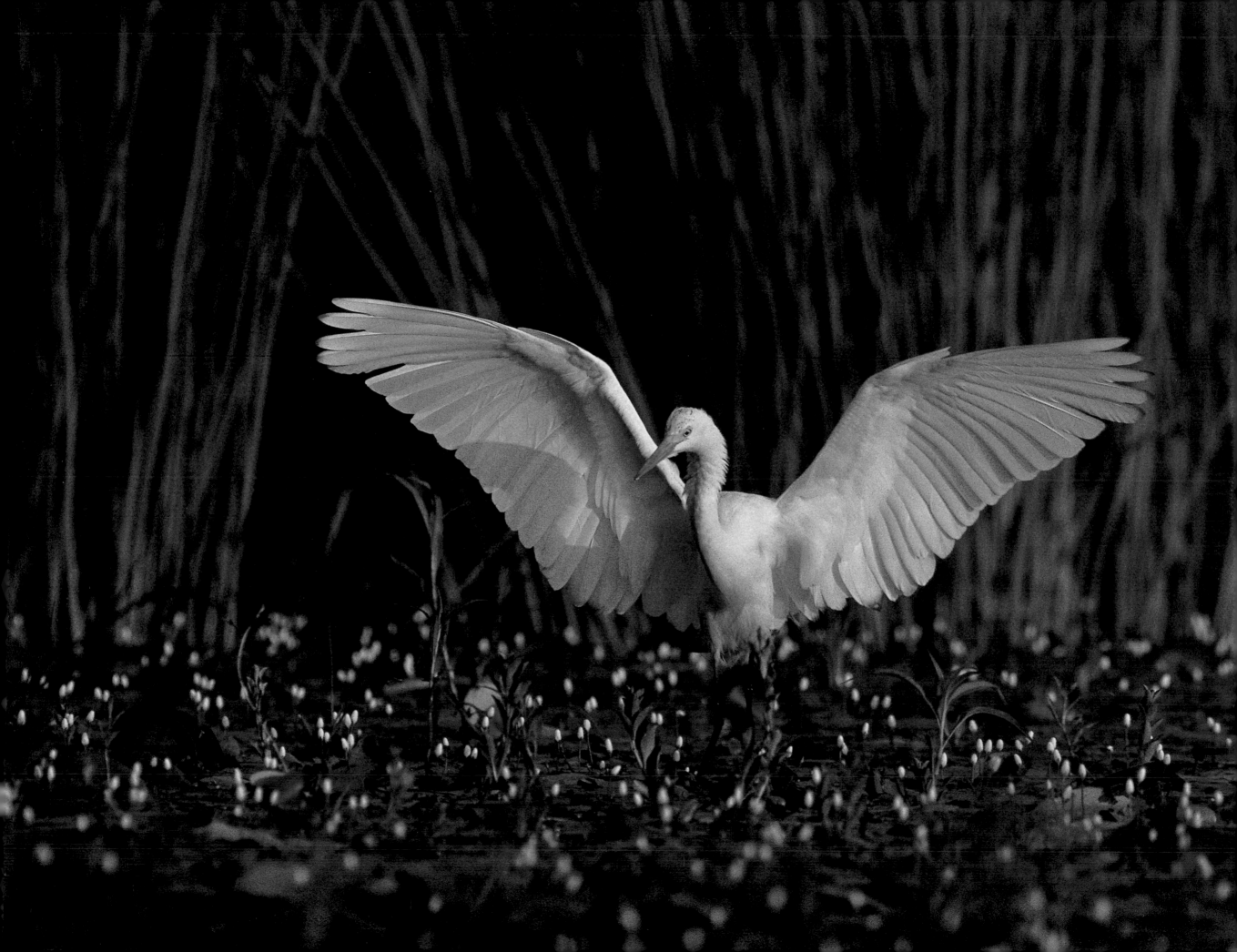

THOMAS D. MANGELSEN

Devoted to a lifetime of documenting the natural world, Tom (born in 1946 in the U.S.A.) spends more than 9 months a year in the field documenting the wild lands and creatures he so cares about.With a background in wildlife biology, he has worked both in cinematography and in still photography, mediums that he believes will touch people on an emotional level and move them to love and protect these fragile places and animals. All of Tom's prints have been captured in the wild, and none of his work has been created using computers. He was awarded Wildlife Photographer of the Year in 1994 by the BBC, and his work has also been published in leading magazines such as *Audubon*, *National Geographic, Life*, and *Wildlife Art*. He has been featured on television programs from "The Today Show" and "Good Morning America," to CNN's "World News." His images have been exhibited in museums across the United States, Canada, and Europe, and are permanently displayed in twelve Images of Nature Galleries across the U.S.

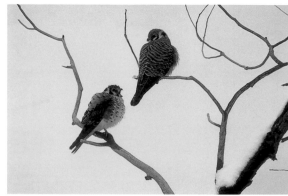

ANDRÉ BÄRTSCHI

Born (1953) and educated in Switzerland, André specialized in the natural history of tropical forests and traveled to Latin America for the first time in 1976. His work has been published worldwide in a number of nature books, including two about Manú and in magazines such as *Geo, BBC Wildlife, International Wildlife, Natural History, Smithsonian,* and *National Geographic*. In 1992, he was chosen the BBC Wildlife Photographer of the Year. Since his very first encounter with nature, he has always felt a sense of peace and happiness being in a tropical forest. The mysterious sounds one hears day and night fascinate him. The contrast between our modern human world called "civilization" and the splendor of a pristine tropical rainforest is what draws him to such distant places as Manú or Candamo. As a wildlife photographer, he strives to document the undisturbed beauty of tropical nature, but also the devastating effects of its systematic destruction, using his images as a powerful conservation weapon.

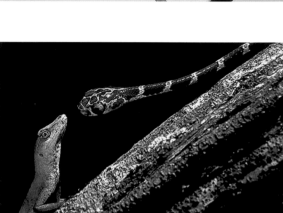
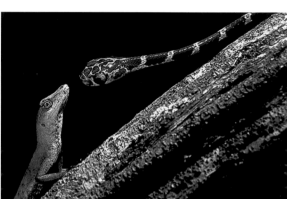

JAMES BRANDENBURG

Born in Minnesota in 1945, Jim began his career as a natural history photographer and filmmaker while majoring in studio art at the University of Minnesota, Duluth. In 1978, he became a contract photographer for *National Geographic*. He has since worked on numerous book and magazine projects with them. Brandenburg has published many best sellers, like *Brother Wolf. A Forgotten Promise* (1993) and *White Wolf. Living With an Arctic Legend* (1988). In 1981 and 1983, he was named "Magazine Photographer of the Year" by the National Press Photographers' Association (NPPA). In 1988, he was named "Kodak Wildlife Photographer of the Year" by the Natural History Museum-London and the *BBC Wildlife* magazine. Brandenburg's photographs have won a multitude of national and international awards with inclusion in *Life Magazine Collector's Edition-The World's Best Photographs. 1980-1990*. In 1991, he was the recipient of the World Achievement Award from the United Nations Environmental Programme in Stockholm, Sweden.

TUI DE ROY

Tui has lived in the Galápagos Islands since she was two, when her family moved there from Belgium, where she was born in 1953. She never attended school, being home taught and learning from nature. She became the first national park licensed naturalist to serve the budding tourist industry. At the same time, an interest in photography coupled with her naturalist's interpretive eye helped to launch her life's career in nature photography and writing. Her first book was *Galápagos: Islands Lost in Time* (1980). She is also co-author of several other volumes and under their own logo "The Roving Tortoise," she and her partner Mark Jones published a photo gallery book, *Portraits of Galápagos*, in 1990. Her new book, *Galápagos: Islands Born of Fire*, appeared in 1998. Tui's photos and writings continue to appear regularly in major magazines. In addition, she has lectured extensively in various parts of the U.S.A., and is currently on the editorial masthead of two nature magazines, *Ocean Realm* and *International Wildlife*. She lives in New Zealand.

ART WOLFE

Born in Seattle, 1951. Art's photographs are recognized throughout the world. By employing artistic and journalistic styles, he documents his subjects and educates the viewer. Over the course of his 20-year career, he has worked in every continent and now spends nearly nine months of the year traveling. Named 1998 Outstanding Nature Photographer of the Year by the North American Nature Photography Association and 1996 Photographer of the Year by *Photo Media* magazine, Wolfe is consistently praised for his vision and control of subtle color differences and lighting. Art published nine books in 1997, including *Primates, Rhythms from the Wild,* and *Tribes.* He has released 41 books to date. In 1998, the National Audubon Society recognized Wolfe's work in support of the national wildlife refuge system with its first-ever Rachel Carson Award. Art's stunning images interpret and record the world's fast-disappearing wildlife, landscapes, and native cultures, and are a lasting inspiration to those who seek to preserve them all.

© Patricio Robles Gil

PATRICIO ROBLES GIL

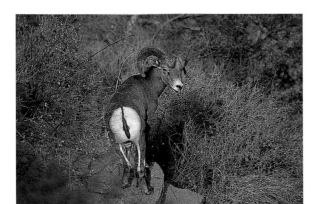

Born in Mexico City in 1954. As founder and president of Agrupación Sierra Madre, he has intensely promoted the conservation of nature. His photographs have appeared in different magazines such as *National Geographic, Outdoor Photographer,* and *Terre Sauvage.* He has worked as editor and one of the photographers for 11 books that he has produced. Outstanding among these are: the trilogy on Mexico's natural and cultural wealth; *Megadiversity. Earth's Biologically Wealthiest Nations,* which in 1998 won the Benjamin Franklin Award, and *Hotspots. Earth's Biologically Richest and Most Endangered Terrestrial Ecoregions.* His work as a promoter was recognized by the North American Nature Photography Association at its annual meeting in 1999. That same year he obtained honorable mention in the BBC Wildlife Photographer of the Year competition. This year he received the Management of Conservation of Nature Award given by the U.S. Fish and Wildlife Service.

© Patricia Rojo

MITSUAKI IWAGO

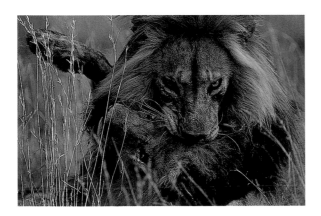

Born in Tokyo in 1950, Mitsuaki has been involved with photography since he was a child. In 1981, he received the Kimura Award, one of the most prestigious awards for photography in Japan, for his work in *A Message from the Sea.* He has taken award-winning images in more than seventy countries for the past 25 years. His work has appeared in numerous magazines, including *National Geographic, Paris Match,* and *Life.* He is the author and photographer of several books, including the world best seller *Serengeti: Natural Order on the African Plain.* He published *Mitsuaki Iwago's Kangaroos.* More recently, he published his work in *Mitsuaki Iwago's Whales, In the Lion's Den, Snow Monkey,* and *Wildlife,* a 603-page volume. Other titles Mitsuaki has published include *Penguin's Land, Bossanova Dogs, Blue Cats, Nature Calls,* and *Australia.* He has also been working in the realm of video producing a program entitled "Mitsuaki Iwago's Nature World," in collaboration with the NHK, the Japanese T.V. network.

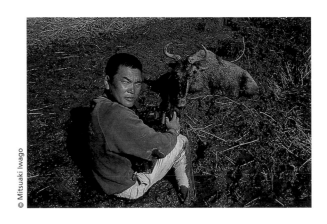

© Mitsuaki Iwago

FRANCISCO MÁRQUEZ

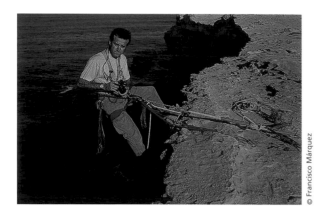

A Spanish national who was born in Paris in 1963, he always endeavors to show the ways and habits of wildlife related to its environment and humans. He is the author of several books and has contributed work to over 100 books published throughout the world. His photographs have appeared in magazines such as *National Geographic, Geo, El País Semanal, Terre Sauvage, BBC Wildlife, Natura, Wildlife Conservation, Canadian Wildlife,* and *Sinra.* He has participated in individual and group exhibits and given courses and lectures, always on the topic of nature, in different parts of Europe. In 1985, he received first prize in the "Foto Natura" contest organized by *Natura* magazine and Kodak in Spain. In 1989, he also won the "Newlook/Nature" contest organized by *Newlook* magazine and Canon in Spain; in 1994, he won second place in the BBC Wildlife Photographer of the Year competition. He is a founding member of the Spanish Association of Nature Photographers.

© Francisco Márquez

FRANS LANTING

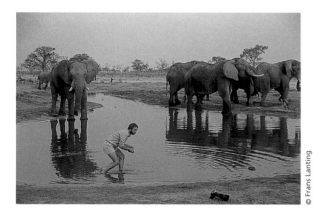

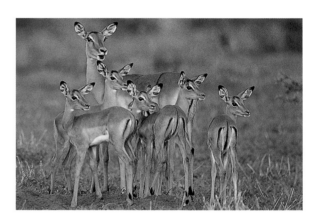

Frans Lanting (born in The Netherlands, 1951) has captured on film arresting images that illuminate seldom-seen aspects of the natural world. On commissions from *National Geographic,* he has tackled difficult assignments in Antarctica, Madagascar, Botswana, and the rainforests of Borneo, Belize, Peru, and the Congo Basin. Lanting's photos illustrate 10 books, four of which he wrote or co-wrote. He was named the BBC Wildlife Photographer of the Year in 1991 for his work in Botswana. Other awards include top honors in the 1988 and 1989 World Press Photo competitions, for his images of Madagascar and Antarctica, respectively. He is convinced that the formula for success for any photographer is "part science, part expedition skills, and part human relation skills." He is a founding director of the North American Nature Photography Association, a columnist for *Outdoor Photographer,* and a roving editor for the National Wildlife Federation, and serves on the board of the National Council of the World Wildlife Fund.

© Frans Lanting

GÜNTER ZIESLER

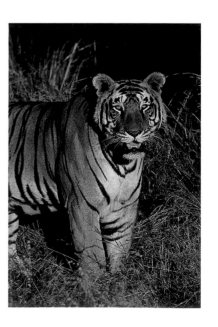

Günter (born in Germany, 1939) says his specialty is not to be specialized. He loves all that is wildlife, be it a minute insect or a majestic tiger. He also loves nature's different expressions and landscapes, from the abundance of life in a tropical rainforest to the arid desert. Obviously, he has evolved some preferences during the past 30 years. A tropical rainforest with its abundance of life forms and secrets fascinates Günter the most, where he likes to wander for days on end, not encountering another human being. Unfortunately, it is also one of the most difficult places for a wildlife photographer. In 1984, he published with his partner Angelika Hofer their first book together, *Safari: The East African Diaries of a Wildlife Photographer,* published in six languages. In 1986, with his Indian friends Valmik Thapar and Fateh Singh Rathore, Günter published a book on the Indian tiger, and in 1987, *A Summer with Geese* was published in four languages. During the past six years, Günter has produced more than 20 large-format calendars and is a contributing photographer to numerous other books; his work is frequently featured in nature magazines worldwide.

© Günter Ziesler

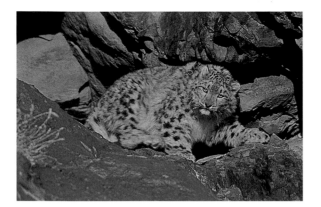

FRITZ PÖLKING

Fritz has been photographing nature for 40 years and is one of the most widely-admired wildlife photographers in the world. Born in Kerfeld, Germany in 1936, he grew up photographing the songbirds that nested in the garden of his family home. He has since won many awards for his photography, including the BBC Wildlife Photographer of the Year competition in 1977. His images of the world's wildlife have appeared in magazines including *Geo*, *National Geographic*, *Der Stern*, and *International Wildlife*. He has published more than 10 books as author or co-author, including *The Art of Wildlife Photography* and a book on cheetahs, *Geparde*, with fellow German photographer Norbert Rosing. He has traveled widely in Africa, Asia, Europe, America, Antarctica, and some of his favorite places are the Masai Mara in Kenya, South Florida in the U.S.A., and the Bavarian Forest in Germany. Fritz lives with his wife, Gisela, in Greven, Germany.

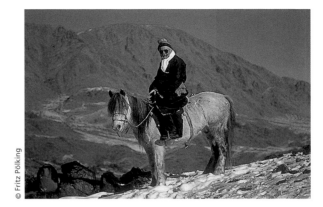

© Fritz Pölking

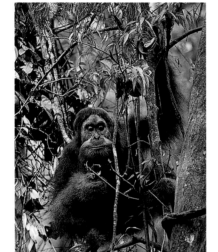

ALAIN COMPOST

All the work of photographer Alain Compost (born in Paris, France in 1952) has been taken among the islands of the Indoncsian archipelago which has been his home for the last 25 years. He lives with his Indonesian wife and three children in Bogor in West Java. On this exciting archipelago, people are a vital part of the ecosystem and Alain has built a huge portfolio of transparencies covering all aspects of life in one of the world's most biologically diverse areas. Since 1976, Alain has been supplying photos for agencies like Bruce Coleman and Bios. His work has appeared in magazines such as *National Geographic*, *International Wildlife*, *BBC Wildlife*, *Science and Nature*, *Paris Match*, and *Figaro*. He is also an experienced 16 mm and video cameraman who has worked for Anglio TV's Survival series, BBC and TV New Zealand Natural History Units, TF1 Ushuaia, Canal Plus, Discovery, and Animal Planet channels. He has been involved as the main photographer in a large number of coffee table and guide books. *Green Indonesia*, published by Oxford University Press, is one of the best representations of his work.

© Alain Compost

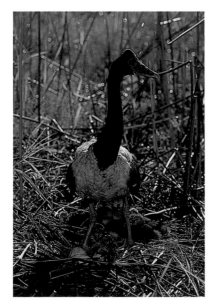

JEAN-PAUL FERRERO

Born in France in 1950, Jean-Paul has been interested in natural history since his childhood, when he was particularly interested in herpetology. Jean-Paul's wide knowledge of wildlife is based upon his thousands of hours spent patiently watching nature followed by meticulous and exhaustive reading. He decided to suspend his studies in psychology to travel and photograph wildlife. His first major project came in 1973 in Australia, where he lives since 1982. Besides photographing nature in his adopted country, he has widely covered areas such as India, Borneo, Antarctica, Papua New Guinea, and Kenya. In 1985, he created the very well-known natural history photo agency Auscape International. His work has been published by major magazines worldwide, as well as in many books. He lives in Sydney with his partner Anne and their son Kallen.

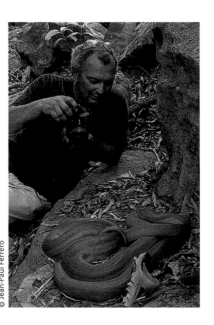

© Jean-Paul Ferrero

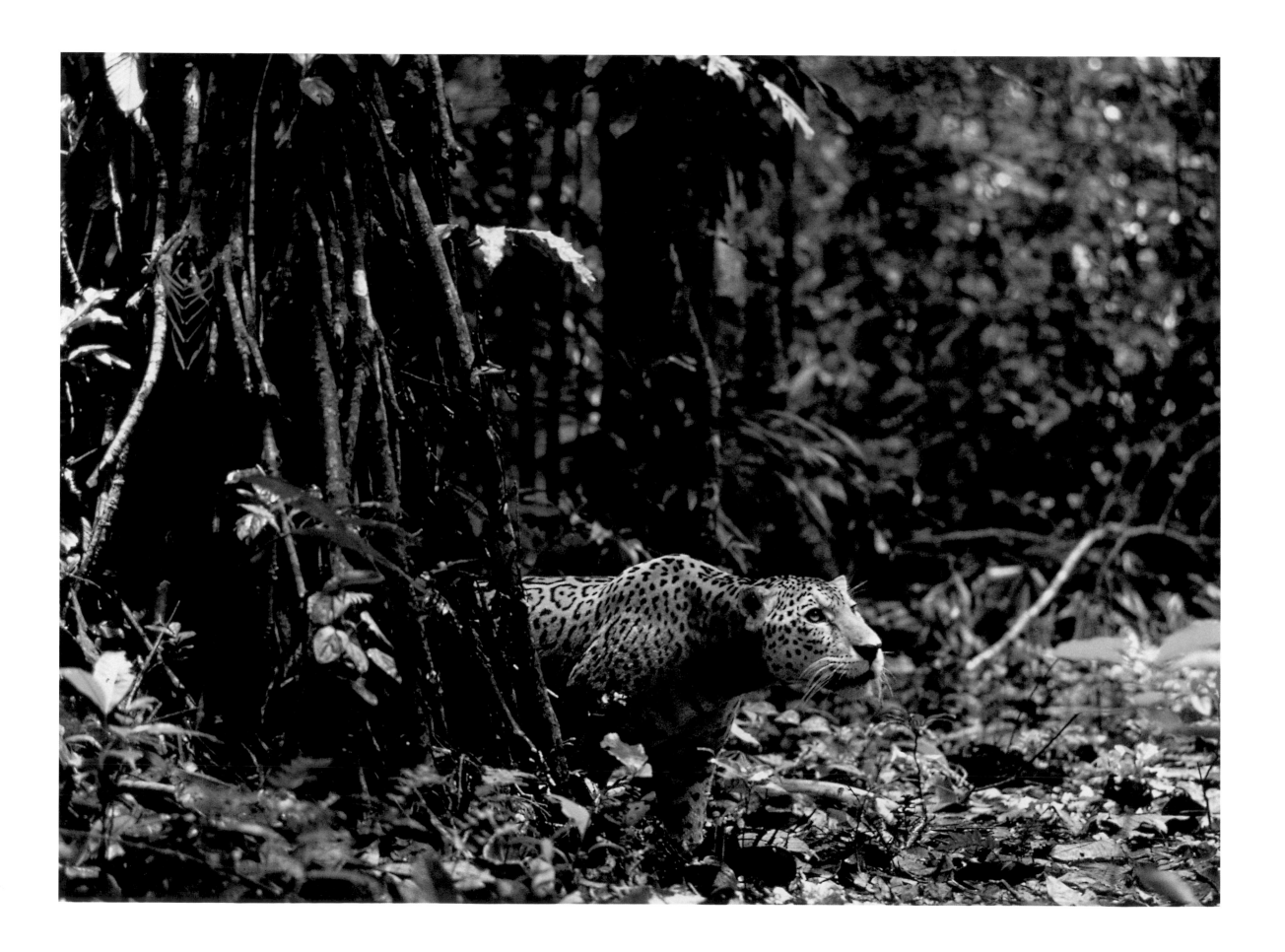

MEXICO

PRODUCTION Agrupación Sierra Madre, S.C., Redacta, S.A. de C.V. EDITORIAL DIRECTION Antonio Bolívar EDITORIAL REVISION AND CORRECTION Susan Beth Kapilian
GRAPHIC DESIGN AND PHOTO EDITING Patricio Robles Gil, Pablo Cervantes, Juan Carlos Burgoa EDITORIAL ASSISTANCE Gabriela Said TYPESETTING Socorro Gutiérrez
MAPS Álvaro Couttolenc, Oswaldo Barrera GENERAL COORDINATION Eugenia Pallares, María Luisa Madrazo, Elena León, Rosalía Luna

SPAIN

PRINTING LIAISON Turner Libros, S.A. PHOTOMECHANICS IndesColor Digital, S.L. PRINTING Julio Soto, S.A.
BINDING Encuadernación Ramos, S.A. GENERAL SUPERVISION Mila Olano

First English edition, 2000

Copyright of this edition is the property of CEMEX, S.A. DE C.V. Copyright 2000, Agrupación Sierra Madre, S.C., Prado Norte 324, 11000 Mexico City.
All rights reserved. ISBN 968-6397-61-2 D.L.: M-35.717-2000 Printed in Spain on Creator Ivory paper made by Torraspapel, S.A.

ACKNOWLEDGEMENTS

Rajesh Bedi, Ernesto Bolado Martínez, Greg Burson (Fuji Film), María Luisa Carranza, Fermín Carrillo Gutiérrez, María de los Ángeles Carvajal, Guillermo Castilleja,
Carlos Castillo, Comunidad Seri Conca'ac, Conservation International-Mexico, Conservation International-U.S.A., Jack Dykinga, Fulvio Eccardi, Stephen B. Freligh,
Elisa García Mijares, William Garrett, David Huerta, Sandy Laham, Raymond Lee, Carlos Manterola, Jesús Enrique Martínez, Roderic B. Mast, Larry Minden,
Cristina and Russell Mittermeier, José Ignacio Moreno, Francisco Navarro, North American Nature Photography Association, Raúl Pérez Madero,
Felipe Ramírez, Reserva de la Biosfera El Pinacate y Gran Desierto de Altar, Reserva de la Biosfera Islas del Golfo de California, Felipe Rodríguez, Patricia Rojo,
Guadalupe Sandoval, Bob Schalkwijk, George Schaller, Secretaría de Medio Ambiente, Recursos Naturales y Pesca (Mexico), Jorge Soberón, Enriqueta Velarde,
World Wildlife Fund-Estados Unidos, World Wildlife Fund-México

On p. 1, volcanic eruption. Spatter cone formation and lava fountaining from radial fissure. Cerro Azul, east flank. Isabela Island, Galápagos. © Tui De Roy;
on p. 2, El Pinacate and Gran Desierto de Altar. © Patricio Robles Gil; *on pp. 4-5, Absaroka-Beartooth Wilderness Area, Yellowstone.* © Thomas D. Mangelsen;
on p. 6, sandstone in kombologie formation, tropical rainstorm approaching. Kakadu. © Jean-Paul Ferrero; *on pp. 8-9, Tiburón Island, Gulf of California.* © Patricio Robles Gil;
on p. 10, trees on the raña. Cabañeros. © Francisco Márquez; *on pp. 12-13, elk in the Firehole River, Yellowstone.* © Thomas D. Mangelsen;
on p. 16, tiger with its prey, a nilgai. Ranthambhore. © Günter Ziesler; *on p. 19, blue-footed booby. San Pedro Mártir Island, Gulf of California.* © Patricio Robles Gil;
on pp. 20-21, morning mist, Jackson Hole Valley, Grand Teton National Park. © Thomas D. Mangelsen; *on p. 304, jaguar in Manú.* © André Bärtschi;
on pp. 306-307, saguaros, paloverdes, and cholla cacti, El Pinacate. © Patricio Robles Gil; *on p. 308, early morning clouds, eastern edge of the Andes.* © André Bärtschi

This book is dedicated to Jean-Paul Ferrero, who died in September, 2000

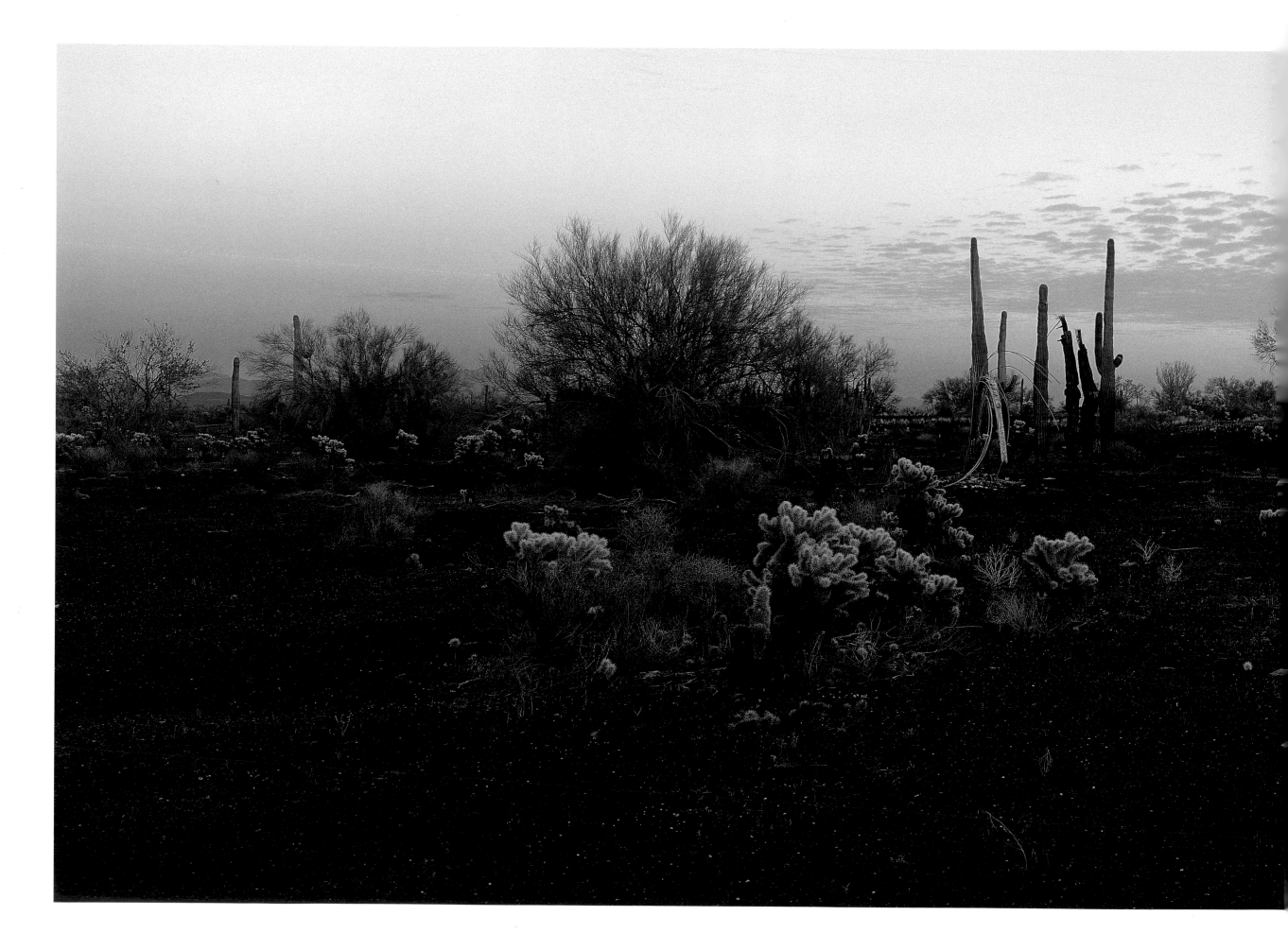

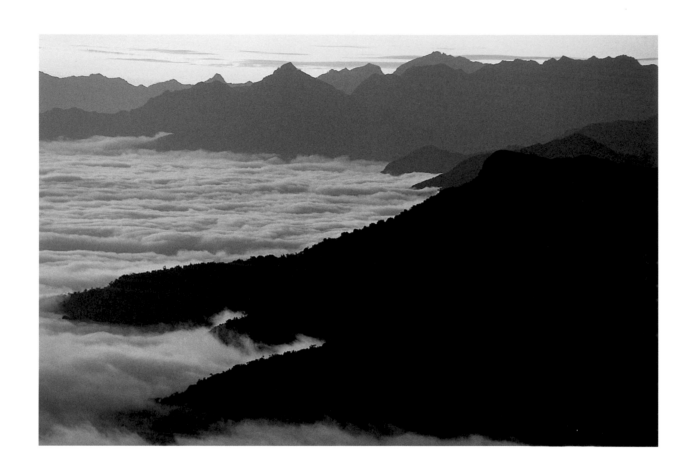